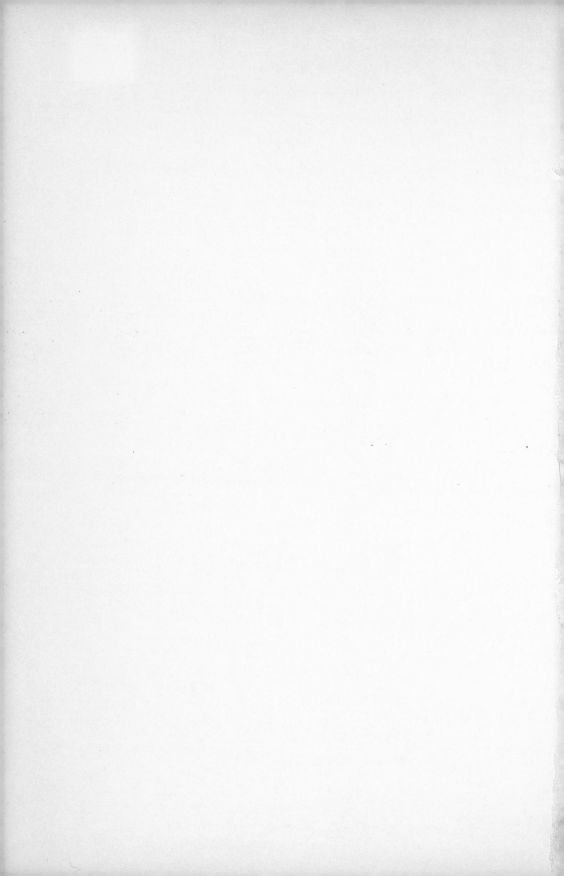

The Political Theory of Painting from Reynolds to Hazlitt

THE POLITICAL THEORY OF PAINTING
FROM REYNOLDS TO HAZLITT

'The Body of the Public'

John Barrell

Yale University Press
New Haven and London
1986

For Tony Tanner

Designed by Mary Carruthers

Set in Linotron Times and printed in Great Britain at
The Bath Press, Avon

Library of Congress Catalog Card Number 86–50362

ISBN 0–300–03720–1

CONTENTS

taste *182*. The relation of form and fable *187*. The well-and ill-employed *192*. The history and division of art *199*. The knowledge and character of the painter *209*. Physiognomy, individuality, and the division of labour *214*.

PREFACE

'THIS WHOLE BOOK', wrote Blake, in the margin of his copy of Reynolds's *Discourses on Art*, 'was Written to Serve Political Purposes'. This book is written to reply, 'of course it was'. So what did Blake mean? Why should he have objected to the fact that the theory of painting set out in the *Discourses* was 'political'?—so were the arguments set out in his own writings on art. How could the fact have come as a surprise to him?—as we shall see, it was no secret, in the eighteenth and early nineteenth centuries, that the criticism of painting had no language to employ but a political language, and had no ambition to develop an approach to painting which was not political. If Reynolds and Blake had been able to imagine an approach which was, or which claimed to be, 'non-political', they could certainly not have imagined how such an approach could justify itself.

But Blake was using the word 'political' in a new sense; a sense which had developed too recently to be included in Johnson's *Dictionary* of 1755. Johnson offers two definitions of 'political': 'relating to politicks; relating to the administration of publick affairs'; and 'cunning; skilful'. Fourteen years later, Junius wrote to Sir William Draper that, to make good his objections to Junius's first letter, he should have proved in his reply that all the failures of the present administration were 'owing to the malice of political writers, who will not suffer the best and brightest of characters (meaning still the present ministry) to take a single right step for the honour or interest of the nation'. Junius's point is not that Draper thinks such writers 'cunning', though he certainly did think that; but that he thinks of them—to paraphrase the appropriate definition in the *OED*—as belonging to, or taking, a side in politics, and so as partisan, factious. To accuse someone's writing of being 'political' in this sense is now, but was not always, to disclaim that your own was 'political' in another; it was, on the contrary, to make that very claim.

What outraged Blake was his discovery that Reynolds's theory of painting was at the service of a particular political interest; and,

accordingly, in his own writings on art, he set out to do what Reynolds had certainly thought of himself, also, as doing: to develop an account of painting by which it would be revealed as 'for the honour or interest of the nation', and so as 'political' in the sense of 'belonging to the state and the body of citizens' (*OED*)—the body of the public. It is the attempt of Reynolds, Blake and their contemporaries to do this—and to decide, as an essential first step, who were the 'citizens' to whom art belonged—that is the subject of this book.

ACKNOWLEDGEMENTS

THIS BOOK began as a seminar-paper on Reynolds and Johnson, written when I first began teaching, with Norman Bryson, a course at Cambridge on eighteenth and early nineteenth-century theories of art and literature, and much of what I have come to think about Reynolds, and about Hazlitt, is the result of my efforts to answer Dr Bryson's searching criticisms. Much of what I have to say about Blake is similarly the result of talking and teaching with David Simpson, who read the first draft of my chapter on Blake and commented on it with characteristic thoughtfulness. The more general argument of the book owes much to Harriet Guest, Sam Kerridge, and Christopher Prendergast, who patiently listened to some very rambling accounts of what I was trying to do, and somehow managed to point them in directions more likely to lead somewhere. There are traces, throughout the book, of observations or information offered by Liz Bellamy, Tim Clark, Stephen Copley, Stephen Daniels, Peter De Bolla, Nigel Everett, John Gage, Nigel Leask, John Mullan, Nicholas Penny, Michael Rosenthal, Keith Snell, David Solkin, Tony Tanner, Anne Wagner, and Tom Williamson. The final form of the book owes a great deal to the immensely attentive report of the anonymous reader for Yale University Press, to John Nicoll, who encouraged and commissioned the book, to Mary Carruthers, for her careful editing of the manuscript, to Janice Gray and Philippe Harari, who typed the manuscript with speed as well as accuracy and to Karen Rigby, who helped with reading the proofs. The book is dedicated to Tony Tanner, whose friendship made my thirteen years at Cambridge so oddly tolerable: I hope that to put it like that will not seem to him too inadequate a way of acknowledging my incalculable obligations to him.

John Barrell
Brighton, April 1986.

LIST OF ILLUSTRATIONS

INTRODUCTION

A REPUBLIC OF TASTE

1. Introductory: the scope of the book

THIS BOOK tells a story, and it can be summarised as follows. In the early decades of the eighteenth century in England, the most influential attempts to provide the practice of painting with a theory were those which adopted the terms of value of the discourse we now describe as civic humanism. The republic of the fine arts was understood to be structured as a political republic; the most dignified function to which painting could aspire was the promotion of the public virtues; and the genres of painting were ranked according to their tendency to promote them. As only the free citizen members of the political republic could exhibit those virtues, the highest genre, history-painting, was primarily addressed to them, and it addressed them rhetorically, as an orator addresses an audience of citizens who are his equals, and persuades them to act in the interests of the public.

This theory, enunciated by Shaftesbury and, less wholeheartedly but no less influentially, by Jonathan Richardson, was not so much challenged as attenuated in the middle decades of the century, by writers less persuaded than Shaftesbury of the importance of the distinction between public and private virtue. This development could be understood by the discourse of civic humanism, in its purest, severest form, only as evidence of the corruption of the state and the dissolution of public spirit, for it was related to the belief that in a complex, modern, commercial society, a society divided by the division of labour and united only in the pursuit of wealth, the opportunities for the exercise of public virtue were much diminished, compared to what they had been in, for example, the republics of Greece, and the importance of the private virtues, and even of what civic humanism regarded as private vices, was much increased. In fact, the mid-century writers on painting and on taste preserve the

language of civic humanism almost intact: we find the same denunciations of luxury, of selfishness, of those who fail to approach painting as a liberal art. But the function of painting has become crucially different: it is now to promote not public, but 'social' virtues, whether public or private.

With the foundation of the Royal Academy, however, in 1768, it became necessary to insist more firmly on the claim that painting had a definite public function; for the Academy was a public institution, at least insofar as its patron was the king; and though George III could occasionally extend his patronage to individual painters, 'not as a *King*, but as a private *Gentleman*', it was well understood that his task, as a patron of the Royal Academy, was to promote the arts in his capacity as 'the head of a great . . . nation'. The Academy was 'an ornament' to the 'greatness' of Britain; its institution was 'in the highest degree interesting, not only to . . . Artists, but to the whole Nation'. The President of the Academy was chosen for his 'known public spirit', the 'BODY of ARTISTS' was a public body, its members were 'public men'. As such, they had a duty to their country: to 'prove' their 'patriotism', and to justify the Academy as 'highly worthy of the protection of a patriot-king, of a dignified nobility, and of a wise people'.[1]

If the Academy was to be represented, and its existence justified, as a public body, this could be done only by reiterating the claim that painting was an art whose function was to promote the public interest, and that claim could be made only by reasserting, in the language of civic humanism, that painting could create or confirm the 'public spirit' in a nation. But the very factors that had led to the attenuation of that claim in the mid-century made it impossible simply to reaffirm it now, without qualification or without an attempt to take account of how modern Britain differed from Periclean Athens, renaissance Florence, or from the ideal polity imagined by Shaftesbury. It was therefore necessary to consider how 'public spirit' might manifest itself otherwise than by acts of public virtue; or to ask how, in a nation where the division of labour had so occluded the perspectives of its members that none of them, or almost none, could grasp the 'idea' of the public, the art of painting could be used to restore that idea to them. It was necessary to ask if painting could represent the private virtues as, after all, public—in such a way as would make it possible to argue that history-painting was still the most dignified branch of the art, and dignified because, even when it promoted the private virtues, it was still promoting the public interest; or to ask whether, if the civic humanist vision of the public had now entirely faded, painting might still be understood as capable of representing a ground of

social affiliation which could substitute for that lost public space. The chapters that follow, on Reynolds, James Barry, Blake and Fuseli, and the pages on Haydon in my final chapter, examine how the civic humanist theory of painting was variously adapted, in answer to such questions, so as to permit the argument that the art could still perform a public function in a society in which, according to Fuseli, 'the ambition, activity, and spirit of public life is shrunk to the minute detail of domestic arrangements', and in which 'every thing that surrounds us tends to show us in private'.[2] This introduction examines the civic humanist theory itself, as it was propounded in the first half of the century by Shaftesbury, Richardson, and George Turnbull, and the attenuation of that theory by such writers as Burke, Alexander Gerard, and Daniel Webb; and it offers some account of how that process of attenuation occurred.

2. *The discourse of civic humanism*

Before we proceed, we shall need some account of the discourse of civic humanism, and I shall borrow one from J. G. A. Pocock:

> Since the revival of the ideal of active citizenship by Florentine civic humanists, there had been a gathering reemphasis on the ancient belief that fulfillment of man's life was to be found in political association, coupled with an increasing awareness of the historical fragility of the political forms in which this fulfillment must be sought. *Virtue* could only be found in a *republic* of equal, active, and independent citizens, and it was a term applied both to the relations between these citizens and to the healthful condition of the personality of each one of them; but the republic was peculiarly exposed to *corruption*—a state of affairs often identified with the dependence of citizens upon the powerful, instead of upon the public authority—and the corruption of the republic must entail the corruption of the individual personality, which could only flourish when the republic was healthy.[3]

This section of my introduction is offered as a comment on that account, and will attempt to situate it in relation to civic humanist writings of the early eighteenth century in Britain.

When Pocock writes of the corruption of the 'individual personality', he does not intend to suggest that the discourse of civic humanism identifies the uncorrupted individual personality as a site or source of value, or not in such a way as a century and a half of the use of that phrase in liberal thinking about politics and ethics might

encourage us to interpret it. For, as he has pointed out, though it is an essential tenet of civic humanism that 'the integrity of the polity must be founded on the integrity of the personality', that integrity 'could be maintained only through devotion to universal, not particular goods'. An attention to 'individual personality', recognised as such by virtue of its difference from the individual personalities of others, invites the charge, in civic humanist writings, of 'singularity', or 'caprice', a wilful refusal, continually or occasionally indulged, to pursue one's true nature and identity: which is to be a *politikon zoon*, a being formed to live in a city, to live in partnership with others, and so to regard the fulfillment of personal development as being achieved only when one has entirely identified one's own interests with those of the public of which one is a member.[4] The measure by which, in a civic humanist polity, the personality of an individual is distinctive, is the measure by which he has failed to subordinate his own interests to, or to identify them with those of his fellow-citizens, considered in their ideal fulfillment. It is the measure, indeed, of how much he has still to do, to become truly a citizen.

It follows that the virtue pursued by the citizen of a republic is public virtue: the private virtues, of which Hume offers as examples *'prudence, temperance, frugality, industry, assiduity, enterprise, dexterity'*, are those which make men 'serviceable to themselves, and enable them to promote their own interest', but they are not 'such as make them perform their part in society'; and, evidently, if a man pursues those virtues with more zeal than he pursues the public virtues, he will attract the charge of pursuing his own interest more zealously than the interests of the public. What, then, are the 'public virtues'? James Thomson identifies them as 'independent life', 'integrity in office', and—supreme over these—'a passion for the commonweal': only on the basis of these, he insists, can a free state survive. Of these, the first defines the essential qualification for active citizenship, for participation in the councils of the state, and independence was represented and guaranteed either (according to Machiavelli) by the right of a citizen to 'bear arms of his own in the public cause and at the command of public authority', or (according to writers such as Thomson) primarily by the ownership of heritable property in land, the income from which also guaranteed to the citizen the leisure necessary for engagement in political life; or by both. On the first of these qualifications, Pocock comments: 'equality among citizens was an equality in arms, and to give up one's arms to another was to give up a vital part of one's capacity for equality, citizenship, and virtue and to become the dependent of those who controlled arms and power'; the second, he situates in the context of

the ideal civic humanist polis as envisaged by James Harrington, one composed of a free hierarchy of independent property owners, responsible and therefore fit to have dependents, and 'those whom lack of property rendered incapable of independence, and so of citizenship'.[5]

The second of Thomson's public virtues is one which can be exhibited, obviously enough, only by a man who has achieved an elective office in the polis; who is a 'public man' in the narrow sense of being a *'publicus'*, a magistrate, and chosen to be so by virtue of his independence and his public spirit. 'Public spirit', on the other hand, a 'passion for the commonweal', or what Shaftesbury calls *'Common Sense'*, the *'Sense* of *Publick Weal*, and of the *Common Interest'*, was a virtue open to be exhibited by the citizen whether in office or not. It is the source of the principle of honour among men, which John Brown defines as 'the Desire of Fame, or the Applause of Men, directed to the end of public Happiness'. It is 'supreme', because it is the end for which 'independent life' exists, and the source of 'integrity in office'; as Shaftesbury explains, it is the term by which we distinguish 'the *natural Affections*, which lead to the Good of THE PUBLICK', from the *'Self-affections*, which lead only to the Good of THE PRIVATE'. 'To love the Publick', he writes, 'to study universal Good, and to promote the Interest of the whole World, as far as lies within our power, is surely the Height of Goodness, and makes that Temper which we call *Divine*.'[6]

The question reasonably occurs, can we really call that temper 'divine', when the scriptures take so little account of the public virtues as defined in the *Characteristicks*? To this, Shaftesbury offers an answer intended to secure the position that the pursuit of public virtue is not only compatible with the doctrine of the scriptures, but is positively the most virtuous pursuit open to us. The scriptures, he argues, concentrate on those virtues the exercise of which carries the promise of a heavenly reward, and they leave *'Private Friendship*, and *Zeal for the Publick*, *and our Country'* as 'Virtues purely voluntary in a Christian': for 'had they been intitled to a share of that infinite Reward, which Providence has by Revelation assign'd to other Dutys', then 'there wou'd have been no room left for *Disinterestedness'*—for virtue pursued for its own sake, exactly, indeed, as the public good is pursued by the ideal citizen.[7]

These remarks by Shaftesbury raise two issues which may seem to fit awkwardly within the account of public virtue I have so far been offering. First, surely *'Private Friendship'*, even if it does not seem to be well-described by placing it among the *'Self-affections'*, still leads only to 'the Good of THE PRIVATE', and is therefore a private virtue? So

it may be; but it differs from the private virtues listed by Hume in two important ways: it is represented by Shaftesbury as being, unlike them, disinterested; and it is so far from being the same thing, he explains, as *'that common Benevolence* and *Charity* which every Christian is oblig'd to shew towards all Men', that it is one of the 'heroick Virtues'. It is found among heroes only, and, in civic humanist writing, Shaftesbury's included, a hero is one who does 'more than merely his duty' to the public. Private friendship may thus be a private virtue, but it is the private virtue peculiarly exhibited by 'the public Soul' of 'Patriots, and of Heroes'.[8]

Secondly, Shaftesbury's account of the divine temper surely extends far beyond simple patriotism, or simple love of the political public of which one happens to be a member? So it does: but so far are true patriotism and the attempt 'to promote the Interest of the whole World' from being incompatible, that they are, within the discourse of civic humanism, virtually identical. For the true patriot does not seek to promote the immediate and short term interests of the public in which he is a citizen: he promotes the interests of that public as it is composed of men who share a universal human nature, with each other and with the members of other publics. That universal human nature finds its fulfillment, as we have seen, in political life, in membership of '*a civil* STATE or PUBLICK', where 'Virtue' is 'the Interest of every-one'[9]; and to promote that fulfillment in one's own country is to perform an exemplary function for the citizens of all countries. For that reason, states may even regard themselves as in competition with other states in the degree to which they enable their citizens to fulfill their civic destiny, for, when they do so, they are striving only to be examples of a universal civic virtue to each other.

From all that has been said so far of public virtue, it will be clear that it is not a mode of virtue open to be exercised by all the inhabitants of a country. If 'independent life' is a qualification for citizenship, and so for the opportunity of exercising 'integrity in office', then whether that independence is based on arms or on land it cannot be made a qualification that many possess. If the prime object of civic humanist political theory is to ensure, as far as possible, the security and the survival of the state, arms cannot regularly be entrusted to the majority of its inhabitants, for, as we shall see, the majority have no 'common sense', no 'passion for the commonweal', and to arm them would give 'the power to decide whether the constitution shall stand or fall' to those incapable of exercising it responsibly. If independence, on the other hand, is seen as primarily guaranteed by the ownership of land, still an individual would require to own land in considerable quantity to be truly independent, not only of others but

of the need to work for a living, and so to have the leisure to occupy himself in public affairs. For as Aristotle, most fully, had explained, leisure was needed for the development of civic virtue and for active participation in politics: a citizen must be released from the menial occupations of a mechanical or mercantile life; occupations that were 'illiberal'—unworthy of a free man.[10]

The distinction between the liberal, the free man, and the mechanic, was essential to the account of citizenship offered by civic humanism, as it had been to Aristotle. According to Aristotle, the condition of the mechanic or artisan made him as unfit for citizenship as was the slave. Though slaves differed from mechanics, insofar as slavery was a 'natural' state, whereas the mechanic life, a sort of 'limited slavery', was 'unnatural', both classes of men shared two related characteristics. To begin with, both were more or less unreasonable: slaves could 'apprehend' reason but could not 'possess' it, while mechanics 'neither understand reason nor obey it but obey their instincts only'. Both exist, finally, only for the satisfaction of the wants of those whom their labour supports, the independent citizens of a state.[11] Second, neither was fit for the practice of virtue: slaves have no 'purposive life', and are capable only of such passive virtues as fit them to be the ancillaries of those who do; and 'there is no element of virtue in any of the occupations in which the multitude of artisans and market-people and the wage-earning class take part'. In no polity, therefore, of whatever form, are slaves regarded as citizens; and though in 'extreme democracies' mechanics have been accorded the privileges of citizenship, in the best polities they are never to be found citizens, for the true citizen is capable of governing, which mechanics are not.[12]

In early eighteenth-century Britain, such arguments as these of Aristotle (and many of them have their equivalents in Plato and other classical writers) took on a form which was to be crucial, as we shall see, for the development of a civic humanist theory of art. Those who follow a mechanical trade will have three things in common, it was believed, which will disable them from the pursuit of public virtue. A man who follows such a trade, it was pointed out, will be following one, determinate occupation, and will discover an interest in promoting the interests of that occupation, and of his own success in it; and his concern with what is good for himself, or for one interest-group, will prevent him from arriving at an understanding of what is good for man in general, for the public interest, for human nature. Second, the experience that falls in the way of such a man will be too narrow to serve as the basis of ideas general enough to be represented as true for all mankind, or for the interests, even, of his own country.

Third, because mechanical arts are concerned with *things*, with material objects, they do not offer the opportunity for exercising a generalising rationality: the successful practice of the mechanical arts requires that material objects be regarded as concrete particulars, and not in terms of the abstract and formal relations among them. We can sum up these beliefs by saying that, to the mechanic, the 'public' is invisible; and that is why, for Shaftesbury, the 'mere Vulgar of Mankind' cannot act virtuously out of public spirit, but only out of '*servile* Obedience'; and, to ensure that obedience, they 'often stand in need of such a rectifying Object as *the Gallows* before their Eyes'. The man of independent means, on the other hand, who does not fret or labour to increase them, will be released from private interest and from the occlusions of a narrowed and partial experience of the world, and from an experience of the world as *material*. He will be able to see the public, and grasp the public interest, and so will be fit to participate in government.[13]

For these reasons, the discourse of civic humanism—at least in its aristocratic, which is arguably its only form—is concerned with virtue only insofar as it is public virtue, which is to say, only insofar as it is the virtue capable of being exercised by a political animal who is capable not only of being ruled but also of ruling. Civic humanist considerations of virtue are always directed to the questions of what factors affect 'the *Duration* of the public *State*', and, as John Brown explains, the 'three leading Circumstances on which the *internal Strength* of every Nation most essentially depends' are 'the *Capacity*, *Valour*, and *Union*, of those who *lead* the People'. For 'the Manners and Principles of those who *lead*, not of those who *are led*; of those who *govern*, not those who *are governed*; of those who *make* Laws or *execute* them, will ever determine the Strength or Weakness, and therefore the Continuance or Dissolution, of a State'. The distinction between those who do, and those who do not, have a claim to be regarded as citizens of a state, was taken, as Stephen Copley has written, 'as a providential fact of nature'—and it continued to be regarded as natural, long after it was easy to describe slavery, as Aristotle had described it, as a 'natural' condition.[14] 'It' (simply) 'happens with *Mankind*', wrote Shaftesbury, 'that whilst some are by necessity confin'd to Labour, others are provided with abundance of all things, by the Pains and Labour of Inferiors'; and 'some men', wrote Bolingbroke, 'are in a particular manner *designed* to take care of that government on which the common happiness depends' (my emphasis).[15]

I have described civic humanism as a discourse, and by that I mean what is usually now meant by the term: that it 'defines the subjects it

will treat in distinctive ways, formulating and giving prominence to particular problems and effectively excluding others from consideration'; and that, in doing so, it 'develops a characteristic vocabulary,' and 'establishes a particular order of priorities in its discussion and implies particular ideological valuations of the subjects it has defined'.[16] And most of all, I mean by that description to call attention to the fact that, as we shall frequently see in the chapters that follow, it is a mode of thinking or writing which may co-exist, whether comfortably or in conflict, with other discourses within the same text; and that it is not a static object, but may be modified by the contexts in which it is discovered, and may modify its vocabulary and its objects of consideration to some degree, before we may choose to decide that a new discourse can be identified as having emerged from the matrix of the old. If my account so far of the discourse of civic humanism has represented it as a body of doctrine which exists uncontaminated and self-contained in the texts I have cited, that impression will disappear, I hope, as this introduction proceeds. But it is an impression deliberately created, for if we seek to consider the progeny, the mutations, the transformations of a discourse, and its relations with other discourses, we seem to need to begin by picturing it as exactly the 'static object' which, in the texts we examine, we will find it never to be.

I make this point particularly to enable me to comment on my earlier suggestion, that the aristocratic form of the discourse we have been examining was 'arguably its only form'. Stephen Copley, among other intellectual historians, has recently claimed that:

> From early on in the century, an alternative version of the humanist tradition is developed by advocates of the newly emergent bourgeois society. In the works of Defoe, Addison, Steele and their contemporaries the value of an aristocratic governing élite in society remains unquestioned, but traditional humanism is redefined to accommodate commerce in its vocabulary of civic virtues, and the definition of the establishment is widened to celebrate the place and values of the middle class citizen.[17]

It would be a lengthy exercise to discuss whether this 'bourgeois' form of civic humanism can be regarded as a form of it at all, if commerce and the private virtues of 'the middle class citizen' are included among its objects of approbation. It will be exactly by their inclusion, of course, that the 'traditional' humanism of Shaftesbury and others will be attenuated, in the middle and late eighteenth century, until it is made to seem too obviously obsolete to account for the social and

economic practices of a modern commercial nation. There is never-
theless a good deal of point in Copley's remark, for in the writings of
the authors he mentions, these new objects of approbation appear to
co-exist comfortably enough with the vocabulary which had been
developed in order to represent them as concerns not worth much
attention from the citizen. It is the achievement, perhaps of Steele in
particular, that he implants within the matrix of civic humanism the
embryo of a discourse which will eventually develop into a matricide,
but which, until it does, will derive many advantages from its associ-
ation with the virtues of its surrogate mother. As we come now to
consider the theory of painting which is a part of the discourse we
have been considering, we will find occasion to notice both the 'tradi-
tional' form of civic humanism, and something which, until it grows
larger and more threatening, may plausibly be described as its 'alter-
native' form, in the writings of Shaftesbury on the one hand, and of
Richardson on the other.

3. The civic humanist theory of painting

We have seen that civic humanist considerations of virtue are
directed towards describing and recommending those virtues which
will preserve a civil state, a public, from corruption. The nature of the
corruption that may infect the body of the public we shall soon con-
sider; for the moment, we should notice that civic humanist accounts
of the theory of painting are directed towards the same end. Prince
Hoare, one of the last writers on painting in Britain to use the vocabu-
lary of civic humanism almost undiluted, was still asserting at the end
of the first decade of the nineteenth century that 'the higher the state
of public taste and public virtue can be raised in any nation, and the
longer that state can be maintained, the higher and longer will be the
glory and pre-eminence, nay, perhaps the safety and existence of the
nation.' So obvious does this truth seem to him, as do the connection
between 'public taste' and 'public virtue', and the consequent truth
that it is the function of painting to instruct us in public virtue, that he
claims his assertion is 'superfluous': 'these are truths which all
acknowledge abstractedly', he writes, and it is only 'the attempts at
realising them practically' which form the 'points of difference in
opinion'.[18]

There may have been a good deal more hope than conviction in
Hoare's claim that the connection between public taste and public
virtue was, by 1810, a connection universally acknowledged; or if it
was, that may have been because, as we shall see at the end of this

introduction, the meaning of the word 'public' was more capacious when Hoare was writing than it had been to Shaftesbury a century earlier, and a universal agreement on the truth of Hoare's claim may not have involved a universal agreement as to its import. George Turnbull, writing in 1740, could have anticipated a rather less ambiguous assent to the summary he offered of Shaftesbury's account of the moral purpose of painting. 'The liberal Arts and Sciences', he writes,

> have but one common enemy, Luxury, or a false Taste of Pleasure; and to guard, defend, and fortify against the Disorder and Ruin which that introduces into the Mind, and brings upon Society, ought to be the main Design of Education: Which can only be done, by establishing early, in the tender, docile Mind, a just Notion of Pleasure, Beauty, and Truth, the generous Love of publick Good, and a right Taste of Life, and of all the Arts which add to the Happiness or Ornament of human Society. Thus alone can the Youth be qualify'd for publick Service, and for delighting in it; and thus only can they learn at the same time how to recreate themselves at hours of leisure, in a manly virtuous way, or without making one step towards Vice.

The liberal arts, by this account, guard the mind, and therefore society, against corruption, by teaching us a 'generous love of the publick Good'; and, as Turnbull elsewhere explains, whatever else they teach—'a just Notion of Pleasure, Beauty, and Truth', and 'a right Taste of Life'—is also conducive to 'the Good of Mankind', so that the study of the liberal arts is the study of public virtue.[19] And because this is the case, an education in the liberal arts is of use to those who may hope or expect to make a career in 'publick Service': it is the virtue of the free—in the sense of 'independent'—man, of the liberal man, the citizen, that is learned from the 'liberal' arts. This seems to be not just their primary but their exclusive function: like Shaftesbury and Brown, Turnbull has no doubt that it is on the virtues of such men that the safety of the state ultimately depends, and he shows no interest in the virtues of anyone else, and no sign that he believes anyone else to be capable of active virtue.

The passages I have just been considering will make it clear, I hope, that when I speak of a civic humanist theory of art, I am not speaking of a theory which simply *borrows* its terms of value from civic humanist writings on politics and morality. In early eighteenth-century Britain, as Pocock has pointed out, 'the dominant paradigm for the individual inhabiting the world of value was that of civic man', and the dominant language of value was a civic language.[20] It was certainly possible to employ this language in contexts which demanded

no particular reflection on the nature of the values it embodied—to use it, I mean, with no evident attention to the model of political life to which, in writers such as Shaftesbury, James Thomson, Bolingbroke and John Brown, it explicitly referred. But the values of civic humanism are not thus simply deposited as ideology in writings on the theory of art, except insofar as the objects and limits of any discourse are ideologically determined; its language is not adopted as a general language of approbation and disapprobation whose specific political reference is apparently unnoticed or left implicit, as it sometimes is in the literary criticism of eighteenth-century Britain; and this is so perhaps mainly because all writers on painting in Britain were obliged to address an issue which literary criticism was not obliged to address, and which made the particularly civic nature of the value-language of criticism, which might elsewhere have remained implicit, unambiguously apparent. This issue was whether painting, which, in common with the mechanical arts, was employed in converting the materials of nature into material artefacts, was truly a liberal art, and worth the attention of the gentleman-citizen whose attention it must solicit if its higher branches, at least, were to survive. When Joseph Weston remarked of the poetry of Pope, that it was 'more elaborately correct and more mechanically regular', 'more delicately polished and more systematically dignified' than Dryden's,[21] it is not clear that he intends by the use of that adverb 'mechanically', to accuse Pope of more than a certain laboured over-attention to technique. The same word used of a painter would have been unambiguous: it would have condemned the painter for a degree of over-attention that marked him as a mechanic, not as a citizen in the republic of the fine arts, and as one whose productions were not worth the attention of the citizens of the republic of taste, whose claim to citizenship was defined in more or less the same terms as defined their claim to citizenship in 'a *civil* STATE or PUBLICK'.

My point is that the civic origins of the value-language of literary criticism were not always displayed, and not that they never were, for those origins could always be indicated by reference, for example, to the 'republic of letters', the state-within-a-state on the model of which the republic of the fine arts, and a republic of taste, were imagined. As the civil state was divided, according to Brown, between 'those who *lead*', and 'those who *are led*', or, according to Burke, between those 'formed to be instruments' and those formed to be 'controls', so in the 'Commonwealth of Letters', some are 'Controulers' and some controlled, and the words that distinguish the two orders are invariably 'liberal' and 'mechanic'. According to Lanzi, writing under the patronage of the Grand Duke of Florence,

the social structure of the republic of the fine arts, in which painters aspired to be citizens, was more complex than this: it contained 'the senate', 'the equestrian order', 'the class of mediocrity', and the 'vulgar herd'; but, unsurprisingly, British writers are content with a simpler division, between liberal citizens and unenfranchised mechanics, both in the republic of the fine arts, and in the republic of taste, where the consumers of the arts were imagined to be gathered.[22] The structure of this republic is made clear by Burke, among numerous others, in his adaptation of Pliny's anecdote of the shoemaker who correctly criticised the representation of a sandal by Apelles, and the next day presumed to criticise also the anatomy of a leg.[23] In Burke's version, it is an anatomist who offers this second criticism; and though both men are right in their judgments, which are made with the authority of their occupational knowledge and directed towards the mere 'representation of sensible objects', Burke makes it clear that they are disqualified, by virtue of that very knowledge, to comment on the higher objects of art, 'the manners, the characters, the actions, and designs of men, their relations, their virtues and vices'. These 'come within the province of the judgment', and judgment is a faculty possessed only by those who have studied in 'the schools of philosophy and the world', and who therefore have a 'skill in manners, and in the observances of time and place, and of decency in general'. 'Taste by way of distinction' consists in 'a more refined judgment' than can be acquired by those who practice a particular trade, and whose narrow interests afford them no general view of 'the world'. The 'controulers', the citizens of the republic of taste, are gentlemen.[24]

4. The qualification for citizenship in the republic of taste

The suggestion that painting was not an art worthy of a free citizen had been made most authoritatively by Plato, who had argued that painting imitated the mere appearance of particular material objects; that in doing so it was 'far removed from truth . . . and associates with the part in us that is remote from intelligence', and that therefore the painter as well as the poet was rightly to be excluded from the properly run state, 'because he stimulates and fosters' the lower elements in the mind, and by strengthening them 'tends to destroy the rational part, just as when in a state one puts bad men in power and turns the city over to them and ruins the better sort'.[25] The refutation of Plato's arguments was already a routine exercise by the early eighteenth century, and one designed to reveal that painting

respected the order of values by which the intellect, like the 'better elements' in a state, was maintained in a position of dignity above the lower elements in the mind and society alike, and that, therefore, the republic of taste did not threaten to invert the social distinctions essential to the proper running of a state, but confirmed those distinctions by replicating them in itself.

The first step was to assert that Plato's objections apply only to the abuse of painting, and not to its proper and moral use: though painting was indeed an imitative art, committed still more evidently than poetry to material representations of an apparently material reality, its true function was to represent, not the accidental and irrational appearances of objects, but the ideal, the substantial forms of things. Painting was thus a liberal art insofar as it was an intellectual activity, disinterested, concerned with objects which, because ideal, could not be possessed; it was an abuse of painting to practise it in pursuit of objects which, because actual, particular, material, could be made the objects of possession and consumption, and thus appealed to our baser, sensual nature. If it could be established that the materials of nature could be used to represent its ideal forms, and that it could 'address the imagination' in spite of the fact that it 'is applied to . . . a lower faculty of the mind, which approaches nearer to sensuality', then it could be freely acknowledged that, when painting departed from its idealising function, to represent mere appearance and the merely particular, it did indeed become the *merely* imitative art, 'the poor child of poor parents' that Plato had described it as. It became, in short, a manual, not an intellectual activity; not a liberal but a 'servile' art, the art produced by a class of men who, because they perform 'bodily labour', are 'totally void of taste', 'incapable of thinking', unable to arrive at ideal conceptions of things, and so who hardly deserve 'to be called men'.[26]

Versions of this argument against Plato were common, of course, among French and German writers of the late seventeenth and eighteenth centuries, writers who were by no means wholly committed to the civic humanist theory of art I am describing.[27] I shall attempt, later in this introduction, to disentangle the civic humanist tradition in Britain from the schools of French criticism from which it borrowed, as well as from the writings of Winckelmann and Anton Raffael Mengs; but for the moment it will be helpful to borrow from Mengs his unusually comprehensive remarks on the distinction between painting conducted as a liberal, or as a servile (or mechanic) art, which are presented in terms almost entirely congenial to the civic humanist tradition. According to Mengs, painting is 'a liberal Art composed equally of mechanism and of science', so that, if those

who pay most attention to the 'mechanism' of the art become 'low imitators of Nature', and address a 'propensity' for 'material things which fall under the senses', those who, in pursuit of the ideal, neglect that mechanism, 'will never produce more than sketches'. Nevertheless, argues Mengs, 'the ideal ... is as much more noble than the mechanical part, as the soul is superior to the body': the argument seems to be based on the notion that mechanics, *qua* mechanics, have no souls, and that notion is spelled out, perhaps, when Mengs states that painting was degraded in imperial Rome by being consigned to the hands of 'miserable ... slaves, incapable of thinking'.[28]

A rational soul is essential to the right use of art, and so to the liberal artist, and for three reasons in particular. First, no art can be called liberal if it is not 'directed by a good theory', and though painting has such a theory, it cannot be understood by artists whose exclusive concern with mechanism is evidence of their inability to think. Second, 'a free man with inclination does all that he can, more or less according to his capacity', but 'a slave does only that which he is commanded to do, and his natural will is destroyed, by the violence it causes to obey'; so that the slave who is subject, either to an external power or to the promptings of his own sensual appetite for material things, cannot be a free man and cannot, therefore, practise painting as a liberal art. Third, a free man, independent both of external power and the promptings of appetite, will be able to follow the dictates of his 'generous soul', and produce works which promote the public interest; the 'pusillanimous' and servile artist, on the other hand, will 'aspire to nothing but interest'—to nothing, that is, but the pursuit of his own interest, a pursuit which aims only at the acquisition of the material objects of sensual gratification.[29]

It is for these and other reasons that the words 'mechanical' and 'servile' carry so heavy a charge in eighteenth-century writings on art. 'Mechanical' continually occurs in contexts which are concerned with the process by which the theory of painting is reduced to a rule of thumb, a practical method, a receipt, and always with the sense that it is the nature of a mechanic to be able to obey the rules of art, but not to grasp the principles by which they are constituted. Thus Reynolds, for example, distinguishes between painting pursued as a 'liberal profession' and as a 'mechanical trade': as the former, 'it works under the direction of principle'; as the latter, it is carried on by men of 'narrow comprehension and mechanical performance', in obedience to 'vulgar and trite rules'. 'Servile' occurs continually in contexts concerned with 'mere' imitation: whether with the 'servile' copying of the great masters out of a humble deference to their authority, or with the servile imitation of 'common nature', through an inability to grasp

ideal or abstract form. In the first case, explains Daniel Webb, an artist becomes 'a slave to some favourite manner'; in the second, those whose 'chief merit is in the mechanic' become 'servile copiers of the works of nature'.[30]

Plato's objections could be met also by appeals to classical authority: that of Plato himself, where he appears to adopt a more generous attitude to the fine arts, or of Aristotle, especially where he includes the art of design among the proper elements of a civic education. But the most popular appeal, by which painting could be established as a liberal profession, was to Pliny's remark that painting 'has always consistently had the honour of being practised by people of free birth, and later on by persons of station, it having been always forbidden that slaves should be instructed in it'. This passage had been borrowed by Alberti, with the comment that 'the art of painting has always been most worthy of liberal and noble minds'; it was repeated by Vasari; and it probably entered the English tradition of writing about art with Junius's translation of his own *De Pictura Veterum* in 1638.[31] The remark was repeated by Aglionby in 1685, and thereafter it became a commonplace in English art theory.[32] It is used most evidently in relation to Plato's worries about the political effects of painting by Webb, who writes that: 'The Athenians passed a law, that none who were not of a liberal birth, should practise in this art: They could not better show the sense they had of its power than in the care they took of its direction. They knew the dominion it had over our passions, and hence were careful to lodge it in the safest hands.' The edict against slaves practising painting can still be found as a justification of the liberal status of the art in the early years of the nineteenth century—until Haydon, lecturing in 1835, and appropriately enough at a Mechanics' Institution, announced that 'one of the most absurd laws in Athens, was the prohibiting the exercise of the fine arts to any but free-born men'.[33]

By these various arguments, most if not all of them borrowed, and by a continual insistence, which we will have occasion to consider elsewhere,[34] of the vast learning necessary to the painter of history, the first task in the attempt to establish a civic humanist theory of art in Britain was performed: properly pursued, painting did not threaten the good order of the mind or of the state, but rather confirmed the grounds of the distinction, between reason and the senses, the franchised and the unenfranchised, on which good order was based. It was thus possible to refute that '*Notion of* Painters' as little better than 'Joyners *and* Carpenters, *or any other* Mechanick', and to 'do Justice' to painting 'as a Liberal Art'; to claim that painting was a part of '*Liberall-Learning*', and so did not 'misbeseem the quality of a

Gentleman', and that it was possible for 'gentlemen' to 'rise to an unprejudiced and liberal contemplation of true beauty' in the works of painters. It could be asserted by Shaftesbury, for example, that 'the TASTE of Beauty', in the contemplation of painting and in the other experiences of life, 'perfects the *Character* of the GENTLEMAN'; or by Richardson, writing as 'a Painter, and a Gentleman', and addressing himself 'chiefly' to other gentlemen, that painting, too, is addressed to gentlemen, and not to 'the Vulgar'.[35]

If those concerned to assert so strenuously and so repeatedly that painting was a liberal art could often speak with one voice, however, they were not always quite of one mind. The apparent agreement between Shaftesbury and Richardson, in particular, conceals a difference between them which—and especially when taken along with other differences—can be understood in terms of Copley's distinction between 'traditional' humanism and its alternative, 'bourgeois' form.[36] What is at stake is the definition of a liberal, a free man, a gentleman. For Shaftesbury, 'real *fine Gentlemen*', the 'Lovers of *Art* and *Ingenuity*', are

> such as have seen *the World*, and inform'd themselves of the *Manners* and *Customs* of the several Nations of EUROPE, search'd into their *Antiquitys* and *Records*; consider'd their *Police*, *Laws* and *Constitutions*; observ'd the Situation, Strength, and Ornaments of their *Citys*, their principal *Arts*, Studys and Amusements; their *Architecture*, *Sculpture*, *Painting*, *Musick*, and their Taste in *Poetry*, *Learning*, *Language*, and *Conversation*.[37]

To this identity, the leisure derived from a substantial unearned income is indispensable; and by virtue of this same independence the gentleman is always imagined to be a free citizen in a free polity, participating in the political life of the state, or at least in a position to do so if the circumstances should require it of him.

For Richardson, as for Steele or Defoe, a man may be a gentleman without being a man of leisure: thus, though only those gentlemen 'who have Leisure' may become connoisseurs, he acknowledges the existence of other gentlemen whose circumstances do not permit them to take a profound interest in painting.[38] And thus, as far as Richardson is concerned, a painter such as himself—and one, indeed, who follows the most commercial branch of the art, portraiture—may be a gentleman, whereas for Shaftesbury most portrait painters were 'mere mechanics'—Sir Godfrey Kneller, he considered, had not deserved the 'gentility' conferred on him by his knighthood. The genius even of 'capable' artists was 'checked and spoilt' by the genre; and only sometimes does Shaftesbury seem

willing to admit that those who practise in the highest genre were liberal artists. Painting, he claims (though not altogether seriously) was 'a vulgar science'; and though, as we shall see, he believed that in a free polity an artist himself is a 'freeman', he still regarded contemporary artists, perhaps without exception, as 'mere mechanics', whatever genre they worked in. When Shaftesbury required a painting to be produced which would exemplify his theory of painting, he felt himself obliged to invent and compose the picture himself, engaging a 'workman' for its mere execution, for the merely manual part of the task, by whose 'hand' Shaftesbury brought his invention 'into practice'.[39] Richardson, on the other hand, is adamant that if it was not 'unworthy of a Gentleman' to be 'Master of the *Theory* of *Painting*', then he could hardly forfeit his gentlemanly character if he was capable 'of Making, as well as of Judging, of a Picture'; for

> Those Employments are Servile, and Mechanical, in which Bodily Strength, or Ability, is Only, or Chiefly required, and that because in such cases the Man approaches more to the Brute, or has fewer of those Qualities that exalt Mankind above other Animals; but this Consideration turns to the Painter's Advantage: Here is indeed a sort of Labour, but what is purely Humane, and for the Conduct of which the greatest Force of Mind is necessary.[40]

5. *Painting and public virtue*

As we have seen, the civic humanist theory of painting distinguishes the liberal man from the mechanic in terms which emphasise that its value-language is a political language: the 'liberal' man is an enfranchised citizen, a participating member of a civil state or public. The highest genre of painting, according to this theory, is heroic history-painting, for this of all genres is best able to represent man according to his true nature and end, which is to be so entirely a citizen that he pursues no interest which is not the interest of the public. It is because the 'heroic kind' addresses itself primarily, if not exclusively, to a public of free citizens that its primary function is—as Turnbull and Hoare have already suggested to us—to teach public virtue, the virtue necessary to the full realisation of this civic identity. Precisely to whom, however, among the class of those capable of practising the public virtues, heroic painting addressed itself, was a question that admitted of different answers. The aristocratic Shaftesbury conceived of his invention, *The Judgment of Hercules*, as 'a piece of furniture' which:

might well fit the gallery, or hall of exercises, where our young
Princes should learn their usual lessons. And so to see virtue in this
garb and action, might perhaps be no slight memorandum here-
after to a royal youth, who should one day come to undergo this
trial himself; on which his own happiness, as well as the fate of
Europe and of the world, would in so great a measure depend.

On this occasion, at least, Shaftesbury seems to have thought of
heroic painting, as Rapin and Dryden thought of epic poetry, as 'a
kind of conduct-book for rulers'. George Turnbull was probably
more typical, not only of the civic humanist theory of art in general,
but also of Shaftesbury's more usual beliefs, in thinking of the genre
as an appropriate ingredient in the education of 'Youth' likely to
enter the 'publick Service', of 'Gentlemen, whose high Birth and
Fortune call them to the most Important of all Studies; that, of Men,
Manners and Things, or Virtue and publick Good'.[41]

The rules for the painting of history were closely modelled on the
rules for the writing of epic:[42] heroic history-painting, indeed, was
often described as 'epic' painting, though later in the century the term
came to be applied to a particular branch of the genre; and those
writers on painting who adhered to the civic humanist theory of
painting in its 'traditional' form would certainly have been willing to
define the function of heroic painting in the terms in which John
Dennis, transposing Le Bossu's theory of epic into the language of
civic humanism, had defined the function of epic—though they
might not have endorsed the tone of that transposition.[43] For Dennis,
this function was 'to encourage publick Virtue and publick Spirit'; to
this end the hero of epic was to be a man of public virtue; and because
the dignity of epic did not allow it to be concerned with anything but
the public character of its hero, the epic poet should not suggest that
this character was either compromised by the private vices he might
happen to indulge, or further dignified by the private virtues he ex-
hibited. As far as the former were concerned, 'publick Virtue makes
Compensation for all Faults but Crimes, and he who has this publick
Virtue is not capable of Crimes'; and, as for the latter, 'the Virtues of
Patience and long Suffering', writes Dennis, with a sneer at the advo-
cates of passive obedience, may be left to be 'taught by Priests', who
'will not fail to inculcate such Doctrines frequently, as being at once
consistent with their Duty and their Craft', and so with their 'Design
to enslave' the people of Britain. Just as infallibly, priests will leave it
to the poet to 'recommend publick Virtue and publick Spirit'.[44] Paint-
ing could promote public virtue, it was believed, by the representa-
tion of the 'great Actions' performed by public heroes, and also

(according to some writers) by portraits of the heroes themselves. Such images would preserve the memory of heroes and their actions, and would 'inflame' the spectator, as, according to Dennis, they inflamed the reader of epic, 'with the love of his Country, and with a burning Zeal to imitate what he admires'. This belief in the exemplary value of heroic images is so universal that it is hardly necessary to instantiate it with quotations: it is summed up most effectively, perhaps, by James Harris, though in this apostrophe he is addressing 'Art' in general:

> thou art enabled to exhibit to mankind the admired tribe of poets and of orators; the sacred train of patriots and of heroes; the god-like list of philosophers and legislators; the forms of virtuous and equal polities, where private welfare is made the same with public; where crowds themselves prove disinterested and brave, and virtue is made a national and popular characteristic.

'Equal polities', 'disinterested crowds', 'popular virtue': we should not be misled by such phrases into believing that Harris imagines that art should depict the ideal republic as one governed by the representatives of a popular majority, chosen by universal suffrage. The 'crowds' here—if Harris is being consistent with his usual beliefs—are crowds of enfranchised citizens, not the mob of ignorant mechanics, the 'mere Vulgar of Mankind'.[45]

On the question, however, of the representation of exemplary virtue, as on many of the questions we have to consider, Jonathan Richardson is not wholly of one mind with the proponents of the 'traditional' form of the civic humanist theory of painting. What is at issue between Richardson and, say, Shaftesbury and Turnbull, is not whether art should offer instruction in public virtue, so much as how public virtue should be defined. In his account of the ideal exemplar of public virtue whom it was the duty of the painter to represent, Richardson departs considerably from Dennis's account of the epic hero, and from Shaftesbury's account of Hercules in the heroic painting he had invented. According to Richardson, the painter who seeks to depict exemplary virtue should show us 'A Brave Man, and one Honestly, and Wisely pursuing his Own Interest, in Conjunction with that of his Countrey'. This formulation is in line with Richardson's attempt to extend the definition of a gentleman to those men of liberal education who pursued private careers and did not aspire to public service, and the formation is made precisely to deny that such private men, if honest and wise, were not also servants of the public. It thus allows Richardson himself to continue in his lucrative trade as a 'face-painter' while claiming to be also a man of public spirit, and it

has the more general convenience of enabling a compromise between the civic virtues of 'traditional' humanism and the mercantile virtues of its alternative, 'bourgeois' form. For Richardson, there was no necessary contradiction between the pursuit of the interest of the public and the pursuit of one's own; and the same willingness to represent public and private virtue as compatible, or even, in certain circumstances, identical, is evident in the reassurance he offers to connoisseurs, that their love of painting is evidence at once of their patriotism, and their prudence: the pictures they buy will help with the 'Reformation of our Manners', and the 'Money laid out' on them 'may turn to Better Account' than almost any other kind of investment.[46]

There is similarly no contradiction for Richardson between the claims that painting will promote the spiritual health of the nation and also its economic wealth, for each of those will promote the other: the reformation of manners, and particularly the cultivation of the private virtues—though by this argument those virtues are also 'public', of course—will enrich the individuals in a nation, which is the same thing as enriching the nation as a whole. To this end, he points out that painting, considered as a manufacture, has an advantage over all other manufactures, compared in terms of the difference in value between the original raw materials and the finished product. Considerations such as these do find a place in the writings of more traditional humanists—it is often claimed, as Richardson also claims, that good design in painting will have a spin-off effect in the improvement of manufacturing design.[47] But the fear of appearing too concerned with the pursuit of luxury, the chief enemy of civic virtue and so of the stability of the civil state, usually confines such suggestions to subordinate clauses and to parentheses, and they are made almost apologetically. Richardson, with the robustness of Defoe, makes them central to his version of how painting can promote the public interest.

Richardson departs from the traditional form of civic humanist theories of painting in his attitude, also, to religious paintings. The questions of whether artists should depict scenes from the scriptures, and whether images of such scenes should be displayed in churches, was a complex and even an embarrassing one for the most ardent proponents of a painting devoted to the promotion of public virtue, and for several reasons. The display of religious paintings in churches was regarded with suspicion on the grounds that it was one of the ways by which the Romish church encouraged superstition, and so exercised a kind of intellectual and social control abhorrent to the citizens of a free state and the members of a reformed church;[48] and

this suspicion often seems to mask another to which it is closely related: that such images tended to celebrate the private and passive virtues encouraged by Christianity, as opposed to the active public virtues—though no writer on painting acknowledges this anxiety with the candour of John Dennis, writing on the difference between the values of epic and of 'priestcraft'. On the other hand, no theory of painting could take itself seriously which did not acknowledge the great Italian painters of religious subjects, and principally Raphael, as the models of the rules and the practice of painting, however much it could be claimed that these artists were themselves pale shadows of the great painters of the Greek republics, who were free citizens and free to celebrate their freedom in their work, while the Italians were forced to paint 'as the priests commanded' and as 'popes enjoined'. By and large, the Italians were admired insofar as it was imagined that they eluded the dictates of their church, to paint images which exalted the 'vile shrivelling passion' of 'beggarly modern devotion', and idealised their figures as the Greeks had done. Insofar as they succeeded in this, their paintings gave an intimation of the eternal forms which, otherwise hidden in a platonic heaven which was adopted as a Christian heaven also, were made available as a new source of rational, natural revelation of the 'Beauties of the Works of the great Author of Nature'.[49]

The discourse of civic humanism was not opposed, of course, to intellectual and social control when it was directed against the potential enemies of the freedom of the citizen and the institutions of a free state—the mob of mechanics; and the usual solution to the problem of whether images of scriptural scenes should be encouraged, and whether they should be (in spite of the hostility of the Church of England) displayed in churches, was that they should be, because they would be of value in reforming the manners of the people at large, to whom they would teach lessons of faith and practical piety. The liberal man, however, at least in the early decades of the century, is treated as if in no need of such lessons in piety, and, as far as lessons in faith were concerned, they could best be drawn from images of ideal form, which could as well be represented in heroic as in religious subjects. Richardson often seems to endorse these views: he sees the value of displaying images of scriptural scenes in churches chiefly in terms of their power to 'improve' the 'people', who, 'being now so well Instructed' by the Church of England 'as to be out of Danger of Superstitious Abuses,' will be 'more Sensibly affected than they can possibly be without This Efficacious means of Improvement, and Edification.' The power of religious paintings to improve the gentleman-connoisseur, on the other hand, is described as largely a

function of the degree to which the 'Ideas' of nature they offer are 'Rais'd', and so enable the connoisseur 'to get Noble Ideas of the Supreme Being'.[50]

But Richardson's extension of the definition of the gentleman to include some, at least, of those who, in their daily lives, found more use for the private than for the public virtues, and for practical piety in particular, leads him to claim, as Steele also claimed, that the connoisseur, as well as the people, could draw direct moral lessons from religious paintings, by which means 'we are not only ... Instructed in what we are to Believe, and Practise; but our Devotion is inflamed, and whatever may have happened to the contrary it may ... also be Rectify'd'. Paintings of 'the good Things of Religion' are 'useful to Improve and Instruct us' as 'a Book of ... Divinity is'; so that a connoisseur, who has access to the lessons offered by paintings as well as by books, will have, not only 'nobler Ideas, more Love to his Country', and 'more moral Virtue', but also 'more Faith, more Piety and Devotion', than another not so instructed. He will be 'a more ingenious, and a Better Man'. According to Steele, indeed, a less ambivalent proponent of 'bourgeois humanism' than Richardson, paintings of religious subjects are the only paintings which will form a 'better man'.[51]

6. *The rhetorical aesthetic*

If painting, or if the worthiest branch of it, the heroic kind, addressed the spectator as the active citizen of a 'civil State or Public', and attempted not only to instruct him in the virtues necessary to that identity, but to 'inflame', to persuade him to exercise them, then it followed for traditional humanists among writers on painting that it must address him rhetorically. Rhetoric, according to Longinus—as here paraphrased by Hugh Blair—was an art peculiarly found among free men: 'Liberty ... is the nurse of true genius: it animates the spirit, and invigorates the hopes of men; excites honourable emulation, and a desire of excelling in every art. All other qualifications ... you may find among those who are deprived of liberty; but never did a slave become an orator.' Rhetoric—I mean political, as opposed to ecclesiastical, or judicial rhetoric—was the most appropriate model for explaining how it was that heroic painting addressed us, because, according to Blair, it proposes as its end 'some point, most commonly of public utility or good, in favour of which' it seeks 'to determine the hearers'. It was, in short, 'concerned with persuading men to act, to decide, to approve; it was intellect in action

and in society, presupposing always the presence of other men to whom the intellect was addressing itself'; and presupposing also that those others were such men as were able to act, decide, and approve—were free citizens.[52]

The comparison between rhetoric and painting had been made by Quintilian and by Cicero; for Alberti, the most important task of painting was to 'move the soul', and he advised painters to get to know orators as well as poets if they wished to advance in their art.[53] The analogy is well established in England by the early eighteenth century: *The Judgment of Hercules*, for example, was, as we shall shortly see, conceived at once as an exhibition of the powers of rhetoric, and as a work which exercised those powers on the spectator. Turnbull defines painting as 'one of the instructing or moving Arts'; it was, like 'oratory', an art concerned with 'illustrating, embellishing, and impressing Truths'. There was, of course, an important distinction to be made between rhetoric and painting, in that the former was 'invariably and necessarily immersed in particular situations, particular decisions, and particular relationships'; it was always a call to the performance of some particular action in pursuit of some particular 'point ... of public utility or good'; whereas painting was concerned rather to 'inflame' us with a general zeal to emulate the particular actions of heroes, should the occasion arise—it is in these terms that Shaftesbury and Turnbull conceive of heroic painting as of particular value in the education of youth.[54] This distinction was acknowledged implicitly, rather than openly recognised, by writers who believed that painting functioned by means of what I shall call a rhetorical aesthetic; it was acknowledged, in short, by the space accorded to painting in the imagined life of the citizen. For painting was there treated as the private recreation of a public man, indulged when public duties permitted, but properly a preparation for the resumption of those duties, or the exemplary study of a man who had earned the right to retire from them.[55]

As Kames points out in relation to epic poetry, it was essential to an art which attempted to communicate rhetorically, that it should make us believe in the reality of the objects it represented—that it should be an art of illusion. 'If once we began to doubt' the 'reality' of an object or an incident, then 'farewell relish and concern'. He argues against the introduction of machinery, of 'imaginary beings' into epic, on the grounds that 'fictions of that nature may amuse by their novelty and singularity; but they never move the sympathetic passions, because they cannot *impose* on the mind any perception of reality' (my emphasis). From Aglionby onwards, those who argue for the rhetorical function of painting insist on the necessity of illusion.

Painting, explains Aglionby, 'by a strange sort of *Inchantment*, makes the little *Cloth* and *Colours* show *Living Figures*, that upon a flat *Superficies* seem *Round*, and deceives the *Eye* into a Belief of *Solids*, while there is nothing but *Lights* and *Shadows* there'. Dryden quotes Philostratus to the effect that painting must deceive the eye and the mind; and Shaftesbury argues that the 'pleasing illusion or deceit' of a painting makes the 'sole use and beauty of the spectacle'. Daniel Webb argues that the best paintings stand 'in the place of the things which they represent', by 'imposing' on our senses; and even in the early nineteenth century—by which time, as we shall see, the influence of Reynolds in particular had almost banished the vocabulary of deceit and illusion from the theory of painting—Opie still declared that one end of painting was 'the giving effect, illusion, or the true appearance of objects to the eye'.[56] As Kames's remarks on epic suggest, the failure of painting to deceive the eye—it is not my purpose here to consider how it could possibly have succeeded in doing so—would entail a failure in its power to persuade; for it is essential to a rhetorical art that we should not be distanced from it, so as to find ourselves in a position to compare a representation with its original in nature. A painting should strike, should move, and should not awaken our interest in the question of its 'likeness'.

This dependence of painting, considered as a rhetorical art, on illusion, gave rise to a problem which—though it was a problem also for late seventeenth- and early eighteenth-century writers on painting in France—was potentially more embarrassing for writers in the British tradition of civic humanist criticism, and was therefore largely ignored. The problem, in the form in which it manifested itself to French critics, was discussed at some length by de Piles, and it is as follows. If the success of painting depends upon its power to deceive, to make it 'seem possible for the figures to come out of the picture, as it were, in order to talk with those who look at them', then surely the painter should depict simple appearances, an unidealised nature, and one we can recognise as continuous with the world outside the picture. On the other hand, argues de Piles, the pleasure of painting derives also from the ideal images it offers, for 'ideal', as opposed to 'simple' truth, 'comprehends an abundance of thoughts, a richness of invention, a propriety of attitudes, an elegance of outlines, a choice of fine expressions', and so on. The disadvantage, however, of ideal truth is that it cannot deceive us: though it may offer us more pleasure, it will also risk putting us in a contemplative frame of mind by which we are detached from the work, and are concerned to judge it. In order to preserve the mimicry of painting, and its power to

delight us with the ideal, de Piles proposes that the artist should endeavour to represent a 'compound truth', composed of simple and ideal, able at once to deceive and to please.[57]

De Piles's solution to this problem is borrowed by a few writers on painting in England, notably by Opie, to whom perhaps it seemed to promise a way of coping with the particular form in which the problem was perceived in England. It was a rule constitutive of a rhetorical aesthetic that a good painting could move all who looked at it: as Turnbull explains,

> the Unlearned are seldom wrong in their Judgment about what is good or bad in any of the Arts . . . the chief difference between the Learned and the Vulgar consists in this, that the latter are not able to apply Rules and Maxims, but judge merely from what they feel; whereas the former can reason about their feeling from Principles of Science and Art.[58]

For civic humanist writers, the difficulty in this position, which had the authority of Quintilian and Cicero, was that the ability of a painting to move us, to persuade us to emulate the action of the great, depended on its success in deceiving the eye. But the fact that the vulgar were ignorant of the 'Principles of Science and Art' meant (as Du Bos, most influentially, had argued) that they were more susceptible to the power of illusion than the liberal, because it was harder for them to be distanced, by an awareness of those principles, to the point where their first reaction to a work of art was to criticise it, rather than to respond to it immediately. Heroic painting, therefore, was likely to be more successful in persuading the vulgar to emulate heroic actions than the liberal, at the same time as it was also true that the vulgar were incapable of performing such actions.[59]

The problem could be dispatched, it might seem, and the value of ideal art reasserted, by acknowledging that the vulgar were more likely to be moved by images of simple or 'common' nature than the liberal: the latter were unlikely to be moved to virtuous actions by such images, because their ability to be so would be intercepted by their disgust at the vulgarity of common nature. If images of an entirely ideal nature, on the other hand, risked departing so far from common nature as to fail to persuade us of their reality, then the solution might appear to lie where de Piles had found it, in the imitation of 'compound truth', sufficiently simple to persuade, but sufficiently ideal to persuade us to act, specifically, in the interests of that universal human nature which was represented in ideal images of the body.

But in whatever way this 'compound truth' could be described, it

could not be concealed that it must involve a lessening of the rhetori-
cal power of art by reducing its power to deceive; and perhaps for
that reason traditional humanism did not adopt de Piles's solution,
which, by reducing the rhetorical power of art, weakened also the
association which the analogy with rhetoric offered, between the
republic of taste and a political republic of free and active citizens. If
traditional humanism was therefore left with the problem, that a
rhetorical and deceptive painting was likely to be more effective in
moving the ignorant than the learned, the problem could be diffused
by conceiving of the ignorant as ignorant not (as the vulgar were) of
'Men, Manners . . . Virtue, and publick Good', but simply of the art
of painting, and by leaving the power of painting to move the vulgar
unconsidered, except as an occasion to exalt by contrast the judgment
of the polite. The contradictions generated by the rhetorical aes-
thetic were thus left unacknowledged, until they were resolved by
Reynolds, at the cost—though it did not seem to him to be so—of
that aesthetic itself, and of the claim that the true function of 'public'
art is to move us to emulate acts of public virtue. In achieving this
resolution, Reynolds appears to have been anticipated, to some
extent, by Richardson, who, like Reynolds, had little interest in the
notion that art addresses us rhetorically, and none at all in an aes-
thetic of illusion. For him, as for Reynolds, painting addresses us by
communicating ideas to our understanding, and it is thus that it puts
'the Soul in Motion'.[60] Richardson, I am suggesting (and I shall
discuss the point at greater length in my first chapter) seems to
develop what I shall describe as a 'philosophical' aesthetic, an aes-
thetic of contemplation, not of action, and one more appropriate to
an audience which wished to claim that it was animated with public
spirit, but which could not so easily claim the opportunity to perform
acts of public—let alone of heroic—virtue.

7. 'The Judgment of Hercules'

I want now to collect up the various features we have so far con-
sidered of the civic humanist theory of painting in its traditional form,
and I can do this best by a discussion of the essay, which Shaftesbury
published in French in 1712, which was added to the *Characteristicks*
in 1713, and which is a plan, following the account of the story in
Xenophon, of a painting of the Choice of Hercules, a painting which
he later 'brought . . . into practice' by 'the hand of a master-painter',
Paolo de Matthaeis. The subject of the picture he describes as
follows:

1. Simon Gribelin, after Paolo de Matthaeis, *The Judgment of Hercules* (1713).

HERCULES . . . being young, and retir'd to a solitary place in order to deliberate on the Choice he was to make of the different ways of Life, was accosted (as our Historian relates) by the two Goddesses, VIRTUE and PLEASURE. 'Tis on the issue of the Controversy between these *Two*, that the Character of HERCULES depends. So that we may naturally give to this Piece and History, as well the Title of *The Education*, as *the Choice* or *Judgment* of HERCULES.[61]

Hercules occupies the centre of the picture, dressed in the skin of the lion he was later to kill, and leaning upon his club. To his left Pleasure is half-reclining on the ground, in an inviting state of undress, with utensils at her side 'to express the Debauches of the Table-kind'. To his right stands Virtue, carrying the 'Magisterial Sword' which is 'her true characteristick Mark', and with a bridle and helmet, emblems of '*Forbearance* and *Indurance*', on the ground beside her. Virtue is pointing into the distance: either, Shaftesbury suggests, to the 'mountainous rocky Way' which leads 'to Honour, and the just Glory of heroick Actions'; or 'to the Sky, or Stars, in the same sublime sense'; but in either case away from 'the flowry Way of the Vale and

Meadows', recommended to Hercules by Pleasure, though (perhaps so as not to make pleasure too attractive) barely represented in the picture.[62]

The choice Hercules must make is not between virtue and pleasure in a loose and general sense, but between civic, public virtue and private vice: between the '*Inaction*', the '*Supineness*', the '*Effeminacy*' of luxury, and 'a life full of Toil and Hardship, under the conduct of VIRTUE, for the deliverance of Mankind from Tyranny and Oppression'—a life devoted, that is, to the defence of republican liberty. And for that reason the picture must communicate with us *rhetorically*: it must recommend the life of public virtue in the same manner as a patriotic orator would recommend it to an audience of free citizens. The alternative to a rhetorical painting is represented by Shaftesbury as emblematic painting; and although Shaftesbury distinguishes his characters by emblems, these are not, he explains, 'absolutely of the *Emblem*-kind', but are—in the case, for example, of Virtue—'portable Instruments', such as she 'may be well suppos'd to have brought along with her'; and the Vale and Mountain, though they have emblematic significance, are still an appropriate and as it were a natural setting for the fable.[63]

To Shaftesbury, emblematic and allegorical art is tainted with the illiberal and idolatrous superstitions of priestcraft; it is deliberately 'enigmatical' and 'mysterious', as if concerned to hide rather than to reveal its meaning. Allegorical figures, distinguished by emblematical attributes, have no 'manner of similitude or colourable resemblance to any thing extant in real Nature'; whereas a rhetorical work, as we have seen, must deceive the eye. 'The compleatly imitative and illusive Art of PAINTING'. Shaftesbury explains,

> surpassing by so many Degrees, and in so many Privileges, all other human Fiction, or imitative Art, aspires in a directer manner towards Deceit, and a Command over our very Sense; she must of necessity abandon whatever is over-*learned*, *humorous*, or *witty*; to maintain her-self in what is *natural*, *credible*, and *winning of our Assent*: that she may thus acquit her-self of what is her chief Province, *the specious Appearance of the Object she represents*.

The introduction of allegorical figures, '*fantastick*, *miraculous*, or *hyperbolical*', into this 'compleatly imitative Art'—and I must confess it is unclear to me why, on the mere grounds that their attributes are not 'absolutely' emblematic, Shaftesbury excludes Virtue and Pleasure from this charge—is dangerous, insofar as we may be 'induc'd' to contemplate 'as Realitys' those 'divine Personages and miraculous Forms, which the leading Painters, antient and modern,

have speciously design'd, according to the particular Doctrine or Theology of their several religious and national Beliefs'. What is more, the emblematic may 'distract or dissipate the Sight, and confound the Judgment' of even 'the most intelligent Spectators'; they may, in short, have the effect of making the painting ambiguous, an issue I shall discuss at greater length in a moment.[64]

The painting may be described as 'rhetorical' in a double sense: for if its function is to be an instructive 'memorandum', the choice which Hercules is being persuaded to make is a choice we too must make, and he is a figure for the spectator. Thus the painting must display the response made by Hercules to Virtue's oratory, a response which is an image of how we, too, must respond to the painting as a whole. The moment to be represented by the painter must be chosen so as to display the rhetorical nature of the encounter: Shaftesbury considers various possible moments, and rejects three of them, as inadequate to represent the force of Virtue's powers of persuasion. At the start of the debate, when the goddesses first 'accost' Hercules, 'he admires, he contemplates; but is not yet ingag'd or interested'; in the middle of the debate, Hercules will be 'interested', but 'divided, and in doubt'; at its end, when Hercules is 'intirely won by *Virtue*', there would be no room 'either for the persuasive Rhetorick of VIRTUE (who must have already ended her Discourse) or for the insinuating Address of PLEASURE, who having lost her Cause, must necessarily appear displeas'd, or out of humour: a Circumstance which wou'd no way sute her Character'. The correct moment to be represented, Shaftesbury decides, is 'when their Dispute is already far advanc'd, and VIRTUE seems to gain her Cause'.[65]

This choice enables Virtue to be represented in an attitude and manner most fully rhetorical: she will be '*speaking* with all the Force of Action, such as wou'd appear in an excellent Orator, when at the height, and in the most affecting part of his Discourse'. She will be '*standing*; since 'tis contrary to all probable Appearance ... that in the very Heat and highest Transport of Speech, the Speaker shou'd be seen sitting, or in any Posture which might express Repose'. In order to express 'the *arduous* and *rocky Way* of VIRTUE', she will be shown in an 'ascending Posture ... with one Foot advanc'd, in a sort of climbing Action, over the rough and thorny Ground'; and, 'as for the *Hands* or *Arms*, which in real Oratory, and during the strength of Elocution, must of necessity be active', she will point, as we have seen, to the mountain, sky or stars.[66] Pleasure must be shown as silent, for she has had her say. She may be drawn, Shaftesbury suggests, with a surprising generosity to 'the Painter's Fancy', 'either *standing*, *leaning*, *sitting*, or *lying*'; but however she disposes herself,

she must appear languid, so that her body expresses her 'Ease and Indolence', and her *'persuasive* or *indicative Effort'*, in a proportion of four to one. Her head and body, however, should entirely suggest *'indulgent ease'*: 'one Hand might be absolutely resign'd to it; serving only to support, with much ado, the lolling lazy Body'. Hercules, finally, may also be represented in a variety of poses; but, judging from the picture, Shaftesbury eventually decided on one which enabled the expression of a transient stage in his response to Virtue's speech, a growing determination, in which 'the Tracts or Footsteps' of an earlier doubt, even of an earlier inclination to pleasure, are still visible. In this attitude, 'he looks on *Virtue* . . . earnestly, and with extreme attention, having some part of the Action of his body inclining still towards *Pleasure*, and discovering by certain Features of Concern and Pity, intermix'd with the commanding or conquering Passion, that the Decision he is about to make in favour of *Virtue*, cost him not a little'—but that Virtue's persuasiveness has reconciled him to that cost.[67]

To enforce its rhetorical point—to ensure that we understand its subject, the choice it asks us to make, the appropriate response it demands—the painting must declare unambiguously to what genre it belongs, or 'what *Nature* it is design'd to imitate', and that it is *'historical* and *moral'*, not 'merely *natural'*. In landscape-painting, Shaftesbury argues: 'Inanimates are principal: 'Tis the Earth, the Water, the Stones and Rocks which live. All other Life becomes subordinate. Humanity, Sense, Manners, must in this place yield, and become inferior'. But in history-painting, the *'first and highest Order'* of the art, the painter must ensure that the representation of *'intelligent Life'*, of figures divine and human, is what principally engages us. To these, the *'other Species* . . . must . . . surrender and become subservient'; for 'nothing can be more deform'd than a Confusion of many Beautys: And the Confusion becomes inevitable, where the Subjection is not compleat'.[68]

The painting must, in short, be as unambiguous as possible, if it is to carry its rhetorical point: a painting, as Shaftesbury explains elsewhere in the *Characteristicks*, must be *'a Whole*, by it-self, compleat, independent'; so that 'Particulars . . . must yield to the general Design', and 'all things be subservient to that which is principal: in order to form a certain *Easiness of Sight*; a simple, clear, and *united View* which wou'd be broken and disturb'd by the Expression of any thing peculiar or distinct'.[69] This general injunction against ambiguity applies in every 'part' of painting, and in every aspect of the particular painting we are considering. As far as the invention is concerned, if all three figures were represented as speaking at once,

the effect would be the same 'as such a Conversation wou'd have upon the Ear were we in reality to hear it'; and if it is not clear from a painting which of the various possible moments in an action the painter had chosen to depict, the mind of the spectator will be left in 'uncertainty'. In the composition of the picture, Hercules, 'the *first* or *principal Figure* of our Piece', should be 'plac'd in the middle', so that we cannot doubt that 'his Agony, or inward Conflict . . . makes the principal Action'. In the matter of character and expression, if the '*persuasive Effort*', for example, of Pleasure, were 'over-strongly express'd', 'the Figure wou'd seem to speak . . . so, as to create a double Meaning, or *equivocal Sense* in Painting'. The colouring, finally, should have a harmonious unity: a 'Riot of Colours'—this is the first use in English, as far as I have been able to discover, of this intriguing phrase—would 'raise such a Confusion' and 'Oppugnancy . . . as wou'd to any judicious Eye appear absolutely intolerable'.[70]

This concern that painting should be as unambiguous as possible is not unique to Shaftesbury: it is expressed, among critics that Shaftesbury may be presumed to have read, by Du Fresnoy, Félibien, Bourdon, Lebrun, and de Piles; even the figure by which an ambiguous work is compared with a roomful of people, all speaking at once, is borrowed from de Piles, as it would be again by Richardson, Hogarth, Winckelmann and Algarotti.[71] It seems to me, however, that this concern receives an unusual degree of emphasis in civic humanist criticism—not only in Shaftesbury, but in Richardson and (as we shall see) in Reynolds—and that it derives from the specifically civic concern which takes such different forms in those writers. I can best explain what I mean by pointing out that the most important argument used by Plato to justify the exclusion of painters from his republic, was that they introduce 'faction and strife' into 'the domain of sight' by distorting the measurements of objects in the process of representing them in two dimensions. The result of this is that a man cannot remain of one mind with himself when he looks at a painting, for the best, the rational part of his mind, which contradicts the measurements of painted objects, is in conflict with the inferior part, which agrees with them. The painter thus introduces dissension into the mind of the citizen, a dissension which is specifically related by Plato to the inversion of the proper relations of the social orders within a state.[72]

I have already had occasion to quote a remark by Pocock to the effect that it was a leading doctrine of civic humanism that 'the integrity of the polity must be founded on the integrity of the personality, and that the latter could be maintained only through devotion to universal, not particular goods'; and in the context of this doctrine,

and Plato's, it will not escape our notice that all the examples that Shaftesbury offers of how ambiguity may threaten the unity of a painting involve a disturbance of the proper relations of general and particular, or of principals and inferiors. 'Particulars' must 'yield to the general Design'—just as, we may reflect, particular good must give way to universal in the state, and within the hierarchy of desires in the mind of the citizen. 'All things' must be 'subservient' to the 'principal'—in the same way as a 'Riot of Colours' must not threaten, or distract our attention from, the clear outline of the hero of Shaftesbury's design, and as inferior nature must yield to '*intelligent Life*' in the highest, the heroic kind. The concern in civic humanist theories of painting, that 'all ambiguity must be removed',[73] may be, in short, a concern with the integrity of the personality of the citizen, achieved by a subordination of private to general interests, and with the order of society, maintained by a submission of inferiors to their natural rulers. If painting does not ensure this integrity and order, it can have no place in the political republic which civic humanism seeks to create or to preserve.

8. Liberty and luxury: the history of painting

I want in this section to consider the history of art, or what might better be called the philosophy of the history of art, which belongs to the discourse I am describing—the account it offers of the 'moral causes' responsible for the rise and decline of painting in particular societies. And though I have so far been concerned to characterise a civic humanist theory of painting in the forms it took before the intervention of Sir Joshua Reynolds, there is on this topic a large measure of agreement among writers on painting at the beginning and end of the eighteenth century, and even at the start of the nineteenth. As far as the rise of painting was concerned, this was invariably understood as, pre-eminently, the effect of liberty: not just the political liberty of a state which is not subject to the dominion of another, and not just that kind of personal freedom which is enjoyed by all who are not slaves; but the freedom, political and personal, which is enjoyed by free citizens who are able to participate in the government of themselves. On the importance of other, subsidiary moral causes—the prevalence of peace, the availability of patronage—there was room for some diversity of opinion; but this belief in political liberty as the efficient cause of excellence in the arts in general, and in painting in particular, is a defining characteristic of

civic humanist theories of civilization. To question it is to place oneself outside the orbit of the discourse, and to occupy a position where, though it might still be possible to deploy the critical vocabulary of civic humanism, it would be impossible to represent the values it embodies as authorised by a coherent political philosophy, or to maintain that the republic of the fine arts, or of taste, was structured as a political republic.

The argument that liberty, in the sense I have specified, is essential if the arts are to flourish, was spelled out in detail by Shaftesbury and by Turnbull. 'There can be no public', insists Shaftesbury, 'but where' the 'people' are 'included': the 'people' understood, of course, as the aggregate of free citizens in a state, sufficiently numerous to establish the state as 'free', sufficiently few to exclude the mob, who cannot aspire to public spirit, and who cannot *see* the public of which they are therefore denied membership. 'And without a public voice', Shaftesbury continues, one 'knowingly guided and directed' by wise rulers and arbiters of taste, 'there is nothing which can raise a true ambition in the artist; nothing which can exalt the genius of the workman, or make him emulous of after fame, and of the approbation of his country'. In a state animated by 'the genius of liberty', in which property is secured by equal laws, issuing from and administered by free institutions, 'everything co-operates . . . towards the improvement of art and science'; and:

> when the free spirit of a nation turns itself this way, judgments are formed: critics arise; the public eye and ear improve; a right taste prevails, and in a manner forces its way. Nothing is so improving, nothing so natural, so congenial to the liberal arts, as that reigning liberty and high spirit of a people, which from the habit of judging in the highest matters for themselves, makes them freely judge of other subjects, and enter thoroughly into the characters as well of men and manners, as of the products or works of men, in art and science.

The arts flourish where they are made the objects of free and equal debate, and that can happen only where the government of a state is similarly a matter on which its citizens may judge 'for themselves'. For Turnbull, the most important moral cause 'to which the mutual Growth, or Declension of all the Arts and Sciences is ascrib'd by ancient Authors' (he has Longinus chiefly in mind) is:

> the Prevalence or Fall of Liberty and publick Spirit. Liberty and publick Virtue are the common Parent under whose Favour and Patronage alone they can prosper and flourish; and without it they sink, decline and perish.
>
> Liberty or a free Constitution is absolutely necessary to produce

and uphold that Freedom, Greatness and Boldness of Mind, without which it cannot rise to noble and sublime conceptions. Slavery soon unmans and dispirits a People; bereaves them of their Virtue and Genius, and sinks them into a mean, spiritless, enfeebled Race that hardly deserves to be called Men.[74]

The model of a free constitution was to be found in the free republics of Greece, and especially in the Athenian democracy. 'Freedom', Hume explained, 'naturally begets public spirit, especially in small states'; and, according to John Robert Scott, in the city-states of Greece, 'each citizen felt himself equally interested with any other to extend the reputation, to exalt the glory, and to enlarge the consequence of the state'. The result of this equal interest was productive, according to James Thomson and numerous others, of a spirit of emulation: a competition among the individuals in a state, each attempting to establish himself as a paragon of civic virtue; and between one state and another, each striving to create a form of government best fitted to serve the interests of its citizens. Because the aim of the competition was thus to furnish exemplary models for all mankind, the reward for victory was enjoyed by everyone: it was 'the prize of all'. It still is, according to James Harris:

> The Grecian commonwealths, while they maintained their liberty, were the most heroic confederacy that ever existed. They were the politest, the bravest, and the wisest of men. In the short space of little more than a century, they became such statesmen, warriors, orators, historians, physicians, poets, critics, painters, sculptors, architects, and (last of all) philosophers, that one can hardly help considering that golden period as a providential event in honour of human nature, to shew to what perfection the species might ascend.[75]

The exemplary public spirit of the Greeks was a continual stimulus to arts: 'whatever flourish'd' in the ancient world, writes Shaftesbury, 'or was rais'd to any degree of Correctness, or real Perfection' in the arts, was 'by means of GREECE alone'; 'nor can this appear strange, when we consider the fortunate Constitution of that People', 'animated' by a 'social publick and *free* Spirit'. That spirit ensured that the arts 'served public virtue': 'such was the spirit of patriotism in Greece', writes Flaxman, 'from the age of Pericles to the death of Alexander the Great', that 'the richest citizens did not endeavour to exceed others in the magnificence of their houses or tables, but employed their wealth for the security and defence of

their country, and in raising noble public buildings and works for the service of religion, and in honour of public and private virtue.'[76]

'Vast sums', writes Scott, were 'expended by the Grecian states on their public monuments and their public works', and the art of painting no less than of architecture and sculpture was consecrated to public purposes: 'I wish', writes Mrs Montagu, of Reynolds,'he was employed by the public in some great work that would do honour to our country in future ages ... The Athenians did not employ such men in painting portraits to place over a chimney or the door of a private cabinet.' The artist was regarded in Greece, according to Pliny, as 'res communis terrarum', 'the common property of the world', a phrase usually rendered by writers in England to mean that he was 'the property of the public'. The 'professors' of the fine arts, according to West, were regarded as 'public characters', or, according to Scott, as 'champions' of the 'people', not 'the combatants in a private contest'. Because the artist in Greece was actuated entirely by public spirit, the demand that he should serve the public accorded fully with his inclinations: he was a 'freeman', not only insofar as only those who were not slaves were allowed to practise painting, but because his duty was at one with his inclination. He was free, too, in the sense that the dignity of his calling and the value of his productions were recognised by the public, so that 'he was not obliged to solicit for employment with humiliating applications, and, when employed, to labour under the multiplied disadvantages of deficient or stinted means, of complying with vitiated judgments, of submitting to the senseless whims of folly and caprice'. He was judged by the public, as by a tribunal of his equals.[77]

It was virtually an article of faith among civic humanist writers on painting, as on other topics, that in Britain the Glorious Revolution had established a form of government comparable with that of Athens in the freedom it vouchsafed to its citizens. It is beyond the scope of this study to discuss just how it could be believed that a mixed constitution, a limited franchise, and a limited monarchy, could offer a form of liberty at once equal to, and likely to last longer than, that of republican Athens, or how therefore a republican political vocabulary could be used to describe the constitution of Britain; but a couple of quotations may serve to exemplify that very general belief. According to Dennis,

As the *Athenians* had Liberty with a Common-wealth, the *English* enjoy the very same Liberty under the Government of the best of Queens, and in so doing are the happiest People in the World ... I desire the Reader to believe, that I am not such a fool to contend

for Names but for Things; that Liberty is Liberty under a limited Monarchy, as much as under a Common-wealth.

And according to Shaftesbury, the differences between a republican government and the 'national constitution, and legal monarchy' of Britain were fully explained by the far greater population and area of Britain as compared with the Greek city-states. The constitution of Britain was 'fitted' to 'hold together' 'so mighty a people; all sharers (though at so far a distance from each other) in the government of themselves; and meeting under one head in one vast metropolis'. The newly-established liberty of Britain appeared to ensure, therefore, that, as Richardson prophesied (and here he is entirely at one with more 'traditional' humanists), 'if ever the Ancient Great, and Beautiful Taste in Painting revives it will be in *England*'; for 'there is a Haughty Courage, an Elevation of Thought, a Greatness of Taste, a Love of Liberty, a Simplicity, and Honesty among us, which we inherit from our Ancestors, and which belongs to us as *Englishmen*'. Shaftesbury was similarly convinced that a 'united Britain would soon become the principal seat of arts; and by her politeness and advantages in this kind, will shew evidently, how much she owes to those counsels, which taught her to exert herself so resolutely on behalf of the common cause, and that of her own liberty, and happy constitution.'[78]

This theme was taken up by Thomson, Akenside, Turnbull, Algarotti, and even by Benjamin West, who still believed that no people were 'so likely to revive good art as the English', at a time when it had become more usual to wonder why they had failed to do so. There was however one slight difficulty in pronouncing these prophecies: for had not the France of Louis XIV succeeded in resuscitating the arts, if not in restoring them to full health, much more effectively than Britain appeared to be doing? 'Where absolute Power is', Shaftesbury insisted, 'there is no PUBLICK'; but where absolute power had been, there Poussin and Lebrun had been also, hardly the equals of the painters produced by the republics of Florence and Venice, but a class or two above Sir James Thornhill and the managers of the British portrait-factories. The most usual way out of this difficulty was the way taken by Shaftesbury and Thomson: the tyranny of Louis had indeed produced painters of genuine merit, because he had endowed the arts so generously— which only went to show how much Britain, when 'imperial bounty'— royal or public patronage—was equally forthcoming, would excel France in the arts, for in Britain they would also have, as their stimulus and subject, a system of liberty.[79]

The freedom of its constitution once established, it might seem that

a state would also need a prolonged period of peace to ensure the successful cultivation of the fine arts; but the necessity of peace is conceded reluctantly, at best, by a discourse on which the example of Sparta is almost as influential as that of Athens. Peace may be inimical to public spirit, which, as Hume pointed out, 'must increase, when the public is almost in continual alarm, and men are obliged every moment to expose themselves to the greatest dangers for its defence'. And so, according to Turnbull, peace will promote the arts in a free society, only if 'Opulence and profound Quiet' do not lull the mind into an equally 'profound Lethargy, apt to effeminate and enervate it'. Better than that would be 'War and Contests', which 'keep the Mind awake, lively and vigilant, rouse the Spirits', and 'inflame the Love of Liberty, by keeping up a warm sense of publick Good, and of our Obligations to contend for it vigorously'. The chief danger, then, to public spirit and therefore to the arts that served it, is the '*vain, luxurious, selfish* EFFEMINACY', represented by Pleasure in her debate with Virtue for the soul of Hercules; and luxury is the inevitable result of commerce conducted on any large scale. As Blake, as committed as anyone of his generation to the civic humanist ideal, explains: 'Empires flourish till they become Commercial', and commerce is 'destructive' to the arts.[80] 'The long reign of luxury and pleasure under King Charles the Second', Shaftesbury believed, had stunted the development of the arts in England. Voluptuousness and acquisitiveness, according to Kames, 'contract the heart, and make every principle give way to self-love; benevolence and public spirit . . . are little felt, and less regarded; and . . . there can be no place for . . . the fine arts' in a mind or in a society so corrupted. And luxury, argued Berkeley, had effects still more fatal than this: 'a corrupt luxurious People must . . . fall into Slavery', for their weakness will expose them to foreign invasion; and even if 'no Attempt be made upon them', they will fall into slavery 'of themselves'—they will become the slaves of their own insatiable appetite for luxury and the pleasures of sense.[81]

The consequences for painting of this decline into luxury will be considered on various occasions by the writers to whom the following chapters are devoted, and there is no need to examine them in detail here. It was extremely difficult for traditional humanists to believe anything other than that, as John Brown claimed, painting was 'debased into Effeminacy' by the decline of public spirit that is brought about by luxury. For luxury, as Kames has already made clear to us, is generated by, and itself generates a selfishness which seduces, because it can afford to seduce, the fine arts from their proper public function. It creates a demand for paintings as articles of private

property; artists become no longer the 'property of the public' but the servants of individual patrons; they are employed to gratify the self-interest of those individuals; of men, that is, not in their uniform civic identity, but as private persons, who differ widely in their tastes, and who will only hesitate to dissolve the public consensus as to what constitutes good taste, if that consensus is represented to them as based, not on the universal principles of human nature, but on fashion. By luxury, the demand for paintings is increased; men set themselves up as painters when their abilities give them no title to do so; and what follows from here had already been described at length by the critics of seventeenth-century France. Thus, as Fréart de Chambray, for example, had explained, painting becomes a trade ('un mestier')—just as, in luxurious societies, war had become a trade, carried on by armies of mercenaries; it declines into mannerism, because men who cannot grasp the principles of art must practise it mechanically, by rule and rote; it becomes ornamental, so as to gratify the sensual appetites of its patrons; and so on.[82]

There were writers, of course, who dissented from this analysis: who could halt the explanatory machine of traditional humanism for long enough to suggest, as Richardson did, that paintings might reasonably be considered as, among other things, articles of trade; or that the increase of commerce, which need not, perhaps, be synonymous with luxury, could lead to an improvement in the art of painting, in the same way as it could stimulate the improvement of other manufactures. But suggestions such as these could not easily be advanced with conviction, because their application could not easily be controlled. They could not be confined to the discussion of a particular issue in the history of art, but threatened the coherence of the whole vocabulary of the criticism of painting, and, in particular, the distinction between liberal and mechanic on which the republic of the fine arts, and the political republic, were both founded.

9. *Theories of painting in France*

I want now to glance at an issue which will probably have been exercising those of my readers who are familiar with German and, especially, with French writings on painting of the late seventeenth and eighteenth centuries: that I have been describing, as a specifically British, and civic humanist theory, what is no more than the common currency of the criticism of painting in other countries of Europe where such criticism was being written. There is, of course, a good deal of truth in this: writers on art in eighteenth-century Britain were

much dependent on French writers of the later seventeenth century in particular, and on Du Bos, whose *Réflexions critiques sur la poësie et sur la peinture* were first published in 1719; and German writers of the middle and late eighteenth century were much dependent on their predecessors in France and Britain, as well as in Italy. Much of what I have claimed as characteristic of the discourse of civic humanism— the distinctions, for instance, between liberal and mechanic, and between rhetorical and emblematic, could be exemplified from continental writings on art. I have already found it convenient to draw on Mengs's account of the first of those distinctions, and I could have used Du Bos, in particular, to describe the second.[83]

But my claim that the British writings on painting that I have been considering employ a civic discourse, and that this distinguishes them from the writings of their predecessors and contemporaries abroad, does not depend on the argument that particular ideas within the British critical tradition were unique to it, but that those ideas develop a distinctive coherence by virtue of their connection with a coherent, and—by the early eighteenth century—distinctively British political philosophy. And I want now to suggest that the writings especially of the French critics from whom the British borrowed, owe their coherence not to a republican account of social and political organisation, but to one best understood in terms of a feudal distinction between estates; that, consequently, the account they offer of how painting addresses us, and what its function might be, is significantly different from what we have encountered in Britain; and that because they do not employ a specifically republican account of history, they did not develop a specifically social and political account of the decline of painting, such as we have found among British writers. Where appropriate, I shall suggest that some of this may be true, also, of Winckelmann and Mengs, who may have been influential, respectively, on Fuseli and James Barry.

I have suggested that the distinction between liberal and mechanic, in terms of the qualifications for citizenship in a political republic, is constitutive of the 'traditional' discourse of civic humanism, and so of civic humanist theories of painting in whatever form they take. The same distinction is made by writers on painting in France: according to Félibien, for example, the art of painting is worthy of occupying a distinguished rank among the liberal arts, but those who have attempted to furnish it with rules have, by concentrating on the less noble parts of the art, left it still among the mechanical arts. Significantly, however, the distinction is more usually made in the form of one between 'nobles' and 'ouvriers'. I make this point with some caution, for both words are ambiguous: 'noble', as well as meaning

'of noble blood', has a range of meanings suggestive of elevation about the common run of things, as it has in English, and as, arguably, it has in the paraphrase of Félibien I have just offered; and in these senses it may be used with varying degrees of emphasis on its connection with notions of the aristocratic. 'Ouvrier', as adjective and noun, can refer to those who perform manual labour, but in seventeenth-century France it can refer also to those employed in professions as well as in trades, and who perform them, by way of distinction, particularly well. When God is described as 'le grand ouvrier', no aspersions are being cast on his condition or employ-ment; nor does van Opstal intend any, when he comments on the profound learning of the 'ouvrier' who created the Laocoon.[84]

When, however, the two terms are directly opposed, they seem to take on the function of the distinction between liberal and mechanic in English criticism, but with the difference, that what is opposed to 'ouvrier' is less a civic than a specifically aristocratic elevation above the merely workaday. We may glimpse this in Poussin's remark on the subject-matter of painting, that 'elle doit estre prise noble, qui n'aye receu aucune qualité de l'ouvrier'; we may see it more clearly in Félibien, when he remarks that different 'ouvriers' apply themselves to different subjects, and adds that 'il est constant qu'à mesure qu'ils s'occupent aux choses les plus difficiles & les plus *nobles*, ils sortent de *ce qu'il y a de plus bas & de plus commun*, & *s'anoblissent* par un travail plus illustre' (my emphases). The point becomes unambiguous in Du Bos's account of genius: geniuses are born, he insists, and so they are 'nobles Artisans'; those without natural genius remain all their lives 'de vils ouvriers & des manoeuvres, dont il faut payer les journées'.[85] The word 'noble' occurs, of course, often enough in British writings on painting: the ideas of a painter, his subject-matter, may be noble; but the word does not appear as one of a pair of terms, in such a way as to call attention so directly to the suggestion that a distinction in terms of intellectual dignity is being figured as a distinc-tion in terms of birth, blood, or condition.

Accordingly, when writers on painting in France refer to Pliny's account of the edicts in Greece against slaves setting up as painters, they interpret it differently from the British, and both interpretations are selective. Pliny's words are 'semper quidem honos ei fuit, ut ingenui eam exercerent, mox ut honesti, perpetuo interdicto ne servitia docerentur': 'painting has always consistently had the honour of being practised by people of free birth, and later on by persons of station, it having always been forbidden that slaves should be in-structed in it'. If in Britain writers on painting chose to emphasise the civic function of art, by ignoring the word 'honesti', with its

suggestion of 'aristocratic', writers in France ignore 'ingenui', men of free birth, and translate 'honesti' only. Thus, according to Fréart, the Greeks permitted only the most 'noble' men to paint; and according to de Piles, 'it was not permitted to any but those of noble blood', 'because it is to be presumed', that the 'Ingredients of a good Painter are not ordinarily found in Men of vulgar Birth'— though he goes on to suggest that we should now employ this distinction only figuratively, and that painters need a noble soul, rather than noble progenitors. Mengs, too, sometimes distinguishes between liberal and mechanic as between a 'noble' profession and a mechanical trade, and explains that in Greece painting was not to be taught to any but free people, 'which in this time signified Nobles'.[86]

The fact that distinctions, within what I had better now describe as the 'realm' rather than the 'republic' of the fine arts, were figured in terms of a distinction between 'noble' and vulgar, rather than 'citizen' and vulgar, may influence too the belief in France that painting functions rhetorically, and by means of illusion, though this belief is less universal in late seventeenth-century France than in early eighteenth-century Britain. As Marian Hobson has pointed out, critics such as Fréart, Poussin and Félibien have little or no interest in the notion that painting deceives the eye or the mind. Du Fresnoy, however, characterises painting as a 'fallacious' art: we must feel able to 'walk round' the figures it depicts. Du Bos argues that though painting may not deceive the mind, it should counterfeit nature, and deceive the eye; and for de Piles, the 'end' a painter should aim at, is 'to impose on the sight': his task is to 'deceive the eye'. In each case, these remarks on the deceptive nature of painting are closely related to its rhetorical function. The connection is made most elaborately by Du Bos, who quotes approvingly the comparison made by Quintilian between the powers of painting and of oratory; and on the nature of the respect paid by the great masters of painting to the rules of their art, he writes:

> Ils ont observé les regles, afin de gagner notre esprit par une vraisemblance toujours soutenuë, & capable de lui faire oublier que c'est pour une fiction que notre coeur s'attendrit ... Ils ont voulu arrêter nos sens sur les objets destinez à toucher notre ame. C'est le but de l'Orateur, quand il s'assujettit aux préceptes de la Grammaire & de la Réthorique: Sa derniere fin n'est pas d'être loüé sur la correction & sur le brillant de sa composition, deux choses qui ne persuadent point; mais de nous amener à son sentiment par la force de ses raisonnemens, ou par le pathétique des images.[87]

In some remarks on oratory in France, Hugh Blair acknowledged that France under Louis XIV had been productive of eloquence 'within a certain sphere': in the pulpit, especially, but sometimes also in 'orations pronounced upon public occasions'. But the eloquence of the French, he argues, is 'flowery' rather than 'vigorous'; 'calculated more to please and soothe, than to convince and persuade'; and he accounts for this by the fact that arbitrary governments give 'a general turn of softness and effeminacy' to 'the spirit of a nation'. There is some jingoistic stereotyping here, in the very British, and very eighteenth-century, notion of the French as a light, frivolous nation, dancing in their chains. But that said, Blair's remarks may point to an important distinction between the function of the rhetorical aesthetic in France and in Britain; for to anyone who comes to read the French critics I am considering after a reading of Shaftesbury, or Turnbull, for example, what is most remarkable is the detachment of that aesthetic in France from the civic context it has in Britain. The nearest thing I have found in French criticism of painting of around 1700 to the demand that painting should teach specifically *public* virtue, is a remark by Du Bos to the effect that painting reinforces the grounds of social affiliation, 'le premier fondement de la société', by detaching us from our own inter-ests, and persuading us to feel for the sufferings of those unknown to us. This idea, which was to be influential on Kames, speaks to us rather of a virtue at once private and disinterested, than of the public virtue of 'traditional' humanism in Britain; and, more usually, the task of paint-ing, to teach, rather than simply to please and touch us, is made very little of by Du Bos. The greatest merit, he claims, of poems and of pictures, is to please: this is the final end they propose to themselves. Du Fresnoy seems to agree:

> Quod fuit auditu gratum cecinere Poetae;
> Quod pulchrum aspectu Pictores pingere curant,

which Dryden translates, freely, but with a sense of what is at issue, 'the Poets have never said anything, but what they believed would please the Ears: And it has been the constant Endeavour of the Painters to give Pleasure to the Eyes'. 'The design of poetry and painting is to touch and to please', Du Bos writes elsewhere; and, perhaps most strikingly significant, 'the sublime of poetry and painting is to touch and to please, as that of eloquence is to persuade'. The comparison between painting and eloquence is here made in terms which, in Britain, would have been understood rather as enforcing a contrast: to traditional British humanism, it is the task of both to please, to move, and so to persuade us to emulate the virtues of heroes.[88]

Whatever the didactic function of painting as it is conceived by the

critics I am now discussing, it remains true that in France, it is a legitimate and final end of painting that it should please as well as move us, whereas in Britain it may please us only in order to move and persuade; that whatever instruction painting has to offer, it does not teach virtue as conceived by the discourse of civic humanism; and that however we might wish to interpret it, to writers on painting in eighteenth-century Britain this emphasis on pleasure would certainly have been understood (as Blair's remarks on French eloquence suggest) as the result of the absence of opportunities for the exercise of public virtue in an absolutist state.

The relative resistance of writers in France to republican ideals of virtue is evident also in their accounts of the rise and decline of art. The most comprehensive explanation, in terms of 'moral', of social causes for the rise of painting, is offered by Du Bos. It depends on the 'happy state' of the country, the inclination towards art of its sovereign and citizens, their consequent generosity towards painters, the availability of good instruction, and a period of prolonged peace. He does not suggest that, as Shaftesbury, Richardson, Thomson, Turnbull, Scott, Barry and Fuseli suggest, the first and pre-eminent cause of good painting is a constitution which is republican, or thoroughly informed with republican values. When he considers the moral causes, more specifically, for the rise of Greek art, he acknowledges the importance of Greek liberty, but it is liberty from the domination of other states, and from the need to work for the necessities of life, that concerns him, not the civic liberty to participate in government—and as it were to underline the point, he promptly offers an encomium to Louis XIV and to Colbert, for securing, to French painters, liberties comparable with those of the painters in Greece.[89]

As for the decline of painting, this may be represented as, according to de Piles, the result of war, of unspecified 'vice', or of regal neglect; more often it is explained in terms of the natural cycle of things human, or of nature, that ensures their inevitable decay; in terms, that is, of the various ideas of cyclical and unavoidable decline that have been catalogued by Peter Burke, and which French writers on painting probably borrowed mainly from Vasari, without borrowing, however, his explanation in terms of the decline of virtue. It is suggested by Fréart that decline may be the result of 'the tyranny of evil government' ('mauvais regnes'), but not, of course, with the suggestion that the government of an absolute monarch is by nature tyrannical, and evil. The notion of natural decay, disjoined from that of the natural decay of political institutions, is at the heart, also, of Winckelmann's account of the decline of art,

which became so perfect, he argues, that it was unable to progress further, and was bound to decay. Such explanations do sometimes crop up in British authors: in Aglionby, for example, and even in Turnbull—who, however, gives far greater prominence to the social and political causes we examined in the previous section.[90]

10. The 'privatisation' of society and the division of labour

Earlier in this introduction, I suggested that we can plausibly describe the attempt made by writers like Defoe, Steele and Richardson, to adapt the discourse of civic humanism so as to make it more hospit-able to the concerns and interests of a mercantile class, as constituting an 'alternative' form of civic humanism. I suggested also, however, that it was a form which would eventually divide from its host discourse and threaten to destroy it, and I want now to make good that suggestion, but also to qualify it somewhat. We can hardly be wrong, if with hindsight we describe that attempt in terms of a conflict between the literary representatives of different social and economic interest-groups: a struggle for hegemony between a mercantile class, relatively powerful economically but, politically, relatively weak, and a ruling class which represented itself—from whatever various sources its wealth was in fact derived—as a landed élite, which had claimed for itself a virtual monopoly of the public spirit and public virtues which alone gave a title to rule. In terms, however, of eighteenth-century perceptions, to describe this process of adapta-tion as the manifestation of a conflict between the interests of land and commerce would have been to over-dramatise one part of that process, which took two related but distinct forms, each dictated by the discursive possibilities open to those who found the traditional form of civic humanism inadequate to the expression of their interests.

On the one hand, the developing discourse of political economy, especially before it was represented as a science by Sir James Steuart, Adam Smith, and their successors, does often appear to be issuing a direct challenge to traditional humanism: a challenge made by writers who, often explicitly identifying themselves as spokesmen of the mercantile interest, assert the necessity of acquisitiveness, of self-interest, to a modern mercantile economy. Such writers, too, offer an account of the social organisation of a mercantile nation which implicitly or explicitly denies the possibility of a 'public spirit' that claims to be based on a comprehensive understanding of the structure and interests of society, available to the disinterested and

preferably landed citizen. Because traditional humanism had no means of understanding trade and commerce except as destructive of the commonwealth, and of public spirit, it could not avoid recognising this economic discourse as a threat to its hegemony; and for the same reason, those who wrote as spokesmen for the mercantile interest had no means of developing their distinctively economic account of human nature and of social organisation, except in the form of a direct challenge to traditional humanism.[91]

But if the discourse of civic humanism had no language in which to describe commerce except as a malignant tumour on the body of the public, it did have—indeed, it *was*—an authoritative language for the discussion of ethical values. For those writers, therefore, who felt that traditional humanism failed to address their interests and concerns, but who did not understand that failure, in some contexts at least, simply as a failure to represent their economic interests, it was neither necessary, nor would it have been prudent, to develop an oppositional mode of thinking and writing about value, even if it was possible for them to do so. It was unnecessary, for it was open to them simply to appropriate the traditional discourse—to inject it with a concern for the private virtue of those who could not aspire to public office, while still asserting—though with considerable qualification—the value and necessity of public virtue. It would have been imprudent, because the authority of the discourse in matters ethical was such as would have made it difficult for an account of value which was not a civic humanist account to be recognised as an account of value at all; and because, properly adapted, the discourse could be used to distinguish a liberal middle-class from its inferiors, in just such a way as, unadapted, it had distinguished a liberal ruling-class from a middle-class now claiming to be its equal in virtue.

Thus, when it is ethics rather than economics which is primarily at issue, writers who find traditional humanism inadequate to their concerns do not come forward as the aggressive spokesmen for the mercantile class but, if they identify themselves at all, as pacific members of 'the middle station of life';[92] they seem to restate, rather than to redefine, the ethical ideas of traditional humanism, as if their intention is benign, and their aim only to strengthen those ideals, when in fact they are changing the ethical priorities on which the discourse is based. What seems to be happening is less a direct challenge than a quiet debate, the outcome of which, however, will determine which interest-group will inherit the discourse and the authority it embodies, and so whose interests it will express and serve. This seems to be what is at issue in Richardson's departures from the ethical and critical priorities of Shaftesbury; and if, except in his discussions of

painting in relation to trade and commerce, Richardson gives few
signs of conscious disaffection from the critical assumptions of the
traditional discourse, that is because it appears to him as the one
legitimate form for critical endeavour, the form he must adopt if he is
to legitimise his own theory of painting, and one which can accom-
modate without strain his concern for the virtues and interests of
'private gentlemen'.

The claim that, to a modern commercial economy whose health
depended on its continual growth, self-interest was of more use than
public virtue, or than such disinterested private virtues as kindness
and compassion, is most memorably associated with Mandeville, but
was asserted, less scandalously but with no less conviction, by Hume,
Josiah Tucker, Sir James Steuart and Adam Smith, among many
others. Thus, according to Tucker and Smith, there was a 'natural
Disposition . . . to *Commerce*' among mankind, a 'propensity to
truck, barter, and exchange one thing for another'. It was clear that
men did not enter into these transactions out of any spirit of disin-
terestedness: as Smith explains,

> man has almost constant occasion for the help of his brethren, and
> it is in vain for him to expect it from their benevolence only. He will
> be more likely to prevail if he can interest their self-love in his
> favour, and shew them that it is for their own advantage to do for
> him what he requires of them . . . It is not from the benevolence of
> the butcher, the brewer, or the baker, that we expect our dinner,
> but from their regard to their own interest. We address ourselves,
> not to their humanity but to their self-love.

It then seemed to follow, as Tucker puts it, that '*Self-Love* is . . . the
great Mover in human Nature'; the 'principle of self-interest' is,
according to Steuart, 'the universal spring of human actions', so that:

> the best way to govern a society, and to engage everyone to con-
> duct himself according to a plan, is for the statesman to form a
> system of administration, the most consistent possible with the
> interest of every individual, and never to flatter himself that his
> people will be brought to act in general, and in matters which
> purely regard the public, from any other principle than private
> interest.

This belief leads Steuart to issue a direct challenge to the principles of
traditional humanism:

> It might perhaps be expected, that, in treating of politics, I should
> have brought in public spirit also, as a principle of action; whereas
> all I require with respect to this principle is merely a restraint from

it; and even this, perhaps, is too much to be taken for granted. Were public spirit, instead of private utility, to become the spring of action in the individuals of a well-governed state, I apprehend, it would spoil all.

Steuart acknowledges the necessity of a form of public spirit, redefined as mere honesty in economic transactions, and to be enforced, of course, by law, since it would be 'absurd' to 'suppose men, in general, honest'; but, he insists, 'were the principles of public spirit carried further; were a people to become quite disinterested; there would be no possibility of governing them. Every one might consider the interest of his country in a different light, and many might join in the ruin of it, by endeavouring to promote its advantages.' As we shall see, it is in the nature of modern societies that it is difficult, if not impossible, to arrive at a vision of the public and its true interests.[93]

An exclusive belief in public spirit as the ground of social affiliation would not only render a nation ungovernable; it would stunt the will to industry, and therefore to the growth of the economy. Thus, according to Hume, the principles of public spirit are simply 'too disinterested, and too difficult to support': 'it is requisite to govern men by other passions, and animate them with a spirit of avarice and industry, art and luxury'. For Hume, 'it is a violent method ... to oblige the labourer to toil, in order to raise from the land more than what subsists himself and his family': he is, like Smith, an advocate of a high-wage economy, which seems to him best to guarantee the safety of the state; for if the labourer is furnished with 'manufactures and commodities', 'you will find it easy to seize some part of his superfluous labour', in times of war, and 'employ it in the public interest'. Mandeville, on the other hand, believes in artificially depressing the wages of labour: it is, he argues, 'Prudence' to relieve the wants of the poor, 'but Folly to cure them', for 'the Poor should be kept strictly to Work', and will be industrious only if their self-interest compels them to be so. But what is at issue here is not the relative benevolence of Hume and Mandeville, or any disagreement as to the degree of disinterestedness in mankind, for both positions depend on the belief that men are actuated only by self-interest, in their pursuit whether of the necessities or the accommodations of life.[94]

The growth of the economy, as Ferguson explains, depends entirely on the recognition and management of the principle of self-interest: 'men are tempted to labour, and to practise lucrative arts, by motives of interest. Secure to the workman the fruit of his labour, give him the prospects of independence or freedom, the public has found a faithful minister in the acquisition of wealth.' And, therefore,

according to Steuart, 'every man is to act for his own interest in what regards the public; and, politically speaking, every one *ought* to do so' (my emphasis). If men are so blind as not to perceive that, or not to act as if, they are motivated only by interest, then self-interest is to be proposed to them as an article of political morality; if they are insufficiently acquisitive, then their natures must be managed, and they must be 'animated' with 'a spirit of avarice'. By arguments such as these, the 'public good', as it had appeared to traditional humanism, is entirely redefined. Thus, for Tucker, the two questions to be resolved by the study of economics are 'In what Particulars doth the Public Good consist? And how shall the Passion of Self-love be directed so as to produce the happy Effects intended?'—the second question precedes the answer to the first, and it effectively determines that answer. For Steuart, 'it is the combination of every private interest which forms the public good'; and 'publick happiness', therefore, as Smith explains, is often the unintended result of all the members of a society acting 'merely from a view to their own interest', and in pursuit of the principle 'of turning a penny wherever a penny was to be got'.[95]

This account has stressed the similarities among the writers I have cited at the expense of the considerable differences among them—in particular, I have concealed a disagreement as to whether mankind has always been acquisitive, or whether it is only, or is particularly so, in modern commercial societies. There would be little point, however, in distinguishing more carefully among those who argue that self-interest is, or should be, the primary ground of social affiliation: the belief in disinterested virtue, of one kind or another, was so far constitutive of the discourse of civic humanism, and therefore of any account of moral or artistic value in the eighteenth century, that all such arguments were homogenised and rejected by those who adhered to that discourse, whether in its traditional form or in the forms to which, in the mid-century, it was adapted; and, at least until the writings of Fuseli and Martin Archer Shee, they were so treated by all writers on painting of any influence.

The response of traditional humanism to these writers on economics was articulated most forcefully, often in advance of the fact, by John Brown. Brown does not deny the efficacy of the 'Spirit of Commerce' to the promotion of one kind of economic growth: it 'tends', he acknowledges, 'at once to the Increase and Preservation of Property'. But the health, and even the wealth of a nation, are not to be measured by the accumulation of individual fortunes; and while the spirit of commerce 'begets a kind of regulated Selfishness', its opposite, 'the Spirit of Liberty and Humanity' begets 'a Spirit of

Equity'. Without such equity, the 'national Spirit of Union', which requires that 'the separate and partial Views of private Interest be in some Degree sacrificed to the general Welfare', must 'ever be thwarted or destroyed by selfish Views and separate Interests'.[96] Brown does not see himself as involved in a merely theoretical debate with the views he rejects: his complaint, indeed, is that accounts of mankind as actuated entirely by self-interest appear to describe only too accurately the present condition of Britain; and so his problem is not simply to redescribe the state of the nation, and to show that the rulers of Britain are in fact motivated by public spirit, but to consider how it might be possible, once again, for them to become so. And this, as we shall see, was almost the same problem as was confronted by writers on art, who derived their critical principles from the same discourse as Brown derived his political principles, and who were wedded, in particular, to an account of the hierarchy of genres by which the various kinds of painting were valued in proportion to their tendency to promote public virtue. Such writers were faced with the task of considering how history-painting could be described or redescribed so as to counter the spirit of self-interest they saw prevailing in contemporary Britain.

Perhaps not until Martin Archer Shee, writing in the early years of the nineteenth century, did the doctrine that self-interest was natural, necessary, and even laudable, have any serious appeal to writers on painting. In fact, Shee launches a violent attack on the 'mercenary sentiments' encouraged by writers on economics, and, in particular, on 'those . . . who consult Adam Smith for their theory of taste as well as of trade; and would regulate the operations of virtù on the principles of the pin manufactory; . . . to whom the world is but as one vast market—a saleshop of sordid interests and selfish gratification'. 'It has of late become so much the fashion', he complains, 'to view every thing through the commercial medium, and calculate the claims of utility by the scale of "The Wealth of Nations", that it is to be feared, the Muses and Graces will shortly be put down as unproductive labourers, and the price current of the day considered as the only criterion of merit.' It quickly emerges, however, that Shee's main objection to Smith is not that he has allowed self-interest to come out of the closet, and to announce itself as a legitimate component of human nature, but that he encourages the belief that the value of art is to be determined by 'the wants and caprices of the million', and not by those occupying 'the summits of civilization', and that this represents 'a political jacobinism, as unworthy of the liberal merchant as of the loyal citizen'. There is, he warns,

a levelling of the principles and feelings, as well as of the ranks and
distinctions of society, and perhaps, in this country at this moment,
the more dangerous of the two; for it works unseen and uncen-
sured; strikes at the ancient nobility of the mind—the privileged
powers of genius and virtue, and would pull down all human per-
fection to be estimated according to the lowest rate of exchange. If
our heads and hearts are to be overrun by a mob of mercenary
sentiments, we shall have escaped to little purpose the disorganiz-
ation of one revolution, to be reserved to suffer the degradation of
the other. Of a system like this, the arts must ever be the first
victims; for they flourish only in the prevalence of feelings which
the sordid and selfish passions effectually destroy.[97]

This defence, however, of the 'ancient nobility of the mind' against
the revolutionary mob of levelling Scotch philosophers, elsewhere
finds expression in an argument that Shee has borrowed from Burke,
and that Burke had adapted from the tradition of economic thought
to which Smith himself had been the most notable contributor. The
argument presents itself as an attack on 'the ingenious speculations of
men whose minds are wound up to an Utopian enthusiasm', which
'inculcates contempt for the gathered wisdom of ages', and which
pretends that it would be both possible and beneficial *'to simplify
society'*, and so check—and here Shee seems to abandon the civic
principles on which his own theory of painting elsewhere seems to
depend—'the progress of wealth, luxury, and inequality'. To such a
simplification, Shee is furiously opposed: 'the finer arts and orna-
ments of life', he claims, 'all the delicate flowers of taste and genius',
are threatened by 'the axe of modern amelioration'; and the echo,
there, of the language of Thomas Paine would have been missed by
none of his readers. Suddenly, the *'Chain* of *Self-Interest'*, which to
Smith had been the cement of society, and to Brown had been 'no
better than a *Rope* of *Sand'*, with no *'Cohesion* between the Parts',
but only 'a mutual *Antipathy* and *Repulsion'*, becomes for Shee the
basis of all social happiness and cultivation:

From the innumerable complications of civil interest and social
dependence; from the influence of wealth and luxury in their most
unrestrained and extended operations; from the inequalities of
fortune, rank, and degree, holding out object to ambition, and
impulse to labour; spurring the poor by necessity, the rich by
distinction; offering ease to diligence, and leisure to curiosity; and
furnishing every individual with his appropriate motive of exertion
in the general struggle, may be traced to arise, whatever softens,
refines, elevates, adorns, and dignifies the character of human

nature . . . those brilliant sparks of civilization, those electric lights
of arts and sciences, which irradiate the otherwise sombre scene of
our existence, and shine the beneficent planets of the social firma-
ment . . . Society is a grand machine . . . Interest, self-interest, is the
firm supporting pivot on which the whole enginery rests and turns;
want, passion, ambition, are the main springs of its operation;
wealth, power, pleasure, glory, luxury, the principal wheels, which
communicating motion to all the dependent arrangements of
minuter mechanism, at length set forward the golden hands of
genius and taste to move on the dial of existence, and point to the
brightest periods of time, and the most memorable epochas of man.
 But these, as Mr Burke says, 'are high matters', not to be . . .
touched by a *rhymer on art* . . .[98]

I have quoted at such length, partly because Shee's argument en-
ables me to exemplify an attitude to the relations of art and interest
which will be notable by its absence from the writings we shall con-
sider later in this book; but partly, also, because his entire abandon-
ment here of the civic principles of Shaftesbury can give us a
foretaste, nevertheless, of how fragile those principles had become
by the early decades of the nineteenth century, and how much in need
of whatever defence could be mounted on their behalf. What unifies
the contradictions in Shee's argument, of course, is a cynical concern
for his own market: where the discourse of political economy threat-
ens the consensus of taste essential to the marketing of art, it is
characterised by the most efficacious term of abuse currently avail-
able, as *jacobinism*, the enemy of the 'ancient nobility of mind' of the
ancien régime. Where it justifies the accumulation of wealth which
makes possible the patronage of the arts, then it is an authority so far
superior to the civic discourse which was the enemy of luxury, that
civic humanism also comes to be represented as jacobinism—and not
at all implausibly, for by now there were radical writers, also,
vigorously competing in the struggle to appropriate the one
legitimate account of political virtue. Both the arguments that Shee
advances so intransigently co-operate to assert that a society exists for
the benefit of its most economically successful members, who exist
for the benefit of the arts, which exist not so much—though Shee will
claim they do—for the improvement of virtue, as for the benefit of the
practitioners of those arts. All this however, as my quotations from
Shee have suggested, is advanced under the cover of a moral tone
so elevated, that his *Rhymes on Art* can at times manage to appear
as a defence of art promoting public virtue in its most Spartan form.

* * * * *

The discourse of political economy was further to complicate the civic humanist account of the public function of painting by the attention it paid to the division of labour as the primary structural principle of commercial society, by virtue of the chain of mutual dependence that was established when men came to specialise in the provision of particular goods and services, rather than attempting to satisfy all their needs by their own various industry. As long as the division of labour did not appear to challenge the distinction between liberal and mechanic, it could be regarded, of course, as actually constitutive of that distinction. The practitioners of particular trades and professions were disabled, by virtue of their specialisation, from perceiving the public interest; and it seemed to follow, as Burke's anecdote of the shoemaker has already suggested, that those who did not pursue such specialisations were thereby enabled to develop a vision of the public, and a public spirit, denied to everyone else, and so also to grasp the true, the public function of the liberal arts; and the same point had been made by Shaftesbury. The developing sense, however, of the enormous complexity of the structures of production and exchange in commercial societies, had the effect of making the claim that anyone could now understand those structures increasingly implausible. Thus, as Ferguson explained,

under the *distinction* of callings, by which the members of polished society are separated from each other, every individual is supposed to possess his species of talent, or his peculiar skill, in which the others are confessedly ignorant; and society is made to consist of parts, of which none is animated with the spirit of society itself.

In 'simple or barbarous ages', Ferguson argues, 'the public is a knot of friends', but in prosperous, commercial nations, 'the public becomes an object perhaps too extensive' for the conception of its members. No one, as Smith as well as Ferguson had speculated, was exempt from this occlusion of the view of the public: the liberal arts, and even 'the business of state', become, in complex societies, 'the objects of separate professions'; 'thinking itself', in an 'age of separations', 'may become a peculiar craft', and even the philosopher is discovered to be implicated in an economy of exchange, and so is not exempt from the self-interest which conceals a view of the interest of the public. All men, in short, liberal and mechanic alike, 'cease to be citizens'.[99]

Not all of this account of the effects of specialised occupations and interests was contested by adherents to the discourse of civic

humanism, which indeed informs Ferguson's and Smith's considerations of the topic. John Brown too had claimed that even among the supposedly liberal there were those dedicated to the 'Pursuit of Gain', in whose minds 'the Idea of a Public has no Place'; and the difference between his position and Ferguson's was that he felt bound to protest at a process he refused to believe was irreversible, and that he declared it to be the result more of a failure of the will and intellect than of inexorable forces of social and economic change. As we shall see, writers on painting, anxious to defend the political and ethical functions of their art, and to justify the foundation of a public body to promote them, were inevitably committed to the same belief. The belief however that the public was disappearing, that it lay somewhere in the centre of an entirely impenetrable labyrinth of intertwined occupations and interests—a belief which had been voiced by Johnson as well as by the political economists of Scotland—made it difficult to assert the old civic humanist belief that the liberal minds of the citizens of a state were still in a position to perceive its interests. In casual moments, and on unimportant occasions, that could still be done: the discourse of political economy could be characterised as the production of illiberal minds, of minds as blind and mechanical as those engaged in the manufactures they promoted: of Tucker's observation that 'a pin-maker was a more useful and valuable member of society than Raffaele', Reynolds remarked in conversation—though he thought the remark worth committing to paper—that it was the 'observation of a very narrow mind; a mind that is confined to the mere object of commerce, that sees with a microscopic eye but a part of the great machine of the economy of life, and thinks that small part which he sees to be the whole'. But in public pronouncements, and, in particular, in public lectures at the Academy, the commitment to an idea of painting as still capable of promoting public spirit could no longer express itself in a simple rehearsal of the confident assertions of writers such as Shaftesbury and Turnbull.[100]

11. The 'privatisation' of virtue and of painting

Within the field of ethics, insofar as it could be disjoined from economics, it was unnecessary, I have argued, for those who sought to construct a space in which the private virtues could be more appreciated, to issue a direct challenge to the discourse of civic humanism, and to frame a new discourse of their own. The traditional discourse could be adapted, so that the private virtues, in particular the soft virtues of amiability, kindness, compassion, could appropriate to themselves some of the dignity of the public virtues. This is a part of

the process which has been named 'the privatisation of virtue' in the eighteenth century, but we should be wary of the phrase. If we look upon works of ethical philosophy in the period as constituting a continuous tradition of thought disjoined from its historical context, we may persuade ourselves that what we observe, from Shaftesbury through, say, to Paley, is a steady devaluing of the dignity of the public virtues, and a steady elevation of the dignity of private virtue, until, by the end of the century, it became possible to represent it as a cause of complaint, that 'by far the greater share of glory attends upon what are called great actions'—which are in fact 'glorious to the individual alone'—than to 'a sober train of benevolence', such as is 'useful to the community'.[101] On its own terms, this account is true enough; but it may be more helpful to understand this phenomenon in the terms of conflict and appropriation I proposed at the start of my previous section. For what seems to be happening is that a discourse, whose function, at the start of the century, was to define the ethical ideals of a ruling class, is being appropriated by the literary representatives of their polite but unenfranchised social inferiors. There seem to be two motives for this appropriation: to adapt it, so as to enable it to describe the virtues of the unenfranchised—I use the term here to apply to those who may be eligible for, but cannot aspire to, public office; and to confuse the distinctions between public and private virtue in such a way as to suggest that, in point of virtue, there is no clear distinction between the moral capacities of the franchised and the unenfranchised.

This is another subject that requires a book to itself, and perhaps only a conspicuous brevity can escape the objections of those better qualified to write this section than I am. So let me ignore, for example, the distinction between Shaftesbury's account of public virtues and affections and Hutcheson's softer and more compassionate 'public sense', and pass over the borrowings from Hutcheson made by the writers whom I shall, briefly, discuss.[102] These are the Scottish writers Hume, Adam Smith and Kames, far more thoroughgoing in their attempt to 'privatise' virtue than any writers in mid-century England.

Each of these writers proposes a taxonomy of virtues and passions which cuts across, or in some other way complicates, the earlier secure division between public and private. Hume, for example, remarks that in 'panegyrics that are commonly made of great men' a distinction is observed between their public virtues—'such as make them perform their part in society'—and their private virtues—'such as render them serviceable to themselves'. But this description of public virtues is evidently different from Dennis's, for example, for

whom all but the heroic virtues were private: for Hume, the public virtues are represented as '*generosity* and *humanity*'; they are not the exclusive virtues of 'public men', but such as may be exercised by anyone who acts disinterestedly in the service of others. Hume also divides the passions and the virtues they prompt into the 'tender' and the 'sublime', where the virtues that derive from the tender passions are '*generosity, humanity, compassion, gratitude, friendship, fidelity, zeal, disinterestedness, liberality*, and all those other qualities which form the character of the good and benevolent'. This list includes within its scope virtues which had often previously been divided among the public and private, according to the extent of their opera-tion and their tendency to promote general rather than particular good: as Hume acknowledges, some small 'delicacies' of love or friendship 'have little influence on society', but must be recognised as 'social' virtues as compared with the self-directed virtues of enter-prise and frugality.[103]

The 'sublime' passions, however, are those which Shaftesbury and Dennis would have recognised as truly heroic, but they may, accord-ing to Hume, be far from disinterested:

> in general, we may observe, that whatever we call *heroic virtue*, and admire under the character of greatness and elevation of mind, is either nothing but a steady and well-establish'd pride and self-esteem, or partakes largely of that passion. Courage, intrepidity, ambition, love of glory, magnanimity, and all the other shining virtues of that kind, have plainly a strong mixture of self-esteem in them, and derive a great part of their merit from that origin. Accordingly we find that many religious declaimers decry those virtues as purely pagan and natural, and represent to us the excellency of the *Christian* religion, which places humility in the rank of virtues, and corrects the judgment of the world, and even of philosophers, who so generally admire all the efforts of pride and ambition.

Heroic actions, Hume claims, benefit chiefly those who perform them, not the inhabitants of the countries whom heroes claim to have saved from destruction. Thus, though 'heroism, or military glory, is much admir'd by the generality of mankind', who consider it 'sublime', 'men of cool reflexion are not so sanguine in their praises of it':

> the infinite confusions and disorder, which it has caus'd in the world, diminish much of its merit in their eyes. When thy wou'd oppose the popular notion on this head, they always point out the

evils, which this suppos'd virtue has produc'd in human society; the subversion of empires, the devastation of provinces, the sack of cities. As long as these are present to us, we are more inclin'd to hate than admire the ambition of heroes.

In his account of heroic virtue, Hume comes as close as ever he does in his writings on morals to a direct challenge to the values of traditional humanism; the challenge, however, remains indirect, partly by virtue of his continual use of local irony—we have heard it, for example, in the phrase 'many religious declaimers', whose opinion we cannot quite believe he endorses—and partly by means of a more general relativism.[104]

For, Hume continues, when 'we fix our view on the person himself, who is the author of all this mischief . . . we cannot refuse it our admiration. The pain, which we receive from its tendency to the prejudice of society, is overpower'd by a stronger and more immediate sympathy.' This sense that our judgments of passions and virtues may be a function of the point of view from which we regard them, is repeated also in Hume's observation that we admire virtues and passions rather according to their conformity with our own dispositions, and our sense of our own capacities, than according to a moral arithmetic of the kind by which Hutcheson had demanded that virtues should be estimated. 'The man of a mild disposition and tender affections', Hume explains, will particularly admire benevolence and humanity; a man of 'courage and enterprize' will place more value on 'a certain elevation of mind'; and this phenomenon 'must evidently proceed from an *immediate* sympathy, which men have with characters similar to their own'. In short, Hume is offering, not a system of morals so much as a phenomenology of our reactions to different kinds of actions and passions; and the effect of this, too, is to complicate the notion that virtues may be estimated by the place they occupy on a scale of public utility. According to who we are—and according, we might add, to our position within society— we sympathise with different virtues; and no moral arithmetic can persuade us that we ought not to esteem acts of friendship more highly than acts of heroism, or even selfish passions and self-directed virtues more than tender acts of charity.[105]

Hume also distinguishes between virtues in terms of those which are 'amiable' and excite our love, and those which are 'aweful', and elicit our respect. This distinction was borrowed and adapted by Smith, to describe, on the one hand, 'the virtues of candid condescension and indulgent humanity', and, on the other, 'the virtues of self-denial, of self-government, of that command of the passions which

subjects all the movements of our nature to what our own dignity and honour, and the propriety of our own conduct require'. Both kinds of virtue, Christian and Stoic, are equally necessary for 'the perfection of human nature'; but though Smith gives no preference to the 'amiable virtue of humanity' over the more heroic virtue of 'magnanimity', it is clear that, like Hume, he regards the latter as owing its origin more to self-esteem than to the social affections. Kames, finally, proposes a distinction between 'social' and 'selfish' passions and actions, where the 'social' however, include acts of particular friendship no less than those of comprehensive benevolence, and where the selfish are perfectly estimable, so long as they do not encroach upon the social.[106]

The point of these remarks has been simply to indicate how the writers I have mentioned all contributed to a complication of the distinction between public and private virtue that had been proposed by traditional humanism. They do not entirely undermine it, but they separate the hard virtues of heroism from the softer virtues of universal benevolence: the former, once prized as public and disinterested, are represented as self-directed, and those once recognised as disinterested but private are grouped alongside those which manifest a comprehensive public spirit, so that all 'social' virtues may now claim to be 'public'. And the effect of this complication was to suggest that social, or public, virtues were capable of being exercised, not perhaps by the vulgar, but by a wider class of men than could aspire to the opportunity of displaying the public virtues described by Shaftesbury, Dennis, or Thomson.

This is the first aspect of the 'privatisation of virtue' whose effect, on the theory of painting, I want briefly to consider, and I want to suggest that it led, in the mid-century, to an account of the function of painting and of the higher genres of literature, whereby their task was to teach social rather than specifically public virtue. This, for example, is Daniel Webb, reflecting on the danger of conceiving of the 'usefulness of Painting' in terms of a hard republican notion of virtue:

> It should seem that legislators, for the most part, divide men into two extremes; to those of finer temper, they propose the good of society, and beauty of virtue, as sufficient motives to action: But the vulgar and sordid natures are, by their leading passions, as pride, fear and hope, to be compelled into virtue. Such systems as these may produce a Spartan severity, or Roman patriotism, but never an Athenian politeness. To effect this, the softer passions, and even elegant habitudes, are to be employed: These only can

humanize the mind, and temper it into a sensibility of the slightest impressions, and most exquisite feelings.

Accordingly, when Webb comes to the criticism of particular history-paintings, he describes them in terms of their ability to refine the amiable passions, rather than to inspire us to emulate the awful virtues of the heroes they depict. In Poussin's painting of the death of Germanicus, we are not, he imagines, prompted to an admiration for stoic magnanimity, but 'to a generous indignation at the cruelty of his oppressor, and an equal compassion for happy virtue'; the *Plague of Athens*, then believed to be by the same painter, 'melts the soul into a tender participation of human miseries: These impressions end not here; they give a turn to the mind advantageous to society; every argument of sorrow, every object of distress, renews the same soft vibrations, and quickens us to acts of humanity and benevolence.' Painting, for Webbs may inflame us to the emulation of virtue, but it does so by softening our resistance, not by steeling our resolve.[107]

In Burke's *Enquiry*, the passions excited by the sublime and the beautiful are divided according to a system similar to Hume's division between the sublime and the tender. Just as, for Hume, sublime actions owe their origin largely to self-esteem, so the sublime is related by Burke to our concern for our self-preservation. For Hume, the tender virtues derive from our social affections, and for Burke the origin of our love of beauty is a love of society; and Burke may derive from Hume a contrast between the sublime Cato and the beautiful Caesar, as examplars of the awful and the amiable passions, the first inspiring fear and admiration, the second love. Alexander Gerard proposes a similar distinction between the sublime and the beautiful; and though the sublime of heroism includes for him a complex of power and humanity—the hero has the 'power' to subject to 'his dominion' '*multitudes* of nations', and 'wide *extended* countries', and a 'benevolence' hardly less imperious, which 'comprehends *multitudes*', and 'grasps whole *large* societies'—Gerard does not imagine that the function of representations of such heroism is to inflame us to emulate it. The moral function of painting, on the contrary, is to 'soften' the mind by its 'charms', and to 'dispose' us to 'friendship, generosity, love, and the whole train of kind affections'.[108]

Reading these passages from Webb and Gerard, we may reasonably suspect that one of the advantages of the increasing emphasis on the 'tender' virtues was that it could put an acceptable face on a commercial society in which economic activity was being extracted, by writers on economics, from the sphere of public morality. As Blake was to point out, in 'The Human Abstract', the

upgrading of such virtues as 'humanity' and 'pity' was especially of benefit to the *victors* of the commercial system, who were offered thereby the consolation of engaging in private moral transactions with its *victims*—transactions necessary to alleviate the suffering caused by a system whose own tough 'necessity' the rhetoric of tenderness was rarely deployed to challenge, and whose effects it was more often employed to conceal. Insofar as painting came to be seen, in the mid-century, as concerned with the promotion of what, from the viewpoint of traditional humanism, were private virtues, it was itself being 'privatised', was being invested with the task of teaching its spectators to take a private pleasure in alleviating the results of activities of which they were the economic beneficiaries, and, either more or less directly, the agents. A privatised painting is thus made complicit with a commercial system assumed to be outside the sphere of the moral, so that its function comes to be to clear up after the accidents—the 'collisions', as they came to be known—which are the inevitable effects of commercial capitalism. This relation of complicity will be rejected by most of the writers we shall be considering in this book, on the grounds, of course, not only that it represented commercial activities as amoral, but that it devalued painting; though this is not to say that they could do other than propose—as perhaps only Fuseli recognised—a range of relations between painting and commercial society in which their complicity is visibly more strained but was invisibly confirmed.

* * * * *

The suspicion for, and devaluation of, the heroic virtues that we have been observing, engendered also a belief that, while the sublime of heroism may have been useful to the republics of antiquity, in constant danger of invasion, and small enough to enable an active concern for the whole body of a people, in the more secure, polite, and extensive societies of modern Europe, representations of heroic virtue may be of small relevance to men whose experience of life was at once more pacific and more private. The sense which continually hovers above mid-century discussions of heroic painting and poetry, that the age of heroism had long passed, was perhaps as much a hope as an anxiety; for if it were true, it would challenge the distinction, in terms of a capacity for public virtue, between those capable of governing and those capable only of being governed. The belief, however, was usually represented as, at least partially, a matter for regret. Smith notices among the 'inconveniences ... arising from a commercial spirit', that 'the minds of men are contracted, and

rendered incapable of elevation', so that 'the heroic spirit is almost utterly extinguished'. In commercial societies, as it seems to Ferguson, the poetry of heroic action is also, regrettably, an anachronism. The superiority of the Greeks, he writes, 'is in no circumstances more evident than in the strain of their fictions, and in the story of those fabulous heroes, poets, and sages, whose tales ... served to inflame that ardent enthusiasm with which this people afterwards proceeded in the pursuit of every national object'. The members of those 'illustrious states',

> from the habit of considering themselves as part of a community ... were regardless of personal considerations: they had a perpetual view to objects which excite a great ardour in the soul; which led them to act perpetually in the view of their fellow-citizens; and to practise those arts of deliberation, elocution, policy, and war, on which the fortunes of nations, or of men, in their collective body, depend.[109]

But if 'to the ancient Greek, or the Roman, the individual was nothing, and the public every thing', then 'to the modern, in too many nations of Europe, the individual is every thing, and the public nothing. The state is merely a combination of departments.' We can now have no occasion for a poetry which attempts to animate the heroic virtues to act in the furtherance of the public interest. 'The remains of an active spirit', the 'examples and the experience of former and better times', are preserved by writings which have become 'literary monuments'; and their function is not to provoke emulation, but to mark the distance between the societies that produced them, and the modern age.[110] In passages such as these, the civic discourse is invited to pronounce its own funeral oration: if civic virtue is buried with the city-state, its passing is mourned; if word comes that it has been seen alive, a posse of Scotch philosophers is sent out to detain it for re-education.

James Northcote believed that the 'grand', the heroic style of painting was 'held very disagreeable' in Britain because it was 'an article totally useless and unfit in respect to the habits of private life'; in some remarks about 'Brutus', Pope's projected epic, Joseph Warton comes near to offering the same opinion. Had Pope completed it, Warton imagines, he would:

> have given us many elegant descriptions, and many GENERAL characters, well drawn; but would have failed to set before our eyes the REALITY of these objects, and the ACTIONS of these characters: for Homer professedly draws no characters, but gives us to collect them from the looks and behaviour of each person he introduces

... It would have appeared (if this scheme had been executed) how much, and for what reasons, the man that is skilful in painting modern life, and the most secret foibles and follies of his cotemporaries, is, THEREFORE, disqualified from representing the ages of heroism ... which alone epic poetry can gracefully describe.

Warton's particular point, I take it, is that Pope's preoccupation with character was, by definition, a preoccupation with the private—with secret foibles and follies—and that he could not therefore lift himself to the representation of action, and (the symmetry of the argument requires) of public concerns. But this does not seem to be, from one point of view, a failing in Pope but in the age: Pope was, after all, 'skilful' in the painting of modern life, which was, quite simply, the painting of *general* character in terms of *private* characteristics; the heroic age is past, and the public world of epic is not the world before our eyes. But Warton will not take the next step and question the value of writing epic at all, in an age to which the epic is foreign, an age not of action but of character; and though the epic may still be defensible, in Warton's terms, as a lesson in action to an age of character, he does not see the need to make that defence, for the notion of epic as the highest kind of poetry seems to him so far from needing a new justification that it remains to Warton one of Pope's greatest failings that he did not succeed in a genre, the function of which Warton imagines he does not need to consider. And yet, quite evidently, his argument requires him to consider the question—as writers, also, on history-painting were obliged to consider it: if epic is the representation of 'the ages of heroism', and those ages are understood as opposite in their character to 'modern life', then what has modern life to do with the heroic, and how can the heroic survive as a mode of art, if it is not also a mode of life?[111]

I shall say more about this issue in my chapter on Fuseli, and more, in my chapter on Barry, about that aspect of the 'privatisation of virtue' by which the private virtues (which, according to Hume, enable men to 'promote their own interest') were capable of being represented, also, as public virtues, contributing directly to the interest of the public. But as I hope this section has shown, we—or the writers I am about to consider—have already enough problems to worry about. If, by the mid-century, the distinction between public and private had become far less secure than it had been to Shaftesbury, Dennis, Thomson and Turnbull; and if, so far as it was secure, public, or specifically heroic virtue, could seem to have no such function as would justify the preeminence of heroic art among the genres of writing and painting; then however the notion of public art could

be redefined, it is clear that those charged by the Academy with the responsibility of restoring 'the dignity of the dying Art' were faced with a difficult task.[112] On the one hand, their membership of the Academy, and all the institutions of criticism, committed them to a defence of those genres of painting which seemed to fulfil a public moral function; on the other hand, they were themselves members of 'the middle station of life', and it may have been a matter of concern to them to question an idea of painting which, by requiring them to exalt the pretended public virtues of a civic élite, obliged them to deny, at the the very same time, their own moral qualifications for citizenship.

12. Summary of argument, and remarks on the 'public' and gender

The chapters that follow discuss the ways in which, in response to these difficulties, the civic humanist theory of painting was variously adapted by those writers on art who, I believe, had most to contribute to the discussion of the issues raised in this book. Reynolds, it is argued, attempted to ground public spirit not on virtue but on a particular kind of social knowledge. To this end he replaced the rhetorical with a philosophical aesthetic, which attempted to promote, in the doctrine of the 'central forms', a uniformity of perception: by central forms we are enabled to discover, not how to act in the public interest, but what our individual characters have in common; and thus the 'public' is made a visible object, as is the basis of our affiliation to it. Barry is represented as attempting to argue that painting should depict the diversity of a society divided by the division of labour, but in such a way as enables its members to grasp the common ends, political and religious, which their divided labours co-operate to achieve. The chapter on Blake, which is in the form of a 'Blake Dictionary' reveals his great dependence on Barry's writings, and argues against those critics who have claimed that his own writings on art promote a 'romantic individualism', or a specifically 'romantic' humanism. Barry and Blake, I claim, were the first writers on art in Britain to attempt to extend the idea of the 'public' of art so that it could include all the members of a state—or rather all its male members—and to develop a theory by which history-painting could represent them all, and reveal to them the terms of their citizenship.

Fuseli, I shall suggest, attempts at times to reaffirm the values of the civic discourse in its purest, its most traditional form, and at others to adapt that discourse so that painting can be argued as capable of creating a substitute for a now-lost public sphere, by enabling the modern spectator, individualised and isolated by the conflicts generated in the

pursuit of artificial wants, to recognise, by a mode of private sympathy, the same plight in others. The final chapter argues that
Haydon, the last writer who attempted to defend the pre-eminence of
the 'grand style' in civic terms, was unable to assert that it could still
perform any public function, and was reduced to defending it simply
as a *style*; and that Hazlitt launched the first fundamental attack on
the civic humanist theory of art and the 'public' painting it promoted,
by claiming that the ends and satisfactions of painting were primarily
private, and by denying the traditional interdependence of the republic of taste and the political republic.

Finally, some remarks on the language of this book, where it may,
for one reason or another, be open to misinterpretation.

When Reynolds was writing his early discourses, it was still easy to
believe that the recently founded Academy could achieve its main
end, of promoting an art which would promote the public interest. By
the turn of the century, however, there was, to most commentators,
no sign that the Academy had succeeded in encouraging the development of a school of history-painting worthy of a great and free nation.
Various explanations were canvassed, but all of them came back to
the same point: that there was no longer a 'public' in Britain, in the
sense of a body of citizens animated with the public spirit which alone
could encourage a public art; the body of the public was now a corpse,
corrupted by the luxury and commerce that the civic humanist
discourse had so strenuously attempted to arrest; the account of
society offered by the economists, that it was structured as a market,
was only too accurate.

Under the pressure of this perception, whether of decline or (to the
political economists) of development, the meaning of the word
'public' itself was perceived to be changing. The word came to be
used less and less to signify 'the commonwealth', 'the community or
people as an organised body', or the government of a 'civil state'. It
came increasingly to signify, instead, 'the country as an aggregate,
but not in its organised capacity', and hence, simply, 'the members of
the community' (*OED*). But it developed another meaning as well. I
mentioned earlier that the Latin *publicus* signified a 'public man', a
magistrate; I did not add that *publica* signified a 'public woman', a
prostitute, a woman who would do anything for anyone, if the price
was right. And around the turn of the century, 'public' comes to refer
more often, not simply to the mass, the totality of a people, but also to
an undefined group of rich consumers of the arts, who had appropriated the term to themselves, without also assuming the civic
identity and the civic responsibilities of a true public. This public was
frequently perceived as mercenary, ignorant, vain, capricious, with

no steady attachment to principle, 'ever governed', as Wordsworth described it, 'by factitious influence' and blown every which way by the breath of fashion. It was, in short, a luxurious, an 'effeminate' public, of easy virtue. The phrase 'the public voice', signifying something like the general will of the citizens of a state, comes to be supplanted by 'public opinion', the mere will of all; or else, as Blake explained, what we now call the 'Public Voice' is the public's error.[113]

This usage, however, is more complicated than my account so far has suggested, because the memory of the unambiguous authority the word had recently embodied is still powerful. Anthony Pasquin, in denouncing those who regarded themselves as the 'public' for art in the late eighteenth century, declared that:

> the mightiest evil to be regretted is, that the VULGAR, who have no knowledge of propriety, should, from their numbers, their riches, and consequently their power, have the national patronage within their dominion; and yet these bipedal reptiles must be uniformly soothed and solicited, under such a forcible designation, as
> THE PUBLIC.[114]

Pasquin's point is complex, and it goes to the heart of the complexity of the word. There is, he is suggesting, a conspiracy in its use, between the rich but vulgar purchasers of paintings, and the artists who satisfy their demand for ornamental, sensual images to gratify their caprice, vanity, and self-interest. The first demand to be called 'the public', so that their taste will be dignified as civic and disinterested; the painters agree to call them that, to encourage the pretence that when this public buys paintings, they are doing so out of a civic duty to promote the arts; and to encourage them, therefore, to buy more. Pasquin's anger exploits the tension between the two senses of public, as *publicus* and as *publica*, a tension we may often observe in the period before the 'public' for the arts came to signify simply the aggregate of its consumers. But, until that time, it is often difficult to gauge the relative strength of the two senses in any particular instance of its use; and when, in the chapters that follow, I cite passages in which the word appears, my interpretations of it will need to be scrutinised, and tested against the reader's own understanding of the relation between its positive and its pejorative meanings.

I had better also explain—if it is not already too late—that throughout this book I have been careful *not* to use a vocabulary purged of sexist reference. When I speak of what 'men' thought, of 'Man' in general, of the spectator as 'he', I am doing so with forethought, and in order to emphasise the point that, in the civic humanist theory of art and the various mutations of it we are about to

consider, women are denied citizenship, and denied it absolutely, in the republic of taste as well as in the political republic. They could not claim full civic membership of the republic of taste because, in the first place, they had no public identity in the political republic, and were thus incapable of public virtue; in the second place, the theories of art discussed in this book all presume that the ability to grasp the relations of general and particular is fundamental to correct taste. But as Mary Wollstonecraft pointed out, 'the power of generalizing ideas, of drawing comprehensive conclusions from individual observations ... has not only been denied to women; but writers have insisted that it is inconsistent, with a few exceptions, with their sexual character'; and this 'imbecility', as Robert Lowth and Samuel Johnson described it, of the 'female mind', meant that women were capable of thinking only in terms of—the phrase is Hazlitt's—'personal ideas'. These were no doubt among the reasons why writers on painting continually assumed that their readers were only men: Archibald Alison distinguishes between male and female beauty in terms of the different forms of 'our sex' and of 'the other sex'; we prefer to see paintings of the naked female, explains Mengs, because, among other reasons, 'we' are at liberty to look at naked men whenever we please.[115]

It was no doubt also with the disabling characteristics of women in mind that Wollstonecraft began the thirteenth chapter of *Mary* (1788) like this:

> When the weather began to clear up, Mary sometimes rode out alone, purposely to view the ruins that still remained of the earthquake: or she would ride to the banks of the Tagus, to feast her eyes with the sight of that magnificent river. At other times she would visit the churches, as she was particularly fond of seeing historical pictures.
>
> One of these visits gave rise to the subject, and the whole party descanted on it; but as the ladies could not handle it well, they soon adverted to portraits; and talked of the attitudes and characters in which they should wish to be drawn. Mary did not fix on one— when Henry, with more apparent warmth than usual, said, 'I would give the world for your picture, with the expression I have seen in your face, when you have been supporting your friend.'
>
> This delicate compliment did not gratify her vanity, but it reached her heart.[116]

Mary's fondness for history-painting, and her refusal to take a vain pleasure in considering how she would wish to be portrayed, are directed by Wollstonecraft against the assumptions about women

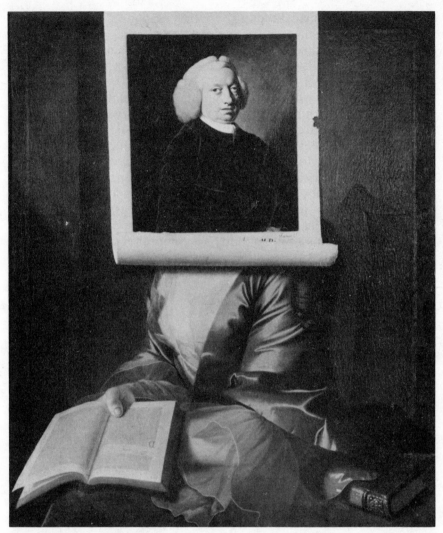

2. Thomas Hudson(?), *Miss Irons* (mid-18th century, date uncertain), private collection. 'A nineteenth century label is on the back of the picture: A picture with a scroll over face by Hudson, Sir Joshua Reynolds Master. The original portrait was one of Miss Irons, a well-known beauty. When the picture came home she did not think it did her justice & returned it to Hudson to have it improved. He painted over her face the scroll having the portrait of (?) Thomas Mudge saying he would put some sense into her head somehow & that Thomas Mudge was the wisest man he knew.' (*Thomas Hudson, 1701–1779*, catalogue of an exhibition at Kenwood, London, 1979, no. 66).

embodied in the civic humanist theory of painting. That theory assumes that, as Shaftesbury had put it, 'Ladies hate the great manner'; that women cannot understand history-paintings, which are public and idealised works, the comprehension of which demands an understanding of public virtue, an ability to generalise, and 'an acquaintance with the grand outline of human nature', which (whether by nature or nurture) is denied to women, who are obliged to remain 'satisfied with common nature'[117]. If the 'ladies' cannot discuss history-paintings, that is because it has been presumed impossible for them to learn how to do so. Portraits, however, work in terms of 'personal' ideas; they aim to present particular likenesses; where they represent virtue, they favour the private virtues; and they gratify the vanity of those who sit for them, and so of women especially, who are known to be especially vain. That women are happy to discuss portraits, only confirms their inability to comprehend the higher, the public genre of art.

I

SIR JOSHUA REYNOLDS

1. Introductory: the coherence of the 'Discourses'

In HIS seventh discourse, delivered at the Royal Academy in 1776, Sir Joshua Reynolds considers the opinion that only 'the good and virtuous man' can acquire a 'true or just relish' of works of art. This opinion, he suggests:

> will not appear entirely without foundation, when we consider that the same habit of mind which is acquired by our search after truth in the more serious duties of life, is only transferred to the pursuit of lighter amusements. The same disposition, the same desire to find something steady, substantial, and durable, on which the mind can lean as it were, and rest with safety, actuates us in both cases. The subject only is changed. We pursue the same method in our search after the idea of beauty and perfection in each; of virtue, by looking forwards beyond ourselves to society, and to the whole; of arts, by extending our views in the same manner to all ages and all times. (134)*

If all men of taste are also men of virtue, they are so, it seems, because they have cultivated a particular habit of mind: the habit of taking 'comprehensive views', and of subordinating their personal interests and concerns to the interests and concerns of some wider 'whole'. Reynolds will not, it seems, explictly endorse the opinion he has considered: to do so would be to engage in an argument too complex to be determined before his audience at the Academy. But it is everywhere clear that he regards the opinion as well-founded, and indeed the connection between taste and 'the more serious duties of life' is crucial to an understanding of the Discourses;[1] which, as I shall be

* All page-numbers in this chapter refer to *Reynolds's Discourses on Art*, ed. Robert R. Wark, 2nd edition, New Haven and London 1975.

arguing in this chapter, are dedicated to an attempt to establish a public painting, whose function will be to confirm the audience for art as the members of a republic, or a community, of taste, and, by that means, to confirm their membership also of a political public.

The principle, that it is the function of art to create and to confirm a republic, or at least a community, of taste, is, I shall argue, the main principle of unity among the writings produced by Reynolds over a period of more than thirty years. In this century, and especially since the publication of Blake's annotations to the *Discourses*, and the reprinting of Hazlitt's most detailed criticism of them, a good deal of the critical discussion of Reynolds's writings has centred on the issue of whether the contradictions in them are real or only apparent.[2] Those who have argued for the consistency of the *Discourses* have represented Reynolds's apparent changes of mind as justified by his occasional claim to be revealing the mysteries of his art in stages, in time with the stages of the education of the pupils at the Academy; according to Haydon, for example, the *Discourses* may have the appearance of inconsistency, but this is simply the result of the fact that they were 'delivered at separate periods to the same men, who were first infants in the art, then became youths, and required other nourishment, and lastly grew to men, and could venture on substantial food'. Against that view, it has been pointed out that the fifteen discourses were delivered over a period of more than twenty years, by the end of which time apparent inconsistencies can still be detected, but the pupils who attended the delivery of the first discourses could hardly still have been in the early stages of their education; and that, as the audience to whom the discourses were read was composed not only of students but of the aristocratic and learned, to whom Reynolds may have wished to make a definitive defence of the aims of the Academy, he should not be imagined as concerned simply with the instruction of future practitioners. Accordingly, it has also been argued that the inconsistencies in the *Discourses* should be understood as proceeding from a change in Reynolds's opinions, from a neo-classic to a more romantic aesthetic—a view based on such remarks in the later discourses as that one task of reason in criticism is 'to inform us when that very reason is to give way to feeling' (231).[3]

Both these explanations deserve to be taken seriously, for both seem, at different times, to be true; but the major change I see in the *Discourses* is best understood as a change in Reynolds's political opinions, or as a change, rather, in the relative authority, as he perceived it, that was attached to the different discourses in which a defence of public art could be mounted. In his early addresses to the Academy, I suggest, Reynolds is attempting to define a republic of

taste in terms of the analogy with the political republic as conceived by the discourse of civic humanism, so that we become citizens of the republic of taste by overcoming the customs, prejudices and interests which conceal from us our true identity, as that may be imagined to be based on the universal and permanent principles of human nature. In this attempt, however, he does not simply repeat the defence of a public, a civic art, that had been offered by Shaftesbury and the traditional humanist writers on painting. He retains a version of the history of painting, and of civil society, by which the health of both is threatened by the growth of luxury; and he makes much of the distinction between liberal and mechanic which I have argued was constitutive of 'traditional' civic humanist theories of painting. But in making that distinction, he gives a new emphasis to one aspect of it in particular: he pays less attention to the difference between liberal and mechanic, polite and vulgar, in terms of the capacity of either for public virtue, and gives far more prominence to the question of their relative ability to abstract general ideas from the raw data of experience. The primary function of art becomes no longer to persuade us to emulate acts of public, or even of private virtue: if art influences our actions, it does so only mediately, and as a result of the successful fulfilment of its immediate aim, which is now to teach us the grounds of our membership of civil society. To this end, Reynolds abandons the rhetorical aesthetic of traditional humanism: painting no longer seeks to persuade, but to display the world in such a way as to make it an instructive metaphor for the world as perceived by an ideal citizen, whose identity is thus also changed, and is defined less by his willingness to act in defence of the republic, more by his ability to grasp the terms of his affiliation to it.

In the later addresses, however—and perhaps as Reynolds observed that the civic discourse was being appropriated by representatives of the very vulgar whose citizenship it had sought to deny—Reynolds begins to change tack. He slackens in his efforts to define a civic art, and a 'universal' republic of taste constituted on the uniformity of human nature in 'all ages and at all times', and begins to consider whether the dignity of his art, and the security of the state, might not better be defended in the discourse of custom, the discourse to which Blackstone and Johnson, and after them Burke, were giving a new power and authority. In these discourses, he begins, accordingly, to advocate an art which would address itself to a national community, a nation state, different in character from other states. And in the case of Britain at least, that difference was defined not in the narrowly political terms of civic humanism—broadly, whether a state was a republic or an autocracy—or in those terms

only insofar as the political organisation of Britain was itself a result of the history, the customs, and of whatever else constituted the national character of the British.

Thus, the kind of public that painting should address changes, and so therefore does the kind of art necessary to address it; what remains constant is the notion that art has a political function which it fulfills when it impresses us with an awareness of our common nature, an awareness whose ultimate end is that we should recognise that our true nature is discovered only as we are members of a political society. In the early part of this chapter, I shall be concerned with Reynolds's adaptation of the civic humanist theory of painting in its traditional form that we examined in the introduction; with the theory he develops, that is, in the first six discourses, and later in the ninth and tenth. This is the theory which, as we shall see, most characterised his thinking in the minds of his successors. I shall then go on to consider what I take to be the main modifications of that position, as they appear in the seventh and eighth discourses, and are developed in the thirteenth and fourteenth, and in two pieces of writing that Reynolds did not publish: his essay on Shakespeare, and the 'Preface' to his 'Ironic Discourse'. But because there is continuity as well as change in his writings considered as a whole; because, at least within the *Discourses*, his conversion to the discourse of the customary is never complete; and because it is when his version of the civic discourse is most threatened that it is most clearly defined; I shall not hesitate to borrow, where it seems appropriate or convenient to do so, arguments from his later writings to exemplify his earlier positions.

2. *The 'Discourses' and the history of painting*

In his early addresses, Reynolds departs least from the traditional civic discourse in his account of the history of art and of civil society. The function of painting was to create or confirm a republic of taste, which would in turn confirm the security of civil society; and however different was Reynolds's conception of that function from that of his predecessors, he could not, as the spokesman for a public body charged with the task of encouraging the production in Britain of a public art, easily concede that the growth of luxury could be anything but detrimental to such an art. Thus for Reynolds, as for the writers we considered in the introduction, the history of painting was the history of a rise and then, as commerce and luxury increased, of a decline; and the success of the Academy would be judged by its

success in reversing, or at least arresting, that decline. The aim of the Academy could not therefore be conceived of in narrowly national terms: it was not simply to put the English school on an equal footing with the art of Italy or France: the duty of the man of taste was to 'extend his views' to 'all ages and all times'; and the Academy must encourage an art which had declined throughout Europe to be revived in England, by reaffirming the principles on which it should be based. The Academy will fail in its true object if it conceives of itself as a merely national institution: to 'answer the expectations of its ROYAL FOUNDER', it must so reform taste that 'the present age may vie in Arts with that of LEO the Tenth'; and *'the dignity of the dying Art* (to make use of an expression of PLINY) may be revived under the Reign of GEORGE THE THIRD' (21).[4]

Reynolds's speculations on history are not sophisticated, or we will not think them so when we have examined those of James Barry or Henry Fuseli, and from time to time in his writings he seems to offer some unconvincing explanations for the decline of art. As far as their decline, or rather their failure to develop in England is concerned, his explanation is the conventional and (with good reason) the accepted one, that when 'we separated from the Church of Rome, many customs, indifferent in themselves, were considered as wrong', among them the practice of adorning places of worship with paintings; and he believes, again conventionally enough, that the spirit of rationalism is now far enough advanced in our religion for there to be now 'no good reason' why 'the house of GOD should not appear as well ornamented and costly as any private house'.[5] But as far as the general decline of art throughout Europe is concerned, this is sometimes represented as the simple result of that fact that the progress of painting is threatened by the 'perfection' at which its 'mechanism' has arrived, or of an indolence in the moderns which prevents them from taking the same pains as their great predecessors took; or else patron and painter alike have simply been 'debauched' by the Venetian artists and their followers, by whom 'a style merely ornamental has been disseminated throughout all Europe' (93, 280, 67). Reynolds often seems satisfied by explanations like this, apparently entirely internal to the history of art itself, or at any rate not explicitly related to the process of decline in general civilization.

But Reynolds can leave the relation thus implicit, because his language, with its references to 'corruption', to 'accident', to 'deformity', would communicate clearly enough to his audience the nature and causes of the decline he points out, which are—as is especially evident when the Venetians and the Dutch are continually being represented as the agents of that decline—the causes which

had traditionally been believed to threaten the civic republic with corruption. His views do not, in fact, seem to have communicated themselves very clearly to Johnson, who, when he supplied the first seven discourses with a dedication to which Reynolds subscribed his own name, informed the king that 'the regular progress of cultivated life is from necessaries to accommodations, from accommodations to ornaments' (3). Johnson clearly intends 'progress' to imply a rise; he is subscribing to what was, by 1778—the year when the dedication was written—the well–established argument that it is commerce which refines and civilizes a nation, not least by enabling the development of the fine arts. But for Reynolds, though he briefly endorses this argument on the first page of his first discourse (13), the third stage of this progress was almost invariably conceived of as a decline.[6] In its infancy, he believes, painting was 'dry', and 'hard'; it had a kind of 'barbarous simplicity' which 'would be better named Penury', as it proceeds 'from mere want; from want of knowledge, want of resources, want of abilities to be otherwise'. The simplicity of the first painters was 'the offspring not of choice, but necessity'. The painters of the second stage 'were sensible of this poverty, and those who were the most sensible of the want, were the best judges of the measure of the supply'. These painters 'emerged from poverty without falling into luxury' (152); they supplied, that is, our real spiritual or intellectual necessities, and a measure of dignified accommodation, so that when we examine the works of Michelangelo, for example, we 'desire nothing else', and 'feel nothing wanting' (83). In the third stage, accommodation gave way to ornament, but an ornament defined as 'luxury' (152), as making 'a parade' of its riches and its art (153), as 'meretricious' (129), as 'profusion' (148), as 'perpetual splendour' (149), as showing 'more luxuriancy than judgment' (64), as 'the lowesty sensuality' (65). This artificial, 'ornamental' style is the enemy of the 'grand style' which is the only properly civic style of painting; the 'ornamental' appeals to our sensual, acquisitive appetites; and particularly therefore to those for whom 'trade and its consequential riches' are not a means (169), to be adapted to the end of intellectual enrichment, but an end in themselves—a distinction in the tradition of Aristotle's, between 'natural' and 'unnatural' finance, which had been repeated in the eighteenth century by Berkeley, Thomson, and John Brown.[7]

It is no accident then that the republic of taste, as addressed in the tradition of history-painting in the grand style, has been corrupted by the Dutch and by the Venetians, who represent 'the Dutch part of the Italian genius', for what distinguishes Venice and Holland is the single-mindedness of their pursuit of trade as an end in itself.[8] Trade

corrupts the citizen as it corrupts the republic: the first, by encour-
aging him to be more concerned with his private interests than those
of the public; and the second, by representing to it an ideal of society
which is held together by a notion of national, rather than civic or
universal, interests—so that for the Dutch, in particular, 'a history-
piece is properly a portrait of themselves'—of 'their own people
engaged in their own peculiar occupations; working, or drinking,
playing, or fighting'—none of these, of course, 'liberal' occupations,
for by 'fighting' Reynolds no doubt means brawling. Such pictures
'are so far from giving a general view of human life, that they exhibit
all the minute particularities of a nation differing in several respects
from the rest of mankind' (69).

The effect of trade, therefore, when it is pursued as an end in itself,
is that, whether on an individual or a national level, it elevates private
over public interests, and the republic is atomised into an aggregate
of 'particular men', or particular nations. Thus another way of rep-
resenting the history of art, is in relation to a rise from barbarism to a
civic society, in which the private is subordinated to the public;
followed by a collapse into a privatised society, private national tradi-
tions of art, and individual styles. Because the first stage of this
history was first accomplished in Greece, the ancients are regarded as
the quintessentially public artists—by Barry and Fuseli as well as by
Reynolds. It is for that reason that artists may imitate, or borrow
from, the ancients, as much as they please: for 'their works are con-
sidered as a magazine of common property, always open to the
public, whence every man has a right to take what materials he
pleases'. The works of more recent artists, however, are 'more the
property of their authors', because the progress of privatisation has
debased style into manner, and they contain more that should be
regarded 'as personal, and appropriated to the artist' (107, 261).

The 'only hope' for the 'revival' of art, Reynolds insists, is that we
should be 'thoroughly sensible of its depravation and decay' (83).
Only on the basis of that awareness can the Academy, and the
Discourses, perform their function, to recall art from what it has
become to what by nature it really is, to its true nature, defined, in
Aristotelian terms, as its highest excellence. To perform that task,
they must at the same time recall men to what is their true and highest
nature, as public men in the most extended sense of the term, citizens
of a universal republic, and to persuade them to subordinate to the
public interest their merely private and merely national identities.
The citizen, like the painter, must 'disregard all local and temporary
ornaments, and look only on those general habits which are every
where and always the same'; he addresses his mind, as the painter

addresses his works, 'to the people of every country and every age' (49).

These announcements, however, of the supra-national nature of the citizen and artist, do not preclude the expression in the *Discourses* of an occasional patriotic fervour: it is legitimate for Reynolds to hope that it will be in Britain that '*the dying Art*' may be revived, not out of the kind of patriotism which might believe that something peculiar to the genius of the English people makes them particularly suited to this task, but because, in the republics of taste and of the fine arts, as in the political republic, a competition for honour and distinction is not only permissible but desirable. In the political republic, as we have seen, the citizens pursue glory in the public service, and compete, 'on a footing of equality', for 'office and in virtù';[9] similarly, in the republic of the fine arts, the 'spirit of emulation' is the mark of a mind which is not servile (247), and in both cases it is imagined that the winners will be those who can most fully represent the public interest in themselves. Patriotism was to be conceived in the same terms: all nations are engaged in a competition for intellectual reputation, and 'the estimation in which we stand in respect to our neighbours, will be in proportion to the degree in which we excel or are inferior to them in the acquisition of intellectual excellence' (169). But in this competition, too, the winners will be those who can most represent, in themselves, the universal interests of civilization; and such a competition for intellectual excellence differs from a competition in terms of trade: that kind of competition can be won only at the expense of the interests of the losers; but a competition in the liberal arts, though won by one nation, is won for them all.

3. Citizenship and the ability of abstract from particulars

As his views on the history of art have already suggested, Reynolds was as anxious as writers earlier in the century had been to establish that painting was to be regarded as a 'liberal profession', and not a 'mechanical *trade*' (93, 117). In one of his earliest essays, he insists that if the imitation of nature is the end of painting, the 'rank' of painting as 'a liberal art' depends entirely on how this notion is interpreted; for where our aim is merely to represent objects 'naturally', so that they have 'such relief that they seem real', our notion of imitation will be 'merely mechanical'.[10] In his first discourse he opposes 'mechanical felicity' in drawing, which is a species of 'fallacious mastery', with the correctness of drawing appropriate to a liberal art

(18–19). By Reynolds as by his predecessors, the term 'liberal' may be equally opposed to 'servile'; so that 'it is a necessary and warrantable pride to disdain to walk servilely behind any individual, however elevated his rank. The true and liberal ground of imitation is an open field', and those who imitate the manner of some master or another are 'narrow, confined, illiberal, unscientifick, and servile' (100–1, 104) whereas the truly liberal painter, a 'great proficient', is able 'to see clearly enough . . . to point out to others the principle on which he works'.[11] The importance of establishing painting as a liberal art is the same to Reynolds as it had been to his predecessors: it is necessary to vindicate it as an 'intellectual entertainment' which, despite being 'applied to somewhat a lower faculty of the mind, which approaches nearer to sensuality', nevertheless 'abstracts the thoughts from sensual gratifications' (170); and it is necessary to attract gentlemen to the study and patronage of art, if they cannot be attracted to it as practitioners. A liberal art is defined by Johnson as one 'worthy of a gentleman'; and as the opposition of liberal and servile makes clear, it is worthy of a gentleman in his capacity as a free man, a citizen.[12]

If painting was to be defined as a liberal art, it was essential of course that it should be recognised as that, by those capable of doing so: gentlemen, free men, citizens. The public for art must therefore be defined in such a way as to exclude all who are not capable of rising to the liberal ideal of art; for if they are admitted into the republic of taste, painting will find itself responding to their presence and to their interests in such a way as will endanger the liberal ideal on which it should be based. A rough and ready way of enforcing their exclusion was to charge for admission to the exhibitions at the Academy, 'to prevent', as Reynolds explained in his 'Advertisement' to the first such exhibition, 'the room from being fill'd by improper Persons, to the entire exclusion of those for whom the Exhibition is apparently intended'.[13] The danger of such 'improper persons' was that painters would be 'seduced' to 'an ambition of pleasing' them 'indiscriminately' (90), and would settle for producing works addressed to the lowest common denominator of the taste of the spectators. Painting would thus be reduced to the mechanical imitation of 'actual nature', of what 'we see and hear every day', for 'the Vulgar', who are 'ignorant of the principles of art', 'will always be pleased with what is natural, in the confined and misunderstood sense of the word' (235, 89, 96). The charge, of course, rather symbolised than effected the exclusion of the vulgar from Reynolds's notion of the 'public'; to be able to afford the price of admission was no guarantee of a liberal mind, and in 1772 Reynolds was still complaining of the 'mixed multitudes' who resorted to 'our Exhibitions' (90). The true need was

for a principle of discrimination by which the mechanical, the vulgar, would be excluded not from the Academy exhibition but from the abstract republic of taste; and as I have suggested, it suited Reynolds's purposes to locate this principle in the relative abilities of the polite and the vulgar to abstract from their experience, for it was on this ability, he was to argue, that the claim of painting to have a political, a public function, was based.

In his ninth discourse, Reynolds offers to give 'a short survey of the progress of the mind towards what is, or ought to be, its true object of attention'. In his most primitive, his 'lowest' state, man 'has no pleasures but those of sense, and no wants but those of appetite'; and indeed, it seems that this remains the state of the majority of members even of nations which then advance to the peak of civilized achievement. For that advance is consequent on the division of society into different ranks, whereby 'some are appointed to labour for the support of others'; and those who are 'appointed' (Reynolds does not say by whom) to this task remain under the dominion of the senses which 'are necessary to direct us to our support' (169–70)— elsewhere Reynolds argues that 'those who have not cultivated their imaginations, which the majority of mankind certainly have not, may be said, at least in regard to arts, to continue in this state of nature' (233). Those, however, 'whom their superiority sets free from labour', turn their attention to 'intellectual entertainments'— or at least, they should do so, if the plenty they enjoy is not to become a danger to the 'security of society' (170).[14]

Those who, by virtue of their mechanical occupations, are doomed to continue in a 'state of nature', are incapable of reasoning, which, in Reynolds's terms, means they are incapable of abstracting from experience. As Thomas Tickell had long before explained, only 'long study and experience' enable men to reduce 'their ideas to certain classes, and consider the general nature of things abstracted from particulars'. The practitioners of mechanical trades, on the other hand, though they are certainly 'born', Reynolds believes, 'with a capacity' for abstraction (233), do not enjoy the leisure necessary to self-cultivation, and so, in Tickell's phrase, 'cannot abstract'.[15] That, for Reynolds, is the fundamental reason why they are excluded from the political republic and from the republic of taste. The political republic is founded on an abstract principle, for participation in it depends on the ability to grasp the common interest of its members, abstracted from their particular interests. It is not 'easy', Hume had explained— and here, if not often elsewhere, Reynolds would have agreed with him entirely—

for the bulk of mankind to distinguish, in a great number of par-

ticulars, that common circumstance in which they all agree, or to extract it, pure and unmixed, from the other superfluous circumstances. Every judgment or conclusion with them is particular. They cannot enlarge their view to those universal propositions which comprehend under them an infinite number of individuals ... Their eye is confounded with such an extensive prospect; and the conclusions derived from it, even though clearly expressed, seem intricate and obscure.[16]

The ability to grasp general truths was essential to the citizen, for it was essential to the safety and continuance of a civil society. It was therefore necessary, Reynolds claimed, not only 'to the happiness of individuals', but still more to 'the security of society', that those who are free men, who are released from the need to labour, should have minds 'elevated to the idea of general beauty', as well as to 'the contemplation of general truth' (170), for the exercise of taste was, for Reynolds, a mode of exercising the same faculties as were exercised in the contemplation of society and its interests. The principles of taste, like those of politics, are abstract principles, and the qualifications for membership of the republic of taste and of the political republic are therefore the same. Both will exclude the practitioners of mechanical trades, who by synecdoche come to represent the vulgar of every condition of life, all those who either do not have the leisure, or will not use the leisure they have, to cultivate the ability to frame general ideas. In short, those who are excluded from both republics are excluded because they 'cannot comprehend a whole, nor even what it means' (202), and therefore cannot comprehend what it is to be a member of a political whole, a civil society.

The distinction between liberal and mechanic, between liberal and mechanical arts, and between painting pursued as a 'liberal profession' or as a 'mechanical trade', is continually represented in the *Discourses* by an opposition between the mind and the hand, between principle and mere practice, and also by an opposition between the kind of art which seeks to address the mind, and that which is addressed to the eye only: a public art has depth, and not a merely superficial appeal.[17] And, related to this second opposition, as well as to his superior ability to 'abstract', is the fact that the man of taste, like the citizen, is capable of extensive, and not merely narrow or confined views of the world he sees around him. For 'the nobility and elevation of all arts, like the excellency of virtue itself, consists in adopting' an 'enlarged and comprehensive idea; and all criticism built upon the more confined view of what is natural, may properly be called *shallow* criticism, rather than false: its defect is, that the truth is

not sufficiently extensive' (125). As in virtue, so in taste; and as in taste, so in politics: for, Reynolds argued— borrowing many of his key phrases from Burke—

> a hundred thousand near-sighted men, that see only what is just before them, make no equivalent to one man whose view extends to the whole horizon round him, though we may safely acknowledge at the same time that like the real near-sighted men, they see and comprehend as distinctly what is within the focus of their sight as accurately (I will allow sometimes more accurately) than the others. Though a man may see his way in the management of his own affairs, within his own little circle, with the greatest acuteness and sagacity, such habits give him no pretensions to set up for a politician.[18]

As we have already observed, to have 'narrow' or 'confined views' is also to be 'illiberal' and 'servile'; and it is so, largely because it precludes the ability to prefer remote to immediate gratifications which as we have seen is a crucial mark of the man of taste and of virtue. The only artists who can be compared with the great masters are 'such as have great views, with fortitude sufficient to forego the gratifications of present vanity for future honour'; neither taste nor virtue 'consist in taking what lies immediately before you', and though 'in the infancy of our knowledge we seize with greediness the good that is within our reach', by 'after-consideration' we learn to 'refuse the present for a greater good at a distance' (31, 124–5).

By an extensive vision, and the ability to prefer the remote to the immediate, we learn not only what virtue is, but also what truly belongs to human nature, 'the most general and unalterable principles' (122) upon which it is founded; and because we thus discover that human nature is, always and everywhere, essentially the same, the language of the *Discourses* repeatedly attributes value to what is fixed, settled, permanent, solid, as opposed to whatever is floating, fluctuating, fleeting, variable. The range of the applications of this opposition in the *Discourses* is very extensive and can be illustrated here by a few examples only; but it can apply to the opposition between the *prima forma* of human nature as against what custom has made it ('the genuine offspring of nature' or 'the capricious changeling', 48), or between the 'stability' of the 'true idea of beauty' as against 'a partial view of nature, or the fluctuation of fashion' (73), or between 'the most correct out line' and mere 'facility' (17, 19), or between the settled virtues of tradition and 'the desire of novelty' or 'caprice' (84). What matters in all these oppositions, however, is that the ascription of value on which they are based must be understood in

relation to a notion of a republic whose security is to be founded on universal and solid principles, if it is to survive the various forms of accident, and to defer the effects of the various forms of corruption, that are incident to the fact that it exists in the dimension of time. They must be understood also, therefore, in relation to the identity of the true citizen, whose nature is unalterable and whose principles are fixed. The man of public spirit and correct taste does not alter, as do the fickle, the *mobile vulgus*, when he alteration finds; and this steadiness in nature and principle is in turn related to his characteristic independence. The citizen of the political republic is independent in terms of fortune—that is to say, he depends not on his own labour but on that of others—and in terms of judgment; the citizen of the republic of taste has a similar independence of judgment, at least: he makes up his mind freely, and not as the servile do, by imitating the opinions of men of rank, or of each other.

As a matter of fact, of course, the judgments of the man of taste, insofar as it is in that identity that he makes them, will always confirm the value of the great tradition in painting. He will always prefer the antique to the modern, the grand style to the ornamental, and will never be tempted to question the place of history-painting as the most elevated of the genres of art. But he forms these judgments not primarily because he defers to authority, but because his grasp of the universal principles of taste reveals to him that the grand style is the embodiment of an art whose highest virtue, like his own, is to be public, to be civic. He recognises that 'that style only is perfect', in which 'the noblest principles are uniformly pursued', and that 'those masters only are entitled to the first rank in our estimation, who have enlarged the boundaries of art, and have raised it to its highest dignity, by exhibiting the general ideas of nature' (73)—those ideas, which are the distinctive possession of the citizen, and the man of taste as Reynolds conceives of them.

There are occasions when the man of taste will fail to act up to that identity, and then he must defer to authority. When he finds that his judgment does not confirm the value of the great tradition, he will of course presume that he is wrong, for he will also presume that 'the duration and stability' of the fame of the great masters 'is sufficient to evince that it has not been suspended upon the slender thread of fashion and caprice, but bound to the human heart by every tie of sympathetick approbation' (28). But these presumptions will not be based on a belief that we should defer to established opinions simply because they are established: his divergence from the uniform judgment of others, his singularity, is not the ground of his mistake, but simply of the presumption that he is mistaken. But in cases where he

therefore corrects his opinion by deferring to authority, he is not fully
a citizen of the republic of taste, because he is not independent; he is a
probationer, in the same situation as the students at the Academy,
who must begin their education with 'an implicit obedience to the
Rules of Art, as established by the practice of the great MASTERS', and
must 'take the world's opinion' rather than their own, until such times
as they are 'emancipated' from 'subjection to any authority', but
what they shall themselves 'judge to be supported by reason' (17, 32,
26). They will only be considered as emancipated, of course, and as
free men of judgment, when their judgment is 'correct'—when they
realise that the rules are not 'fetters', but the expression of universal
principles, the grasp of which is their title to freedom (277, 17).
Where the man of taste finds that his judgment of a work does not
accord with that of other citizens of the republic, he will therefore
'feign a relish', until he feels 'a relish come'; and Reynolds compares
his situation with that of the probationary citizen who frames his
judgments according to an 'agreement' or a 'supposed compact', until
such time as his judgment becomes correct, and he can dispense with
such a fiction, because he has no need of it (277).[19] If it were not the
case, of course, that all men of taste, and all citizens, are capable of
mistaken judgments, there would be no need for the public painting
advocated in the *Discourses*. The main justification Reynolds offers
for 'lighter amusements', for the cultivation of the 'arts of elegance', is
that they enable an understanding of the grounds of social affiliation.
Those whose habits or occupations have rendered them incapable of
thinking in abstract terms cannot need them, for they have no means of
grasping the general truths the arts afford; and those who are citizens
could not need them either, because already possessed of the general
knowledge and public spirit they promote.

4. *The philosophical aesthetic*

The inability of those who are not numbered among the liberal, or the
potentially so, to abstract from particulars, is not represented by
Reynolds simply as a negative characteristic, by virtue of which they
simply fail to qualify for citizenship in the republic of taste, or in the
ideal political republic whose structure it replicates. The inability to
abstract is the result of a failure to subdue 'the gross senses' (244), the
sensuality and appetite which are satisfied only by the acquisition,
possession and enjoyment of the luxury which threatens the security
and permanence of society. On the basis of this belief, Reynolds
attacks, throughout the *Discourses*, the doctrine that 'the only busi-
ness of the art' is 'deceiving the eye', or that 'the true test of all the

arts' is 'solely whether the production is a true copy of nature' (50, 241). If those remarks leave room for the possibility that one aim, at least, of painting, may be deception, Reynolds elsewhere presents that aim as legitimate only in the lower branches of the art. If the various genres of painting had been ranked by writers earlier in the century according to their tendency to promote public virtue, Reynolds ranks them partly according to the degree to which they can dispense with illusion, with the realistic representation of common nature. 'The different branches of our art', he believes—adapting the argument of de Piles's essay 'Of Truth in Painting'[20]—promote 'different truths', a 'greater' and a 'lesser': the 'larger and more liberal idea of nature', which 'addresses itself to the imagination', and 'the more narrow and confined', which 'is solely addressed to the eye' (268). This is the ground of the distinction, within history-painting, between the grand and the ornamental styles (71):[21] 'the want' of that 'naturalness or deception' which gives to the 'inferior', the ornamental style, its 'whole value', is 'no material disadvantage' in 'heroick subjects', for in proportion as objects appear more 'real' to the eye, they must fail to achieve the ideal character which pleases the mind and the imagination.[22] The lower genres, also, 'take their rank and degree in proportion as the artist departs more, or less, from common nature' (236–7), and offers us ideal and abstract, not real and deceptive, images of objects. Reynolds's account of the hierarchy of genres and styles is in accord, however, with the account offered by traditional humanism, insofar as both can be understood as ranking the genres of painting according to the degree in which they encourage our public spirit; for by Reynolds's theory, as we shall see, the ability to abstract and to recognise the general truths arrived at by the process of abstraction from particulars is a necessary, and may even be a sufficient, condition for the development of public spirit.

To the argument that no imitation can 'strike the imagination'— which is, according to Reynolds, 'the great end of art' (59)—if it does not deceive the eye, Reynolds replies with a version of the argument that Johnson had used in defending Shakespeare's failure or refusal to observe the unities of time and place. De Piles had claimed that a painting which successfully deceives us 'elevates insensibly, and transports us, as it were, from one country to another, without our perceiving it'—it creates in us, if not an unwilling, then an unwilled, a spontaneous suspension of disbelief, essential if we are to be touched and moved by objects and actions which must appear real if they are to touch and move us. But according to Reynolds, there is no merit in painting a figure with such relief that it looks as if we could 'walk round it'; in giving 'the gloss of stuffs, so as to appear real'; or in

representing any of the minute details and circumstances which might be supposed fortuitously to attend a heroic action. If there were, and if our pleasure in art depended on our being deceived, we would prefer wax-works to paintings, and would demand that statues be painted (160, 19, 193, 176).[23] The pleasure we derive from the higher branches of painting never depends on the belief that we are really witnessing the events it depicts, any more than does the pleasure we derive from the higher genres of drama. In all 'theatrick representation', Reynolds argues,

> great allowances must always be made for the place in which the exhibition is represented, for the surrounding company, the lighted candles, the scenes visibly shifted in your sight, and the language of blank verse, so different from common English; which merely as English must appear surprising in the mouths of Hamlet, and all the court and natives of Denmark. These allowances are made; but their being made puts an end to all manner of deception (239).

It may be true that:

> the lower kind of Comedy, or Farce, like the inferior style of Painting, the more naturally it is represented, the better; but the higher appears to me to aim no more at imitation, so far as it belongs to any thing like deception, or to expect that the spectators should think that the events there represented are really passing before them, than Raffaelle in his Cartoons, or Poussin in his Sacraments, expected it to be believed, even for a moment, that what they exhibited were real figures.
>
> For want of this distinction, the world is filled with false criticism. Raffaelle is praised for naturalness and deception, which he certainly has not accomplished, and as certainly never intended (238).

In short, argues Reynolds, painting, at least considered in its perfection, 'is not only not to be considered as an imitation, operating by deception, but . . . is, and ought to be . . . no imitation at all of external nature' (232). The opinion that it is, is a vulgar opinion, held by those who have not 'advanced to the higher state' of being able to abstract from experience, but remain in a state of 'gross common nature', wandering in the dark labyrinth of the particular, and so 'merged in sense', as James Harris had put it, that they 'never once dream any thing to be worthy of pursuit, but what either pampers their appetite, or fills their purse'; and 'imagine nothing to be real, but what may be tasted or touched'.[24] To derive the principles of art and criticism from such men, Reynolds expostulates, would be the

same as if 'a judge of morals and manners' were 'to refer controverted points upon those subjects to the opinions of people taken from the banks of the Ohio, or from New Holland' (233).

I suggested in my introduction that, according to traditional humanism, it was essential that a painting should deceive the eye, for if it did not, it could not address us rhetorically; and I suggested also that one disadvantage of the rhetorical aesthetic was that it could make no clear distinction between the responses of the learned and ignorant, even to heroic painting, for a successful picture, like a successful piece of oratory, would move or persuade every member of its audience. True, the learned could judge of the principles by which a successful painting had been composed, but this act of judgment had to be imagined as being made only after their initial, involuntary response, for if they were prompted to judge a work even as they were being moved by it, it would cease to move them. The paradoxical result of this was that the vulgar, who in some accounts could be included among the 'ignorant', might be more persuaded to emulate acts of public virtue, which they could not however perform, than the learned, who could perform them.

Reynolds's abandonment of the notion that the primary aim of painting is to deceive the eye, puts the distinction between the liberal and vulgar on much firmer ground, though with the result, as we shall see, of increasing the number of those entitled to style themselves 'liberal'. And it also involves an abandonment of the rhetorical aesthetic itself. At one point in the *Discourses*, when discussing the Venetian style, Reynolds does suggest that painting may function rhetorically: 'the powers', he writes, 'exerted in the mechanical part of the Art have been called *the language* of Painters; but we may say, that it is but poor eloquence which only shews that the orator can talk. Words should be employed as the means, not as the end: language is the instrument, conviction is the work' (64). His point is that the ornamental, the Venetian style, mistakes the means for the ends: so entirely is it addressed to 'the eye or sense' that it pleases without moving or convincing us; the concern of Venetian painting with illusion, far from reinforcing its rhetorical appeal, prevents that appeal from being made, and the style remains 'a mere struggle without effect' (64). If this suggests, however, that painting is, properly, a rhetorical art, which strikes the imagination, however, in proportion as it does not attempt to deceive, that suggestion is nowhere else taken up by Reynolds. For his aim throughout the *Discourses* is to argue for what I have called a 'philosophical' aesthetic, in terms of which the imagination is the power of abstraction itself, and the faculty which spontaneously registers the power of the abstract, the

ideal. The imagination is 'struck', not by the reality of an image, but by its general character; it is 'convinced', not as rhetoric convinces us of the need to do something, but as philosophy convinces us of the truth of a general proposition. If for Shaftesbury, the 'sole use and beauty' of painting was 'pleasing illusion or deceit',[25] and the function of that deceit was to persuade us to emulate acts of virtue, for Reynolds, the primary aim of painting was to offer the imagination abstract, ideal, representative images, whose function is not, in the first place, to dispose us to any particular action, but to enable us to grasp what we each have in common with others. If, for the advocates of the rhetorical aesthetic, a painting fails to move us in proportion as it fails to deceive us, for Reynolds it fails to affect us with an awareness of our common nature in proportion as it attempts to deceive.

The foundation of Reynolds's philosophical aesthetic is the ability to abstract from particulars: taste, and genius, which differs from taste only in that it has 'superadded to it a habit or power of execution' (120), are the power to select and combine the actual, detailed appearances of particular objects so as to produce not individual but ideal images, the representatives of classes, of species. Such images are the mark of a liberal art, not only because the ability to abstract is an ability peculiar to the liberal mind, but because an abstraction cannot be possessed as a particular object can be. Deceptive images of individual things may inflame our sensual, acquisitive instincts; representative images do not; and, for that reason, they are appropriate to 'public' paintings in the restricted sense of paintings owned not by individuals but by 'the public', whereas images of particular objects tend to be conceived of as articles of private property.

It hardly needs saying that the claim that painting should represent ideal, not actual nature, was, or was believed to be, almost as old as the art itself: the story of Zeuxis selecting and combining the best points of the maidens of Croton to produce his painting of Helen is one of the founding anecdotes of European art-criticism.[26] Nor, of course, among the moderns, was that claim confined either to advocates of a philosophical aesthetic or to critics, like Reynolds, who believed that the ideal was the result of abstraction from particulars. We have already noticed the problems raised for the rhetorical aesthetic by what was, in fact, an almost universal acceptance of the claim that the higher branches of painting were obliged to idealise nature, a claim whose authority was such that it could not be ignored by the most dedicated advocates of art as illusion. That a painter should adapt the appearances of things so as to conform with an ideal image in his own mind had been endorsed by the authority of Raphael; and the belief that the painter must 'endeavour to correct

and amend' the deformed and decaying things of 'sublunary nature' so as to make them conform, as far as possible, with 'those first forms which are called Ideas', was the central tenet of neo-Platonic criticism of painting. More pertinently, among critics whose notions of the ideal were shaped by empiricist accounts of the process of abstraction, Jonathan Richardson, as we have already seen, had argued that painting addressed us in part by means of a philosophical aesthetic, by proposing abstract images of perfection to the understanding, and Alexander Gerard had made the power of abstraction central to his account of taste. The 'conclusions' of taste, he claimed, 'cannot be formed without a vigorous abstracting faculty, the greatest force of reason', and 'a capacity for the most careful and correct induction'; 'in order therefore to form an able critic, taste must be attended with a philosophical genius, which may subject' the objects of art and nature 'to a regular induction, reduce them into classes, and determine the general rules which govern them.'[27]

Reynolds's aim, however, in arguing that painting should represent ideal and not common nature, and that the ideal is produced and recognised by the faculty which abstracts the general from particulars, is significantly different from those of the various authorities I have cited. His riposte to neo-Platonic notions of the ideal was that 'great ideal perfection and beauty are not to be sought in the heavens, but upon the earth. They are about us, and upon every side of us'; and are discovered by the 'long laborious comparison' of one object with another (44). At the same time, the philosophical aesthetic is far more central to his account of the function of painting than it was to Richardson's or Gerard's. Reynolds believes, as did Gerard, that by means of an account of ideal beauty as abstract beauty, it would be possible to represent it, however elevated above our everyday experience, as grounded in that experience, and not as dependent on a claim to individual intuition, inspiration, or a quasi-religious enthusiasm (43, 95, 120). But he also believes, as Gerard gave no sign of doing, that because all those able to abstract from particulars would be able to recognise the ideal as a true and adequate representation of the individual experience of each of them, it would have the effect of promoting a uniformity of taste, and would enable us to overcome the differences in how we each see the world, so as to recognise a nature common to us all, and our own common, human nature. Even in this, however, I do not attribute to Reynolds any remarkable originality, but only such as derives from his making the abstract ideal, 'the central form', the cornerstone of his account of what a 'public' art might be.

Before we examine the doctrine of the central form, however, it

will be helpful if we remind ourselves of the argument of my introduction: that in developing their accounts of a 'public' art, the lecturers at the Academy were in fact developing an account of how art might *once again* perform the public function that it had performed in Greece and in the Italy of Michelangelo and Raphael. Thus Reynolds was writing at a time when the 'public' was felt to be becoming more and more invisible, and the societies of Europe, and of Britain in particular, were believed to be becoming more and more 'privatised'. The opportunities, so it was believed, for the exercise of the public virtues were diminishing, and the value and usefulness of those virtues were being questioned by those with no opportunity for exercising them. The structure of society was thought to have become too complex for individuals to be able to understand their relation to the public, and the centrifugal force of private interests and appetites was felt to be encouraging them not even to attempt to arrive at such an understanding. The task of the *Discourses* was thus not simply to define a public art and a republic of taste, but to show how such an art could be produced, and how, once produced, it could create such a republic, by membership of which a man of taste could come to understand the nature of his duties and of his affiliation to the political commonwealth.

The difference between defining a public, and creating one, and Reynolds's awareness of that difference, is nowhere more evident than in his account, rudimentary though it is, of the psychology of perception. There is, Reynolds argues, 'a general uniformity and agreement in the minds of men', based on the 'original frame' of the mind, and 'we have no reason to suspect there is a greater difference between our minds than between our forms; of which though there are no two alike, yet there is a general similitude that goes through the whole race of mankind' (131). The 'original frame' of the mind is programmed to enable us to emerge from the world of sense to the world of ideas; for those who, by virtue of their station in life and the liberal education it affords them, are enabled to pursue this course of development, it should follow that they arrive at the same general ideas of nature, for the differences among the experience of each of them, as we observed in the introduction, become insignificant when the range of that experience is as extensive as it will be in those not bound to mechanical occupations.

As then the 'internal fabrick of our minds' is 'nearly uniform', 'it seems . . . to follow of course, that as the imagination is incapable of producing any thing originally of itself, and can only vary and combine those ideas with which it is furnished by means of the senses, there will be necessarily an agreement in the imaginations as in the

senses of men (132).' It seems then to follow, or at least Reynolds wishes it did, that the minds of men, which should all produce more or less uniform general ideas, should be pleased by the same representations of them in art. But of course they are not; and Reynolds treats this as the result of a habitual preference for attending to the accidental deformities which distinguish one object from another in the same class, rather than to the 'great characteristick distinctions' (192) which define the general classes to which objects belong. If we do not develop the power of selecting and combining the data furnished by the senses, or if we develop it only partially, or each to a different degree, then the differences in our experience, however unimportant when that power is developed, prevent us from arriving at a collective understanding of the near uniformity of that experience and of our own natures. For it is of course from a failure of the abstracting power that the preference for the accidental derives. It is a preference, for it is the offspring of desire; it is the mark of a sensual, appetitive attitude to nature, which will characterise the vulgar at any time, but which, in an age of increasing luxury, will threaten to characterise also the liberal, or those who, by virtue of their independence and education, should be so. It will so characterise them not only as it persuades them, directly, to covet luxuries, but as it represents that covetousness to them in the form of an injunction to be fashionable and to desire the fashionable; to allow their caprice, and not their reason, to direct their pursuits; and to persuade them to prefer the singularity of a fashionable and capricious identity to the uniform identity of the citizen.

In such a time, society is no longer to be regarded as divided between the mechanic and the servile, on the one hand, who have no potential to aspire to be citizens, and the liberal, on the other, who are citizens already. It is divided simply between those who cannot hope to achieve citizenship, and those who have a title to it, but a title still to be legitimated. It is when the latter are considered in these terms that the *Discourses* ask to be read, not simply as an attempt to define, but as an attempt to create a public; and when they are preoccupied by this task, their mood changes from the indicative to the subjunctive, and 'is' becomes 'ought'; our minds are not, but should be, uniform, for we are not, but ought to be citizens. The passage in the seventh discourse from which I have mainly drawn my account of Reynolds's notion of the uniformity and agreement of our minds and imaginations, is followed by a passage insisting on our *duty* to *make* our minds and imaginations uniform and agreeable with those of others.[28]

It is Reynolds's notion of a 'public' art, of an art which will be a

'publick benefit' (171), that its function is to create a true public out of what is at present simply an audience, a congeries of spectators. It achieves this aim by exhibiting to them images which are 'analogous to the mind of man' (133)—to the original frame of that mind. These images, by exhibiting the world as it would appear to us if our imaginations were not seduced by appetite, should make us aware of the original uniformity of our minds, an awareness essential to the legitimation of our title to citizenship. If the citizen, in his most exalted form, achieves honour in proportion as he can approximate his nature to the universal nature of man, so, according to Reynolds, 'all the arts receive their perfection from an ideal beauty, superior to what is to be found in individual nature'; and 'the whole beauty and grandeur' of painting consists 'in being able to get above all singular forms, local customs, particularities, and details of every kind' (42, 44).[29] This is the 'presiding principle' of the art, 'that perfect form is produced by leaving out particularities, and retaining only general ideas' (61, 57). It is the principle:

> which regulates, and gives stability to every art. The works, whether of poets, painters, moralists, or historians, which are built upon general nature, live for ever; while those which depend for their existence on particular customs and habits, a partial view of nature, or the fluctuation of fashion, can only be coeval with that which first raised them from obscurity (73).

The terms in which this principle is framed are analogous to those which distinguish stable from unstable republics, and the ideal form of a republic from the corruption that threatens its continuance; and they suggest, as we shall see, that the 'presiding principle' of the art of painting is based on another principle, more fundamental: that the function of art is to create a durable republic of taste, which will facilitate the creation of a durable political republic. This is the function of the 'philosophical aesthetic' and of the 'central form', and it is a function which determines Reynolds's account of the rules of painting and of the hierarchy of genres.

5. The central form and the body of the public

The most famous expression of this presiding principle was given by Johnson, in what is also probably the most famous essay on the theory of literature produced in eighteenth-century Britain: Imlac's dissertation on poetry, in the tenth chapter of *Rasselas*. For all its familiarity, it will be helpful to have an excerpt before us:

The business of a poet, said Imlac, is to examine, not the individual, but the species; to remark general properties and large appearances: he does not number the streaks of the tulip, or describe the different shades in the verdure of a forest. He is to exhibit in his portraits of nature such prominent and striking features, as recal the original to every mind; and must neglect the minuter discriminations, which one may have remarked, and another have neglected, for those characteristicks which are alike obvious to vigilance and carelessness.[30]

From Imlac's account, it appears that details are to be omitted in the interest of ensuring that readers should all be able to recognise the original object in nature of which the poet offers a representation. Too much detail may prevent them all performing this act of recognition, for the experience of each of them is different, is private to each of them, in so far as it is detailed. One may observe what another has missed, and with the same concern in mind, Reynolds criticises Bernini for representing David, just going to throw a stone from his sling, as biting his under-lip: Bernini 'might have seen it in an instance or two; and he mistook accident for generality' (61). But still, for Johnson, the experience of each of us is uniform enough for us all to have general ideas: however diverse our experience, there is always a substratum of the common on which the possibility of communication depends. The representation of 'general properties' will be a representation, therefore, of what the experience of each of us has in common with that of everyone else.

However, it is clear throughout Reynolds's writings that the more confined is our experience, the less able will we be to distinguish what are the general properties of objects, and what are their details: effects of differences in our experience, which might differentiate our imaginations and the general ideas they produce, can be overcome if our experience is sufficiently extensive. We have seen that experience is most confined, and views made most partial, by the profession of a particular occupation, and that is one reason why for Reynolds the mechanic cannot be a citizen of the republic of taste: one reason why he cannot abstract, is that his experience is too confined for him to be able to do so. Mechanics will be good judges of the general properties of objects with which their trade makes them particularly acquainted— Reynolds repeats, as Burke had done, the example of the shoe-maker who was a particularly acute critic of the form of a sandal represented by Apelles,[31] and, moving up the social scale a little, the 'Naturalist', he acknowledges, may be an excellent critic of the kind of landscape in which is represented 'every individual leaf on

a tree' (233, 199). But these are precisely the reasons why we should not delineate sandals or leaves with a minute fidelity to their original details: if art is to strike the imagination of man in general, it will have failed when it particularly strikes that of any man in particular. The properties of the objects that a poet or a painter represents must be such as are 'alike obvious to vigilance and carelessness', and the painter should cultivate the habit 'of looking upon objects at large, and observing the effect which they have on the eye when it is dilated, and employed upon the whole, without seeing any of the parts distinctly' (194). The best judge of a painting formed on this principle, and the person to whose perception it will be particularly addressed, will be the common observer of nature, who will be, of course, the independent citizen, bound to no trade, whose consequent leisure, and extensive, comprehensive vision, will give him the opportunity to gain a breadth of experience unconfined by the particular interests and objects of any specific calling.

The omission of detail is not, however, either for Reynolds or for Johnson, to be enjoined on artists simply so that they will be able to confirm that the liberal and the polite are citizens by virtue of their independence—able at once to comprehend and to represent in themselves the essential and original uniformity of human nature, unaltered and fundamentally unalterable by false notions and acquired habits. For no one, as we have seen, can be at all times a complete representative of his species. An artist leaves out particularities, and retains only general ideas, so as to present those with the potential to be thus representative, with images that enable them to realise that potential, by realising what their experience has in common with others, and by identifying and excluding whatever is private, singular, peculiar to themselves. The educative function of this aesthetic is clear from the continuation of Imlac's dissertation, in which his description of how a poet is to fit himself for this task is necessarily also a description of the public that his work must create:

> He must divest himself of the prejudices of his age or country; he must consider right and wrong in their abstracted and invariable state; he must disregard present laws and opinions, and rise to general and transcendental truths, which will always be the same . . . He must write as the interpreter of nature, and the legislator of mankind, and consider himself as presiding over the thoughts and manners of future generations; as a being superiour to time and place.[32]

The similarity of this description of the tasks of the poet, with Reynolds's description of the tasks of the painter, will be evident enough: both, for example, owe their duty to a supra-national public,

which entitles them to disregard the 'laws' as well as the 'opinions' and 'prejudices' of the national community in which they happen to live; both are to be regarded as 'legislators', but in a universal, and not in any particular, society. But, most important of all, both have a duty to fit their characters to their task; they cannot be representative of the species except insofar as they strive to make themselves so; and as their task is to be legislators, both have a duty to form their audience into a public, for no one is a citizen of the republic of taste by the fact of his birth, however gentle that may have been.

It is to the task of shaping an audience into a public that the doctrine of the central form, as set out in the third discourse, is dedicated. The central form is the form that we arrive at, as it were by a process of averaging the various different forms exhibited by the objects of any species, be they swans, doves, or men.[33] By this process, we arrive at an understanding of the 'common form' of a species: either, in Reynolds's first formulation of the doctrine, the form that its members exhibit more often than any other, or more 'than any one kind of deformity';[34] or else, in the third discourse, the form that none of them individually exhibit in perfection—for all objects have their 'blemishes and defects'—but the form designed for them by 'the will and intention of the Creator', however disfigured by accident in 'actual nature' (44–5). It is by exhibiting this form in his works that a painter primarily fulfills his function, to create a public; for when we recognise the 'original' of an object represented by its central form in a painting, what we are recognising is not simply the object itself, but the ground of agreement between our experience, and our minds and imaginations, with those of other observers who also recognise it. The central form is thus what is 'analogous' to the original frame of the minds of all of us, and it is a representation of the highest common factor of our nature—for if our true nature is grounded on universal principles, and our actual natures are only various as they are variously deformed by accident, the central form is the means by which, in recognising what our minds have in common, we recognise our nature in its highest, its universal form.

That the function of the central form, therefore, is to create a public, is the same as to say that its function is to enable us to recognise at once the ground of community amongst us, and the highest potential of our nature, for the two are the same. That these are the functions of the central form is most clear in Reynolds's account of the central form of the human body. Human bodies are 'no two alike', which is to say that they are all variously deformed, and it is of course by 'peculiarities' in the human figure, by 'blemishes', that we are 'cognizable and distinguished one from another' (131, 102). That

is to say, we recognise each other by observing what is singular, what is deformed, about each of us, and by thus emphasising how we differ and minimising what we have in common, we find ourselves living in a world of individuals among whom it is more convenient for us to observe differences than similarities.

But this mode of everyday, of vulgar perception, which does not unite but divides us from each other, because it is based on the perception of difference, must also be based on the assumption of a common form in terms of which that difference can be registered. This vulgar perception is capable only of perceiving a difference because it does not have the capacity to abstract from particulars in such a way as to grasp the similarity which is the ground of difference; and though all of us, whenever we recognise an individual, seem to perceive in this vulgar manner, those who have the power or the potential to abstract from their experience will also be able to recognise the substratum of common form among all individuals. The artist, therefore, in representing the central form of the human body, invites his spectators to recognise, in each figure that he represents, the ground not only of the uniformity of our natures and our experience, but of the social sympathy that exists between us, or would exist, if we could develop the habit of seeing uniformity as the ground of all singularity. For in recognising the central form of the body, we recognise at once ourselves, each other, and the resemblance of us all; and this experience of recognition is the ground of social affiliation. The bodies represented to us by the central form are public bodies, and they enable us to see that we are members of the body of the public.

It seems to be this function of the central form that Thomas Warton recognised, in his poem 'On Sir Joshua Reynolds's Painted Window at New College, Oxford' (1782). 'The powerful hand' of Reynolds, Warton exclaims,

> has broke the Gothic chain,
> And brought my bosom back to truth again;
> To truth, by no peculiar taste confin'd,
> Whose universal pattern strikes mankind;
> To truth, whose bold and unresisted aim
> Checks frail caprice, and fashion's fickle claim.[35]

In returning Warton himself to the province of truth, Reynolds has also returned him to his nature, as a member of the genus man: for the central form, the 'universal pattern' strikes all men as it strikes him; it strikes them as 'mankind', as men who, in rising above 'caprice' and 'fashion', recognise in that form their own forms, and so their own common and universal nature.

The notion that it might be one function, at least, of the history-painter, or of such a painter in the great or grand style, to display the ideal as the pattern of the genus, to 'represent in every one of his figures the character of its species' (50), so as to enable us to recognise our true and universal human nature, was not new to Reynolds. It had been suggested by Bellori, for example, and by Poussin, who had argued that 'painting is nothing but an idea of incorporeal things even though it shows us bodies, for it only represents the order and the mode of the species of things and it is more intent upon the idea of beauty than on any other thing'. Jonathan Richardson had similarly suggested that 'one End of Painting' was 'to endeavour to Exalt our Species as much as possible to what we conceive of the Angelick State'; this end was particularly aimed at by 'grace and greatness' of style, which 'raises our Idea of the Species, gives a most Delightful, Vertuous Pride, and kindles in Noble Minds an Ambition to act up to That Dignity Thus conceived to be in Humane Nature'. Passages such as these are not easy to interpret: among the numerous meanings of the word, 'species' could be a synonym for the Idea of Platonic philosophy, it can retain one of its Latin meanings—'beauty'—and it could signify what we now call a 'genus', and, also, a class of individuals which, with other classes, composes a genus. The general import of these various remarks, however, seems close to Reynolds's notion of the central form, as does Kames's belief that

> We have a sense of a common nature in every species of animals, particularly in our own; and we have a conviction that this common nature is *right*, or *perfect*, and that individuals *ought* to be made conformable to it. To every faculty, to every passion, and to every bodily member, is assigned a proper office and a due proportion: if one limb be longer than another, or be disproportioned to the whole, it is wrong and disagreeable.[36]

This sense of a common standard, Kames believed, because it is applied to passions as well as to bodily members, could be used, and indeed was regularly used by men, to determine standards of behaviour, so that 'if a passion deviate from the common nature, by being too strong or too weak, it is also wrong and disagreeable: but as far as conformable to common nature, every emotion and every passion is perceived by us to be right, and as it ought to be; and upon that account it must appear agreeable.'[37] We might imagine that Reynolds would follow a similar line of argument, and suggest that the conviction that the central form creates in us of our common nature, by representing to us our common form, might also persuade us to act in conformity with a common standard or moral behaviour.

But in fact the notion that this conviction might persuade us to act in a certain way is given far less stress by Reynolds than it was by Kames or even by Richardson: for Reynolds, that conviction is rather the result of previous moral actions, by which we have subdued 'the gross senses', than the stimulus to further such actions. Thus, Reynolds does compare, as we have seen, the man of taste and the man of virtue, and the comparison is, I have suggested, essential to his account of taste, insofar as both have achieved an emancipation of the mind from appetite. But unlike Kames, Reynolds does not be- lieve that art can persuade us to virtue, or even demonstrate to us what virtue is, and when he offers to explore the connection of virtue and taste, he does so very tentatively. 'If taste', he writes, 'does not lead directly to purity of manners', it does, he suggests, obviate 'their greatest depravation, by disentangling the mind from appetite, and conducting the thoughts through successive stages of excellence, till that contemplation of universal rectitude and harmony which began by Taste, may, as it is exalted and refined, conclude in Virtue' (171). That subjunctive 'may' seems to express a hope or wish rather than a belief.

It may be, as Richard Payne Knight was to argue in a consideration of Reynolds's theory of painting, that it is of the nature of painting that we can do no more than hope that the exhibition of central forms may conduce to the reformation of morals, by persuading us, as Richardson had put it, to 'act up' to the dignity of our nature as represented by the ideal. 'The only moral and beneficial effect' of painting, Knight argued,

> beyond the furnishing matter of intellectual amusement to with- draw the mind from pursuits of low sensuality or wasteful frivolity, consists *perhaps* [my emphasis] in raising man in his own esti- mation, by exhibiting the perfections of his nature in the abstract; exempt from those faults and defects, with which almost all indi- vidual instances more or less abound. There is in every product of creation a certain central combination and proportion of relative form, which we are taught by observation and inference to consider as most appropriate to its particular species; and where this is most complete, the object appears most perfect and beautiful in its kind. This, painting . . . can express, as far as it consists in exterior struc- ture; which is, indeed, but a comparatively humble and unimport- ant part in a rational and intellectual being; but is nevertheless all that can express the qualities of the higher and more important, to the most universal medium of perception, vision. To accomplish this end, the artist must exhibit the genuine man, as formed origin-

ally by his Creator, undisguised by any adscititious trappings of ornament or concealment.[38]

It may be that Reynolds's reticence or tentativeness on the question of how art promotes virtuous action are based, as Knight seems to suggest, on a consideration of the nature of painting itself, which cannot argue, or demonstrate, but can only represent the forms of nature. But it seems to me to derive from considerations more complicated than this, and to explain why, I will find it helpful to compare Reynolds's theory of the function of the central form with what is certainly the fullest anticipation of it in the civic humanist tradition of writings on painting, Shaftesbury's account of 'symmetry' in his treatise on the visual arts, unpublished in the eighteenth century, to which he gave the title 'Plastics'.

It is a fragmentary text, a collection of abbreviated notes, and it is often difficult to grasp Shaftesbury's exact meanings, or to understand how one part of his argument relates to another. Early in the work, he discusses what he calls the 'typography' of art, the representation of creatures in terms of the types to which they belong, or, as he puts it, 'the just imitation of nature according to natural history and the ideas or species of the several forms, animal or vegetative, to some end and with some intent'. That intent he illustrates as follows:

In a single figure of a human body: 'A man. Why? What man?' Answer: 'A strong man.' Therefore here something learnt.—'A beautiful, well-made man.' Again something learnt.—'An ugly, cruel, dangerous man.' Therefore caution, discernment taught; the mind profited, advanced; and fancy, judgment improved; knowledge of the species, of our own species, of *ourselves*, the best and chief knowledge, a step hither . . . Nothing being more pleasant to human nature from the beginning as this learning, viz. This is this: distinguishing into species and classes (the way to record, remember, lay up, draw consequences), and helping society, and communion of thought and sense; information mutual, delightful.[39]

As far as it goes, this appears to conform fairly closely with Reynolds's theory, though, as we shall see, the notion that painting should represent the different species of the genus man, divided thus into the 'strong', the 'beautiful' and the 'ugly', was to cause problems for Reynolds. But still it is clear that from an examination of the 'ideas' of mankind as represented by art, we arrive at an improved knowledge of 'ourselves' and so of our species, at a 'communion of thought and sense', and so at a collective and 'mutual' knowledge of 'our own species, of *ourselves*'.

We do not, however, learn anything about *virtue* from such representations; we learn who we are, but not what we should be. For 'in painting', Shaftesbury argues, 'symmetry . . . is separate and abstract from the moral part and manners . . . the moral part in painting . . . is expressed in the air, feature, attitude, action, motion', and 'is therefore wholly lodged in that part of painting called the movements, where action, passion, the affections are shown. Thus Characters which in painting are mere forms are not moral.'[40] It is only when figures are represented in action that painting can teach us virtue, for painting, as far as Shaftesbury is concerned, can teach us virtue only by persuading us to act virtuously, as Virtue herself had persuaded Hercules.

It is not easy to understand, in the argument of 'Plastics', why Shaftesbury should not have considered that a representation of the ideal of each species should not persuade us to 'act up' to the dignity of that species, though if the species represented by painting include the 'ugly, cruel, dangerous man' it is clearly fortunate that it does not. But it is to the point that Shaftesbury believes we recognise the forms of species by an 'innate idea of forms', which is possessed even by 'the poorest ignoramus', who, when 'brought to see nudities' in a 'clear light' would be able to 'distinguish between the true and natural, and the unnatural deformed kind'.[41] The public virtues, on the other hand, which painting persuades us to emulate by the representation of figures engaged in moral actions, are not able to be performed by the 'poorest ignoramus'; and if Shaftesbury's separation of 'typography' from the 'moral part' of painting was not intended to safeguard the claim that the virtues taught by the higher branches of painting, those which do display figures in moral actions, were uniquely the public virtues, it is certainly convenient to that claim.

By contrast, Reynolds's similar refusal to claim that the exhibition of central forms has a 'directly' moral effect on the spectator may derive from a quite different notion of the public function of painting. On the one hand, he denies Shaftesbury's innate sense, and makes the recognition of the ideal dependent on education, and on the 'long laborious comparison' of objects: it is not a recognition that the 'poorest ignoramus' is capable of making. On the other, he is content, it appears, to make public spirit a matter not of the disposition to perform acts of public virtue, but of an ability simply to overcome the tyranny of sense in an understanding of general truth. This ability results in an understanding of the grounds of social affiliation—of what is common to the nature of us all, and of how that common nature is a social nature, for its perception is the reward of our refusal to cultivate a divisive singularity.

This is an understanding which, however unavailable to the vulgar, is available to a larger class of men than those capable, according to traditional humanism, of performing heroic actions. Thus, by Reynolds's theory, a larger class of men can now regard themselves as having a title to citizenship in the republic of taste, but for that very reason the understanding which confirms that title cannot be represented as leading them to find their fulfilment as citizens in performing acts of public virtue. Nor, of course, could they find it in acts of private virtue, which may be performed even by those incapable of abstraction, and which anyway could hardly be claimed as an appropriate form of virtue to be encouraged by a theory of painting as an art which creates and confirms a public. Thus, the title to citizenship in Reynolds's republic of taste becomes simply an ability to see in a certain way, not to act in a certain way; though that ability is shown to be the result of the virtue involved in 'disentangling the mind from appetite', it is finally a form of public spirit which finds expression in *acknowledging* one's membership of civil society, but also, perhaps, in acknowledging one's inability to act upon that society. It is an appropriate form of citizenship for an unenfranchised class of the polite; and appropriate, too, to an age in which the 'public' was coming to be seen as 'an object too extensive' to be acted upon.

6. *Form, fable, and character: the dangers of ambiguity*

The presiding principle, that the particular should make way for the general, 'extends itself', Reynolds argues, 'to every part of the Art'; 'it gives what is called the *grand style*, to Invention, to Composition, to Expression, and even to Colouring and Drapery' (57). And as we shall see, as he applies the principle to each of these departments into which the art of painting had traditionally been divided, it continues to be revealed as an expression of the more general principle to which, I have argued, the *Discourses* are dedicated, that art should create and confirm a public.

In considering the rules that Reynolds lays down for the conduct of these various departments of painting, we shall notice that he is far more concerned with the form of paintings than with their fables; it is the radical but the inevitable result of his abandonment of the rhetorical aesthetic, that he shows no interest in the notion that the fable should be chosen for its tendency to offer examples of virtue for the spectator to emulate. He does state that the subject of a history-painting ought to be 'either some eminent instance of heroick

action, or heroick suffering', for there must be something, 'either in the action, or in the object, in which men are universally concerned, and which powerfully strikes upon the publick sympathy' (57). But he shows no interest in amplifying this belief; it seems to have been taken over from traditional humanist criticism—from such statements as Dennis's, for example, that the fable of epic must be a 'General Action', 'something in which all might be equally concern'd'—but taken over as an article of faith which Reynolds is bound to repeat, but cannot repeat with conviction, because he cannot square it with the other parts of his creed. As far as the fable is concerned, his main concern, is that it should be generally known— that it should not be ambiguous, or open to misinterpretation; and to this end he points out that the great events of Greek or Roman fable or history, and the 'capital subjects' of the scriptures, are 'sufficiently general' for these purposes, for they are 'familiar and interesting to all Europe, without being degraded by the vulgarism of ordinary life in any country' (58).[42] And as we shall see, this rule, that the subject of a work should not be open to misinterpretation, is also the rule Reynolds applies to those parts of a painting which are more concerned with form than fable.

For Reynolds, what a picture means is of course an important consideration. But meaning for Reynolds has very little to do with the literary, with the subject as 'commonly supplied by the Poet or Historian' (57); it is certainly not something which is so far given by the subject, that an account of what is being done in a picture is an account of the meaning it should have for its public. Indeed, it seems that ideally all history-paintings should have the same meaning, and they may have this even if they do not have anything that Reynolds can recognise as a subject. Rubens's *Marriage of St Catherine*[43] has no 'interesting story' to 'support' it; 'nothing is doing'; but it acquires meaning by its exhibition 'of that superiority with which mind predominates over matter, by contracting into one whole what nature has made multifarious' (201). In his consideration of how a painter should represent Alexander, his only concern is that, though Alexander was 'of a low stature', he should appear in a painting as 'a great man' (60). That Alexander's greatness, at least as we might measure it by the value, and not by the difficulty of what he accomplished, might have been open to question, does not concern him; for if Alexander appears in a painting, his primary function there is not to be an example of vice or of virtue, but to be an image of an ideal human nature.

In terms of its fable, then, a painting is unambiguous simply insofar as that fable is generally known: we all know what is happening, what

has happened and will happen, but the importance of this knowledge seems to be, for Reynolds, that if we did not have it, we would be distracted by our uncertainty from those aspects of the work in which its true meaning is to be found.[44] Similarly, it is important that the fable be so general as not to be merely local or national in its significance; but largely, it seems, because such a fable is most conducive to the representation of ideal—not local or national—forms. But because the burden of meaning is carried by the painting's form, the most important rule is that form should not be ambiguous. A painting that is ambiguous on the level of form will have one of two effects, either of which will disable it from performing the function of creating a public. Either it will divide the attention of the individual spectator, in such a way as to leave him at a loss as to how to respond to it—for he will not know where to look first, or in what proportion to bestow his attention on the various images it contains; or else it will divide one spectator from another, by permitting each to interpret it as he wishes.

A picture which is ambiguous insofar as it 'divides' the attention of the individual spectator, does so by dividing his attention between the main figures it represents and the subordinate details it contains; and the *Discourses* are full of warnings against this practice. Thus, a painter will not 'waste a moment upon those smaller objects, which only serve to catch the sense', and 'to divide the attention', for 'the mind is apt to be distracted by a multiplicity of objects'. 'The detail of particulars, which does not assist the expression of the main characteristick, is worse than useless, it is mischievous, as it dissipates the attention, and draws it from the principal point.' A picture should 'be kept unembarrassed' by 'those little . . . concomitant circumstances' that may 'any way serve to divide the attention of the spectator' (50, 77, 192, 58).[45] I offer so many examples (and could offer many more), only to insist upon the importance of this issue to Reynolds. The danger of ambiguity for Shaftesbury was that it blunts the rhetorical point of a picture; for Reynolds it threatens rather to blur the image of the ideal; but for whatever different reasons, both seem to agree that, by dividing, distracting, dissipating the attention of the spectator, a painting will threaten the integrity of his civic character. By Reynolds's account, this integrity is threatened when a painting permits him to enjoy it in his singular, his private character, which will be excited and attracted by particulars: by the representation of local customs, which interest him in the differentiation of national cultures and not in the uniformity of the universal republic; by the accidents of nature, which invite him to be pleased by the representation of what is transient, impermanent; and by ornament, which

appeals to his sensual nature, his appetite to acquire material objects, and to persist in treating paintings themselves as material objects, and not as sensible metaphors for intellectual qualities. A painting which divides the attention in this way will not, as ideally it should, abolish the private character of the spectator, but allows it to compete for mastery with his public character. Some detail, some circumstances concomitant with the figures, is of course essential: 'the figures must have a ground whereon to stand; they must be cloathed', and so on; but 'none of these ought to appear to have taken up any part of the artists's attention. They should be so managed as not even to catch that of the spectator' (59).

In the fourth discourse, in which Reynolds attempts to apply the presiding principle to the various departments of art, the degree to which the meaning of a work of art is treated as a function of its form results in a merging of his discussions of invention (that part of art which has particularly to do with subject) and composition. For if the main principle of invention is that a picture should not be open to misinterpretation, and should not distract us from its representation of a universal human nature, this principle will be observed as much by the manner in which figures and lights are disposed as by the refusal to represent little details for the spectator to dwell upon.

The primary rule of composition, as Reynolds inherited it from the tradition of criticism, is given by Du Fresnoy:

> Fair in the front, in all the blaze of light,
> The Hero of thy piece should meet the sight,
> Supreme in beauty; lavish here thine art,
> And bid him boldly from the canvas start:
> While round that sov'reign form th' inferior train
> In groups collected fill the pictur'd plain.

But this rule, that the principal figure should appear in the centre of the picture (the 'inferior groups' collected 'around' him), and in the principal light, is considerably softened by Reynolds, perhaps out of a conviction that French theorists tend by the rules they promulgate to promote the creation of an absolute empire of taste rather than a republic: de Piles, for example, had observed of Du Fresnoy's rule that the principal and central figure of a painting should appear 'like a King among his Courtiers'—the kind of observation that led Fuseli to characterise his criticism as 'founded on prescriptive authority, more than on the verdicts of nature'. Reynolds agrees with Du Fresnoy, as with Bourdon, de Piles, Du Bos, Richardson, and various

other critics,[46] that, if to the principal figure and light, others are added, they should not compete with those principals; and that there always should be a principal light and figure, or everything will be 'so dispersed, and in such a state of confusion that the eye finds no repose any where' (59, 126). But he does not regard this rule as obliging the painter to obey Du Fresnoy to the letter:[47] what matters is simply that 'the principal figure should be immediately distinguished at the first glance of the eye' (156); the rule, he adds in a manuscript note, should be 'observed as much as a right judgment dictates the necessity and no more, there is no confusion or uncertainty where to look'.[48] The rule, then, is simply that the painting should be unambiguous, not that its meaning should be forced upon us as if we were not capable ourselves of judgment; though to this end it is essential, for example, that the figures in a painting should not be so many as to prevent the painting being recognised as 'one complete whole', and that the failure of a composition to be thus unified should not be justified on the grounds that the 'hurry and confusion' in the composition of, say, a battle-piece, are appropriately mimetic of a similar confusion in its subject (65, 125).

It is also essential to colouring that it should not be distracting: 'all trifling or artful play of little lights, or an attention to a variety of tints is to be avoided' in favour of 'a breadth of uniform, and simple colour'; the Venetian painters, in disregarding this rule, reveal that they 'are more willing to dazzle than to affect' (61, 63).[49] And the rule that the attention should not be divided by a minute attention to particulars is applied to drapery as well: so that students should not compete amongst themselves to see who can imitate various stuffs with the greatest fidelity, for in history-painting drapery 'is neither woollen, nor silk, sattin, or velvet: it is drapery' (19, 62).

As the Florentine and Roman schools are the founders of the tradition of art in the grand style, in which public values are embodied, so the Venetians are seen by Reynolds as the originators of all those vicious practices by which the attention is divided. It is they who 'cultivated with care' those 'parts of the Art that gave pleasure to the eye or sense', whether by their 'capricious composition, their violent and affected contrasts, whether of figures or of light and shadow', by 'the richness of their drapery', and so on. It is important to point out what is being said here: it is not simply that Venetian art divides the attention, but that to divide the attention in these ways is to invite the spectator to be attracted to what is capricious and singular, not universal; to the transient, and not to the permanent (for the Venetians' colouring is full of 'bustle and tumult', not 'quietness'); to the ornamental, the sensual (their colouring is not

'chaste'), to 'luxuriancy', and not to those intellectual qualities which can alone guarantee the 'security of society' against the dangers of plenty (64, 170). It seems to be, in short, to do with the character of Venice as a commercial state, preoccupied with the material goods that can be acquired by commerce, that produced among them an art which threatens the integrity of the citizen by dividing his attention.

At times, Reynolds appears to be attracted by the possibility of an eclectic art which might join the public virtues of the grand style with the more private pleasures of the Venetian, and as we shall see in his later discourses he proposes a notion of how this might be done without dividing the community of taste.[50] But when Reynolds's humanism is at its most Spartan no such possibility can be admitted; it is as impossible for the two styles to exist together, he insists, 'as that in the mind the most sublime ideas and the lowest sensuality should at the same time be united' (65). Though at times in the earlier discourses he attempts to acknowledge some value in Venetian art, as long as 'uniformity be preserved, and the general and particular ideas of nature be not mixed' (71), it is impossible to see, if all particulars distract the attention from general ideas, that the Venetian style could ever aspire to the condition of a public art. To some extent, of course, all paintings must be a mixture of the general and the particular, if all accessories to the principal and central forms are to be imagined as particular (58–9); and all must be a mixture of the intellectual and the sensual, if all colouring is, in some degree, an appeal to sense. And it may be that Reynolds imagines that these aspects of the art which, when too much cultivated, divide the attention, can best be organised, and given their 'proper rank' (32) within the republic of taste, by a notion of a hierarchy among them for which we can find a model in a mixed constitution—as, for example, the burgesses whose wealth derives from commerce, are admitted into the Houses of Parliament, but should always be in a minority there as compared with the representatives of landed property and the permanent interests of the state. By such an arrangement (I do not suggest that the analogy is present to Reynolds's mind), the ornamental style, 'properly placed and properly reduced', may be employed 'in softening the harshness and mitigating the rigour of the great style', but not in such a way as might threaten to 'over-power' the 'manly strength and energy' of its natural superior (80).

In Reynolds's discussion of character and expression, the concern that an ambiguous painting will divide the attention of the individual spectator, and compromise his integrity, is related to a concern also that it may divide the public, in such a way as to be interpreted differently by different individual spectators.[51] As far as character is

concerned, the doctrine of the central form, as I have so far outlined it, suggests that no differentiation at all, in terms of character, of the form of the human body is permissible: by 'character', Reynolds understands, broadly speaking, the different types into which the human race can be divided by differentiations of anatomy. If that doctrine were to remain unmodified, the ideal picture would be, at its most inventive, simply an arrangement of central forms—one seen, perhaps, from the front, another from the rear, others from the side, and so on, unambiguously composed, but all equally representative of a uniform human nature, for any differentiation of the ideal anatomy of the central form will conceal or compromise that uniformity. The artist would, in short, be limited to producing one version after another of the three graces, and the more each version resembled every other, the stronger would be the presumption that he had succeeded in his function as a public painter. But as soon as he attempted to represent a complex fable—and however unimportant Reynolds thought the fable, a work without one would confuse the spectator as much as if its fable were ambiguous—his work would fall short of one of the most important aims of public painting, that it should not be open to misinterpretation; for without some degree of differentiation in terms of character, it is hard to see how any fable could be unambiguously communicated.

To resolve this problem, Reynolds proposes that we should think of the 'human kind' as a 'species', which is divided into a certain number of characters, or, as he calls them, 'classes', to each of which belongs a different style of beauty, and a different central form. Thus there is the class of strong men, whose central form is represented (or as nearly as any work of human invention could represent it) by the Farnese Hercules; there is the class of active men, represented perhaps by the 'Gladiator' (the Borghese Warrior or the Dying Gaul);[52] the 'delicacy' of the Apollo Belvedere is apparently a representation of the central form of another class of masculine beauty; and there is even 'a common form in childhood, and a common form in age' (46–7). The difficulty of this position, as later critics were quick to realise, is that there is no limit to the number of classes we can invent in this way; and the more we do invent, the more we seem to shatter the uniformity of human nature which a public art exists to represent. Reynolds is evidently aware of the difficulty, but he is not able to solve it; for he seems equally aware that if the central form does not admit of any differentiation by character, the business of history-painting cannot be carried on, and that if it does, the business cannot succeed. To answer one aspect of the problem, he acknowledges that the central form of different classes cannot represent the 'highest

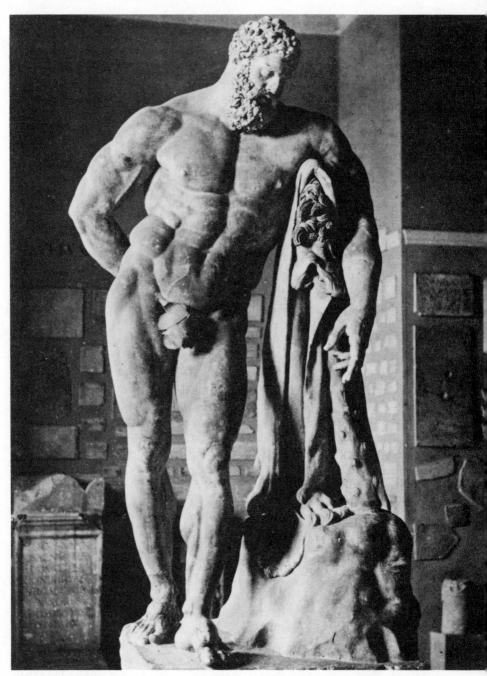

3. *Hercules Farnese*, Naples, Museo Archaeologico Nazionale.

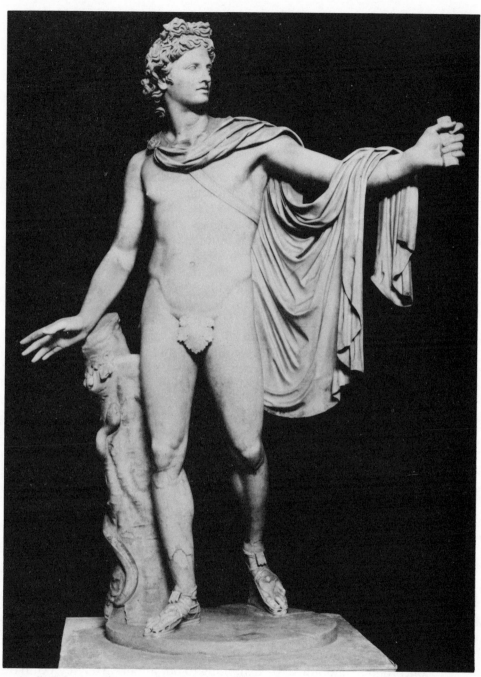

4. *Apollo Belvedere*, Rome, Musei Vaticani.

perfection of the human figure', and seems to propose that if a painter is to represent that perfection, he must re-unite the characters that Reynolds has found himself obliged to separate; 'It is not in the Hercules, nor in the Gladiator, nor in the Apollo', that perfect beauty is to be found; it is in 'that form which is taken from them all, and which partakes equally' of the characteristics of them all, 'for perfect beauty in any species must combine all the characters which are beautiful in that species. It cannot consist in any one to the exclusion of the rest: no one, therefore, must be predominant, that no one may be deficient' (47).

It is not very clear how a painter is to set about producing a figure which, in some legible manner, represents man as at once strong, active, delicate, young, old, and so on; and Reynolds is aware of this aspect of the problem as well. Thus, he criticises Pliny's account of a statue of Paris, by Euphranor, in which, according to Pliny, 'you might discover at the same time three different characters; the dignity of a Judge of the Goddesses, the Lover of Helen, and the conqueror of Achilles':[53] as Reynolds points out, 'a statue in which you endeavour to unite stately dignity, youthful elegance, and stern valour, must surely possess none of these to any eminent degree' (79). The point is important, for as we shall shortly see in his account of expression, the problem of such a figure which is at once all these different things, may be that there is nothing to stop each of us seeing in it, according to our caprice, our interest, or our willingness to be persuaded by others, whatever we wish to see; and if we all wish for different things, the statue is not exhibited before a public, but before a mixed multitude of individual and private spectators. As far as sculpture is concerned, Reynolds does manage to arrive at some form of a solution to his problem, for in a statue character may be represented by '*insignia*' more than 'by any variety of form or beauty'. This was the method of the ancients, among whom 'the idea of the artist seems to have gone no further than representing perfect beauty, and afterwards adding the proper attributes, with a total indifference to which they gave them' (181–2); that is, they simply fashioned one beautiful woman after another, and then identified them as Aphrodite, Athene, Hera, or whoever, as occasion demanded. As Reynolds makes this point, however, in the course of distinguishing between the limited potential of sculpture as compared with painting for the representation of character and expression, it does nothing to solve his main problem, and clearly an art which aims to represent, not single figures, but the interaction of several, will not communicate its subject very efficiently if all those figures are more concerned to announce, by exhibiting to our attention a lyre, a club or a thyrsis, who they are, than what they are doing.

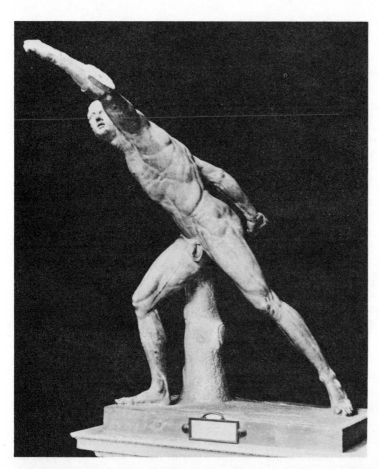

5. (left) *Borghese Warrior*, or *Borghese Gladiator*, Paris, Louvre.

6. (below) *Dying Gladiator* or *Dying Gaul*, Rome, Musei Capitolini. As Reynolds's interest in the 'activity of the Gladiator' is an interest in the potential for activity represented in his physique, it is possible that it is this work he refers to as the 'Gladiator', and not the *Borghese Warrior*.

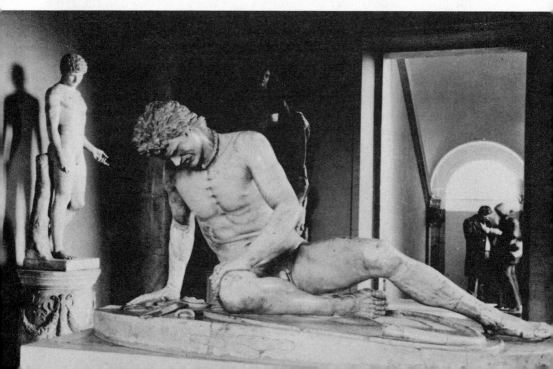

The problem posed by the issue of how to represent character, is augmented when Reynolds turns to a consideration of the expression of the passions, for once again he seems to be faced by two mutually exclusive imperatives. On the one hand, any representation of the passions must distract us from the image of a uniform human nature: 'if you mean to preserve the most perfect beauty *in its most perfect state*, you cannot express the passions, all of which produce distortion and deformity, more or less, in the most beautiful faces' (78); you cannot express them, of course, because they differentiate and disfigure the central form, but also because expressions, like that of Bernini's David, are always in some measure the expression of a particular man, and are always transient, and not a representation of an unalterable human nature. But without expression, the figures will be 'insipid'; and when represented in situations which demand a passionate response, will be open to misinterpretation if they appear to remain entirely unmoved. Unsurprisingly, Guido is Reynolds's example of an artist who fell into this contrary error: his 'daughter of Herodias with the Baptist's head' has 'little more expression than his Venus attired by the Graces' (78).[54] It is not clear that Reynolds is able to find any more satisfactory solution to the problem of expression than he does to the problem of character; he does, however, propose that expressions, where represented, should be dignified by being as little transient as will be consistent with the need to make them legible. At least this seems to be what we should infer from his repetition of the traditional rule that 'each person should . . . have that expression which men of his rank generally exhibit. The joy, or the grief of a character of dignity, is not to be expressed in the same manner as a similar passion in a vulgar face' (61). Since history-painting, properly public art, has as little as possible to do with the representation of the vulgar, the rule seems to be that expressions should partake of the stability, the permanence of character exhibited by the free man, and not of the more fleeting and more fickle character of the mechanic, of the *mobile vulgus*. For the more an expression can be held, as if before a camera with a slow exposure time, the less it will distract us from the ideal of an unalterable human nature, and the less it will succumb to the threats posed to that ideal of permanence by the accidents of time.[55]

The main rule, however, that Reynolds wishes to see observed in the representation of the passions, is derived from his anxiety that a painting should not be open to misinterpretation: for 'the attempt to unite contrary excellencies . . . in a single figure, can never escape degenerating into the monstrous, but by sinking into the insipid; by taking away its marked character, and weakening its

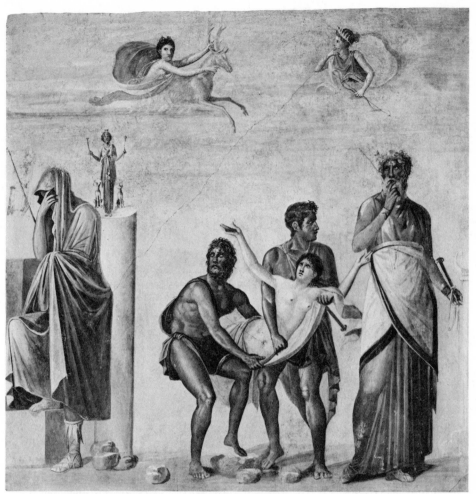

7. *The Sacrifice of Iphigenia*, Naples, Museo Archaeologico Nazionale, from the House of the Tragic Poet at Pompeii: the conception of the subject is evidently derived from accounts of Timanthes's version of it.

expression' (78). The failure to represent a clearly marked character, a clearly legible expression, will arise, it appears, from the attempt to represent, in particular, a 'mixed passion', and Reynolds offers as an example of the dangers of such an attempt 'the Cartoons, and other pictures of Raffaelle', where 'the excellent master himself may have attempted this expression of passions above the powers of the art'; and as a result, though the figure of Sergius Paulus has an expression 'not in the least ambiguous', Raphael's 'indistinct and imperfect marking' has elsewhere 'left room for every

imagination, with equal probability to find a passion of his own'
(221, 78–9). The same criticism had been made by Daniel Webb:
there is, he had claimed, 'something equivocal and undecisive' in
the expressions of the figures in the Cartoons; 'they are often made
out more, by the imagination of the beholders, than by the pencil
of the painter: To some, they convey imperfect ideas; to others, differ-
ent. I hardly have known any two agree in the sentiments which they
imputed to the several auditors of St Paul'. For this reason,
Webb admires more the 'manifest' expressions represented by
Aristides, Timomachus, and Apelles, whose lost works Webb writes
as if he had seen as clearly as Blake had seen the lost painting
and sculpture of the states which once flourished 'among the Rivers of
Paradise'.[56]

Yet, however uncomfortable Reynolds was, with the tendency of
the passions to violate the purity of the central form, he found the
attempt to represent a mixed passion no more dangerous than the
representation of no passion at all. When Timanthes, in his version of
the sacrifice of Iphigenia, had represented Agamemnon hiding his
face in his cloak, his intention, perhaps, was to make the very point
that Reynolds has made, that the mixed emotions of horror, guilt,
and even relief from anxiety, could not be depicted by painting.
Therefore, as Pliny, Webb, and Lessing among others had pointed
out, he left the expression of Agamemnon to the imagination of the
spectator, but, according to Reynolds, with too little guidance as to
how his imagination should be exercised (163–4).[57] In the case, how-
ever, of the Cartoons or of the Iphigenia, the result will be the same:
the work will be open to interpretation and thus to misinterpretation;
in a variety of opinions as to what passions are represented by the
painter, or are left to be supplied by the spectator, only one, at best,
can be right, and the others must be presumed to proceed from
caprice, idiosyncrasy, or interest: an ambiguous art cannot be a
public art.

7. Private art and private interpretation

As Ernst Gombrich has pointed out, ever since Vasari, at least, there
had been a considerable body of critical opinion disposed to regard
the determinability of an image, its openness to interpretation, as a
virtue—if not in relation to the interpretation of character, at least
with regard to the process by which the imagination might complete
the forms which the artist, with a becoming nonchalance, a courtly
sprezzatura, had sketched rather than finished: a popular analogy for

this process of interpretation was Leonardo's suggestion that a painter might find ideas for images in walls stained with damp.[58] We might imagine that Reynolds, who quoted Leonardo's suggestion with approval (37), would also approve of this opinion, inasmuch as it could seem to be based on the notion that it is the mark of a liberal art that it leaves the spectator free to interpret an image according to his own judgment, a freedom which, insofar as he is truly a man of taste, he will be unlikely to misuse, since his judgment will be correct and his imagination uniform with that of other citizens.

And Reynolds indeed approves an idea of painting by which a greater 'idea of a whole', and a 'greater quantity of truth' may be expressed 'in a few lines or touches, than in the most laborious finishing of the parts' (201), a finishing which, because laborious, is mechanical. This approval is not inconsistent with his demand for clarity of marking, nor is that demand in conflict with the growing admiration for a painterly sketchiness. For the arguments in favour of sketchiness must be understood always in relation to certain conditions: they do not, as Reynolds points out, give a licence to 'carelessness' or to the want of a certain kind of 'exactness' (202)— Leonardo too had argued that the ideas offered by damp-stains should be 'reduced' to 'complete and proper forms'—[59] and, broadly speaking, they are to be understood as concerned either with works which, when seen at a proper distance, do not appear to be indeterminate, but are so only when we examine them at close range; or with preparatory drawings. As far as such drawings are concerned, Reynolds himself has just this attitude to them: they give 'the idea of a whole', though they 'appear careless, and in every respect unfinished' (198); but evidently he feels that he can hold this attitude without compromising his opinion on the need for clarity of marking in paintings, and indeed, as we shall see, such an attitude if anything confirms that opinion.

It does not seem to do so at first, however; for in his longest discussion of the pleasure afforded by sketches and drawings, Reynolds argues—as de Piles had also argued—that one source of the pleasure they offer us is precisely that they return us to ourselves as individuals, whose imagination is not uniform, and who may take a singular pleasure in contemplating images which allow us a freedom of interpretation not countenanced elsewhere in the *Discourses*: from:

> a slight undetermined drawing, where the ideas of the composition and character are, as I may say, only just touched upon, the imagination supplies more than the painter himself, probably, could produce; and we accordingly often find that the finished work dis-

appoints the expectation that was raised from the sketch; and this
power of the imagination is one of the causes of the great pleasure
we have in viewing a collection of drawings by great painters.
These general ideas, which are expressed in sketches, correspond
very well to the art often used in Poetry. A great part of the beauty
of the celebrated description of Eve in Milton's Paradise Lost,
consists in using only general indistinct expressions, every reader
making out the detail according to his own particular imagina-
tion,—his own idea of beauty, grace, expression, dignity, or love-
liness ... (164).

Elsewhere in the *Discourses* it is represented as no less than a public
duty that we should make our ideas of beauty conform with the public
idea of it, and we are told that 'the idea of beauty is of necessity but
one' (52). Now, suddenly, it seems that we each may have, and may
be allowed to enjoy, our *own*, different ideas of beauty, and enjoy the
same freedom of interpretation as, according to Edward Young and
James Harris, the readers of Milton were allowed, in the images they
formed to themselves of the beauty of Eve; a freedom as great,
indeed, as Sterne had allowed his reader, whom he always left 'some-
thing to imagine, in his turn'—most notably, the beauty of the widow
Wadman, whom Sterne invites us to draw for ourselves on a leaf left
blank for the purpose. Harris had represented it as a weakness
inherent in poetry that we were obliged to imagine Eve for ourselves,
by our 'own proper genius'; 'when we view Eve as painted by an able
painter', on the other hand, 'we labour under no such difficulty;
because we have exhibited before us the better conceptions of an
artist, the genuine ideas of perhaps a Titian or a Raphael'. Reynolds
gives no sign of believing that it is a disadvantage of sketches that we
are free to interpret them as we wish, or as best we can; but the
permission he here grants us, is granted only in relation to what he
certainly regarded as *private* images: as Shaftesbury had explained of
preparatory sketches, they were 'not for Ostentation, to be shown
abroad, or copy'd for publick view'.[60] They are images which the
painter did not imagine would be viewed by posterity, or by a public;
images which were usually not framed and hung but kept by artists
and collectors in the portfolio; or—if occasionally hung—not in the
showrooms of the house, but in the private apartments. Such images
are enjoyed and interpreted in private, are not so much looked at by
the spectator, as overlooked, looked at over the shoulder of the
artist.

 That such a pleasure may be taken in what Sterne calls the free and
'private interpretation'[61] of the indeterminate, only in the private

space inhabited by the sketch, is clear enough from the continuation of Reynolds's argument:

> ... but a painter, when he represents Eve on canvas, is obliged to give a determined form, and his own idea of beauty distinctly expressed.
>
> We cannot on this occasion, nor indeed on any other, recommend an undeterminate manner, or vague ideas of any kind, in a complete and finished picture. This notion, therefore, of leaving any thing to the imagination, opposes a very fixed and indispensable rule in our art,—that every thing shall be carefully and distinctly expressed, as if the painter knew, with correctness and precision, the exact form and character of whatever is introduced into the picture (164).[62]

We need not, I think, puzzle over the notion that the painter, too, may have 'his own' idea of beauty: the phrase is careless, and suggests not that that idea is his personal property, but that the image he represents must not be open to be imprinted with the *spectator's* 'own ideas'. For a few lines after this passage, Reynolds opposed the idea of beauty which the painter must represent 'carefully and distinctly' with the 'uncertain and doubtful beauty' (164) which the spectators will perceive, when it is their own idea of it that they discover in a painting. The point of the distinction Reynolds is making here, is that a painting should be conceived of as an act of communication with a public, as a sketch is not. The admiration and ownership of pictures which, though produced in the public medium of oil and canvas, do not appeal to what we have in common with other men, or do so only imperfectly, may put our status as public men in doubt; that status will not however be threatened by the ownership of such images executed in informal graphic media, which occupy a space in the system of art, and in the house, where we may legitimately regard ourselves as temporarily released from our obligations to the republic of taste and to the political republic. In that private space we may enjoy images which are fleeting, unstable, transient, quickly produced and quickly enjoyed, taken out and put away again, and not, as the phrase is, 'on permanent exhibition'. What in the public media of oil or fresco may be private vices may, in charcoal, chalk, watercolour, pencil, pen and ink, be regarded as simple pleasures which raise no moral issues; for we may indulge our caprice in those moments when we are not acting as citizens on the public stage; and the very theory of citizenship which then affords us that licence, is what denies it on other occasions.

This opposition, between painting as a public medium, and the

private and informal graphic media, raises an important question in relation to the doctrine of the hierarchy of genres. Is Reynolds suggesting that all paintings should be regarded as public works, and addressed to the spectator as a member of the public? Or might it be— for the opposition is outlined in the course of the discussion of Timanthes's painting of Iphigenia and Agamemnon—that history-painting is the public art *par excellence*, as the 'slight undetermined sketch' is the extreme of a private art; and that the lesser genres of painting occupy some space between them? The question is important, for it raises the issue of how works in the lesser genres are to be painted, and how they are to be valued. On the one hand, the mere existence of the lesser genres seems to be a source of regret to Reynolds: they are visible reminders, and their popularity in England is a forcible reminder, that the republic of taste is still to be created, and that its potential members are still a long way from legitimating their title to citizenship. Or—and this is perhaps even more a matter for regret—their popularity may be an indication of the infiltration, into the republic of taste, of private men with no title to citizenship, who are however sufficiently powerful, in economic terms, to set 'the taste of the time' (52), and who threaten to appropriate the productions of the artist to their own personal gratification.

On the other hand, if, as it now appears from our consideration of the sketch, there are private spaces in the life of a citizen as there are in his house, so the lesser genres—landscape, portrait, comic genre painting—may have the same licence enjoyed by sketches, to address members of the republic of taste in their capacity as—at some times, in some situations—private men. Or do they at least have some degree of that licence, a degree proportioned to their mixed destination, to be displayed, not concealed as sketches are, but to be displayed in private spaces, as cabinet-pictures? That cabinet-pictures may properly be regarded as private works, and may enjoy the same freedom from the need to be marked with an unambiguous exactness, seems to have been the opinion of James Northcote, Reynolds's most successful pupil, who considered that 'it is only in large pictures that the indispensable necessity exists of marking out with precision and distinctness all the parts; such precision . . . is not to be found nor required in the smaller size, as small pictures never proceed much beyond sketches'.[63] Here, it seems, indistinctness is not justified by distance, but by a notion of the informality appropriate to a cabinet-picture.

The question, of whether we are to regard the lesser genres as in some degree private pictures, also affects, as I have said, how we are to value them, not only how they are to be painted. For a division between works of art on the basis that some directly promote public

spirit, while others, with whatever degree of justification, do not do so, may be crucial to the question of the integrity of the citizen, and is crucial also to the division in the republic of taste, between those who are and those who are not members, on which the political function of art depends. Does the citizen ever admire works in the lesser genres in his capacity as a citizen? Or are those genres addressed to him in his purely private function? Or are they not addressed to him at all, but to the private men excluded from citizenship? It is as essential to Reynolds as to Shaftesbury that, in the judgments we make on a painting, we should not be 'uncertain to what rank, or rather kind of excellence, it aspires' (178); but in relation to the lesser genres, such certainty is not easily come by. Should we regard them as imperfectly public works, which, judged by the principle that the function of painting is to create a public, must be found wanting, or should we regard them as licensed to depart from that principle?

The issue clearly confuses Reynolds, and there are good reasons why it should. To begin with, of course, he himself happens to work largely in a lower genre, and the moral dignity of his own example is at stake. But perhaps more important, to his reputation as a teacher if not as a painter, are the repercussions that his answer will have on his notion of public spirit. For if it is the case that we should behave in relation to 'our lighter amusements' with the same determination to search for steady, durable and substantial values that directs us 'in the more serious duties of life' (134), it seems that we are never off-duty, and that the citizen is never released from his obligation to regard any departure from the universal principles of human nature as an unjustified indulgence of singularity. If, however, other citizens do regard themselves as released, in their lightest and most innocent amusements, from their civic obligations—as Reynolds seems to suggest they are, in his discussion of sketches—then to persevere unswervingly in our public character, when others have temporarily laid it aside, may be to cultivate a singularity which may also invite an accusation of pride.

We can collect opinions from the *Discourses* which seem to confirm both these attitudes to the lesser genres and to their relation to the ideal of a public art. Thus, Reynolds can enjoin his students to keep their principal attention 'fixed upon the higher excellencies'; they may finish as 'very imperfect' painters, but they will be imperfect painters 'of the highest order'; but equally he can argue that we 'have the sanction of all mankind in preferring genius in a lower rank of art, to feebleness and insipidity in the highest' (77, 249).[64] The techniques encouraged by any branch of the art apart from the grand style of history-painting are 'dangerous sources of corruption', and the minor branches can aspire to value only in proportion as they eschew the

attempt to deceive the eye, and are injected with the values of the grand style: they 'take their rank and degree in proportion as the artist departs more, or less, from common nature' as represented by central forms (18, 236–7). Thus, for example, the 'small curious high-finished cabinet pictures' of the Dutch are addressed 'to the eye only',[65] and insofar as they do not therefore aspire to be more than 'servile imitations' of 'what we see . . . every day' (235), they have no claim to address our minds, and no place in a liberal art.

But the existence of the lesser genres cannot simply be ignored, and not least because most of the students who listened to the *Discourses*, and entered painting as a profession, would find themselves obliged to practise in them, and with this and with perhaps more personal considerations in mind, Reynolds can argue that 'whether it is the human figure, an animal, or even inanimate objects, there is nothing, however unpromising in appearance, but may be raised into dignity, convey sentiment, and produce emotion, in the hand of a Painter of genius' (196–7).[66] In this tolerant mood, it can even appear to Reynolds that the very qualities which seem to mark the lesser genres as illiberal—unworthy 'petty excellencies', 'little ornamental helps'—are 'essential beauties' in portrait, landscape, and still-life, and without them 'the artist's work will be more short-lived than the objects of his imitation' (70–1). The painter in these genres has the same right to the name of a painter as a satirist, an epigrammatist, and so on, has to the name of a poet (52); and though 'the quick, sprightly turn' would 'but ill suit with the majesty of heroick Poetry', in that it would shake the pretensions of epic to be a durable representation of a durable human nature, it is 'the life and beauty of epigrammatick compositions'. In his *Journey to Flanders and Holland*, Reynolds criticises Lairesse for representing 'not drapery' but 'white sattin' in a heroic picture, but makes no objection to the naturalness with which the same fabric is represented by Terburg, in 'the *cabinet* of M. Gart' (my emphasis).[67] The rule that Reynolds promulgates when he is in this mood, is that beauties have 'their proper lustre' in their 'proper place', but it is a rule he continually questions: to admire greatly the lesser styles and genres is to want 'sense, and soundness of judgment', and to want these is to want an essential qualification for citizenship (77, 130).

The confusion in Reynolds's attitude towards the lesser genres in general, is reproduced in his consideration of the individual genres of comic-painting, landscape and portrait, which he glances at from time to time through the *Discourses*: here again, he seems to be uncertain whether these genres are to be judged as failing to perform the public function that is the justification of a liberal art, or whether

they are somehow licensed to ignore it. On the one hand, those comic painters who 'have applied themselves ... to low and vulgar characters, and who express with precision the various shades of passion, as they are exhibited in vulgar minds' deserve praise only 'in proportion, as, in those limited subjects, and peculiar forms, they introduce more or less of the expression of those passions, as they appear in general and more enlarged nature' (51).[68] But if they are therefore to be regarded as practising in an imperfectly public, and not a private genre, and are valued only as they approach the virtues of the grand style, they are not it seems obliged to follow the rules of composition that derive from that style. Thus, in the representation of 'ludicrous subjects', a figure may be represented as 'looking at the person who views the picture', in such a way as confuses the subject-object relation of spectator and image, but this 'ought never to be practised in a grave historical composition'.[69] Comic painters, it seems, have a licence to 'divide the attention' of the spectator, with all that that implies for the integrity of his character.

In his first discussion of landscape in the *Discourses*, Reynolds makes an acknowledgement of his uncertainty about how landscape-painters should conduct themselves, which is in effect an uncertainty about their status in relation to the division between public and private art. The virtues of Claude's landscapes seem to be those which would elevate landscape into, at least, an imperfectly public genre: for Claude 'was convinced, that taking nature as he found it seldom produced beauty'. His pictures are thus abstractions of objects in actual nature copied in his sketchbook, and thus are representations of 'general nature', purified of the 'particular, accidental' effects of light. The landscapes of Rubens, however, are considerably 'animated' by the introduction of those effects, so that it 'is not easy to determine' whether landscape painting has 'a right to aspire so far as to reject' the 'Accidents of Nature'; and the implication of those words, 'right to aspire', is that a painter like Claude may be aspiring above his station, as painter of private images, and endeavouring to pass himself off as a public man who has no time for the 'accidental' and the 'particular' (69–70).[70]

As far as one can judge, Reynolds decides in favour of Claude, and in favour of landscape being permitted to aspire if not to achieve: he clearly approves Claude's decision to eliminate 'accident' from his works, which would have risked 'catching the attention too strongly'—distracting it from the 'general nature' he sought to represent—and would have projected into the fluctuating dimension of time images that should aim at stability, at 'quietness and repose' (70). And for the most part, Reynolds's view seems to be that the

more a landscape-painting is dignified by the presiding principle which distinguishes the grand style, and the more it aspires to the virtues of a public art, the better it will be; for what is at stake is whether a landscape should be an ideal or a merely exact representation of nature: whether it will appeal to 'the common observer of life and nature', or merely to the naturalist (237, 199). This attitude to landscape is however considerably complicated by Reynolds's discussion of Gainsborough, in which he is preoccupied by an indistinctness of marking which produces ambiguity, and which, therefore, we would expect him to regard as inadmissible in a public painting.

Reynolds's praise for the apparently indistinct style of representation favoured by Gainsborough—so that, from close up, we cannot make out even the general forms of objects—is often treated as an act of special pleading, or of belated generosity, in which he departed from his principles in order to do justice to his dead rival, to whom alive Reynolds had been less than generous. But it may seem that, on the contrary, his praise of Gainsborough's technique is the result of a late realisation that, far from threatening the uniformity of response to be elicited by a public art, Gainsborough's technique could provide him with an unexpected and gratifying confirmation of his principles. For though, Reynolds argues, from a viewing-position close to his pictures, we cannot grasp the forms that Gainsborough represents, still, at a certain distance, 'this chaos, this uncouth and shapeless appearance, by a kind of magick . . . assumes form, and all the parts seem to drop into their proper places'. At a distance, the marks become legible, and—as the word 'proper' suggests—they become legible in such a way as to ensure that we all read them in the same way (258).

Thus, however 'odd' are Gainsborough's 'scratches and marks' (257–8)—what Pasquin was to call his 'undetermined, dashing, stroky, scratchy, thunder and lightning manner',[71] and however much that word 'odd' suggests a reprehensible singularity of manner, his landscapes achieve the end of elevating a lower genre by a concentration on general effect and by the exclusion of mere imitation. But this achievement is to be recognised as such, only because of the particular character of the objects which the landscape-painter has to represent. For if we can all make out the forms of trees from the shapeless appearances that announce their presence in Gainsborough's landscapes, that is because the forms of trees are infinitely various and accidental, and, because we are not obliged to compare them with any specific tree or type of tree, we can all agree (though probably with different tree-shapes in our minds) that the uncouth marks, at a proper distance, are trees indeed.

Now, if these forms were more particularised by Gainsborough, they would be merely accidental, and confirm that the paintings are content to be regarded only as private pictures; as it is, however, the 'general shapes' that they assume, and which appear to signify that Gainsborough is aspiring to the more public kind of landscape painted by Claude, seem themselves to be the product of accidents of technique, only justifiable because used to represent forms which are themselves accidental, and certainly not admissible in a work which aspires to the condition of a public art. For it is a licence peculiar to the landscape-painter that he may 'take the advantage of accident' as Rembrandt did, who 'appears often to have used the pallet-knife to lay his colours on the canvass, instead of the pencil', and the advantage of this method is that the knife 'does not follow exactly the will'. 'Accident', in the hands of an artist who knows how to take advantage of it, 'will often produce bold and capricious beauties of handling and facility, such as he would not have thought of, or ventured, with his pencil, under the regular restraint of his hand' (223)—as Richardson had argued, 'there is often a Spirit, and Beauty in a Quick, or perhaps an Accidental Management of the Chalk, Pen, Pencil, or Brush in a Drawing, or Painting, which 'tis impossible to preserve if it be more finish'd'.[72] However, it is only 'fit' to take advantage of this kind of accident, Reynolds claims, 'where no correctness of form is required, such as clouds, stumps of trees, rocks, or broken ground' (223). The representation of accidental forms by accidental methods, and the indulgence of caprice that this allows, are not permissible, it seems, in the representation of the body, the prime object of representation in the grand style and in works whose public aspiration is acknowledged; thus, of two paintings by van Dyck, which Reynolds saw in Brussels, he notes that 'they are slightly painted, and certainly not intended for public pictures'.[73] Sketchiness, indistinctness, a capricious looseness of handling—these are allowable only in works which, because their aim is to represent the accidental, are understood to be private pictures; though the more general the natural forms that an accidental technique produces, the more a landscape may approach the virtues of a public work.

Reynolds seems, in short, to be making a double claim for Gainsborough. On the one hand, landscape is to be regarded as an imperfectly public genre, which is to be raised in dignity by the artist, as best he can, by subordinating the particular to the general. On the other hand, the very process by which this is done—by Rembrandt and Gainsborough, if not by Claude—suggests that the genre in which he works is a space in which he—and we, in admiring his pictures—are released from our obligations, as public men, to obey

our will and to ignore our merely capricious desires: landscape, according to de Piles, was a genre in which 'the painter has more opportunities, than in any . . . other . . . to please himself'.[74] The same double claim for landscape—as a genre both public and private—is implicit in Reynolds's approval of Gainsborough's 'eager desire . . . that his pictures, at the Exhibition, should be seen near, as well as at a distance' (258). That desire proceeds from a proper 'disdain for the notion that painting is an art of mere imitation, mere deception; but it also indicates a concern to display the means by which a painting achieves its effects—a concern that Reynolds will not allow in painters aspiring to work in the grand style (59).

On balance, however, it seems that Reynolds chooses to ground his praise of Gainsborough's landscapes on a decision to regard the genre as a private one, and not as the imperfectly public one that it had been in his account of Claude. So much, at least, is suggested by his comparison of Gainsborough's method as it was applied by him to landscapes and to portraits. For though he seems to approve of the portraits also for achieving a 'general effect', a 'whole together', the means by which they achieve this are now seen as more questionable. What interests Reynolds is that the portraits manage to achieve that 'general effect', rather than a minute accuracy, in the representation of the features of his sitters, while at the same time they are 'remarkable' for their 'striking resemblance' to their 'originals'; for in earlier considerations of portraiture in the *Discourses*, these two achievements had appeared to him to be mutually exclusive (259, 72). In fact, Reynolds argues, the general effect and the striking resemblance both proceed from a lack of finish, an indistinctness which allows, and positively invites, the imagination to supply what is lacking.

Now, as long as we conceive of the portrait as existing in a private space, occupied by the sitter's friends, this practice may be justifiable, Reynolds suggests: for they know the sitter, and will be prompted by the portrait to complete the resemblance 'perhaps more satisfactorily . . . than the artist, with all his care, could possibly have done'. But as soon as this sketchy, undetermined, and as it were unfinished portrait attempts to make its way in a more public space, this advantage disappears: if we do not know the features of the sitter, each of us will amplify the hints given by the portrait differently, and should we afterwards come to meet the sitter, we will not recognise him from Gainsborough's representation; for there is a 'great latitude which indistinctness gives to the imagination, to assume almost what character or form it pleases' (259). The illusion of resemblance is not the only thing which will be weakened when the portrait is translated into a more public context; the means by which the 'general effect',

also, is produced, will fail, in proportion as we regard Gains-borough's portraits as public pictures, to impress us with the very idea that is the end of that general effect. For they will fail to communicate to us an idea of our uniformity, as members of a public, as that idea is to be confirmed by the shared interpretation of an image that is produced by a clarity of marking, and they will return us to the condition of private individuals, who interpret paintings as we wish to interpret them.

The indulgence which Reynolds grants to Gainsborough's por-traits, insofar as they may be regarded as addressed only to the sitter's friends and family, is not one he is usually very ready to grant to portraits, and perhaps to some extent because his own honour was engaged in the status of the genre. His usual advice to the portrait-painter is that 'the grace, and . . . the likeness, consists more in taking the general air, than in observing the exact similitude of every feature', or in the 'minute discrimination' of 'peculiarities' (59, 200); and this advice is given on the basis of an insistence that portraiture should aim, as far as possible, at the excellencies of the grand style, and so at a clarity of marking though not at a laboured fidelity. He acknowledges the problems of painting portraits in this way, when they are commissioned by those who regard them as private pictures, in which the sitter is to be represented as 'a particular man', for though, 'if a portrait-painter is desirous to raise and improve his subject, he has no other means than by approaching it to a general idea', and by omitting 'all the minute breaks and particularities in the face', it is 'very difficult to ennoble the character of a countenance but at the expense of the likeness, which is what is generally required by such as sit to the painter' (70, 72). More clearly than landscape, then, portrait is thought of by Reynolds as a genre which should aspire to be (however imperfectly) a public genre, and largely because, in any representation of the human body, the aim of the painter must be to approach it in 'the Historical Style' (88), as an image in which we shall be able to recognise the general form of human nature, as a means of recognising also the ground of social affiliation. A portrait painter who is obliged to submit to the demand for a mere likeness will represent a notion of human nature as differentiated by the pecu-liarities of individuals, and not as united by the similarity among them; his portraits will become, as Hazlitt said Lawrence's were, 'private, not public property'.[75]

As the kind of social affiliation that is proposed by an ideal of uniformity is egalitarian—at least for those who can afford to buy the uniform—so of course the mode of political affiliation to be rep-resented by portraits in the 'Historical Style' will be republican. Thus,

Titian (the only Venetian painter to whom Reynolds concedes a grasp of the liberal nature of the art) has, as a portrait-painter, 'a sort of *senatorial* dignity', and his sitters are represented with a 'nobleness and simplicity of character', which, 'seeming to be natural and inherent', 'has the appearance of an unalienable adjunct' (67, 50, my emphasis). The failure, on the other hand, of French critics of art, to understand such an ideal of portraiture is exemplified for Reynolds by de Piles's advice, to communicate to portraits a 'presumptuous loftiness':

> *If*, says he, *you draw persons of high character and dignity, they ought to be drawn in such an attitude, that the Portrait must seem to speak to us of themselves, and, as it were, to say to us, 'stop, take notice of me, I am that invincible King, surrounded by Majesty:' 'I am that valiant commander, who struck terrour every where:' 'I am that great minister who knew all the springs of politicks:' 'I am that magistrate of consummate wisdom and probity'* (149)[76]

The confusions that arise in Reynolds's account of the lesser genres is of no great consequence to the value of a theory which, insofar as it is concerned to define an ideal of the public and of a public art, can afford to glance at those genres only in passing. For it is only the grand style of history-painting that is fully equal to the task of uniting a mixed multitude of spectators into a public; and to enter into the kind of detailed account of the lower genres would no doubt have seemed to him to involve paying them a degree of attention that they did not merit. It is a characteristic of the *Discourses* that they are everywhere full of a sense of the 'depravity' of post-renaissance art, of which the crucial symptom is the popularity in the eighteenth century of the lesser genres; and so they are full of a belief that the timeless ideal of a civic republic of taste has been corrupted by the process of the privatisation of society to which that popularity attests. But in spite, or perhaps because of that belief in the ubiquitous workings of corruption, it is equally a characteristic of the *Discourses* that they are reluctant to examine the causes and details of that corruption, as if Reynolds believed that, because the grand style aims to represent the ideal of an unalterable human nature, the theory which justified the value of that representation should, like the art it justifies, be pitched far above the level of the merely local and accidental contingencies of contemporary life.

8. Originality and nobility

I want to conclude this account of Reynolds's adaptation of the theory of painting that had found expression in the discourse of civic

humanism, by considering two related issues that involve the nature of 'original genius'. The first may demonstrate the degree of his affiliation to the traditional discourse, and of his resistance to the individual and the singular, with their connotations of the private. The second may help us measure the degree of the departure he made from that discourse, in proposing—as by now I hope it is clear he does propose—a 'bourgeois' version of it, but one which does not appear to question, as the writings of some of his immediate predecessors had done, a commitment to the view that the primary endeavour of painting should be to confirm the members of its audience in their civic identity—to confirm them, that is, as a public.

The first of these issues is whether, or in what sense, an artist should strive to be 'original'; and we can start by observing, that if it is essential to the notion we entertain of how an artist becomes original, that he must strike boldly away from the common road, then we might expect that, by Reynolds's theory, the artist in the great style, obliged to represent as uniform an idea of beauty as possible, will be more valued the less original he is, or the more he effaces his own style and personality. If there is only one idea of beauty, Reynolds argues, there is 'but one great mode of painting' (52); there is, in fact, only one public style, the great style; and in proportion as a painter departs from it, by cultivating his own genius as something different from that of others, then the more 'singular' he must become, and 'singularity' is always the sign of an adherence to private concerns, and an imperfect awareness of one's duties to the public. This, by and large, was Shaftesbury's opinion: 'the good Poet and Painter . . . are afraid of *Singularity*; which wou'd make their Images, or Characters, appear capricious and fantastical'.[77]

The issue, however, is more complicated than we might expect, because the meaning of the word 'originality' is itself, in the eighteenth century, more complicated. An artist who is 'original' may be one who has the power of 'originating' images or inventions out of his own mind, and so far as they do derive from his own mind, we might expect them to be different from what other artists produce. This meaning of the word lies behind Richardson's approving repetition of the proverb that 'Painters paint Themselves', and West's celebration of the fact that 'style and character' are 'as various as the individual genius of every artist'. But a painter may also be 'original' when he copies his images as closely as possible after nature, which is the 'origin' of the imitations he produces: the gestures of Virtue, in *The Judgment of Hercules*, should be 'original, and drawn from NATURE her-self', states Shaftesbury; Johnson complains that Milton's descriptions of nature 'do not seem to be always copied from

original form', and West himself praises Leonardo as an 'original', in that he 'traced' the passions 'to their sources', and to their 'radical principles'.[78] Both these senses seem to be crystallised out of the same notion—that a painter becomes original by not imitating other artists, but by the direct imitation of general or common nature—and the difference between the senses may be a function of the attitude we choose to take to that notion. Thus an original artist may be expected to be unlike others in that he does not copy them, and we could choose to see his works therefore as originated by his own genius, as that differs from the genius of others. But we might also expect the works of an artist to resemble the works of another, insofar at least as both *are* original, and imitate nature directly. If we imitate other artists without reference to nature, we may be misled into believing that their accidental faults are just representations of nature; but, on the other hand, some artists have imitated nature so well, that to imitate their works may help us understand how nature is to be imitated, and so how we too may become original.

Reynolds often employs the words 'original' and 'originality' in ways that seem to leave his ambiguity unresolved. Thus he condemns the '*Pittori improvvisatori*' of contemporary Italy on the grounds that, 'notwithstanding' their 'common boast . . . that all is spun from their own brain', their works have 'very rarely any thing that has in the least the air of originality'; that therefore they 'impress no new ideas on the mind'; and that this is the result of the painters' failure to 'correct' their works 'from nature', or from observation of 'the works of others' (214). On the one hand, Reynolds seems to present it as a paradox that the works of the 'improvvisatori' are not original, when apparently they have no origin but the brain of their inventors; on the other, he suggests that they would have been more original, had they been closer to general nature, and had they been conceived with the 'assistance' of other works. Similarly, when Reynolds claims that Carlo Maratti 'had no . . . strength of original genius', and does not 'captivate us by that originality which attends the painter who thinks for himself' (85), it may seem that, by contrast, the works of an original painter will be 'spun from his own brain', and we may imagine that his originality will register with us in terms of the difference of his works from those of others. But equally, Maratti's lack of originality may be the result of the fact that, in copying others, he did not copy nature, and so created his ideal images at second hand, and was unable to approximate to that uniform ideal which is to be found only by a study of original nature. A similar ambiguity may be present in Reynolds's promise to his students that, at the Academy, 'every mind may imbibe somewhat congenial to its own

original conceptions' (16). Does this suggest that Reynolds approves an originality that expresses itself in individuality, or that the Academy will encourage students to imitate their own conceptions of original nature, and not those of other artists, or of their teachers? And if the latter is the case, might it not follow that the more their originality is allowed to flourish, the less individual their works will become, as each becomes more a first-hand imitation of nature itself?

If passages like these remain ambiguous, there are, elsewhere in the *Discourses*, many remarks which suggest that, for Reynolds, originality is not to be measured in terms of difference. Thus, he argues, a good artist does not strive for 'new thoughts'—he asks himself, instead, when inventing a picture, what is it that such and such a character would do, and how would he or she appear, in such and such a situation? (148); he consults nature, and the sign of his having done so is his lack of novelty.[79] It was, Reynolds remarks of Raphael, 'from his having taken so many models, that he became himself a model for all succeeding painters; always imitating, and always original' (104): Raphael learned, in short, how to be original, how to imitate general nature, by imitating others, and we may do the same by imitating him. Again, 'original' and 'rational' inventions, Reynolds claims, are achieved by the imitation of other artists; and though 'an artist should not be contented with this only', but 'should enter into a competition with his original', he will not become himself original by endeavouring to make his works different from those of his models, but by trying 'to *improve* what he is appropriating to his own work' (107, my emphasis)—by making his images closer to general nature, and in that sense more original.

That this is the primary sense Reynolds attributes to originality may be confirmed by comparing a figure frequently used in the *Discourses*, with Edward Young's version of the same figure in his *Conjectures upon Original Composition*. For Young, originality is certainly a matter of being different from other writers: 'all Eminence, and Distinction, lies out of the beaten road; Excursion, and Deviation, are necessary to find it; and the more remote your Path from the Highway, the more reputable'. 'In the Fairyland of Fancy', he continues, 'Genius may wander wild'; for 'the true Genius is crossing all publick roads into fresh untrodden ground', while the writer who is merely a 'well-accomplish'd Scholar' is 'up to the Knees in Antiquity', and 'treading the sacred footsteps of great examples'.[80] Reynolds similarly advises his students not to 'tread' in the 'footsteps' of the 'great masters', but he does urge them 'to keep the same road' (30); for the great masters are those who have all 'travelled the same road with success' (28); we should not be 'seduced' (33) from the

'beaten path' in search for 'something uncommon or new' (84), for
those who have 'wandered farthest from the right way' (16) are lost to
the great style.

What is at issue between Young and Reynolds is not simply
whether we are to value works of art and literature primarily as they
differ from each other, or as they aim at a common end; for in accord-
ance with his admiration for individuality, or singularity of achieve-
ment, Young conceives of literature, not as public art, but as one
produced and enjoyed in private—and no writer on the visual arts
was to think of painting in that way until Hazlitt. Young, though still
sufficiently imbued with the vocabulary of civic humanism to demand
that works of literature should be dedicated to 'the *Public Good*', and
to 'the sacred interests of Virtue, and real Service of mankind', has no
time for the ideal of civic uniformity that is one of the foundations of
Reynolds's aesthetic. At our birth, Young observes, 'no two faces, no
two minds, are just alike; but all bear Nature's evident mark of
Separation on them'. For Reynolds, this was the crucial problem
faced by the public artists anxious to communicate to us the grounds
of social affiliation: how to reduce the chaos of the particular and the
idiosyncratic to a common, a central form. For Young, the problem
is the opposite:

> Born *Originals*, how comes it to pass that we die *Copies*? That
> medling Ape *Imitation*, as soon as we come to years of *Indiscretion*
> (so let me speak), snatches the Pen, and blots out nature's mark of
> Separation, cancels her kind intention, destroys all mental Indi-
> viduality; the letter'd world no longer consists of Singulars. It is a
> Medly, a Mass; and a hundred books, at bottom, are but One.

To preserve originality, in Young's sense of the word, authors must
write at a distance, and in seclusion, from others—in a 'letter'd
recess', a 'Closet', a 'cloister'.[81]

Reynolds's use of the image of the highway suggests that, if orig-
inality is to him a virtue, it is to be measured not by the distance a
painter puts between himself and the common road, but by the dis-
tance he manages to advance along it, towards the 'originals' of
nature; if ever originality in the great style is the laudable effect of the
difference between one mind and another, this is the paradoxical
result of the fact that in his pursuit of the uniform ideal of beauty a
painter is bound to fall short: it is 'the lot of genius' always 'to contem-
plate and never to attain' the 'ideal excellence' he seeks (14, and see
171). By the nature of that failure, by how and why he falls short, the
particular quality of his mind is revealed, and thus its originality in the
sense of its distinctiveness; but when we admire that originality, what

we are really admiring is the uncommon strength of a mind which has made every effort to conceal its distinctiveness, its singularity, and to approximate itself as far as possible to a common style and aesthetic. Reynolds can admire singularity for its own sake only in lesser artists, like Salvator Rosa, whose character for one reason or another prevents them from attempting the great style. Such artists are permitted to develop their own, 'characteristical' style, a style Reynolds describes as 'irregular, wild, and incorrect', but also as 'original' in the sense that it is 'less referred to any true architype existing either in general or particular nature'. It is significant, however, that Reynolds's one unambiguous use of 'original' in this sense occurs in the context of his discussion of an 'inferior' style; in the great style, a worthier kind of originality is to be achieved, precisely *by* referring to 'general ... nature' (85); and in the great style 'characteristical' marks, such as are 'peculiar' to an individual, are 'always defects'. They are 'what is commonly called the manner', by which an 'individual artist is distinguished' (102); and 'manner in painting is like peculiarity of behaviour',[82] it is singularity, and is so far from what the great style aims at, that the truest and most valuable originality will be its very opposite.

This genuine originality, it will seem to follow, is not to be achieved by ignoring the established rules of art. In his second discourse, Reynolds expatiated on the kind of freedom eventually enjoyed by an artist who has first been disciplined by a regular education in the principles of the grand style, and who 'may be indulged in the warmest enthusiasm, and venture to play on the borders of the wildest extravagance' (27). But this and other similar flights of rhetoric need to be interpreted with some care. Sometimes they seem to function as a carrot to entice the students onward, by reassuring them that the rewards to be won in the remote future are far more delightful than any immediate gratification available to them by cultivating mere facility or dexterity. Sometimes, indeed, they seem to attribute an unconditional freedom to the artist of genius, who is claimed to exercise 'a sort of sovereignty over those rules which have hitherto restrained him'; but as Reynolds is scornful of the 'popular opinion' that genius is entirely exempt 'from the restraint of rules', such passages seem to indicate that a genius is only thus sovereign in the sense that he endorses, by a free act of judgment, the rules which earlier he was simply obliged to obey (27, 120). Even when the artist seems to 'consider the rules as subject to his controul, and not himself subject to the rules', and even when he 'extends the limits of the art',[83] the lessons he has learned from the great tradition of art are so 'woven into his mind' (279), that, in his most apparently capricious and sportive

productions, he will be confirming the principles on which that tradition is founded; for those artists who have 'enlarged the boundaries of art' have always done so 'by exhibiting the general ideas of nature' (73). In short, the genius 'controuls' the rules only insofar as, with the development of his judgment, those rules appear to him, not as commands to be obeyed, but as principles to be observed; and as the *Discourses* continually make clear, the more apt image for the 'public' artist is not the arbitrary ruler, but the citizen of a civic republic, engaged in a contest for honour which will be won by whoever can to the greatest degree fit his personality to that universal character.

It may be therefore—though I make the point tentatively—that the markedly more hospitable attitude to originality as a measure of difference, which is displayed by the French critics influential on British criticism, will again help us to separate the French tradition of art-criticism from the civic humanist tradition in Britain. Du Fresnoy had argued that 'every painter paints himself in his own works', and that the painter should not pay 'such strict homage' to nature 'as not to quit when Genius leads the way'—though equally he should not 'presume from Nature wholly to depart'. Poussin wrote approvingly of style as 'a particular manner and skill . . . which comes from the particular genius of each individual'. De Piles argues that a painter should 'form such a general idea of the passions as may suit his genius: For we all think differently, and our imaginations are according to the nature of our constitutions', and Du Bos complains of painters without genius that there is 'nothing singular in the expressions' they represent. Perhaps it is the necessary divorce between a *republic* of the fine arts—Du Bos, at least, claims to write as a member of 'la République des Lettres'—and the structure of the civil state in France, that makes singularity there something to be admired: as if the republic of the fine arts offered a substitute for the freedom which could not be exercised by participation in the civil state—a freedom which is therefore experienced and valued as singularity, as private freedom, in that it must be construed as in opposition to one's political identity.[84]

I can introduce the second of the issues I have undertaken to discuss, by saying that one implication of Reynolds's repeated insistence that a 'public' artist should emulate his predecessors in the great tradition, and not simply imitate them in a servile way, is that in the republic of taste, and in the political republic on which it is modelled, it is the mark of a true citizen that he does not acknowledge distinctions of rank, but only of merit. This is, as we shall see, of some importance to Reynolds's notion of the status of the artist, and of the

values embodied by the profession, and is related to another charac-
teristic of the public artist, his ceaseless industry: the knowledge of
the principles of taste is acquired by 'a laborious and diligent investi-
gation of nature, and by the same slow progress as wisdom or know-
ledge of every kind'; and, more particularly, an understanding of the
practice of painting is achieved only by an 'unceasing assiduity' (134,
25). This need for industry has to be insisted upon all the more
urgently, in that its rewards are so far deferred, and the advances
made by an artist so imperceptible, that, 'like the hand of a clock,
whilst they make hourly approaches to their point', they 'proceed so
slowly as to escape observation' (33).

It is of course essential to the notion of painting as a liberal art that
this industry be understood as a form of *intellectual* labour. So far
does Reynolds seek to minimise the degree of manual labour in-
volved in painting, that to take pains with it is a kind of 'superfluous
diligence' (194), for by an undue concentration on the mechanism of
painting an artist is seeking 'a shorter path to excellence' (18) than the
road trodden by the masters of the great tradition. The general ideas
exhibited in their works are the fruits of 'continual exertion'; the
minute particularities represented by other artists are 'the laborious
effects of idleness' (202–3).[85] Now as I suggested in my introduction,
the terms 'liberal' and 'mechanic' are rarely, if ever, transposed by
British writers on art into a version of the opposition we find every-
where in French criticism, between 'noble' and 'ouvrier'; and though
in my next paragraph we will encounter an apparent exception to that
rule, it will turn out to be an exception that proves it. The word
'noble' itself, however, was, as we saw, often used by British writers
to emphasise the elevated qualities of a liberal art and mind—as
Pocock has noted, 'it was hard to define the civic ethos in other than
aristocratic terms',[86] though we must not confuse the aristocratic with
the feudal. Thus, at the start of his fourth discourse, after distin-
guishing between painting as a 'liberal' art, and the mistaken notion
of it as a 'mechanical trade', Reynolds remarks that insofar as it is a
liberal art, it 'is addressed to the noblest faculties'; the perfect style,
he remarks elsewhere, is the one in which 'the noblest principles are
uniformly pursued' (57, 73). This notion of the 'nobility' of painting
has a certain appropriateness to Reynolds's account of the grand
style, insofar as the highest kind of art so effectively conceals the
means by which it is produced, that it seems not to be the product of
labour at all, for all 'the marks' of 'subordinate assiduity' are effaced
(59).

The means by which the artist of genius has risen to nobility are as
invisible to us as are the labours of the workman to the aristocrat he

supports. But insofar as paintings are, for Reynolds, entirely the product of a certain kind of labour, he is anxious to disentangle the art from such notions of rank as appear to connect its 'nobility' to a notion of noble birth, where that notion can be used as a metaphor for a certain inspiration granted to the painter, or a dignity attributed to him, through no virtue—no industry—of his own. Thus, on a number of occasions, he calls into question the implications of the metaphor: writers of all nations, he observes, have represented the ideal of perfect beauty as if it were the unearned gift of inspiration: 'it is this intellectual dignity, they say, that ennobles the painter's art; that lays the line between him and the mere mechanick'; but 'enthusiastick admiration seldom promotes knowledge', and tends instead to conceal the 'solidity and truth of principle' upon which the art is founded, and which is open to be discovered simply by 'attention', 'skill', and 'care' (43–4). A few pages later he repeats the point: Bacon, he notes, had ridiculed the idea that a painter could produce beauty by attention to the rules drawn from anatomy, or by a process of selection, and believed that he must work '"by a kind of felicity, ... and not by rule;"'[87] but 'if by felicity is meant any thing of chance or hazard, or something born with a man, and not earned, I cannot agree' (46). And later, again arguing against the notion of inspiration 'as a *gift* bestowed upon peculiar favourites at their birth', he acknowledges that the notion has a very 'captivating and liberal air', but insists that the effects of art are the result of 'long labour and application of an infinite number and infinite variety of acts' (94).

We could regard all these passages as no more than an acknowledgement of what to Reynolds seems an incontrovertible fact, which requires to be emphasised the more in the context of a series of lectures delivered to students, among others, at the Academy. Those students were not drawn from the hereditary nobility, but if they later became moderately successful they would find themselves engaged in professional transactions with aristocratic patrons, and there was no harm in warning them now of what they would frequently discover in the future—that however much their character could be described in terms which could describe also the character of a liberal aristocracy, their patrons would continue to treat them as tradesmen. In a few cases, their artistic success might lead to such social success as Reynolds himself enjoyed, and they might come to be treated, sometimes, as on a footing of apparent equality with their patrons; but it was still worth reminding them that only by a laborious diligence would they ascend to a position which many of their patrons occupied simply by right of birth. Thus, however anxious Reynolds is to define painting as a liberal profession, as distinguished from a mechanical

trade, he also thought it worthwhile to call it a 'trade' (191) in order to distinguish its practitioners from its patrons.

But such considerations will not, I believe, entirely account for Reynolds's frequent distinction between those who achieve their membership of the republic of the fine arts by effort, and those who behave as if their right to membership of the republic of taste derived from their right, by birth, to be members of the political republic. I can best substantiate that belief by quoting the written record of a spoken observation by Reynolds on the nature of happiness:

> It is not the man who looks around him from the top of a high mountain at a beautiful prospect on the first moment of opening his eyes, who has the true enjoyment of that noble sight: it is he who ascends the mountain from a miry meadow, or a ploughed field, or a barren waste; and who works his way up to it step by step; . . . it is he, my lords, who enjoys the beauties that suddenly blaze upon him. They cause an expansion of ideas in harmony with the expansion of the view. He glories in its glory; and the mind opens to conscious exaltation; such as the man who was born and bred upon that commanding height . . . can never know; can have no idea of;—at least, not till he come near some precipice, in a boisterous wind, that hurls him from the top to the bottom, and gives him some taste of what he had possessed, by its loss; and some pleasure in its recovery, by the pain and difficulty of scrambling back to it.[88]

We can read this passage simply as a more than usually eloquent rehearsal of a moral commonplace, that a happiness which is achieved after suffering and effort is a good deal more worth having than a happiness which, because its possessor has never known suffering, is the less grateful to him on that account. But the passage seems to say a great deal more than that, and must be understood in the context of the frequent use in the eighteenth century of the extensive prospect as a metaphor for the extensive political, moral and social comprehension that characterised, it was claimed, the aristocratic member of a civic republic; and the appropriateness of the metaphor derives from the fact that in Britain, especially, that comprehensive vision was regarded as a function of an independence enjoyed by the aristocracy specifically because they were the independent freeholders of fixed, landed property.

In that context, Reynolds's remarks can indeed be read as what Lawrence Lipking has called them, an 'impassioned outburst',[89] the more impassioned because this account of how a 'noble sight' may be truly enjoyed is addressed to a noble company, 'my lords', who claim to enjoy it simply because 'born and bred upon that commanding

height', from which they seem to observe and *command* the view below. To distinguish between the kind of enjoyment which they derive from the prospect, and the kind enjoyed by those who have to toil up to that eminence, Reynolds suggests that to the 'lords' the prospect is not really a metaphor at all: they may presume that the 'expansion of the view' produces a similar 'expansion' of their 'ideas', but it does not; and if to them the prospect has any metaphorical application, it is simply as a figure for the 'eminence' they enjoy as a result of the nature and quantity of their inherited fortunes. The figure achieves its full significance only—the topography of all this may suggest—for whoever can appropriately be represented as a labourer, who 'works his way up' to the eminence 'from a miry meadow, or a ploughed field, or a barren waste'.

I am arguing, in short, that the passage needs to be understood in relation to what I have described elsewhere as a crisis in the perception of the character and function of the 'gentleman' in the mid-eighteenth century, conceived of as a public man in a civic republic.[90] That crisis, I have argued, derived partly from the effort to understand the 'comprehensive vision' of the gentleman in terms of a natural theology which represented the order of nature and the universe as providentially designed, and therefore, to those who could view it comprehensively, but not to the 'sordid sons of toil', as offering a revelation of the existence of a beneficent deity. The problem engendered by this effort was that, if the comprehensive observer could see a perfect universe, in which whatever is, is right, his function in the republic is reduced simply to observing a social order which his public virtues cannot act upon, to improve it, for all is already as it should be. But the crisis derived from another source as well: from the fact that, as the laws of capitalist economic activity were explored, society came increasingly to be understood as an economic association, the result of the complex interdependence of individual, private interests, and less as a political association, whose stability was threatened by private interest, and which could be saved from corruption only by the heroic virtues and actions of disinterested public men.

The perception of society as an economic association had, as we have seen, two awkward implications for the claim to natural hegemony of the independent man of landed property and of no determinate occupation. To begin with, it questioned his ability to comprehend such a society, which was now represented as being infinitely complex, and, if open to be comprehended at all, open only to the comprehension of the philosopher disciplined in the science of social investigation, and, in particular, in political economy. Secondly, it rehabilitated private interests as no longer what threatened to divide

society, but as what held it together; and in thus revaluing private interest, it elevated the private virtues, and particularly those conducive to the pursuit of private interest in the production of goods and services. If the more interested one was, and the more one worked and produced, the more one contributed to the stability of the social structure, then the man who claimed to be disinterested, and produced nothing, could come to seem a very marginal member of a society which was particularly incomprehensible to him, for an understanding of it depended on a knowledge of a host of minute details of the process of production and distribution which were, as Defoe pointed out, beneath the notice of a gentleman: social knowledge was to be acquired by a practical experience within society, not by a fastidious separation from it, on a rural eminence. If the claim of the gentleman to comprehend a society understood to be structured as a market could still be vindicated, it could only be so if—like Peter the Great—he descended from his eminence to investigate it in detail, or if, like Roderick Random in Smollett's novel[91], or like the weary climber in Reynolds's 'outburst'—he worked his way, step by step, up to that eminence.

I am arguing, then, that Reynolds's account of happiness has considerable implications for his notion of the republic of taste. For it suggests that, insofar as the aristocratic patrons of art may be regarded as 'citizens' of that republic, they are described as such only by 'a forcible designation'—by which I mean, in this case, a designation they have the power to force out of the painters they patronise. Their claim to be men of taste is assumed, not 'earned'; it has involved no labour, no exertion, no diligent investigation of nature; but true taste, as well as executive excellence, is a product, and a product of labour, and the true republic of taste, like that of the fine arts, is a bourgeois republic, a civic association in which men emulate each other on the basis of what they do, not of what they are, or claim to be. I have thought it worthwhile to spell out in such detail what I take to be the implications of Reynolds's questioning of the use of the word 'noble' as a term of value in the republic of taste, not because it is an issue he makes much of—he does not—but because that questioning seems to me to offer another example of the fact that the civic humanist language of the tradition of art criticism is not simply inherited by Reynolds as a structure of received values, but is one that he seems to work on, with some sense of how it may need to be modified in response to an awareness of the disjunction between the 'unchanging' social values embedded in that language, and the changing values of the society in which he worked. In this light, it may be related to his attempt to base his vindication of history-painting in

the grand style on form more than on fable. That attempt may be based, I suggested, on the notion that public spirit may now need to be understood in terms of an ability to perceive, rather than to act upon, the public, and that therefore the polite but unenfranchised should now be admitted to citizenship in the republic of taste. But his questioning of the values implied by the term 'noble' goes rather further: it seems to deny even that limited ability to those who assume their taste is noble merely because their birth was.

9. *The discourse of custom*

The opinions and arguments that I have so far considered are those which find expression in the first six discourses, and thereafter they are occasionally re-stated, without must modification, most clearly in the ninth, tenth, and eleventh; it was these opinions and arguments which came to be thought of by later writers on painting as representative of Reynolds's teaching. That teaching did not, however, continue unchanged, and as early as the seventh discourse, delivered in 1776, we find the adaptation he has made, of the traditional civic humanist theory of painting, being infiltrated, or being obliged to co-exist, with a new theory, by which the ideal of a civic republic of taste, founded on the unalterable principles of human nature, begins to be converted into the notion of what I shall call a 'community' of taste, conceived of as a national community, bound together by custom and justifiable prejudice. This new notion never became securely established, however, in the works published during Reynolds's lifetime, and in those works it is never clear how far he recognised it as a new departure, or how far it seemed to him to be in conflict with his earlier beliefs—for that reason, as I said at the start of this chapter, it is often possible to use extracts from his later discourses to illustrate an account of his earlier position. But in two essays which he wrote in the 1790s, but which were not published until this century—the preface to the 'Ironic Discourse', and the essay on Shakespeare[92]—he shows himself to be fully aware of how far the discourse of custom deployed there was incompatible with his earlier, civic discourse; he goes so far, indeed, as to argue that we need 'a new code' of criticism by which the civic discourse might finally be supplanted.

The reasons for this awareness are not difficult to understand. When the discourse of custom first began to attract Reynolds, as it had already attracted Johnson, it was not conceived of by either man as providing a range of arguments by which the discourse of civic humanism might be qualified or challenged. Its target was elsewhere,

as is made especially evident by Johnson's political pamphlets of the 1770s,[93] which are directed against the use being made, by the supporters of John Wilkes and by the American colonists, of the political theory, and the discourse of natural rights, developed by Locke in the second of his *Two Treatises of Government* (1689–90). That theory, which had previously been used to justify the limitations set on the power of the monarchy after the Glorious Revolution, was now seen as capable of supporting a demand for further constitutional changes such as threatened to disturb the settlement arrived at in 1689, and the system of checks and balances then designed to limit the power of the different groups in the state whose interest had been most consulted in the framing of that settlement. But by limiting the power of those interest-groups, the system of checks and balances had also confirmed it, by making the health of the state entirely dependent, or so it was believed, on a continuation of the established distribution of power among the crown, the peerage, and the commons, and among the landed and the moneyed interests. The settlement therefore could not be disturbed, for example, by an extension of the franchise, by—in the case of the Wilkes affair—a greater deference to the rights of the Middlesex electors, or—in the case of the American colonists—by an acknowledgement of the principle that the duty to pay taxes might involve a right to direct political representation. The demands both of the Middlesex electors and of the American colonists were identified, certainly by Johnson, as finding expression in the language of Locke, and as deriving from the claim that, if those to whom the people have assigned political authority infringe the trust placed in them, or—not occasionally but consistently—use their power in such a way as not to protect but to put at risk the rights of the governed, then the compact on which society is based is dissolved, the state of nature is come again, and men are free to choose new governors, and even to frame a new system of government on whatever terms they can agree to. Final authority was with the people; they had reassumed it at the revolution, and could reassume it again, in the event of a consistent abuse of power on the part of their governors.

The answer that Johnson, in particular, made to these demands, was made by asserting the authority of custom over that assigned to the people in Locke's second treatise. Governments are not founded, Johnson argued, on the consent of the people, or on such theoretical fictions as the 'original compact'. They are, on the contrary, 'formed by chance, and gradually improved by such expedients, as the successive discovery of their defects happened to suggest'; they are 'fabricks of dissimilar materials, raised by different architects, upon different

plans'. Accordingly, they 'are never to be tried by a regular theory'; they owe their legitimacy to the simple facts that they are established, and that, more or less, and with whatever defects, they work—and the same cannot be presumed of any untried, theoretical system of government, which represents itself as rational, but is in fact 'the delirious dream of republican fanaticism'. 'We must be content', he argues, with whatever governments we have; 'should we attempt to mend their disproportions, we might easily demolish, and difficultly rebuild them. Laws are now made, and customs are established; these are our rules, and by them we must be guided.'[94]

The laws by which we are ruled have their authority in custom—whether because, as in the case of the common law, they are 'customary' laws, or, as in the case of statute law, they are framed by institutions whose own authority is customary, in the sense that it is established by their longevity. And because each nation has developed its own system of government, it is presumed by the discourse of custom either that the people of a nation come, over centuries, to adapt themselves to the system of government under which they live, so that to assent to its authority becomes second nature; or that the customs of a country derive from the national character of its people: its customs, its government, are 'connatural' with that character.[95] They may be presumed to be an expression of the people's will, of their collective if inarticulate understanding of their long-lived and long-term interests, and so are a far more trustworthy expression of their voice than the clamour of those who, in pursuit of short-term interests and the rectification of minor abuses, demand major changes in the constitution. In either case, custom—proverbially defined as 'second nature'—and even a frank prejudice in favour of established arrangements and practices, were the expression of the collective spirit of a nation; it was by customary beliefs and acceptances that a people was constituted as a *nation*; and no nation could be constituted, as a political collectivity, by theories of government which, because 'rational', and framed for the use of 'rational' men, could be recommended to any nation whatsoever, without thought for its national character.

There is much in the discourse of custom which is inimical to the discourse of civic humanism—in particular the suspicion of rationality, and the concern with nationhood, as opposed to the universal ideal of what a public, a civil state, should be. It is therefore no accident that, as we shall see in Reynolds's first attempts to employ the discourse of custom, the main casualties suffered by the civic humanist theory of painting he had developed are the claims that painting should appeal to 'all ages, and all times', and to 'mankind' in

general, and that ideal beauty is an ideal arrived at by the process of abstraction which had been analysed most influentially by Locke. But because, I suggest, the civic humanist discourse is not at first the immediate target of the discourse of custom, the incompatibility of the two was not, at first, very clearly perceived. By the early 1790s, however, the situation had changed considerably. Word had arrived from France that the members of the constituent assembly had not only embraced a Locke-like belief that kings could be cashiered, but had appropriated the civic humanist discourse itself; if the republican rhetoric of civic humanism could no longer be represented as compatible with the discourse of natural rights, then it could not now be presumed to be easily compatible with the mixed constitution and the limited monarchy of Britain. A version of the civic discourse was discovered in the writings of the arch-fiend Rousseau; and finally the jacobins were identified, by Shee and by Coleridge, among others, as civic humanists. 'When a nation is in safety', wrote Coleridge in 1800,

> men think of their private interests; individual property becomes the predominating principle . . . and all politics and theories inconsistent with property and individual interest give way, and sink into a decline . . . But is the nation in danger? Every man is called into play; every man feels his interest as a *Citizen* predominating over his individual interests; the high, and the low, and the middle classes become all alike Politicians; the majority carry the day; and Jacobinism is the natural consequence. Let us not be deceived by words. Every state, in which all the inhabitants without distinction of property are roused to the exertion of a public spirit, is for the time a Jacobin State.[96]

Coleridge, it will be observed, has no objection to the language of citizenship, of public interest predominating over private, of public spirit, as far as this might be deployed by those whose property is sufficient to buy them the right to deploy it. But if it is to be spoken also by improper persons, who cannot afford to aspire to the privilege of self-sacrifice, then it had better be abandoned along with the language of natural rights, original compacts and popular consent, which had also been misappropriated by the unpropertied.

As the discourse of civic humanism came increasingly to be identified, by the proponents of customary wisdom in taste and politics, with the discourse of natural rights, the incompatibility of the civic discourse and the discourse of custom became strikingly apparent, to Burke especially, who, with the death of Johnson, had become Reynolds's intellectual mentor, and so to Reynolds himself. And thus Reynolds came to argue, as I have said, that criticism now

needed 'a new code', for he now recognised quite clearly that it was no longer the primary duty of art to create a universal republic of taste. Art should create, instead, a customary community of taste, to develop in a people a sense of its nationhood, of belonging to one nation rather than another, and to provide the justification of social and political privilege which the civic humanist discourse could no longer be relied upon to provide.

In fact, Reynolds's slow conversion to a full acceptance of the authority of custom was, to some extent, a reconversion; for in his earliest accounts of taste, published in *The Idler* in 1759, he had based his aesthetic entirely on a notion that 'the most customary form . . . is in each species of things . . . the most beautiful'—I quote from what is the most likely source of Reynolds's opinion, Claude Buffier's *Traité des premières vérités et de la source de nos jugements*, as summarised by Adam Smith in his *Theory of Moral Sentiments*, published some months before the *Idler* essay in which Reynolds gives his first account of the central form. In that essay, Reynolds argues that we prefer the central form of a species—the 'form', in Smith's words, 'which Nature seems' always 'to have aimed at' in her creations— because, seeing it more often than any particular kind of deformity, we are more used to seeing it; and though there may be other reasons why we prefer some of nature's works to others, the most general and important is habit and custom. Because Reynolds believes that central forms are—however seldom, as Buffier had acknowledged— manifested in actual nature, and so do not require to be abstracted from a universally defective creation, our ability to recognise them is a simple function of our experience: 'the power is acquired', he argues, 'even without seeking after it'; and only foolish theorists (he has Hogarth in mind), who believe it possible to invent some more universal theory of beauty applicable to all species, cannot perceive what is open to be observed by a natural common sense.[97] The argument is not quite as democratic as I have made it sound—for though taste is acquired without any tedious and deliberate comparison of object and object, and without the need of any power of abstraction, it can be acquired only by those who have a sufficient breadth of experience to realise what forms nature most usually produces; the myopic mechanic, we may presume, cannot acquire it.

When he came to write the early discourses, Reynolds revised this position entirely, and it was not inappropriate that he should do so, as he was now attempting to found the republic of taste on the analogy with the political republic, the fundamental division in which was that between those who could and those who could not think. Mere breadth of experience on which no intellectual operation had been

performed, and mere natural common sense, could not guarantee that distinction as surely as could the power to abstract; and, as Pocock has argued, in a civic republic 'the decision-making structure was more than a community of custom; to the experience of the many must be added the superior reflective capacity of the few'. And equally fundamental to civic humanist political theory was the distinction between the universal, the original frame of the human mind and human nature, and habit or custom as what occluded our perception of that original; for 'custom at most could affect men's second or acquired natures, but if it was the end of man to be a citizen or political animal, it was his original nature or *prima forma* that was [to be] developed', and developed in such a way as would enable it to realise its potential to be 'reflective'—in Reynolds's terms, to abstract from particulars.[98] It was now essential to Reynolds's theory that central forms were not available to be observed in actual nature; all objects in actual nature must now be argued as defective, so that the ability to perceive the central form will depend on the development of the ability to abstract; a correct taste was no longer ingested as second nature, as the uncultivated fruit of experience. In particular, the central form was now to be discovered by 'being able to get above . . . all local customs', and for Reynolds, all customs are now local: 'the prejudices', he writes,

> in favour of the fashions and customs that we have been used to, and which are justly called a second nature, make it too often difficult to distinguish that which is natural, from that which is the result of education; they frequently even give a predilection in favour of the artificial mode; and almost every one is apt to be guided by those local prejudices, who has not chastised his mind, and regulated the instability of his affections by the eternal invariable idea of nature (49).

This is the doctrine that begins to be questioned in the seventh discourse, delivered on 10th December, 1776—the year of Bentham's *Fragment on Government*, a riposte to William Blackstone's recent thorough exposition of the principles of English common law; the year of Thomas Paine's *Common Sense*; and, most significantly, the year of the American Declaration of Independence.

10. A customary community of taste

The seventh is the most complex of Reynolds's addresses to the Academy, because it attempts to rehabilitate the value of customary, while insisting that its rehabilitation does not threaten the aesthetic he

had earlier advanced, and, far from endangering the creation of a civic republic of taste, may actually serve to promote it. Because the claims made and the pleasures legitimated by the discourse of custom are defined uncertainly, under cover of this apparently unwavering commitment to a version of a civic humanist theory of painting, I shall need to trace the argument of this address rather doggedly; for it is in its progressive but uneven development that the problems involved in the defence of the customary are to be discovered, and that the continuity, through all his revisions of opinion, of Reynolds's attempt to argue that the function of art is to create a public, whether universal or national, is to be understood.

The seventh discourse begins, disarmingly enough, in view of what follows—with an attack on the kind of wisdom we imbibe by the fact that 'we naturally adopt and make our own' the 'opinions generally received and floating in the world'. Because, as we have seen, the distinction between what is durable and what is transient, what is solid and what is fluctuating, is an important constituent of the value-language of the *Discourses*, the word 'floating' invites us to be on our guard immediately, and rightly so, it seems; for because we are in the habit of accepting without reflection opinions which come into our possession 'like current coin in its circulation', we find ourselves in possession of 'many adultered pieces . . . which, when we seriously estimate our wealth, we must throw away'. One such worthless and floating opinion, Reynolds suggests, is that '*tastes are not to be disputed*', a saying which has a spurious pretension to truth, based on the unfortunate fact that we apply the term 'taste' to 'that act of the mind by which we like or dislike, whatever be the subject', so that 'our judgment upon an airy nothing, a fancy which has no foundation, is called by the same name which we give to our determination concerning those truths which refer to the most general and most unalterable principles of human nature' (120–2).

So far, so familiar; but now the argument, by comparison with the earlier discourses, takes a surprising turn: for apparently about to distinguish between floating opinions about airy nothings, and serious determinations of universal principle, Reynolds offers us instead a distinction between '*real*' and '*apparent* truth'; and it turns out that '*apparent* truth', or 'variable' opinions and prejudices, may be just as well based on the 'most unalterable principles of human nature' as are those truths which are as fixed as if based on 'mathematical demonstration'. '*Real*' truths are those which result from 'the real agreement or equality of original ideas among themselves', from 'the agreement of the representation of any object with the thing represented', or from 'the correspondence of the several parts of any

arrangement with each other'—the truths, that is, as far as the arts of design are concerned, of form, likeness, and composition. All these have, apparently, 'unalterable and fixed foundations in nature, and are therefore equally investigated by reason, and known by study'; and the taste 'which conforms' to real truth 'is, and must be, uniform'. The second sort of truth, however—apparent truth, or 'truth by courtesy'—is 'not fixed, but variable'; but for as long as the opinions and prejudices on which it is founded survive, 'they operate as truth' (122).

The move that Reynolds is making here is not especially remarkable, except in the wake of the earlier discourses; for this rehabilitation of custom depends upon a distinction, not uncommon in eighteenth-century aesthetics, between customs so universal as to have become 'a second nature', and customs or habits merely local, personal, or transient. Reynolds gives a good example of this distinction later in the seventh discourse: how, he asks, do we show respect to our superiors?—in one context by bowing, in another by kneeling, in a third by prostration, in a fourth by pulling off our hats, in a fifth by removing our shoes. The particular mode by which we show respect is a local custom, and varies by time and place; but the general custom, observed at all times and places, of which all these local customs are merely instances, is that, in the presence of our superiors, we make ourselves 'less' (134–5). The difficulty of adapting this example into a rule by which a painter might be directed to represent general rather than local customs would have been obvious to Bishop Berkeley; but whether or not it was to Reynolds, he offers it as a rule, that in proportion as customs and prejudices are 'generally diffused' and survive through time, the more they become stable, permanent, uniform, and so 'deserve . . . to be considered as really true'.[99] The taste, therefore, which 'conforms' to such customs, approaches near to certainty, but recedes further—it becomes, indeed, 'more and more fantastical'—as prejudices become 'more narrow, more local, more transitory' (122–3).

Having thus redescribed some 'floating opinions' and 'variable truths' as solid, durable, and general, Reynolds appears to withdraw a step, though only, as we shall see, the better to leap forward. He reasserts his earlier belief, as if it were entirely congruent with this new one, that the foundation of taste must be in principles which are exempt from change, invariable and fixed in the nature of things, and that it will be so only insofar as we can bring taste 'under the dominion of reason': 'the arts would lie open for ever to caprice and casualty, if those who are to judge of their excellencies had no settled principles by which they are to regulate their decisions'. That foundation is,

apparently, still what it had been in the earlier discourses: 'the presiding principle' of 'the general idea of nature'. But that principle too is about to be redescribed: the general idea is now to be discovered by the elimination of 'whatever notions are not conformable to those of nature, *or universal opinion*', and deformity is now 'not nature, but an accidental deviation from her *accustomed* practice' (123–43, my emphases). We seem to be back with the central form as it had been defined in *The Idler*, except that the ability to grasp the general idea of nature is now a function of the ability to distinguish merely local customs and opinions from universal ones—and that, as we saw in Reynolds's account of the various modes of showing respect, presupposes an ability to abstract.

We may defer a consideration of the significance of the metamorphosis of variable opinion into fixed principle, because Reynolds defers it, and indeed, in his next few pages his main concern is to suggest that the character of the civic republic of taste that he had defined in the earlier discourses is unchanged by the change in his definition of general nature. Accordingly, he rehearses a few familiar positions and attitudes. Dutch painters who represent the 'particularities' of actual nature are condemned for singularity, for 'how can that be the nature of man, in which no two individuals are the same?' Beauty does not lie immediately before us, or in our first opinions, for the discipline whether of morals or of taste teaches us to 'refuse the present for a greater good at a distance' (124–5). A painting must not 'perplex' or 'distract' the eye by confused composition or unharmonious colouring; indeed it must not just attract, but 'fix' the attention (126, 129). A painter must not represent the 'poverty and meanness of our nature', but the 'heroick arts and more dignified passions', and so teach the spectator to '"venerate himself as man"' (129–30)—the quotation, from Goldsmith,[100] emphasising the universal by the omission of the indefinite article. Most remarkably, in view of what follows, the rehabilitation of custom makes no difference to the rules Reynolds had earlier announced for the representation of drapery: ideally, the figure should still be displayed naked, or in drapery of no specific fabric or identifiable fashion (127–8).[101] None of the rules, it seems, has changed, and a public art is still one which presents forms 'analogous' to the 'original frame' of the mind (131–3).

What that original frame might be, however, and what might be analogous to it, are now to be determined on new grounds. Before, the principles of an unalterable human nature were to be discovered, primarily, by a process of abstraction; and though to disagree with the majority view of the nature of those principles would be a ground for

presuming oneself in error, it would not be the ground of that error. Now, however, it is only 'from knowing what are the general feelings and passions of mankind, that we acquire a true idea of what imagination is; though it appears as if we had nothing to do but to consult our own particular sensations, and these were sufficient to ensure us from all error and mistake'. It seems we now need to know the feelings of mankind, not because they are part of the material from which we abstract the idea of human nature, but because they tell us, quite directly, what human nature is. And now, 'the well-disciplined mind acknowledges this authority, and submits its own opinion to the publick voice'; if a man thinks he is 'guarding himself against prejudices by resisting the authority of others', he is opening himself to be charged with 'singularity, vanity, self-conceit, obstinacy, and many other vices'. The discourse at this point becomes less a lecture on the principles of the art of design than an abstract of the beliefs outlined by Johnson in his later political pamphlets, and can leave us in no doubt about the degree to which Reynolds's theory of art is, at base, a theory of society: 'this submission to others is a deference which we owe, and indeed are forced involuntarily to pay', for 'we are never satisfied with our opinions, whatever we may pretend, till they are ratified and confirmed by the suffrages of the rest of mankind' (132–3). The foundation of Reynolds's aesthetic has thus changed entirely, from abstract reason to opinion and custom, though still, at this stage, to custom as universal, supra-national. Though the rules of painting are still to be derived from the great tradition (composed, in Reynolds's most Johnsonian style, of 'what has pleased, and continues to please' and 'is likely to please again', 133),[102] in the earlier discourses great works were great because analogous to a mind scraped clean of the accretions of custom and prejudice, and whatever presumption about their value was afforded by their popularity, they were not valuable because approved by referendum.

There may appear to be a contradiction between the opinions I have been citing, and the position that will be announced in the preface to the 'Ironic Discourse', that 'matters of taste' should be determined 'by weight rather than by tale' or tally; but Reynolds is not, in the seventh discourse, to be understood as advocating the kind of submission to the opinions of a simple majority of mankind that he was later to deprecate.[103] For the purposes of his argument, the 'rest of mankind', to whose 'suffrages' the individual should submit, are only those who are enfranchised members of the republic, and the franchise is certainly still thought of by Reynolds as extremely limited. The disjunction is with his earlier views; for the principles of art are now determined by citizens who need not, as we shall see,

always vote in conformity with the fixed principles of reason, when their prejudices and opinions are at variance with them.

Among the papers which Hilles believed to be manuscript drafts for the *Discourses* are a number of notes which justify Reynolds's new defence of the authority of prejudice, in which it appears that Reynolds was contemplating the possibility of arguing a traditional case for this defence of customary rule, that the voice of the people (or at least of the enfranchised) was the voice of God:

> Prejudice Is the Wisdom of the Supreme and the chief engine of Political Wisdom it is the ray of the divine Wisdm which when catchd by Man approaches nearer to divinity.

> can any thing be more benevolen[t] more consistent with divine wisdom than giving us that disposition to like and prefer & esteem that the most beautifull that we are most accustom'd to

> I have endeavord to distinguish the different kinds of Prejudices, those narrow ones which we have from a partial & confined view, and which are to be eradicated, and the more enlarged which is the wisdom of the creator.[104]

A clear defence of prejudice in this form never appeared, I think, in Reynolds's published writings, and perhaps he felt that it might be inappropriate to mount a defence of the 'arts of elegance' on so grave a base. But they are very much of a piece with Burke's apotheosis of prejudice (which they seem to anticipate) in the *Reflections*, where among the reasons why we cherish the prejudices enshrined in the constitution is the fact that God 'willed' the state, and that our political system has the form it has 'by the disposition of a stupendous wisdom'. The advantage of this argument to both Reynolds and Burke is of course that it further challenges the supremacy of reason; for if 'naked reason' is the voice of man, the wisdom 'latent' in custom and prejudice is the voice of God, and a state adhered to out of custom and prejudice will be a far more steady association than one founded in the decisions of a faculty whose primary function is imagined to be, as Burke described it, the 'exploding' of 'general prejudices'.[105]

In the later discourses, Reynolds's distrust of reason, insofar as it is something opposed to prejudice and custom, becomes more explicit than it is in the seventh discourse. In the thirteenth, delivered in 1786, he warns his audience against 'theories' of art based upon 'principles falsely called rational', and not upon the 'mass' of the 'collective observation' of mankind; for that kind of reason 'will probably comprehend but a partial view of the subject'. 'Our conduct in life as

well as in the Arts' ought instead to be governed by 'habitual reason', by which we feel a thing to be true, though we cannot demonstrate its truth, and which is the result of the 'accumulated experience of our whole life': it is, he asserts, 'our happiness that we are enabled to draw on such funds'—and perhaps there he does suggest that unlike 'cold considerations' and 'argumentative theories', this prejudice is a providential dispensation (230–1). In the fifteenth discourse, he cautions 'the young Artist' against being 'seduced from the right path, by following what, at first view, he may think the light of Reason' (270). This discourse was delivered some six weeks after the publication of Burke's *Reflections*, which, as we shall see, were immediately influential on Reynolds; but the distrust it evinces of enlightenment, and of '*newly-hatched unfledged* opinions', 'however tempting their novelty' (269), is already implicit in the seventh discourse, written fourteen years before.

What then is the significance of this change for Reynolds's theory of art, and for his attempt to define a republic of taste? At the point at which we left the seventh discourse, Reynolds's main concern seemed to be to minimise the effect which his changed account of 'the general idea of nature' might have on the practice of the painter, and there are good reasons why that effect should have been minimal. One characteristic of the discourse of custom, particularly as Reynolds might have learned it, in the 1770s, from Johnson, is that the division between general and local customs can take the form of a division, as it were, between the general will and the will of all: what we are all accustomed to do or to believe is opposed to what each of us in fact does and believes, and becomes a rule (as stable as that generated by an abstract, original human nature) by which we should regulate our behaviour. In the early part of the seventh discourse, Reynolds seems to be advancing his argument along these lines by distinguishing the 'real' customs of men from their actual behaviour. But later in the same discourse, as he makes an attempt to move from general principles to individual precepts, he shows a far greater willingness to admit that even local and transitory customs may, in certain circumstances, be represented by the artist.

It was perhaps an admission he could hardly avoid, as his discussion of deference has already suggested, for it would certainly be difficult to represent the 'general' custom of showing deference—by making oneself less—except by representing one or other of the local modes of doing so. The admission had in fact been foreshadowed at an early stage of the discourse, in a brief remark to the effect that 'in no case' ought the taste for the 'narrow', 'local' and 'transitory' to be 'wholly neglected', if 'it does not stand, as it *sometimes* does, in direct defiance

of the most respectable opinions received amongst mankind' (123, my emphasis). His later account of how an artist should defer to the taste which 'conforms' even to local customs is based on two arguments, in relation to both of which, however, he continues to insist that 'apparent or secondary truths' 'ought not to pass their just bounds', or 'weaken the influence of those general principles, which alone can give to art its true and permanent dignity' (141–2). But it is very hard to see, in the case of both these arguments, how a boundary can now be set between real and apparent truth, when both arguments turn, as we shall see, on the degree to which an artist may dwell on the representation of ornament, and when we have repeatedly been told in the earlier discourses that in proportion as he admits the ornamental, he will inevitably 'weaken' the 'permanent dignity' of art, by concealing the general idea of nature.

The first argument Reynolds offers is that the arts receive their 'peculiar character and complexion' from 'ornaments', and that we find in ornament 'the characteristical mark of a national taste; as by throwing up a feather in the air, we know which way the wind blows, better than by a more heavy matter'. There is nothing in the bare statement of this position which is new, and the comparison of ornament with a feather appears to represent it as a thing unworthy of any weighty attention. Nevertheless, Reynolds makes this remark in the course of arguing that though ornaments should not be ranked with the 'positive and substantial beauties' of painting, the art would be imperfect without the kind of pleasures they offer (135). Before, the characteristic and peculiar mark of a taste merely national was exactly what a public, a civic artist in the grand style should strive to efface; for the true end of art was the creation of a civic republic of taste, of value because it enabled us to overcome national—local— customs so as to recognise more clearly the supra-national ground of our humanity. To this end, it was a commonplace argument that the language of natural signs was a universal language, unlike the various national languages spoken by vernacular literatures: the argument had been advanced in its most uncompromising form, characteristically enough, by John Brown (he is writing of the style of the scriptures):

There is, in Philosophical strictness, but one *unvary'd Language* or *Style* in *Painting*; which is 'such a Modification of *Light* or *Colours* as may imitate whatever Objects we find in Nature.' This consists not in the *Application* of *arbitrary Signs*; but hath it's Foundation in the *Senses* and *Reason* of Mankind; and is therefore *the same* in every Age and Nation. But in the literary *Style* or *Language*, the

Matter is far otherwise. For Language being the *voluntary* Application of *arbitrary* Signs, according to the Consent of different Men and Nations, there is no *single uniform Model of Nature* to be followed. Hence *Gracefulness* or *Strength* of Style, *Harmony* or *Softness*, *copious* Expression, *terse* Brevity, or *contrasted* Periods, have by turns gained the approbation of particular Countries. Now all these *supposed* Beauties of Speech are *relative*, *local*, and *capricious*; and consequently unworthy the Imitation of a divine Artist; who, to fit the Speech he *ordains*, to the great Work of *universal Instruction*, would, we may reasonably suppose, strip it of every *local*, *peculiar*, and *grotesque* Ornament; and convey it unaccompany'd by all, but the more *universal* Qualities common to every Tongue.

Whether or not Brown believed it possible for writers who are not divinely inspired to strip their style of local and temporary ornaments, is not made clear; but it is clear that, if it is not possible, then they cannot avoid—as painters can—a style which betrays their national origins. And for Reynolds himself, even in the seventh discourse, one way of distinguishing local from general customs was by the test that Addison had advocated for the distinction of true wit from false, that it should be translateable (134).[106] Now, less than a page later, he is offering as a defence of ornament, in painting, poetry, and oratory alike, the fact that it *displays* national characteristics and pecularities, and he argues that it may be encouraged in this, if the accidents of nationality do not conceal the substance of the universal, as, in the earlier addresses, they were bound to do.

The disruptive effect of the customary on the civic discourse should now be apparent, to us if not to Reynolds. As we have noticed throughout this chapter, Reynolds's version of the civic humanist theory of painting functions in terms of an opposition between the ideal, the universal, and the public, on the one hand, and, on the other, the ornamental, the individual, and the private. The discourse of custom, however, inserts a third term into this opposition, the *national*: an attention to ornament may still of course be evidence of a private and acquisitive spirit; but if it is an attention shared by all the members of a national community as they inspect a work of art produced within their own culture, and if the ornaments in the work are properly dematerialised by representing them in terms of their 'general character', then what the spectators are attending to will no longer be the materiality of ornament, but its capacity to instantiate the national character of the work, and, with it, the spectators' membership in a national culture.

It is crucial to Reynolds's attempt to win assent to this new position that he has been conducting his whole argument about custom and nationality by reference to an analogy—which would certainly have been recognised by his audience—between the representation of, and the appeal to, custom in painting, and the notions of English customary law which were so important an ingredient in contemporary ideas of Englishness. Thus the phrase 'local customs' would have been recognised as a legal phrase, used to apply to the particular customs of a locality within a national community, which should, according to Blackstone, be 'sacrificed' to the general customs of the nation, in the interest of arriving at the convenience of 'one uniform and universal system of common laws'. But one thing which Reynolds has done with this analogy, hitherto in his argument, is to represent general customs as supra-national, and local customs as the peculiar practices of individual nations within the universal republic of taste. He has done this by asserting, in the early pages of the seventh address, that a customary aesthetic is no less universal in its application than are the universal principles of human nature, considered as first nature, on which he had earlier founded that republic, and thus by asserting the virtual identity of general custom and general nature: as if general customs were not national, but were entirely compatible with the universal principles by which the ideal, trans-national republic of taste should be governed. The symmetry of the argument then requires that local customs be related to the municipal law of an individual realm, 'the law', according to Blackstone, 'by which particular communities, or nations are governed', which in England of course is primarily common, in the sense of customary law.[107]

This analogy between local customs and customary law might therefore have obliged Reynolds to insist (as he had for a while insisted earlier in the seventh address) that in painting local customs should be 'sacrificed' to the 'universal system'; for, according to Blackstone, they are practices 'in contra-distinction' to those of 'the rest of the nation at large', and 'contrary to the law of the land'; and if England is merely a province of the universal republic of taste, its peculiarities should not be displayed in its painting. But the analogy with law equally offered Reynolds the opportunity of approving the representation of local customs in English painting, by analogy with the approval so commonly evinced in England of the customary law as contradistinguished from the legal systems of other European states. The customary law of England was widely regarded as something so 'connatural' with the genius of the English, so much an emanation of an English disposition to freedom, that for Reynolds to refer to the local peculiarities of the nation as 'local customs', and then

to demand that they be 'sacrificed' to a universal aesthetic, would not easily have been countenanced by his readers. To indulge a district within a nation, or a nation within a universal republic, 'with the privilege of abiding by their own customs', is inevitably to allow them not to subscribe, in certain particulars, to the universal law; but if that nation is England, the case is entirely altered, and the indulgence will be difficult to withhold, for it involves the very survival of English liberty. Thus to permit an English painter, at least, to represent local, in the sense of national customs, is to grant him a properly English liberty, and to encourage him to promote, at least to some degree, a national community of taste, whose members he encourages to recognise the similarity of their tastes and practices by becoming aware of how they differ from those of other nations.[108]

I do not want to make too much of the issue: the argument that we may derive a certain pleasure from paintings which display 'the characteristical mark of a national taste' is an argument insisted upon in the essay on Shakespeare, but it is not repeated elsewhere in the *Discourses*, at least in so many words. Yet it is, in a sense, repeated on every occasion when, in the later discourses, Reynolds suggests that 'a complete, whole, and perfect taste' will include a taste for the ornamental, and will not necessarily demand the exclusion of 'local and temporary prejudices' if it can be argued that these 'have still their foundation, however slender, in the original fabrick of our minds' (141). In the context of the contemporary arguments being mounted in defence, for example, of the identifiably English charac- ter of Shakespeare, our 'national genius'; or of the idiosyncrasies of the English language, as reflecting the 'genius' of the people; or of the English common law and customary constitution as 'connatural' with that genius—any admission of ornament on the grounds that it is a representation of a national taste necessarily implies that it is proper for a painter to represent to a nation its own characteristics, and so to confirm his audience in their sense of belonging, no longer just to a civic republic of taste, but also, in due measure, to a national community.

This implication is at once reinforced, and justified as compatible with the civic discourse Reynolds seems almost to have abandoned, by the second argument Reynolds offers in favour of the notion that a painter should not entirely neglect the ornamental, and thus should to some extent acknowledge the narrow, local and transitory pre- judices of his audience. This argument is a conventional one in the criticism of art, and is derived, indeed, from a conventional defence of the moral character of the arts as a whole, as compared with the sterner character of philosophy. It is that ornament, and colouring in

particular, 'procures lovers and admirers to the more valuable excellencies of the art' (136).[109] The language, borrowed from Dryden's translation of Du Fresnoy, is well-calculated: ornament takes on the character of a procuress, because (the assumption is) it can most easily move its potential audience by an appeal to their sensual rather than their rational nature. But the ends will justify the means, because our taste, when fully developed, will transcend the sensuality which first attracted it. By exploiting its mechanism, its sensual nature, painting can lead us to apprehend it as an intellectual, a liberal art; ornament, which was earlier the very agent of corruption, is now its enemy, and serves only to attract us to the 'more valuable'—the more liberal—'excellencies' of painting; and it will follow, also, that if we can be attracted into the civic republic of taste by ornament, so we may also be attracted into it by a prior attraction to the local, in the sense of the national. Thus the compatibility of the discourse of custom and the civic discourse can be affirmed: the first makes us aware of ourselves as members of a national community of taste, and that is a necessary first step to our becoming citizens of the universal republic.

But it soon emerges that the main point of reassuring us of the compatibility of the two may have been to allow the definition of a national taste, and a national community of taste, to proceed more smoothly, undisturbed by worries about the final destination of the argument. For the reassurance offers Reynolds the opportunity to claim that the main danger to the establishment of a civic republic of taste is the attempt to create it too soon, without paying sufficient attention to the frailty of human nature, and its strong attachment to the local and the familiar:

> Whoever would reform a nation, supposing a bad taste to prevail in it, will not accomplish his purpose by going directly against the stream of their prejudices. Men's minds must be prepared to receive what is new to them. Reformation is the work of time. A national taste, however wrong it may be, cannot be totally changed at once; we must yield a little to the prepossession which has taken hold on the mind, and we may then bring people to adopt what would offend them, if endeavoured to be introduced by violence (140–1).

The similarity of this position with the arguments by which Burke would advocate slow reformation of the constitution, as opposed to revolution, is obvious—I am thinking, for example, of Burke's advice that 'time is required to produce that union of minds which alone can produce all the good we aim at. Our patience will achieve

more than our force'. Indeed, although a national taste, insofar as it is national, must be presumed to be vitiated, so great are the dangers of attempting even to reform it, that it may be the part of wisdom to allow men to linger indefinitely with their unreformed, but at least stable and established, taste; for, Reynolds argues, and again in a tone reminiscent of Burke and Johnson, 'ancient ornaments, having the right of possession, ought not to be removed, unless to make room for that which not only has higher pretensions, but such pretensions as will balance the evil and confusion which innovation always brings with it' (139). As Johnson had argued, 'all change is of itself an evil, which ought not to be hazarded but for evident advantage'.[110]

While Reynolds waits, then for the republic of taste to be established, he will not, it seems, be unduly disturbed, if painting manages to create at least a national community of taste, in which our identity as individuals may be subordinated, not to any universal and civic identity, but merely to our identity as Englishmen. Until the work of reformation is complete—or at least until it is started—prejudice must be deferred to; and towards the end of the discourse, and as Reynolds allows more and more room for a painter to address, not merely the common prejudices of mankind, but local prejudices as well, we begin to get a hint of the revisions in the rules of painting that will be announced more fully in the eighth discourse, and will invite us to enjoy the pleasures of variety and sense, not in anticipation of, but at the expense of the disciplines of uniformity and intellect. Some of these hints seem modest enough: thus it is not surprising, for example, that in the lesser genre of portraiture, a deference to transitory prejudice will dictate that, if we wish to dignify a subject, we will choose a dress half-way between the antique ('for the sake of dignity') and the modern ('for the sake of likeness'). In this way the portrait will conform at once with 'more learned and scientifick prejudice', which is how Reynolds now chooses to describe 'apparent truth' (or even perhaps the universal and unalterable principles of taste), and with 'those prejudices which we have in favour of what we continually see' (140)—or of 'the vulgarism of ordinary life' (58), as the earlier, more civic Reynolds had described it.

It is surprising, however, to see this advice extended to sculpture, when Reynolds reflects on the statue of Voltaire, by Pigalle,[111] who had represented the meagre and emaciated philosopher entirely naked—consequently, the statue 'remained in the sculptor's shop, though it was intended as a publick ornament and a publick honour to Voltaire, for it was procured at the expense of his contemporary wits and admirers' (140). It is crucial to the point of this anecdote that the

representation of Voltaire was intended as a public work, and that it was a sculpture. For, according to Reynolds, it is a characteristic of sculpture that it admits of no styles or genres except the grand style, and that it admits of no ornament, and certainly of no such compromise as portraiture allows between antique and modern dress: if the figure is not to be represented naked, it should be clothed in drapery, as sparingly ornamental as possible (175–6, 187). But these rules are offered in the tenth discourse, in which Reynolds was temporarily to reassert his original civic principles. Reynolds's point is that the statue of Voltaire would have succeeded, if the sculptor had had 'that respect for the prejudices of mankind which he ought to have had' (140), and had made some such compromise as the portraitist is advised to make. The statue would thus have been that much less of a public work in the terms of the earlier discourses; but in the terms of this one, it would have been more public, because it would, at least, have been seen—it would have attracted an audience which might, in time, have learned to graduate towards being a public.

In Reynolds's manuscript notes for this discourse, there is a passage in which the implications of this deference to custom, in relation to drapery, are taken further, in terms that suggest that, whereas Reynolds had earlier tended to think that portraiture was best regarded, not as a private but as an imperfectly public genre, he may now have been considering it as licensed to depart so far from his original notion of a public art, as to gratify our prejudice entirely at the expense of our original nature, even where that prejudice encourages us to continue in a practice that our reason tells us is corrupt. The passage is worth quoting at length: Reynolds has been considering the divine wisdom that is in prejudice, and how it may be manifested in everyday conversation:

> every body must have observed how cold a general observation is receiv'd by a company who are entertaind by a story or character of a person whom the company are acquainted with Thus in regard to what concerns Painters the fashon of dress will any one that speaks from their real tast and feeling say that people dont appear more pleasing more agreable in the dress of the times than in a Painters imaginary dress; If they ask their reason indeed they will answer no; but if they ask their tast they will agree this is upon the same ground as the instance mentiond before (of acquaintance) the present over powers the general Idea As in morality the present temptation over powers the distant Ideas of rewards.[112]

This passage comes a long way in a short time: it starts, it seems, by

suggesting that our prejudices contain a latent and divine wisdom, and ends by arguing that our prejudices encourage us to give into temptation—it is hardly surprising that this train of argument did not find its way into print. Nevertheless, it represents a remarkable extension of the licence allowed to prejudice and custom; for not only are they now the embodiment of taste, and opposed to reason, but they rightly instruct us to prefer immediate gratifications to remote rewards, when even in the seventh discourse itself it had been the mark of a public man that his preference should be exactly the opposite. As far as the portrait-painter is concerned, it seems he no longer need represent his sitter in 'imaginary' dress, a compromise between general and local, public and private, antique and modern: it is his duty to give into temptation, and to attract an audience of private persons to his portrait, by clothing his sitter in the fashion of the times. And prejudices in favour of such ornaments are no longer to be justified on the grounds that they lead us from being private, or national individuals, towards membership of the republic of taste: it is enough justification for them that they are shared, even if they confirm us in what, but for the presence of a providential wisdom, would be error, and would encourage us to exhibit qualities the very opposite to those of a citizen.

In the eighth discourse, Reynolds continues to demonstrate how the rules and principles of his theory of art are to be modified by his reconversion to an idea of beauty as based on custom. An important convenience of his revised aesthetic is that it enables him to appear to defend the principles announced in the earlier discourses from the charge that they promote an art so entirely uniform that it would, ideally, be as devoid of ornament, colour, character and compositional variety as possible, and would only be able to avoid uniformity insofar as an artist is bound to fail to reach that ideal. The defence he mounts, however, of variety and ornament, precisely because it is based on a defence of custom, or second nature, seems to question the very principles he still claims to be pledged to promote. That he does still claim to defend them is made plain at the opening of the discourse: art, it seems, must still be based on a knowledge of 'intellectual nature', and this, apparently, is a 'higher' and more 'venerable' tribunal than 'authority', and it can be nothing else than a knowledge of the unalterable principles of human nature, as discovered by an intellectual process of abstraction (145). But slowly, through the discourse, the uniform structure of the theory originally based upon those principles is dismantled. To begin with, that part of our nature to which art is ideally addressed, our intellect, is redescribed so that it may be made to contain a range of qualities and

dispositions that were previously no part of it; and, secondly, the universal human nature to which art is addressed is expanded, so that it comes to consist not only of the mind, but of the body also: art must engage us, not only as intellectual but as sensual creatures as well.

By the first of these moves, Reynolds rehabilitates one of the very things which the customary aesthetic itself had been advocated to oppose: for among the 'intellectual qualities and dispositions' which Reynolds now requires the painter to 'satisfy and affect' are included not only 'our love of . . . variety, and contrast', but also 'our love of novelty'. These qualities, argues Reynolds, 'refer to a certain activity and restlessness, which has a pleasure and a delight in being exercised and put in motion' (146). Throughout the early discourses, Reynolds had paid a certain, rather grudging lip-service to the need for variety and contrast, largely in asides which were hardly allowed to interrupt his plea for a public art addressed to a uniform human nature (see for example 127). But he had had very little time for the 'desire of novelty', which had 'no place', he affirmed, in the 'great style', and could only be approved as 'the result of a busy mind of a *peculiar* complexion'—as, that is, a kind of petty excellence, of value only in the works of painters whose 'irregular, wild, and incorrect' works declared their complete unfitness to be considered as public artists (84-5, my emphasis).

How then does Reynolds attempt to rehabilitate the love of novelty? Partly, as we have seen, simply by announcing that it is an 'intellectual' disposition, and thus proper to be satisfied by a liberal art. Beyond that, he has two strategies. The first, and the more extreme, is to argue that though the mind 'is an active principle', it 'has likewise a disposition to indolence', and that novelty therefore makes 'a more forcible impression on the mind, than can be made by the representation of what we have often seen before'. The implications of this remark for Reynolds's earlier position are considerable; for it seems that, if novelty in the earlier discourses was the enemy of uniformity, a disposition to admire a uniform art would now be an indolent disposition, and not a rational pleasure deriving from the fact that it is the function of art to represent general ideas which are analogous to the imagination which is uniform to all of us. Reynolds avoids acknowledging this implication, first by relating the pleasures of uniformity not to the uniformity of the 'original fabric' of the mind, but to our second nature, and to the 'indolence of our disposition' insofar as that is evinced by our 'affection to old habits and customs'. And this leads him to his second strategy, which is to advocate 'novelty' while at the same time insisting that its pursuit may, but must not, 'be carried to excess', for 'where all is novelty, the

attention, the exercise of the mind is too violent'. Thus novelty, contrast, variety, all 'contribute to the perfection of Art, when kept within certain bounds'; but 'if they are carried to excess', they 'become defects, and require correction' (146–7).

This strategy is part of an argument in terms of which not only variety but 'sensuality' itself—that entirely pejorative term in the language of the civic discourse, continually used to describe the vulgar by contradistinction from the liberal—is once again, and more thoroughly, rehabilitated. 'Our taste', argues Reynolds, 'has a kind of sensuality about it, as well as a love of the sublime; both these qualities of the mind are to have their proper consequence, as far as they do not counteract each other' (153–4). Sensuality, it seems, may be allowed to co-exist with the intellect on the same conditions, as, within the intellect, the love of novelty may co-exist with the need for uniformity: that they do not overpower the original aspects of our human nature which they are now required to support, if our taste is to be 'complete' and 'whole'. Once again, the model for their co-operation seems to be that of a mixed constitution: one which allows, in the terms of Burke, for the principles of both 'conservation' and 'correction'. But whereas, before, those aspects of art which appealed to our sensual natures were to be admitted, with some reluctance on Reynolds's part, into the constitution of the republic of taste, only because they might be more dangerous if excluded from it, and it was understood that their title to admission was a function only of the unfortunate and inescapable fact that a language of natural signs must enter the intellect via the senses, now they are being viewed in a much more positive light, as *constituent* parts of a customary community of taste. The task of 'novelty' is to safeguard the constitution of that community against inertia, indolence—against what Burke was to describe as the 'obstinacy that rejects all improvement',[113] and, in this light, local as well as general customs are enrolled on the side of the uniformity which novelty seeks to invigorate. A rather different argument applies to sensuality, which, insofar as it finds its pleasures in ornament, is allied with local customs as these also may be seen as varying the uniformity of the general idea of nature, represented by general customs. But as a taste for sensuality, as well as the love of novelty, is now to be regarded as a constituent part of human nature, they both have their own satisfactions to seek, which the artist may legitimately pursue on their behalf, as long as those satisfactions can be represented as being consistent with the ends of the community of taste as a whole. Rules can be drawn up, as they are in the eighth discourse, to prescribe not just how the novel and the sensual should be kept in check, but how their legitimate interests may be protected.

Throughout the discussion of taste in terms of custom, in the seventh and eighth discourses, and, later, especially in the thirteenth and fifteenth, the 'presiding principle' is steadily refashioned, so that, for example, it becomes the main (though not the exclusive) duty of the artist to present to the eye 'the same effect as that which it has been *accustomed* to feel', and the task of reason sometimes 'to inform us when that véry reason is to give way to feeling' (159, 231, Reynolds's emphasis). But the principle, I have been suggesting, which presides even over that principle, that it is the function of art to create a republic, or a community of taste, remains consistent. Indeed, it seems to remain more consistent in Reynolds's eyes than it does in mine, for because, even in the later discourses, the language of value he uses is still largely drawn from the civic humanist tradition of art criticism, it is not at all clear how far he noticed what I have argued to be a shift in the nature of the association that art seeks to create. The shift may have been concealed from him, indeed, not only by his value-language, but by his apparent belief that the developments in his argument could adequately be accounted for, and justified as consistent, by a pedagogical principle which dictates, paradoxically enough, that though the function of variety and orna- ment is to lead us towards an admiration for a uniformity which excludes all ornament, the principles of uniformity must be taught first, in case the students of painting and taste should be seduced from those principles by a prior attraction to the pleasures of the unstable and the sensual. But that he did come to recognise how his ideas had changed is made very clear by the preface to the 'Ironic Discourse', and, more particularly, by the unfinished essay on Shakespeare, at one time perhaps intended by Reynolds for inclusion in Malone's edition of his collected writings.[114] Both works offered Reynolds the opportunity to challenge the civic humanist tradition, and to promote his notion of a customary community of taste, with more freedom than he permitted himself in his capacity as president of a great public institution.

11. A new code of laws

The 'Ironic Discourse', and its far more interesting preface, were written in 1791, in response to Reynolds's reading of Burke's *Reflec- tions*. In both the preface and the discourse proper, Reynolds sets out to attack the notion that political and aesthetic issues could be determined by an appeal to majority opinion, and so by taking no account of the weight of those who subscribed to an opinion, but only

of the number of those subscribing to it. Nothing, he insists, can be determined by a majority of the 'half-educated', who would presumably—for Reynolds explicitly acknowledges the connection between his 'Ironic Discourse' and Burke's *Reflections*—prescribe laws to the republic or community of taste with the same degree of insight as was possessed by the 'country clowns', or the 'taylors and carpenters', 'of which', according to Burke, 'the republic (of Paris, for instance)' was composed.[115]

Like Burke, Reynolds attempts to safeguard the right or the 'few' rather than the 'many' to act as legislators in art or politics, and he does so by redescribing—by comparison with the early discourses— the means by which the principles of either are to be discovered. To ground them on reason is to risk appearing to make them open to be determined by 'common sense adapted to the meanest capacity', or by anyone who claims to be a rational man simply by virtue of being literate. The battle-cry Reynolds attributes to these rational men— 'Let us pull the whole fabric down at once, root it up even to its foundation. Let us begin again upon this solid ground of nature and of reason'—is reminiscent both of Paine's exhortation, 'Lay then the axe to the root', and of Burke's attack on the notion that the principles of liberty can be 'settled upon any abstract rule', or that the science of constructing, or renovating, or reforming a commonwealth can 'be taught *à priori*'. The 'tree of knowledge', writes Reynolds, 'on which they pretend to say that mankind now have battened, does not grow upon a new made, slender soil, but is fastened by strong roots to ancient rocks, and is the slow growth of ages. There are but few of strength sufficient to climb the summit of this rock, from whence indeed they may look down to us and clouds below.'[116]

An understanding of principles in taste and politics alike is available only to the few 'whose view extends to the whole horizon', and not to the 'near-sighted', capable only of the management of their own affairs, their private interests. Those who are not capable of the 'labour and study' necessary to an understanding of the science of politics must therefore be excluded from political assemblies on the same grounds as the vulgar are to be excluded from the Academy exhibition; for just as they threaten the republic of taste with corruption, by setting standards at the lowest common denominator of a mass appreciation, so in political assemblies 'the worst will appear the best, as being within their narrow comprehension'. Reynolds's denunciation of those who are determined to 'rescue the world from the worse than barbarous tyranny of prejudice, and restore the sovereignty of reason' is particularly evident as a departure from the position developed in the early discourses, insofar as the 'prejudice'

that he seeks to defend is always, in the late eighteenth-century conservative political theory, a prejudice in favour of the 'customary'.[117]

The starting-point of the unfinished essay on Shakespeare is a defence of Shakespeare's practice of mixing tragic and comic scenes and characters within the same work.[118] Reynolds bases his defence on a challenge to the demand made by 'theoretical systems' of ethics and criticism, that 'a man ought totally to keep separate his intellectual from his sensual desires'; against this, Reynolds argues that the mind is 'accustomed' by 'long habit' to doing two different things at once; indeed, it 'always desires to double, to entertain two objects at a time'; and the mixed drama is thus more in accord with the customary, the second nature of man than is the single drama. 'Man is', Reynolds asserts, 'an inconsistent being, a professed lover of art and nature, of order, of regularity, and of variety'; he 'loves novelty', and 'therefore cannot long continue his attention without some recreation'; and critics, who 'seem to consider man as too *uniformly* wise' (my emphasis), have formed their rules 'for another race of beings than what man really is. They do not form their rules always from experience of what does please, but what in their great wisdom they think ought to please—as if they should say man ought to like what is regular only, his passion for variety is vicious'. But Shakespeare, who wrote his dramas by observing the actual desires and passions of his audience, has a more comprehensive understanding of human nature, which he realised was a mixture of the intellectual and the sensual. He is 'superior for universality of powers' to the dramatists on whose practice the rules of drama have been based; and when 'a great genius has continued for ages to please, and to please by means contrary to the established art of pleasing, it is then high time to overhaul the rules of art, that they pass a new examination, that they be made more agreeable to the nature of man'.[119]

This demand for new rules is apparently of such importance to Reynolds that the text of the essay, unrevised as it is, repeats it on no less than three other occasions. 'It may be a question worthy the consideration of critics whether this civilised age does not demand a new code of laws'; 'from universal approbation is it not time to make a new code?' 'it is time for a new code of laws, or at least for the old to be fairly and candidly revised'. So often, and so urgently, is the demand made, that Reynolds can hardly have helped noticing the similarities, both between the position of the critics he has been attacking, with their insistence on the uniformity of mind and art, and the civic theory he himself had advocated in his early discourses, and between the position represented by Shakespeare's practice, and the 'new code' he had begun to propose in 1776. The appeal to pedagogic

principle, which had justified his change of direction in the *Discourses*, is now being used metaphorically, to justify what is now to be frankly acknowledged as a revision of opinion: for all of us now, he argues—and not just the Academy students—are 'out of our apprenticeship'.[120]

The nature of the new code is unambiguous. The greater universality of Shakespeare arises from the opinion—never before expressed so directly by Reynolds—that 'art in its most perfect state is when it possesses those accidents'—the very accidents which it had before been the duty of the public artist to discard—'which do not belong to the code of laws for that art'; and it is quite evident, here, that it is the legal code of the civic republic of taste which thus fails to legislate for perfection and for genius: the rationalism of the discourse of natural rights, attacked in the 'Ironic Discourse' and its preface, has been entirely conflated with the rationalism of the civic humanist tradition, which had prescribed rational laws to art as Burke's main opponents, Richard Price and, latterly, Thomas Paine, had not. It is also evident that the 'accidents' which the 'most perfect' art now admits include local and national customs: thus, a writer 'will run the risk of being even ungrammatical in order to preserve the idiom of the language': he will offend, that is, against what was called 'universal grammar', in order to safeguard the 'genius' of the national language. More importantly, the 'effect' of a picture is now found to reside in 'the background'—in the 'place', the 'occasion', the local and transitory site of the fable, which earlier had been circumstances to which only a minimum of attention should be paid. The new code will clearly be framed in order to create and confirm a national community, not a civic republic, of taste.[121] Its task will be to establish the 'Englishness' of English art as a constituent—the prime constituent—of its value, to confirm the nationhood of the English, and to represent that nationhood as something which can legitimately be described only in the counter-revolutionary language of custom and justifiable prejudice.

We shall not, however, hear a great deal more in this book about custom. To some extent, this is an indication of the continuing authority of the civic humanist discourse in the criticism of painting, an authority it maintains in spite of a suspicion of the political tendency of that discourse; for without an appeal to that discourse, it would have been extraordinarily difficult to argue for the supremacy of history among the genres of art; this, no doubt, is one reason why the value-language of civic humanism never entirely disappeared from the *Discourses*, and why an aesthetic based on the discourse of custom emerges most fully in an essay by Reynolds on dramatic

literature, not on epic, or on epic painting. To some extent, too, the failure of the discourse of custom to establish itself in the Academy, at least, may have been a result of the fact that the most thoughtful and thorough of the lecturers there in the decades after Reynolds's death were Barry and Fuseli, both of whom had begun to form their theories of the public function of art during the period in which the earlier discourses were being delivered; and Blake, who left off annotating the *Discourses* after the eighth, shows no signs of having registered the new emphasis on the customary contained in that and the previous discourse. But more to the point, all three of these writers and were more sympathetic than Reynolds had been to the radical political movements which the discourse of custom had been revived in order to attack.

If these writers, as they respond to Reynolds's writings, show most interest in his earlier positions, that is no doubt because they, like the author of the first six discourses, were also concerned to foster an ideal of public art in the civic humanist tradition, and one way in which that could be done was to question and to develop the arguments of those discourses in which that tradition of criticism was most clearly embodied. Insofar as they showed an interest in intellectual systems which could be interpreted, in some lights, as opposed to that tradition, it was not the discourse of custom, but of political economy, that engaged them; they used it to describe both the structure of modern society, and the nature of the corruption that endangered its survival. In the civic republic of taste that Barry, Blake, and (sometimes) Fuseli still hoped to establish, the discourse of custom had no place; for one of its functions, as Reynolds had deployed it, was that, by attributing the virtue of stability to second nature, and even to local customs and prejudices, it concealed the distinctions between the universal and the particular, the intellectual and the sensual, the public and the private, which in different ways Barry, Blake and Fuseli were determined to expose.

II

JAMES BARRY

1. Introductory: Barry and Reynolds

I HAVE argued that Reynolds's early discourses should be read as an
attempt, not just to reassert the civic function of history-painting as it
had traditionally been defined by humanist criticism, but also to re-
describe that function for a society which seemed to afford, and a
public which enjoyed, less scope for the exercise of the public virtues
which history-painting was expected to encourage. This attempt at
re-description is apparent, I suggested, in four particular aspects of
Reynolds's thought: in the movement away from a rhetorical aes-
thetic in his account of the process by which art educated its audience
and so created a public; in the suggestion that public spirit might now
more usually be evinced by an understanding of the grounds of
social affiliation than by a disposition to perform acts of public virtue;
in his hints about who could now be expected to grasp a society as a
whole, and could therefore be expected to be able to perceive the
public interest; and in his movement towards a notion that the arts
might best be directed to the creation of a national community, rather
than a civic republic, of taste.

James Barry was elected to the Royal Academy in 1773, and was
professor of painting there from 1782 until his expulsion from the
Academy in 1799. Throughout his career, he refused to work in any
of the genres of painting except history and formal portraiture; he
was reputed, at least, though this is hard to establish from his
writings, to be committed to a republicanism so uncompromising that
it was suggested by one of his fellow-academicians that it made him
unfit for membership of an institution whose patron was the king; and
he was contemptuous of everyone whom he considered, whether in
their paintings or in their pronouncements upon painting, to have
compromised the high civic ideal of art.[1] His career and character, in
short, suggest that he did not share Reynolds's sense that this ideal
required to be much adapted to the needs of a late eighteenth-century

audience; and this in spite of the fact that he seems to have been filled with a more urgent sense than was Reynolds, of how the ideals of the political republic and the republic of taste had been undermined by corruption.

Barry is, indeed, so convinced of the depravity of modern society that he is extremely pessimistic about the possibility of restoring the history-painter to a position of pre-eminence among artists, or of restoring to history-painting its ideal civic function; but this pessimism does not prevent him from asserting that the ideal was entirely adequate—without being redescribed in any way that would compromise its purity—to interpret the life of a complex, various, commercial society, in which art could still be 'subservient to all social duties' (2: 595),* and could still teach a form of public virtue. If artists, or if writers on art, compromise the civic humanist ideals of painting, then according to Barry this is not an action forced on them by the increasing invisibility of the public; they compromise because they calculate—mistakenly—that it is in their interest to do so, and because an attention to their private interests prevents them from arriving at a true understanding of the continuing adequacy and value of the civic traditions of art.

There were two main reasons why Barry was able to assert that a civic art was still able to describe a complex modern society and to communicate to its members a sense of their civic identity: he was less alarmed than Reynolds at the prospect of a society whose members were more various, less uniform, than Reynolds had suggested they should be; and he was unwilling to conceive of the political republic as the merely secular organisation that it appears to be in the *Discourses*. Reynolds never overcame his anxiety that variety of character must necessarily compromise uniformity of moral purpose, and even in the later discourses, where his notion of human nature is expanded to include a love of variety itself, it seems to be no less crucial to a national community than it had been to a civic republic of taste that its members should all have the same character, however capacious that character might be allowed to be. For Barry, except perhaps in his earliest writing, some varieties of character could perfectly well co-exist—though some could not—with uniformity of purpose, and it was therefore in relation to the representation of character that he departed furthest from the teaching of the *Discourses*. But he disagreed with Reynolds also on the social composition of the republic of taste: for to allow that art might represent a considerable variety of character was also, for Barry, to allow a greater enlargement than

* All volume and page numbers in this chapter refer to *The Works of James Barry*, ed. Dr Edward Fryer, 2 vols., London, 1809.

Reynolds had envisaged of the audience to whom art was addressed, until all men—though perhaps no women—are seen as potentially citizens of the republic of taste; or perhaps, indeed, until all men are enfranchised *except* those whose citizenship Reynolds had acknowledged. If the 'mechanical' and the 'servile' wish to realise that potential, they need no lengthy re-education in the principles of abstraction; they have only to consult the doctrines of the Christian religion, and their consciences, instead of their interest, and they will find themselves enfranchised. If the economic organisation of modern society makes the public, and the objects it exists to attain, harder to make out, the teachings of religion still make them unambiguously apparent.

2. Barry's 'Inquiry'

Barry's first account of character occurs in his *Inquiry into the Real and Imaginary Obstructions to the Acquisition of the Arts in England*, a work which is, as Burke pointed out to him, rather haphazardly arranged, so that Barry's reflections on character, which he developed more fully in the lectures he later delivered as professor of painting at the Royal Academy, appear in the margin of his attack on a number of writers—Du Bos, Montesquieu and Winckelmann— who had suggested that, for climatic reasons, the national character of the English made them unfit to develop a creative genius, and to develop the kind of physique which such a genius might wish to represent in the arts of design.[2] The 'imaginary' obstructions described by these writers are disposed of by the argument that the nature of the people of England is to no significant extent the result of climate: national character, by which Barry understands both the characteristic disposition of a nation and the characteristic bodily frame of its members, is the product of 'education' (2: 219), a term which Barry uses as we might use the term 'culture', to include the religious institutions, the political and economic organisation of a society, and much else.

For Barry, there is not, in fact, a great deal that can be demonstrated about the peculiar character of a nation, or about a national culture: 'commerce', 'war', and 'curiosity' about other nations, blur the outlines of that character, which is further subject to continual reconstruction by changes in 'ignorance, knowledge, modes, customs, religion, politics, arts, and opinions of every kind', by the state of the sciences at one time or another, by how far 'industry or dissipation happens to prevail', and by how far habits 'are influenced by the peculiar passions and fortunes of leading men'. When 'the

intricacy and complication of these matters', Barry argues, 'and the extreme difficulty of ascertaining the degrees of their influences in all the combinations and successions of the combinations are fairly considered, they become to all the purposes of human enquiry accidental and arbitrary' (2: 263–4). These considerations convince Barry that the attempt to describe a national character whose basic nature remains unchanged through time will be futile: he has no interest in such notions as 'the genius' of the English people, as he has no truck with the idea that art might seek to create a national community of taste. But though he considers that the character of a nation changes too often and too completely for us to be able to perceive any continuing identity in it,[3] he does believe that its character or the culture at one time or another is capable of being described, and that the characters that prevail among the nations of modern Europe— France and Italy as well as England—are such as make the production of a civic or a public art now extremely unlikely: they are 'real' obstructions to the acquisition of the arts.

Barry's criticism of the notion that the English characteristically exhibit an inferior bodily structure, which deprives English artists of the opportunity to study the ideal, is a good example of a technique he uses throughout the *Inquiry*, whereby he analyses an 'imaginary' obstruction and converts it into a 'real' one, but into one which, because it is now perceived as a product of education and not of climate, can in theory, or in time, be overcome. He begins by pointing out the difference that education can produce 'in so limited a subject as dogs': a greyhound, brought up by Lycurgus in the kitchen, showed no aptitude for hunting: a cur, on the other hand, by constant exercise, was 'habituated to the chase'. Barry gives Plutarch as the source for this anecdote, which may also be alluded to in *The Wealth of Nations*, in which Smith gives an account of how the different characters of men are influenced by education far more than by their original nature; and though Barry disagrees with Smith in believing education is more influential than nature on the characters of dogs as well as of men, his account of how the variety of the characters of men has arisen is very close to Smith's (2: 219).[4]

'Man', argues Barry, 'is fitted to an infinity of pursuits, and consequently liable from those pursuits to an infinity of differences, as well in his bodily structure, as in the texture and extent of his mind'. The different characters that people assume are for Barry, as for Smith, largely the effect of the division of labour. Barry does not entirely dismiss the influence of nature: every individual has, he concedes, 'constitutionally an idiosyncrasy or peculiar tendency of disposition', but 'the coup d'oeil and great outlines of the human character, will

always be formed by the objects that his fortune and situation has [sic] made him acquainted with'. Those objects include the range of 'accidental and arbitrary' influences on national character that we have already encountered; but the most useful way of understanding how people have the appearances they do is to ask such questions as these:

> Is he bred at Wapping or St James's? Is he bred a smith, a mercer, or a soldier? Does he till the land? Is he a waterman, common-council-man, or is he a waiter at a tavern or coffee-house? If a woman, does she sell fish or millinery ware? Is she a fat, greasy cook, or has she the delicacy, vapours, smelling-bottles, flirt, giddiness and low spirits of higher life? (2: 219–20).

When he wrote the *Inquiry*, Barry seems to have regarded every kind of differentiation produced by the division of labour as a result of corruption; as if the division of labour, as it had developed in modern societies, was entirely the result of the need to satisfy the artificial wants that luxury creates. If physical character is the product of the division of labour, as well as of a range of less tangible influences incident to the culture of a nation at a particular time, it follows for Barry that in no modern nation can we expect the ideal form of the human body to be significantly more visible than in another: all nations are as easily distinguishable from each other as are 'different trades', and equally remote either from an original, or an ideal, human nature. In France, for example, the refinements of modern life has 'poisoned' the 'attitudes' of 'the polished people' by 'little, affected, ridiculous propretè, and ... grimace, which have almost blotted out every trace of natural genuine action', and the common people of France, insofar as their 'fortunes and circumstances' enable them to imitate their superiors, develop characters which are a 'ridiculous mixture' of polite elegance and 'those peculiar modes of action and attitudes which are formed amongst handicrafts, by the exercise of particular trades' (2: 277).[5]

Now we might imagine that a critic, anxious to re-establish an idea of painting as properly concerned to impress upon its audience an awareness of their common identity as citizens, would argue that to arrive at the image of that civic and uniform human nature, it was essential, as Reynolds put it, 'to get above all singular forms, local customs, particularities, and details of every kind.' This is not quite the move Barry makes, however, for it is essential to his notion of character that we cannot arrive at an image of an ideal figure, able to represent the ground of unity among mankind, by subtracting from the figures we see all the accidental differentiations produced by education, in the hope that we will be left with the pure image of

mankind as it might have been before all marks of differentiation arose. For Barry, such a process of subtraction is neither possible nor useful. It is impossible because, by another version of an argument we have already met, we can never 'be so furnished with the facts, as to obtain a distinct view of all these ingredients which compose the human character'—whether of the character as it appears in different nations, or as it might have been before history began. 'We can never decompound sufficiently' to discover 'the original stamina' of human nature 'in their simple and naked state'. It is unhelpful, because the image of human nature in that naked state would not be an ideal image at all: there is 'nothing in human nature but rude materials', and the state of mankind before it was differentiated by the various influences of education would be exactly as Hobbes had described it. As far as Barry is concerned, 'what we see every where of horses, dogs, grain of all kinds, fruit, flowers, &c. is the result of an infinite number of intentional and accidental combinations': beautiful forms, whether of flowers, dogs or humans, are as much the product of culture as are the deformed bodies we encounter in modern nations (2: 220-1, 223).[6]

To arrive, then, at an image of the *beau idéal* of the human body, we do not have to perform the unimaginably complex process of abstraction that Reynolds believed the artist had to perform; if we attempted to perform it, we would get the wrong result. To arrive at that image, we should ask instead, what is the nature of man?—what is his nature, that is, in the Aristotelian sense of the word, not his rude original nature but the highest good which he is capable of achieving and was formed to achieve? And when that question has been answered, we should then ask what kind of education will enable him to achieve the highest development of his nature. The answers Barry offers to these questions seem to be different in the *Inquiry* and in his later writings. In the *Inquiry*, no doubt in part because he uses the Greeks as the prime example of a nation which had asked the right questions, the answer he offers is the same as Aristotle had offered: that it is the nature of man to be a political animal, and the citizen of a state. In his later writings, where he has the space to consider the question at greater length, it appears to be the nature of man that he should exercise the virtues which promote the safety of the society of which he is a member, but also that he should be *religious*: 'mere moral, peaceful, civic demeanour, and the mere equitable commerce of meum and tuum' is not enough (2: 448). But because 'Christianity has so elucidated [the] question about the natural rights and legal equality of mankind, as to make the sullen spirit of tyranny utterly inconsistent with all its governments' it follows that the governments

most conducive to the realisation of man's nature will be republics, and that most of the ends for which man has been framed will be achieved by the kind of education that the 'Grecian republics' offered their citizens (1: 373, 364).

According to the *Inquiry*, an understanding of the civic nature of man will enable us to understand the tasks which a man must be expected to perform in his capacity as a citizen, and the kind of education that he must receive if his mind and body are to be enabled to perform them. One argument conventionally used to explain the superiority of Greek art—and Barry quotes Shaftesbury to this effect—was that the Greeks were a relatively uncorrupted race, among whom were to be found more complete approximations to the perfect standard of the human figure than among later, more degenerate nations.[7] It is not clear how far Barry subscribes to this argument: at one point, he claims that sculptured portraits of the Greeks show them to have differed as much as do the inhabitants of London from the ideal figures represented in sculptures of the Greek gods. There is a certain convenience for Barry in this claim, for, insofar as he wants his theory to point out the process by which modern artists might learn to represent the ideal form of the human body when they cannot find it among 'the people about the streets of London' (2: 231), he wants to use the Greeks as examples of artists who, because they were the most possessed of the civic ideal, were also the most able to represent the character of the ideal citizen. But because they were possessed of that ideal, the Greeks were not simply content to represent it in statuary: they developed a system of education which was designed to encourage the forms of men to approximate to the ideal standard, and not, as do modern systems of education, to oblige them to depart from it.

To make his point, Barry quotes at length from Solon's contributions to Lucian's dialogue 'Of Gymnastick Exercises', a translation of which had been appended by Gilbert West to his *Dissertation on the Olympic Games*.[8] 'Our first and principal concern,' says Solon,

> is how to make our citizens virtuous in mind, and strong in body . . .
> For we are by no means of opinion, that it is sufficient for us to be,
> either in mind or body, those things only that nature made us.
> Either part of us stands in need of discipline and instruction, by
> means of which the good that is in us may be rendered much better,
> and the bad amended and redressed.

By some parts of their education, the citizens of the Greek republics are 'instructed, as to their minds'; by the gymnastic exercises, they are taught 'to accustom their bodies to hardships and fatigues', until

they develop a 'compact, well-ordered, and beautiful frame of body', far different from the bodies of the Scythians—Solon's respondent is a Scythian— which are 'softened and melted almost with luxury and cockering'. But the discipline of the exercises is not, of course, an end in itself:

> There is a contest . . . of another kind, and of much more general concern, in which all good citizens should be engaged; and a crown, not made up of olive, pine, or parsley, but comprehending the happiness and welfare of mankind, as liberty, private and public wealth, &c. All these things are interwoven in this crown, and are the result of the contest I speak of, and to which these exercises and these labours are not a little conducive.

The physical discipline of the exercises is thus directed towards the realisation of the civic nature of the participants, by making them hardy and vigorous soldiers, and by preparing them for the performance of their other public duties; for a healthy body, according to Solon, is essential to a citizen in both his military and his civil capacity (2: 221–2).

That the Olympic exercises had produced among the Greeks perfect examples of ideal beauty had been argued by numerous writers and painters, from Rubens to Barry's contemporary, Algarotti,[9] but Barry departs from the conventional wisdom of this tradition: the exercises did not, he believes, convert the bodies of those who performed them into the most ideal imaginable representations of the human frame. The Greek artists were able to elevate their 'ideas of perfection far above any thing nature had produced, even with all the superadded advantages of the best education'; they did not, therefore,

> content themselves with merely copying what they saw: they justly considered even the completest individuals, only as approximations to an abstract perfect standard. They accordingly took from one, added to another, increased, diminished, and produced a combined consistency and harmony of parts, adapted to the several classes of character.

Barry does not say what he means by the 'several classes of character', or how there can be several classes of an abstract perfect standard, and we have to wait for the lectures for an explanation of the remark. What I want to point to here is the process by which the Greek artists are understood by Barry to have produced their images of that standard, which is also the process by which later artists may produce them. For all Barry's talk of 'abstraction', in the quotation

above and elsewhere in his writings, he does not imagine that ideal images are produced in the same way as, for Reynolds, we arrive at a knowledge of central forms; if for Reynolds the ideal image is produced by an act of abstraction, for Barry, the process of abstraction is posterior to the knowledge of the ideal, and in no way produces it. When Zeuxis hired the Mecca Ballroom at Croton, and organised a line-up of the most beautiful maidens of that city so that he could select, from one a limb, from another a facial feature, to construct his ideal image of Helen, then for Reynolds he was, in the act of judging the competition, actually arriving at a knowledge of the perfect standard. For Barry, he already had a knowledge of that standard, and in judging the competition he was selecting the models which would guide him in the act of representing that ideal, not those which would help him apprehend it (2:224).

Thus for Barry the perfect standard is not the average form of the objects in a class or species: such an average would either be, as we have seen, a rude original, or it would be too much subject to the accidents of our particular experience, for in a modern and corrupt nation, where all bodies are variously deformed, though it may be true that the average of the aggregate of deformities would function as an image of what we have in common, it would not necessarily be an image of what, in a moral light, we should be. An understanding of the characteristic forms that the artist should exhibit can be arrived at only by an attention to the ends for which we are created: thus the superior forms of the Greeks, insofar as these were produced by the gymnastic exercises, are not the cause, but the effect, of a knowledge of the perfect standard. If the great Italian artists fell short of the Greeks in their representations of that standard, this was not primarily because the models available to them were more defective— though, if they were, that would certainly have made the task of representing that standard more difficult—but because they seem not 'to have been completely in possession of this principle of collecting and combining the scattered beauties of nature, and *according it with the character of their figures*' (2: 225). The emphasis is mine; for Barry's point is not so much that the Italians did not, like Zeuxis, select and combine, but that they were less aware of the need to guide their selection by a moral criterion—by a consideration of the moral character they wished to represent. As we shall see from the lectures, such a principle of selection as is here attributed to the Italians might produce 'mere Beauty', but it will not produce images of 'moral excellence'—images, that is, of the human body as characteristically adapted to perform actions 'advantageous to morality and the interests of mankind' (1: 398, 401, 392).

If Barry does not imagine that images of moral excellence will be produced by abstracting the central form from scattered images, nor does he imagine, as Reynolds does, that the character of a figure will be determined by abstracting its 'ruling characteristick' from the details that obscure it. If the perfect standard is produced by asking what kind of body is necessary for the performance of what kind of moral actions, Barry can see no reason why in that standard should not be included the 'minutiae and detail' of the figures. The part of the *Inquiry* in which the issue of detail is considered is very clearly written in opposition to the opinion of Reynolds that 'the grand style, and an attention to exactness in the minuter parts of the figure are incompatible', and that Michelangelo is an example of an artist who 'was above attending to . . . exactness'. On the contrary, argues Barry, Michelangelo was 'most remarkable' for 'precision, and . . . attention to the detail or smaller parts of his figures', as also were the sculptors of the Apollo Belvedere and of the Laocoon. So attentive, indeed, were these artists, that they 'so far agree with the Dutch taste, that the forms they executed were equally made out with study, attention, and accuracy'; the difference is that the models used by the Dutch 'were not equally well-chosen'. In the chapter of the *Inquiry* in which this question is considered, Michelangelo seems to have been exonerated from the charge laid against the Italian artists in my previous paragraph; for what justifies the representation of minute detail in his works and in those of the Greeks is that, unlike the Dutch, the artists in the grand style are representing the human frame as adapted to the fulfilment of a moral purpose. To that end, it is essential to exhibit them in all their fine anatomical detail; if they are generalised, or covered with drapery, they will 'differ but little from any other', and they will also cease to be admirable examples of the civic character (2:249–51).[10]

So far, Barry has appeared to disagree with Reynolds on two main issues: on the method by which the artist arrives at an understanding of ideal form, and on the notion of how it is that painting may perform its function of enabling us to become worthy citizens, not just of a republic of taste, but of a civic republic; an artist, according to Barry, should represent to us images not of what we have in common, but of what we ought to be, and, unlike Reynolds, he believes those two aims are different. But Barry does not seem so far to have done much to question the uniformity of the ideal: he may argue that the ideal should be an image of our common moral purpose, not of our common appearance, but if 'the infinity of pursuits' to which man is fitted seems to have produced an infinity of physical characters, all but one of those pursuits—the exception being the pursuit of civic virtue—seem to have produced deformed figures, apparently adapted to corrupt pursuits; the perfect standard still seems to be a

uniform standard, from which, in Reynolds's words, 'every deviation is deformity'. It is unlikely that Barry imagined his theory would have been interpreted in this way: he has acknowledged that the figures an artist represents should be 'adapted to the several classes of character', and in saying so he was appealing to a long tradition in the history of criticism whereby it was recognised—as Reynolds had briefly recognised—that 'perfect beauties', representative of different characters, may co-exist as ideal images, 'though of different kinds'.[11] This truth was well-established before Reynolds, in his anxiety to insist on the uniformity of the civic character, had complicated the issue, and Barry no doubt did not imagine that he would seem to have been complicating it also.

Nevertheless, the issue could not be resolved by a simple adherence to tradition; for Barry has situated it in the late eighteenth-century discourse of the division of labour, by which most deviations from an original frame are seen to be determined by the nature of that division; and in this new context he is obliged to make his views on variety of character more specific than earlier writers had done. He must consider, for example, whether the ideal is an image of a harmoniously proportioned body which has somehow escaped the determinations produced by the performance of particular, divided tasks; or whether it, also, is determined by the nature of the tasks it is imagined to be capable of performing, and is harmonious because those tasks develop all the possible excellencies of the body. He must ask whether, if there are 'several classes of character', there is a variety of separate tasks which are 'advantageous to . . . the interests of mankind', and produce bodies variously adapted to their performance, or whether only the task of the citizen, as defined by republican theory, is thus advantageous, and all the other tasks by which a society is sustained are corrupt, or at least unworthy of representation.

3. Public and private bodies: Grace, Character, and Deformity

It is to questions such as these that Barry turns in the first of two lectures on design, which he delivered at the Royal Academy in 1785; and he approaches them by means of a tripartite distinction between 'beauty', more or less the central form of a species, and deviations by 'excess or deficiency' from that form, which he names 'character' and 'deformity'. His account of beauty is very close to Reynolds's, but, as we shall see, the similarity implies less a respect for the theory of the *Discourses* than a scepticism about the value of representations which are merely beautiful. For Barry, as for Reynolds, there is only one

idea of beauty: it admits, according to Barry, no 'difference' or 'variety', and 'is, like truth, a point' (2: 12)[12]; it is 'essential, and independent of national or temporary institutions or opinions'—a conventional opinion, but one which, like the insistence that the idea of beauty is unmixed with sensuality, may perhaps have been made with some urgency, in that this lecture was first delivered after the delivery of Reynolds's seventh and eighth discourses. And, like the central form in the early discourses, beauty 'is, and must be, founded on the unalterable nature of things, and independent of all particular dispositions'; it is 'immutable, and . . . eternal' (1: 395–6).

The value-language of this is familiar enough, and apparently deployed with such conviction that it may well seem to us that for Barry, as for Reynolds, it will be hard to permit the artist any licence to depart from an ideal so well-equipped, it seems, to represent all that is of permanent value to mankind. If such a licence is to be permitted, it will, we might expect, be granted with some reluctance, but only to admit into a painting as small a degree of variety as will serve to prevent its becoming monotonous or repetitive. And like Reynolds, Barry tries to introduce a notion of variety into the idea of beauty itself, by permitting the various classes of a species to have a central form of their own; so that, it seems, an artist has only to ensure that his design comprehends a sufficient variety of the classes of the human species— differentiated into male and female, young and old—to ensure at once that his work is sufficiently interesting to capture the attention, and sufficiently uniform to represent to us the 'unalterable nature of things' by central forms which, insofar as we all recognise them as such, represent to us a general and unalterable human nature as well.

If Barry remains dissatisfied with a theory of art which commands the artist never to deviate from the ideal of beauty, this is because he believes, unlike Reynolds, that a painting produced in obedience to that command cannot embody a moral content—cannot be 'advantageous to morality and the interests of mankind'—in terms of the forms it depicts. As far as the central form of the human body is concerned, we have seen that Barry is unimpressed by the notion that the image of what we all have in common will be an image of what we all should be; and the pleasure we take in representations of human beauty is for him no different from the pleasure of seeing representations of the central forms of 'quadrupeds, birds, fishes, trees, and flowers', where 'moral agency does not exist'. Such forms certainly 'excite in us agreeable sensations', but there is no ethical interest in 'unity, variety, and harmony' except in association 'with other valuable or worthless qualities' (1: 385–6).

For Barry, beauty is no more than a state of pure determinability.

It is 'equally adapted to all the several animal destinations proper to [a] species', and so the beautiful man is an image of man as, in the words of the *Inquiry*, 'fitted to an infinity of pursuits', but engaged in none of them. It is not, of course, to be confused with the rude original body that we would discover (if we could 'decompound sufficiently') to have belonged to man before his powers and faculties were developed by education, but is rather an ideal image of his universal potential to perform any task. That potential cannot, however, be realised, except by compromising the universal status of the beautiful, for by the particular nature of the tasks he performs, the form of a man is changed, and departs no less surely from the ideal standard of beauty than from the rude, pre-historical body undetermined by education. But because, for Barry, it is only by works that man can achieve the highest development of his nature, it is only the representation of the human body as adapted to the performance of particular tasks, physical or intellectual, that a painting can become, on the level of form, a moral statement. For that reason, we should 'hesitate in our election' of beauty, and permit 'prudence' to instruct us in a knowledge of the degree to which the pleasure we take in beauty may be compatible with our character as moral agents (1: 398, 395).

In his *Reflections upon Beauty and Taste in Painting*, Mengs had argued that:

> Nature is like a Republic, to which belong all its inhabitants and citizens, but all are not of an equal rank, and dignity; . . . all the parts cannot be equally beautiful and perfect; and here it is necessary to reflect, that the parts most beautiful and perfect, are often less useful than those which are less perfect.[13]

This reflection was taken rather further by Barry: as far as the human body is concerned, an image of 'mere beauty' can never be more than 'insipid', and can become a moral image only by being compromised—by being distorted, that is—into character, by which it will become an image of what we should be and should do; or into deformity, an image of what we should avoid. In announcing this rule, Barry has slightly overstated his case; for there is, it emerges, one quality which can be added to beauty 'without altering its constituent parts'. The exception is grace, and it is the exception that proves the rule. The Graces are, according to Barry, the 'natural attendants' of beauty, and their function is to 'make the soul and sensations of the heart, visible in the external figure; and by their affecting sensibilities and happy transitions, [to] produce in the whole together an air and aspect the most amiable, most tender, and the most endearing'. For that reason, grace, though it may be the accompaniment of 'a perfect

or beautiful body of either sex' is 'more eminently observable in the
female', for the sensibility and tenderness of women 'are greater than
that of the male, and the superior softness and delicacy of their bodily
frame is more in unison with those tender sensations' (1: 399–401).
Barry's distinction between the functions of the male and female
body is very close to, and perhaps borrowed from, the distinction
made in *Paradise Lost*:

> For contemplation hee and valour formd,
> For softness shee and sweet attractive grace.
>
> (Book IV, lines 297–8)

It is worth pointing out that these lines from Milton are discussed
by Mary Wollstonecraft near the beginning of her *Vindication of the
Rights of Woman*. She remarks of them, 'I cannot comprehend his
meaning, unless, in the true Mahometan strain, he meant to deprive
us of souls, and insinuate that we were beings only designed by sweet
attractive grace, and docile blind obedience, to gratify the senses of
man when he can no longer soar on the wing of contemplation' (*A
Vindication*, 19). Barry was an admirer of Mary Wollstonecraft and
entertained 'a very different opinion of female capabilities, from
those modern Mahometan, tyrannical, and absurd degraded notions
of female nature, at which her indignation was so justly raised', and
was disgusted at a system of education which left a woman 'no better
than a mere toy of amusement'. Nevertheless, the system of female
education he advocated was one in which the capabilities of women
would be realised by fitting them to become 'the well-instructed
companions and confidential associates' of their husbands, their
'helpmates' in 'body and mind', who recommended themselves to
their menfolk by 'the dear heart-felt offices of satisfaction and utility',
and by their efforts 'to excel each other in pleasing, and creating a
superior interest in the other sex'—a task in which, he assures us,
their wishes and their destination happily coincide (2: 594, 597). That
destination can be deduced from the gentleness of their frame and
their 'soft affecting sensibility', the legible indications that they were
made to be wives and mothers, and this united character—the quali-
fications of wife and mother are described in the lectures in such a
way as to be indistinguishable—is the only character they can have.
Though at one point in his lectures Barry remarks that the characters
of Correggio's Madonna and Magdalen are 'essentially different' and
'accurately discriminated from each other', he seems to have no
words in which to describe their difference, but only their similarity:
both are 'remarkable' for elegance, delicacy, beauty, grace, and in-
teresting sensibility (1: 400, 437).

Insofar, indeed, as grace is the only quality that can be added to

beauty without beauty being changed, and insofar as women can be represented as more than simply beautiful only by being shown as graceful, it seems that, for Barry, women have no characters at all—not because, as for Pope, they are always different, but because, ideally, they are always the same, and always the same as each other. Unlike Daniel Webb, and unlike Archibald Alison, to whose account of beauty Barry's is particularly close, Barry does not believe that grace can give character to the body—its charm, indeed, and its appropriateness to the bodies of women, is that it does not do so. 'A high degree of particular character,' Barry argues, will inevitably distort the image of beauty, but such a character can belong only to men; for, like Alison and various others among his contemporaries, he regards it as an essential difference between the sexes, that 'the whole and every part' of men's bodies 'indicates an aptness and propensity to action, vigorous exertion, and power';[14] and power is, for Barry, the essence of character. For if pure beauty is a state of pure determinability without content, of the empty potential to perform tasks which can never, however, be performed except at the expense of pure beauty, the 'several classes of character' are distinguished from beauty by the different ways in which they 'so evidently define and manifest their peculiar powers'; and those, like women, who have no powers to manifest, can have no characters (1, 400, 398).

If for Burke the beautiful was primarily a feminine, and the sublime a masculine principle, for Barry, grace, which does not compromise beauty, is eminently a feminine quality, and character, which distorts beauty, is a masculine quality, and is the source of sublimity in works of art. For 'particular characters consist . . . in those deviations from the general standard for the better purpose of effecting utility and power, and become so many species of a higher order; where nature is elevated into grandeur, majesty, and sublimity' (1: 400). The sublime is, for Barry as for Burke, a 'modification of power'; but mere power in itself, disjoined from utility, is not for Barry, as it seems to be for Burke, a cause of the sublime: character, in Barry's understanding, is a modification of beauty produced by the 'vigorous exertion' for which the male body was designed by the Creator, but only as that exertion finds expression in actions which conduce to the realisation of the destiny of man, which is to be a citizen of a political republic, as the principles of that republic have been elucidated by the Christian religion. There is no such thing for Barry as a *bad* character, though there is certainly such a thing as a misuse of power: 'character', by definition, is 'admirable, generous, venerable'. Thus Polyphemus, who was for Burke a type of the sublime, cannot be so for Barry: he 'might be able to perform as many feats of strength as Hercules, but we detest his brutal, savage disposition, and reserve

our love and admiration for the hero whose actions were directed by a humane and generous philanthropy' (1: 401–2).[15] The Cyclops would be, for Barry, a type of deformity: for what distinguishes those modifications of beauty that we describe as character and as deformity, is that the first indicates 'a more peculiar adaptation to certain characters of advantage and utility'—of advantage, that is, to 'morality and the interests of mankind'—while the second 'has no reference to anything useful or advantageous, but rather . . . the contrary'. Deformed bodies may be 'useless' or 'deficient'; they may also, however, be strong but 'cumbersome', like the body of the Cyclops. How we are able to distinguish between a Herculean figure who is a character, and a figure who is merely deformed, is an issue which is best deferred to a later section of this chapter (1: 385–6).

Barry's discussion of beauty and character is very close, as I have said, to the account of beauty offered by Alison in his *Essays on the Nature and Principles of Taste*—so close, indeed, that one of them may have influenced the other. Alison argues that 'the Beauty . . . of the Human Form does not arise from any certain proportions which are solely and essentially beautiful'. Alison's theory differs from Barry's in finding the height of beauty in the 'expressions' of 'peculiar characters or dispositions of the MIND', whereas Barry finds bodies adapted to 'corporeal' and 'mental' activity equally capable of sublimity (1: 386); but insofar as beauty does, for Alison, arise from mere physical proportion, then this is the result of the '*Fitness*' of the human body for one or other of the 'important ends' for which it was 'designed'. 'The common professions of society', he argues,

> demand the exertion of certain members of the body, in preference to the rest; and each has the tendency, therefore, to give peculiar strength and amplitude to these peculiar members. Such appearances of the human Form are perhaps unpleasing to the general spectator, as deviations from the common forms. But to those who consider them in view of the ends which they serve, they not only acquire the beauty of proportion, but the form would appear to them imperfect and unsatisfactory without these appearances. Every one expects a different conformation of members in the soldier, the sailor, the waterman, the shepherd, the huntsman, the ploughman &c.; and every painter accommodates himself to this expectation. If we ask what is the cause of this difference of our expectation, we shall find it to be our previous knowledge of the purposes which they serve; that the conformation which is suited to the end, has always to us the Beauty of proportion; and that, when we assign our reason for our approbation, the reason is always that of fitness for the occupation of the person.

What is sublimity of character to Barry, is to Alison the beauty of fitness. One of the most interesting phrases in this passage is 'the general spectator', who is alone in finding beauty only in abstract, 'common forms', undistorted by the division of labour. The suggestion seems to be that this general spectator is himself an abstract, a 'common' man invented to represent what is common among the members of a society, all of whose forms are variously determined by that division. This general spectator demands that beauty should express the abstract uniformity of human nature, but it is a demand that none of us, individually, endorse. We each of us admire the 'fitness' of bodies adapted 'to the various business and occupations of life', for each of us may be aware that in a society divided by the division of labour, the character of its members, and perhaps also the uniformity of their nature and interests, can be represented only by differentiating their forms. If this interpretation seems fanciful, it may seem less so when we have examined further Barry's account of character and society.[16]

If Reynolds was unhappy with the notion of character, that was because to acknowledge that a painter may modify the form of beauty to represent character, is to acknowledge that he may paint *characters*: character is an implicitly plural notion, and that is why to say that women have, ideally, only one character, is to deny them any character, except as contradistinguished from men. Reynolds's concern that any differentiation of a uniform human nature would involve a departure from the universal identity of the citizen was a concern which had always exercised writers attempting to define civic virtue. It had exercised Aristotle, whose reflections on the issue are particularly relevant to the disagreement between Reynolds and Barry where he offers an analogy between citizenship and seamanship:

> Now a citizen we pronounced to be one sort of partner in a community as is a sailor. And although sailors differ from each other in function—one is an oarsman, another helmsman, another lookout man, and another has some other special designation—and so clearly the most exact definition of their excellence will be special to each, yet there will also be a common definition of excellence that will apply alike to all of them; for security in navigation is the business of them all, since each of the sailors aims at that. Similarly therefore with the citizens, although they are dissimilar from one another, their business is the security of their community, and this community is the constitution.[17]

The virtue of the citizens of a state is thus uniform, insofar as they are all concerned with the safety of the polity; but it may be various,

insofar as they each have different contributions to make, relative to that concern. As far as painting is concerned, they may therefore exhibit different characters, in the sense that the particular task entrusted to each of them will cause the body of each to deviate in different ways from the central form: the character of the oarsman will be marked by the particular development of his muscle, that of the pilot by his habitual expression of sagacity, and so on. They will all, however, be adapted in some way to serve the interests of the state; and if, according to Barry's theory, the oarsman ceases to employ his strength, or his intellect, in the service of the community, but employs it instead towards its corruption, he will cease, at once, to be a citizen and a character, and will become, like Polyphemus, a type of deformity.

The nature of Aristotle's analogy will perhaps make it clear why Reynolds might have been unimpressed by such a notion of how a civic art may represent character, and equally why Barry has been persuaded by the notion. For Aristotle's analogy depends on the assumption that it is the function of the citizen to do something, and to do something determinate for the safety of the state; whereas, for Reynolds, the citizen, because he was a liberal man, was (as Fielding described a gentleman) 'bred up to do nothing'[18]—or nothing, certainly, that might cause his body to be distorted by the effort of doing it. The function of citizens was, for Reynolds, uniform, the same for all: it was to observe the structure of society, rather than to act upon society; and for that reason a work of art could instruct them in this duty by its form, rather than by exhibiting to them actions which they should emulate. Barry would no doubt have regarded such an attitude as appropriate to a mere portrait-painter, who depicts the human figure not in action, but 'in its moments of still life' (2: 248). For Barry, as we shall see, the citizens of a republic of taste or of a political republic, founded on the principles of 'natural rights' and 'legal equality' (1: 373), were not exclusively gentlemen; and the virtues of a citizen could perfectly well be represented by a variety of forms, different modifications of the central form, which marked the different contributions each citizen might make to the safety of society.

For a number of reasons, however, it was still necessary that the varieties of character should be arranged into classes, and a perfect standard established for each class. To begin with, as we shall see, Barry believes that representative forms are more easily recognised than particular forms, and so we will grasp the meaning of a strong or an intellectually active body if it is made thus evidently representative of the *kind* of excellence it is intended to communicate. Secondly, if the function of painting is not just to enable us to recognise what we

all have in common, or even what the various members of a class have in common, but to show us how to excel as citizens in our particular callings, then the forms of character must be represented in their ideal perfection. This standard of perfection for each type of character was represented by the Greeks in their paintings and sculptures of the various gods, who were 'copied after the abstract ideas of whatever was found to be most majestic, most beautiful, graceful, or interesting in human nature'; and although in his *Lectures* Barry interprets this as the fortunate result of an erroneous system of polytheism, in his late fragment on his painting of *Pandora*, he suggests that 'the relish and pursuit' of the various excellences represented by the Greek deities were planted in human nature by the 'Almighty Creator', finally 'to bring us to Himself, where *only* all those perfections of the exterior figure . . . can be found united in their most sovereign completeness'.[19] A man, it seems, or a citizen, cannot unite in himself the various types of character: he can only serve the state, and thus serve the end for which he was created, by being, and by doing, one thing and the same. The ideal body which Reynolds imagined might be created by uniting the grace of Apollo, the strength of Hercules, and the activity of the Gladiator, is not, for Barry, an image of the ideal citizen, but an idea of the omnipotence of the universal creator, and thus an idea, also, of the body of the public, of which each character-type is a member (1: 365; 2: 148).

It seems that the division of labour, so far from threatening to deform the republic by fragmenting the ideal uniformity of its citizens, is in fact essential to its security, and threatens only to deform the ideal of beauty. And so it should: for that ideal is not only 'tasteless and insipid', but 'lying and contradictory', when not united with the quality of grace, or determined by the exertions that produce character (1: 401). Pure beauty is lying, is contradictory, because it offers an idea of the body as 'calculated for the greatest variety of ends', but can represent none of them: its empty potential can fulfil its promise of omnipotence only in the *idea* of the deity—not even in the *image* of God, for we have no means (as Reynolds himself implied in his account of Euphranor's statue of Paris) of representing the union of all possible characters, except by extinguishing each of them. Barry has no sense, of the kind developed by Schiller and briefly by Fuseli, that one function of images of pure beauty, of pure determinability, might be to restore to us an idea of the range of our potential, which has been narrowed and determined by the single and divided tasks that each of us is obliged to perform in a society in which work is structured by the division of labour.[20] For Barry, a man is what he does, and does what he is, and however much his character—in the sense of his specific physical determination—is the product of education, once assumed it

seems to become his second nature, by which his body is entirely determined. But Barry might well have argued that Schiller's account of the function of images of beauty only compounds their mendacity, by promising a release from an identity to which, as we walk away from the image, we are ineluctably returned.

For Barry, then, an art which is to be moral, civic, and sublime, can be so only by representing, as the Greeks did, the 'several' and divided 'perfections particularly adapted to each walk of character', and the last phrase, clearly adapted from the phrase we use to distinguish occupations—'each walk of life'—suggests that by the representation of characters an artist will be able to represent the various occupations by which the citizens of a society make their contributions to 'the public': to the security, the well-being, and the survival of society (1: 365–6, and see 392). This suggestion had been made, too, by Turnbull, with whose *Treatise* Barry was familiar. 'Mankind', Turnbull had argued, are 'able to arrive at their highest Perfection and Happiness only by their united Force'. This is 'the necessary Basis of social Union, and of all the noble Enjoyments resulting from social Intercourse and well-form'd Government'; and it seems to have been for this reason that, of all the works of art produced in antiquity, the shield of Achilles, as described in the *Iliad*, was for him the best, and the archetype of a civic art, for on it were represented 'all the Occupations, all the Ambitions and Diversions of Mankind'.[21] For Barry, however, simply to paint 'all' the occupations of men is not quite the point: for the division of labour in modern societies produces many forms among men which are adapted to perform tasks which are neither 'useful' nor 'advantageous' to 'the interests of mankind', but are, as we shall see, fitted only to the production of articles which satisfy artificial wants.

4. A democratic republic of taste

If Barry, like Reynolds, believed that the function of art was to promote the security of a civic republic, the ideal form of that state was different to each of them. Barry was a republican in the more particular sense, that he thought the institution of all but the most severely limited monarchy, whose title would be acknowledged to derive entirely from the popular will, was inimical to freedom, and that the principles of the Christian religion were most conducive to civic life in a state without a king. He believed that the true Christian would enjoy freedom, in the truest sense of a freedom of the conscience and will, 'under any tyranny', 'but in a free state'—and his models of

the free and Christian state were the republics of pre-reformation Italy, and the democratic Swiss cantons—'the virtues of such a man would be a *public* treasure'—the emphasis is mine, for Barry's point is that only in such states is the contempt of the true Christian for 'the allurements of wealth, honours, and powerful favours' properly valued, and put to use, in the public service; in other kinds of polity, his dedication to freedom is likely to remain a private virtue, which maintains his own integrity, but can do nothing to guarantee the integrity of the state (2: 456).

When the members of the Royal Academy were discussing Barry's behaviour prior to expelling him in 1799, one reason put forward in favour of his expulsion was:

> That this being a Royal Academy it was sufficient ground for suspension or removal to prove that a Member avowed democratical opinions,—which Barry had done saying a *Republic* was the proper Government for Art to flourish under,—That he has highly commended *David*, & Mrs. Wolstencraft & commended their principles.

Barry was also an admirer of the 'ingenious Mr Godwin', and of Horne Tooke, whom he described as 'strongly biased to integrity and public service'. He had supported the American colonists, and had been invited by a representative of the United States Congress to paint 'the heroic exploits of George Washington'; as an Irish catholic, he denounced the tyranny of the English in Ireland, and the attempts of George III and his ministers to subvert the liberties of the catholics there. His desire for religious toleration, by which the emancipation of the catholics in England would be secured, led him to associate with some of the most influential advocates for the extension of the rights of full citizenship to dissenters—notably, with Priestley, and with Richard Price, against whose opinions on the revolution in France the early pages of Burke's *Reflections* were directed.[22]

It was essential to Barry's belief that the function of art was to create or to confirm a *democratic* republic, that all men, and all women, were potentially citizens of the republic of taste. The theoretical basis of this belief in universal citizenship is most clearly stated in the same lecture on design in which he had distinguished between beauty and character, and in which he also argues that the general ideas of beauty, and of the several classes of character and deformity, were not, as Reynolds had argued, invisible to those who, by virtue of their confined occupations, were unable to arrive at abstract ideas, or to comprehend the idea of a whole. That distinction, Barry argues,

between the liberal and the mechanic, in terms of the ability to abstract, is based on a failure to recognise that 'the mere animal powers of man are in themselves capable of calculating with great subtilty', and that without such an ability, even 'the ordinary actions of life', such as standing, walking and running, let alone the complex actions of the 'equilibrist, the tumbler, or the fencer', would be impossible, for each of them is the result of 'an infinitude of experiences which it is impossible to retrace'. When we consider the complicated nature of such actions, in which we accurately and instantaneously calculate degrees of force, resistance, and a good deal else, we should learn not 'to be too ready to fix limits to what we may call rude, unlettered sensation' (1: 386–7).

The point of this argument is not that animals should be citizens, but that the rude and unlettered should not be left unenfranchised on the grounds that they lack an ability that even animals exhibit. But it is perfectly evident to Barry that, if general ideas are arrived at by abstraction—and he is now agnostic on this point—then the abstracting powers of even the most illiterate are quite sufficient to enable them to grasp the general ideas of objects which for Reynolds the artist had to strive so hard to discover. General ideas of forms— Barry here agrees with Shaftesbury and Hogarth—are 'recognised by all men';[23] indeed, 'our ideas of the several species of sensible objects, and generally relative proportion of their component parts with each other, and with the whole together, must necessarily be much more perfect than our own particular ideas can be, respecting those relatives in fleeting and transitory individuals'. We have a much clearer idea of the 'general structure' of men and of horses than we can have of the detailed appearance of any man or any horse. The fact that the general forms of species 'do not escape even the most vulgar observation' is revealed at every moment in our ordinary, everyday conversation: 'Good, better, and best are bandied about through all ranks of society, and nothing can be more evident than that every particle of this . . . must unquestionably be referred to a standard'. Our possession of that standard—unconscious though it may be, until represented to us by art—is more specifically revealed by our use, to describe people's appearance, of such 'homely phrases' as: *'squabbish and short, slim and tall, the hatchet or the pudding face, rabbet shoulders, pot belly, spindle shanks, knocked or baker knees, club feet, porterlike, tailorlike,* and so forth.'[24] All these epithets 'indicate sensations exceedingly complex', but not, apparently, so complex as to restrict an ability to employ them to those too polite to do so. 'In short', Barry argues, 'general ideas are the first ideas we acquire; we know the species before we know the individual'; and if

the fact that general ideas are 'extensively observed upon' has not been generally recognised, that can only be explained in terms of a prejudice against the 'rude and unlettered', or by the fact that 'it is one thing in children and uneducated people, to feel those sensations, and another to speak accurately about what they feel' (1: 384–7).

Barry assumes that we ascend, from the ability to perceive the general ideas of objects, to the perception of such general concepts as beauty, order, or goodness. He does not presume to know how this process works, but he offers two possible explanations, either of which he regards as adequate to account for the fact that such concepts also are common property, and not the exclusive acquisition of a restricted class of liberal men. It may be, he suggests, that 'our standard or abstract ideas of beauty, order, and goodness, result solely and immediately (by a kind of arithmetical calculation) from the mere exercise of our contemplative powers on external objects'; or it may be that 'the result of our contemplation of those external objects' goes no further than 'to furnish us with the necessary *media* for the recognition of a former and more perfect knowledge of those interesting qualities which the soul might have enjoyed in a prior and more perfect state'. But in either case it is evident that it is our 'Beneficent Creator' who has 'impressed us with those superior ideas', or with the ability to arrive at them. For such ideas are essential to an understanding of the principles of religion, and were given to us 'as a rule and law, continually to point out that election and conduct which is most becoming and most conformable to our nature as moral agents'. They operate, in fact, as our conscience, and it cannot be supposed that God endowed only the polite with the ability to distinguish between good and bad, right and wrong (1: 393–4).

The intention of this argument is two-fold. To begin with, the argument announces that the aesthetic standard which God enables us to develop is a moral standard, whose function is to judge men in terms of their forms and of the various moral objects they should aim at. The second intention is to abolish any distinction between the 'liberal' and the 'servile' which is based on the belief that the latter, whether by nature or by the nature of their occupations, are unable to arrive at general ideas, and for that reason are not qualified to be citizens either of the political republic or of the republic of taste: all are capable of recognising the general ideas that a civic art depicts, and all are capable of telling right from wrong. It is true, Barry concedes, that our ability to recognise beauty and goodness may vary according to the 'attention employed upon them', but he seems to mean by this that it varies according to the degree of attention we

choose to pay to the promptings of our conscience; for the ability cannot depend on an *original* ignorance of those concepts, but is weakened only, he explains, by prejudice, affectation, or, most often, by self-interest. But even 'the most envious and selfish' recognise the standard—they attempt to disregard it when their 'personal interests' are engaged, but 'out of the sphere of their *own* collisions' they are 'ready enough to acknowledge this *true, beautiful*, and *amiable* in all matters'.[25] It is true that our taste will be more or less correct as 'our knowledge of the essential qualities is more or less accurate and extensive, and our judgment . . . more or less sound'; but the knowledge and judgment that are employed in the decisions of taste are of the kind that are not so much acquired by learning, as forgotten by prejudice, affectation, and interest (1: 394, 404).

The terms of value employed by the language of civic humanism are redefined by such considerations as these. Barry can describe, for example, the competition among citizens in striving for the common good as 'noble emulations', and can talk repeatedly of the 'ennobling' function of art; but like Reynolds, and more consistently, he attempts to detach the idea of civic and intellectual nobility from its connection with notions of social rank: the 'ignorant' are of all classes, and the 'thoughtless rabble' is composed of both the 'polite' and the 'vulgar' (1: 364; 2: 287, 309). It remains important that the artist should receive a 'liberal general education', but, as we shall see when we come to consider Barry's account of the ideal character of the artist, this does not involve a lofty inattention to mechanical pursuits, nor a contempt for the 'mechanical' aspects of painting, for to him these are of far more importance to the creation of a civic art than they were to Reynolds. The artist who is merely a mechanic is 'sordid', because he has surrendered his freedom to his appetite for gain, and has agreed to produce paintings designed to be possessed as private, not public property; he is 'divested of intellectual capacity', and has no 'genius for ethical and refined views', only because he has 'got rid' of his conscience; and to become a free man, a citizen of the republic of taste, he has only to learn to listen to it (1: 414, 389, 363n). Though it is still a characteristic of 'servile' artists that they are 'vulgar copyists' of objects unworthy of attention, they are servile not because of an inability to be anything else, but because they are 'held in vassalage by those degrading, contaminating motives, which unhappily induce but too many to sacrifice the dignity and glory of art to the paltry convenience or emolument of the artist'. They may be servile, in certain societies, because the rank of the artist is subject to 'political debasement', and he is not considered capable of the qualities necessary to a citizen; but more often, in modern and Christian

societies, it will be because of their 'own sordid and contemptible election in preferring pelf' and 'servile interest' to 'glorious duty' (1: 393, 372, 363n).

5. *The relation of form and fable*

If we all recognise the general ideas that art can represent, and can recognise them 'easily', it seems unlikely that Barry would have imagined that the ends of art are secured when it persuades its audience that they share a common knowledge and therefore a common nature. According to Reynolds, the audience can discover their common identity by the discovery that the central form is an image of what their experience has in common, and can persuade them also that their interests are therefore common; according to Barry the mere representation of ideal forms of character will do no more than make the audience conscious of a common and aesthetic standard that none of them had ever, properly speaking, been without. He does, however, acknowledge that, though art has much else than this to do, there is a value in the representation of forms which are generally recognisable as forms adapted for action; and 'it is no argument to the contrary', he states, 'that the consequences which result from this recognition' are not always beneficial. If some of the audience insist on ignoring the lesson implicit in ideal forms of character, that 'our nature' is to be 'moral agents', and persist in preferring their private to the public interest, that is not because they do not recognise their common knowledge and interest, but because they choose to ignore it. Though for Barry the function of art is 'to advance the interests of mankind by placing the cause of virtue and real heroism in the most forcible, efficacious, and amiable light', it does not seem that it can succeed in this function in the case of those most malignant and selfish spectators, for if they will not obey the voice of God, they are not likely to obey any human voice (1: 394, 408).

But how does art instruct the less hopeless cases, if they are already in possession of the standards which, for Reynolds, it was the main object of art to impress upon them? In his answer to this question, Barry takes far more seriously than did Reynolds the traditional notion that a painting can instruct us by the fable it exhibits. In a consideration of the exhibition of pictures in Italian churches, he describes them as 'serving at once for books, intelligible to the unlettered, and for memorials to assist the recollection, and give fervour to the hearts of those who were better informed: and whenever the works of art have not answered these purposes, it is an abuse'. In his

Letter to the Society of Arts, he explains the object of his series of pictures in the Adelphi on the progress of human culture:

> the matter of which the work was composed was of that nature as to come usefully and substantially home to the great occasions of life . . . those who were anxious for the improvement of others, can and do find there some little hints which afford them an opportunity of making ample, agreeable communications of information to their families, their pupils, to their friends and companions . . . This is the use which works of art ought to afford, and which they would afford, if those who in these matters take upon them to cater for the public were properly qualified for such an undertaking.

By the first of these accounts, it appears that paintings should be immediately intelligible to the 'unlettered'; but by the second, and later account, it seems that paintings should represent fables which are sufficiently interpretable to enable the knowing to explain their content to the ignorant, and which have a moral content and a universal significance such as to make this explanation worthwhile. But they should also be sufficiently intriguing to excite the desire for explanation in the first place, and for that reason the fable should not be 'so brought down to the understanding of the vulgar, that they who run may read: when the art is solely levelled to the immediate comprehension of the ignorant, the intelligent can find nothing in it, and there will be nothing to improve or to reward the attention even of the ignorant themselves, upon a second or third view' (1: 372; 2: 437, 314–15).

Passages like these make it clear why Barry was not only willing but anxious to produce paintings which required elucidation by his writings: the meaning of a picture may lie largely and perhaps exclusively in the explanation that can be given of it in language. Such an account, however, of how pictures mean, and of how they instruct, may raise a number of problems, some of which can be dispatched without much ceremony. It may seem, perhaps, that if a painting acquires meaning only as it is explained to the ignorant by the intelligent, then such a notion of meaning compromises the democratic theory of art that Barry has seemed to be advocating. There is a weak and a strong ground for this objection. We may make it an article of faith that in a democratic republic every citizen must be presumed to have as much information as everyone else, but this is not, perhaps, a belief that need detain us. But we may reflect that the explanation of a painting, offered by the 'intelligent' to the 'ignorant', may not be made in good faith, or at least may not easily escape determination by ideology, but may be distorted by the interests of whoever is doing

the explaining—a consideration that does not seem to have occurred to Barry, or that he discounts on the grounds that those in possession of the meanings of his pictures must therefore also have absorbed their lessons, and must be presumed emancipated from private interest.

A second objection would be that once the fable of a painting has been explained, the painting itself will be exhausted. If by this is meant that only a painting which is infinitely interpretable is infinitely inexhaustible, then the objection will have to be conceded, in the case of Barry's criticism no more, however, than in the case of almost every writer on art prior to the Romantic period. If we mean, on the other hand, that once a fable has been explained, whether at the second, third, fourth or tenth view, there will no longer be any profit or pleasure in looking at it, then for Barry that would be true only if the fable itself did not demand the representation of the good, the true and the amiable, which, however readily we recognise them, it is always a pleasure to recognise again. That pleasure is a legitimate one, however, only after the explanation of the painting has been grasped: the explanation must come first—and this is what justifies Barry's immensely long accounts of his own works—because without it, the forms of character will remain forms only: they will not teach us much, because we can recognise them so immediately, and if, considered as pure forms, they have anything to teach us, it will only be insofar as the painter minutely discriminates the anatomical features of each character, and so sharpens our sense of precisely how it is that bodies may be adapted for the performance of virtuous tasks.

But, considered simply as forms, disjoined from the interpretable narrative in which they participate, the ideal figures may teach us something that is directly counter to the interests of mankind: that virtue consists in being able to perform great or virtuous actions, rather than in actually performing them. But a well-formed body is an indication of an aptitude, only, to perform the tasks that it is the duty of a Christian and citizen to perform, and there is no value in such an aptitude unless it issues in their performance. As I have suggested, it may well appear that in Reynolds's theory public spirit is a matter of being rather than doing, and in such a theory, historical portraiture may be as valuable a genre of art as history-painting itself; but for Barry it is clear that no value attaches to the representation of the body except in the context of the fable in which it is situated, of the actions which it performs. We may all recognise the good; the point is that we should be encouraged to do it, and be shown examples of occasions on which virtuous actions have been performed.

Because Barry believes that works of art should be 'useful' and

'exemplary' (1: 470), both in the forms they exhibit and in the actions they propose for emulation, he is able to stay far closer to the rules of art as proposed by traditional civic humanism, by which the form and fable were represented as inextricable, than Reynolds was able to. Thus, in his second lecture on 'design', when he turns to issues concerning the design, the invention of the whole painting, rather than the production of beautiful and characteristic forms, he regards the figures that an artist represents in the same way as he regards the facts and events recorded by the historian: they 'are nothing but as they are exemplarily made subservient to moral agency by furnishing lessons for the improvement of the head and heart'. Thus also, there is nothing edifying in Roubiliac's statue of Hercules tying a bow-knot: 'the great degree of muscular exertion and action manifested on so trifling an occasion, does not make the character seem more Herculean, but rather heightens the absurdity', and this character, it seems to follow, becomes 'cumbersome', and so deformed. The figures, he writes, of 'St Mark, St Nicholas, St Catherine, St Sebastian, and so forth, ought never to be brought together without story, business, or connexion, merely to be exhibited like a parcel of chairs, tables, or other furniture' (2: 446; 1: 421, 472). It is unlikely, of course, that Reynolds would have been inclined openly to contradict such a rule; my point is rather that he did not choose to issue it. One qualification, for Barry, of the superiority of Michelangelo over Raphael is that although Michelangelo's characters are 'as to the drawing, executed with more truth, spirit, and science, than any thing that has appeared since the resurrection of the arts', 'he is not always correct in his adaptation of the character to the subject'; whereas, in Raphael's figures, 'the energy of action and expression ... always arises out of the occasion, and are happily and justly proportioned to it' (1: 423, 429–30).

Considerations such as these make it clear why, for Barry, there is no problem in distinguishing between similar figures which are, however, types of character and of deformity. If we ask how we can distinguish, say, between a Herculean figure which is a type of character, and another which is a type of deformity, Barry would be able to answer that such a problem does not arise in life, and should not in art. For we do not see mere 'figures' in life, we see people— acting, expressing their thoughts and feelings, engaged in contexts in which they perform the parts of moral or immoral agents; and thus we can always tell whether their bodies are being used for the 'advantage' and 'utility' of society, or for the contrary. Painting, similarly, does not, or should not, represent mere 'figures' in 'still-life' (2: 248) but in contexts which represent to us the proper and moral exercise of

the various bodies of men: thus we will learn the various useful ends to which our bodies are variously adapted, and will learn, by contrast, to what useless ends they may also be employed. The forms of figures disjoined from fable may well be ambiguous; but that is only to say that they should never be so disjoined, and that, in history-painting, as Shaftesbury and Winckelmann had argued, they should always be represented as engaged in moral actions.[26]

Barry's account of the principles of composition, chiaroscuro and colouring exhibit a similarly greater concern than we find in the *Discourses* for the union of the form of a work with its fable. He is as concerned as Reynolds that the attention of the spectator should not be divided. To some extent, this concern proceeds from a straight-forward wish to ensure that a work should be 'of easy comprehension to the sight'; the objects represented should be united 'for the pur-poses of easy and collected vision'. The nature of Barry's main criticism, however, of works which divide the attention is rather different from Reynolds's; and though he, like Reynolds, believes for example that 'a too great variety . . . must perplex, distract the sight, and destroy all unity of idea and comprehension', his point is not so much, as Reynolds's was, that a work which is thus disunited will divide our attention between the merely physical ornaments it con-tains, and the ideal figures it represents, but that it will divide it between those ornaments and the fable that it is intended to communicate (1: 473–4, 462). 'The quantity or degree of . . . uni-formity and variety must be regulated by the sentiment proper to the subject': so that 'the first and chief' rule of composition is that the materials should be disposed 'in the manner best calculated to enforce and ennoble' the 'main scope or end, which the subject pro-poses' (1: 473, 458). Now, because it is largely the figures in a history-painting that define its subject, it is not at all likely that a picture composed according to this rule would differ at all from one painted after reading the *Discourses*; the point is rather that, though for both painters a picture which divides our attention will distract us from its meaning, for Reynolds that meaning is to be looked for in the form of the figures, for Barry in the actions those figures are not only adapted to perform, but are actually performing.

The same emphasis on the relation of form and fable informs Barry's remarks on chiaroscuro: thus, for example, 'every thing admissible in the chairo-scuro should fairly follow from that natural order, in which the groups and other objects have been necessarily arranged for the better expression of the subject'; and, as far as colour is concerned, Barry felt none of the distaste of the early Reynolds or, as we shall see, of Fuseli, for the 'sensuality' of colour:

he announces simply that the best colouring is that which is 'happily adapted to the subject' (1: 497, 533).

6. *The well- and ill-employed*

It will be helpful if at this point I attempt to sum up Barry's theory of art as it has emerged so far from this account, so that we can compare it with Reynolds's; and I want to suggest that the difference between the two theories can be reduced to a disagreement about the nature and function of uniformity as an aesthetic, and so also as a political, principle. For Reynolds, in the early discourses, the uniformity of the image that a painter represents must be compromised as little as possible by variety, because in representing the unalterable principles of nature he is to be understood as representing, more or less figuratively, the unchanging nature of the ideal citizen who is proof against the corruption threatened by time and accident. For Barry, the unity of an image does not have to be represented by the same degree of uniformity, and he has a far clearer perception than the early Reynolds of how variety, far from endangering the unity of a work, may actually be constitutive of that unity, and need not be admitted merely as a grudging concession, either to the weakness of our nature or to the exigencies of narrative. The point is made, for example, when he remarks of the Laocoon, that 'it is difficult to say which is most to be admired, the vehement, direct, and uniform address of the subject, or the graceful and skilfully variegated manner in which it is communicated' (1: 459). It is hard to imagine the early Reynolds being assailed by any such doubt: for him, the 'variegated manner' could not have 'communicated' the uniformity of the subject, and could be justified only insofar as, without endangering that uniformity too much, it could make it more palatable.

As an artistic principle—as disjoined, for the moment, from the social—the notion that variety is constitutive of unity finds expression, for example in Barry's attitude to accidents, and to local customs and usages. The question of whether art should admit accidents is not to be solved by a simple rule, by which they are simply proscribed: what determines whether or not they are to be admitted is the degree to which they are allowed by the artist to conceal his moral aim, and the degree to which they may actually promote it. As far as local customs and usages are concerned, it is essential to Barry's idea of history-painting that the history should be right: the rules of 'costume'—the selection of detail in conformity with 'the circum-

stances of time, places, usages, characters, and manners'—must be observed; whereas for Reynolds, it would hardly have mattered whether they were accurately observed or not, for the point was not to represent them at all.[27] On the other hand, the circumstances must never, Barry insists, become so much the object of the painter's attention that they cease to be in conformity with the idea. But when the mind of the painter, and his moral purpose, is visible in all he does, there is no danger that the variety of his imagery will conceal the unity of his aim; so that though 'the ideal in the composition of the story, fable, or subject' should be 'purged of all dead, uninteresting, impertinent circumstances', it need not be purged of *circumstance*, for the idea by which he is possessed will 'seize upon' and 'unite' all 'those transitory, though happy'—happy, because in conformity with the idea—'accidental effects and graces, which may be extended to the most unimportant things, even to the folds of a drapery' (1: 413, 415).

It is an important justification of Reynolds's hostility to ornament that ornament is not only accidental—is not, by definition, a part of essential and substantial form, but an accessory to it—but is also sensual, partly because it locates an image in the material world, and threatens our ability to grasp the ideal forms of objects as metaphors of an ideal state of mind. That Barry's theory is more hospitable to colour, to accident, and whatever else Reynolds had regarded as primarily attractive to the senses, is of a piece with his belief that painting, though it is not addressed to the body, should nevertheless represent the body not simply as a metaphor for the soul or intellect, but as an object itself demanding attention and cultivation, if the citizen is to be adequate to the tasks the performance of which constitutes his claim to citizenship: one of the purposes of the Adelphi sequence, he explains, was to illustrate 'the absolute necessity of cultivating both our mental and bodily faculties', if the 'foundation of civilized society' is to be secured by the 'pursuit of truth and justice' (2: 574). We have already seen that, because that pursuit is an active one, and because it must be carried on by various tasks whose variety may be represented by discriminations of character, the work of art should represent variety in unity by exhibiting different characters united by a common purpose.

We saw also, in the introduction, that writers on economics in eighteenth-century Britain had developed a model of social organisation—or had, rather, revived the model offered by Plato—by which the coherence of society was not endangered by the variety of tasks that its members performed, but was constituted by that

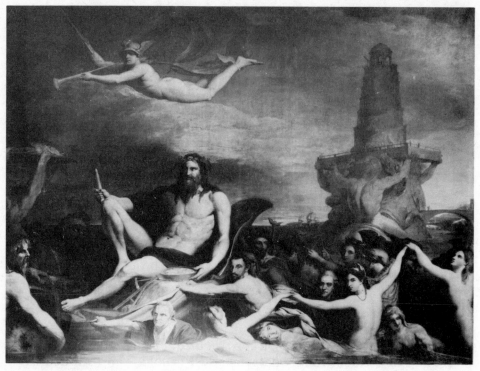

8. James Barry, *Commerce or the Triumph of the Thames* (1777–84) London, Royal Society of Arts.

variety, and by the interdependence necessarily created among them
by the fact that no one was occupied in producing all the goods
necessary to his or her survival. That Barry himself adopts such a
model of social unity, suggests that for him there was no reason why
history-painting should not be hospitable to the representation of
trades and occupations which, by a more elevated idea of the genre,
would have been excluded from it. As John Brown had argued,
'every Profession is honourable, when directed to its proper End, the
Publick Welfare'; and what determines for Barry whether or not an
action or task is worthy to be represented in painting is its tendency to
promote that end, and not whether it was an object too mean to be
illustrated in a genre traditionally employed on fables of noble
heroism, or on 'mechanical' subjects—such as, for example, the
miraculous draught of fishes—only when redeemed by their prior
representation in the scriptures.[28]

There is no direct statement in Barry's critical writings that it may

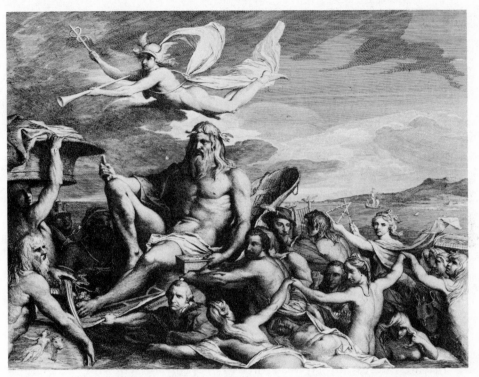

9. James Barry, etching and engraving of plate 8 (first published 1792).

be a part of the business of a public painter to represent trades or applied arts, but there is in his paintings: in the fourth of the series of pictures painted for the Great Room of the Society of Arts in the Adelphi, for example, an allegorical representation of commerce, and, more particularly, in the fifth, where among the recipients of premiums at the Society of Arts are a farmer and a girl who has excelled in needlework, and among the inventions represented are a crane, a hydraulic machine, a winnowing machine, a machine for ventilating mines, and a jack.[29] These inventions find a place in the painting because their tendency was to promote civic virtue, and to resist corruption: Barry believed that the government of Britain, because of 'the accumulation and inveteracy of certain abuses of ancient usages', could only be carried on by corruption, but that the evils of corruption had been:

in some degree resisted and counteracted by that extensive pursuit

of improvement in all the various branches and articles of manufac-
tures and commerce, which has given occasion for so much rec-
titude, amenity, and polish of the right kind, and have [sic]
imprinted on the minds of the good people of England a deep sense
of the value of excellence.

Such an improvement, unencouraged by government, could not be
expected, however, to continue indefinitely: some 'salutary reform'
was required, for 'we cannot, for any time, or in any tolerable degree,
enjoy the gifts of God, without disposing ourselves to merit and
preserve them by just and equal laws':

> whenever we have the justice and magnanimity to submit ourselves
> to the guidance of those laws, we shall not be long before those
> fruits and blessings of industry are showered down upon us; [but]
> ... under certain degrees of brutal violence, injustice, pressures,
> and partialities, either these blessings will never be given to us, or
> they will fly from us and be withdrawn, whenever we have rendered
> ourselves unworthy of the Divine favour (2: 571–2).

What is at issue here is revealed by the opposition between 'equal
laws' and 'partialities': between a system of government based on the
principles of equality as elucidated by Christianity, and one in which
private interest intervenes either to prevent our acquiring the bless-
ings of industry, or (as will be the case in modern societies) to prevent
us holding on to them for any length of time.

The numerous warnings throughout Barry's writings of the dangers
of private interest are all directed to the point that it should be a
consideration of the interest of society—the interest of its members
as moral agents—that determines what articles, whether of
commerce or the fine arts, should be produced. Barry may accept the
view that the unity and strength of a society is the result of the
co-operative labours of its members, but he is not so entirely con-
verted to the principles of political economy as to agree that this unity
could be the result of labour directed to immoral ends. In his account
of the fourth of the paintings he executed for the Society of Arts, a
series 'consecrated' to 'the *melioration*, *liberties*, and *reform* of man-
kind', he makes a clear distinction between those occupations in a
modern society that do, or do not, conduce to social unity and to
virtue:

> If through the means of an extensive commerce, we are furnished
> with incentives to ingenuity and industry, this ingenuity and indus-

try are but too frequently found to be employed in the procuring and fabricating such commercial matters as are subversive to the very foundations of virtue and happiness. Our females ... are totally, shamefully, and cruelly neglected, in the appropriation of trades and employments; this is a source of infinite and most extensive mischief: and even of the males, the disproportion between those who are well and ill employed in this country, is not as it will be when our legislators shall be as eagerly intent upon preventing evil, as our ancestors have been in furthering party views, and obtaining state emoluments (2: 574, 333).

It is not clear quite why Barry believes that there should be more opportunities for the employment of women, when his commitment to what we now call 'Victorian values' persuades him that women are properly employed as wives and mothers. But it is clear that he had no time for the argument of Hume, for example, that 'the more labour ... that is employed beyond mere necessaries, the more powerful is any state; since the persons engaged in that labour may easily be converted to the public service'—in particular, to the needs of military defence. He would no doubt have had still less time for the empty moralising of Burke, his former patron and mentor, who was to acknowledge, in his *Reflections*, that in a modern, commercial society 'many wretches are inevitably doomed' by 'the social economy' to work 'from dawn to dark' in 'innumerable servile, degrading, unseemly, unmanly, and often most unwholesome and pestiferous occupations'; but who believed that nothing could be done about this, because it was 'generally pernicious to disturb the natural course of things, and to impede, in any degree, the great wheel of circulation which is turned by the strangely-directed labour of this unhappy people': 'the laws of commerce ... are the laws of nature, and consequently the laws of God'.[30] The division of labour, Barry believes, if dictated entirely by the market, will produce character and deformity indiscriminately, according to whether what is produced is what is needed, or merely what is desired, and the market makes no distinction between the kind of occupations in which men and women are 'well' or 'ill' employed. That distinction can be made only by asking what occupations are 'advantageous to morality', and it is the task of the artist who seeks to create a public art, and thereby to serve the political republic, to represent only those characters which are adapted to public utility, or, if he represents deformity, to do so only in works whose satiric intention is unmistakable.

The unity of a society organised by the division of labour was not,

for Barry, as it was for the political economists, the unintended result of the interdependence of men who subdivided their labours simply to pursue their private interests more efficiently. The notion that the vice of private interest could become, in such a way, a public benefit, was to him simply a contradiction; as was the notion that industry should still be regarded as a virtue when directed solely towards securing a private interest, an end which was not virtuous. Thus, though he extends the moral function of art to include 'the utility and improvement of mankind . . . *in private and public virtue*' (2: 306, my emphasis), for him the private virtues are virtues only as they are directly and deliberately employed in the service of the public, and in that sense, all virtues are public virtues. Now for writers on economics also, private and public virtues could be identified, but only because those who exhibited the private virtues, industry or frugality for example, in the pursuit of their own interests, were also unknowingly serving the public. But those whose station in life allowed them to practise only the private virtues, could not recognise those virtues as public virtues also, because they had too narrow a view of society to arrive at any understanding of the concept of the public. Private virtues could be seen also as public virtues only by those in a position to observe their tendency to promote the interests of the public at large. To Barry, such a view would have been based on an inadequate understanding of the moral nature of humanity; for the dictates of our conscience do not tell us that we should practise virtue for our own sake, but for the sake of mankind in general.

By such attitudes towards trade and towards virtue, Barry is able to extend the scope of a civic art, so that it can represent the range of virtuous actions performed by the members of a modern, commercial society whose unity arises out of the division of labour. Because he has defined all private virtue as, properly speaking, public, he can do this without compromising the notion that the function of a civic art is to promote the public virtues, while suggesting that such virtues are no longer to be looked for exclusively in the representation of public men, and indeed it seems to Barry that those men are the least likely to practise them, in a state whose government can be carried on only by corruption. My admiration for Barry's account of the social and political function of painting is not unqualified, as the last section of this chapter will make clear; his achievement, nevertheless, is considerable; for he has been able to adapt the principles of the civic humanist tradition of art criticism in such a way as to enable history-painting to address all the members of a society, and in doing so to represent an idea of civic virtue much more capacious than could be

represented by exemplary fables of heroes; while at the same time he can claim that this has involved no adaptation at all, and certainly no compromise. For his theory manages to re-unite those aspects of painting—form and fable, general form and an attention to detail, general truth and attendant circumstances, the discrimination of character and the representation of an ideal of uniform moral purpose—that the early Reynolds had divided, and that the later Reynolds had been able, tentatively, to bring together, only at the expense of the civic ideal itself.

7. *The history and division of art*

It was one thing, however, to produce a theory of art by which history-painting could be claimed to be adequate to represent all the moral activities of a modern commercial society; it was quite another to imagine that such a society would respond by encouraging the production of a public art. Barry certainly cherished no illusion that the theory would, of itself, engender the practice: at the end of his second lecture on design, he insists that there is nothing in the nature of art itself which makes impracticable the ambition to restore the art of painting to its condition of two hundred years before, but his 'charity and humanity' advises him against encouraging his students to devote themselves too whole-heartedly to its realisation. The prospects afforded to the history-painter are 'blank', and it might be wiser for them to withdraw from their studies forthwith, when they are still in a position 'to make a prudent retreat without dishonour', for they will never find the opportunities to display the gifts they have so assiduously cultivated. He points out repeatedly in his writings that there is no living to be had by a painter in Britain unless he is willing to devote himself to portraiture. He campaigned ardently for the purchase of the Orleans collection by the nation, so that those studying to be history-painters would have the opportunity of learning from the best models; and he argued also for the Academy's collection of plaster-casts to be increased;[31] but he had no real hopes that either measure would educate 'the taste of the public' as it would that of the students themselves; and with a well-justified cynicism he suggested that the main purpose of acquiring such collections might only be to afford the more liberal members of the profession 'some amusement, and prevent the ennui of inactivity', for at least they would be able 'to lounge over what . . . other artists had done', if they could not do anything themselves. His pessimism derives from a belief that it is not too soon to expect the public in Britain to learn to appreciate the higher genres of art; it is too late. If the Reformation had not prevented the taste for

painting from growing up, in Britain, alongside the taste for poetry and the other arts, something might have been achieved; but 'the nation is now formed, and perhaps more than formed', and 'the last degree of perfection in the arts' will certainly not be achieved by 'a corrupt and declining people'. If ideal art is to be revived, it may be that 'the glory of obtaining this palm is reserved for some other new people, where the shoot of vigour and virtue may have ample room to expand themselves'; and though, as patriots, we must regret that it is not reserved for Britain, as the frustrated practitioners of a civic art 'it will become us to rejoice' in the 'advancement' of art, wherever it occurs (1: 452–3, 510; 2: 243).

The roots of Barry's pessimism are to be looked for in his under-standing of history, and in the first of his Academy lectures he offers an account of the history of art, which to him exhibits a more or less repetitive structure, though not one which is the result of any inevit-able, cyclic process. The structure—which admits of considerable variation as it is repeated—is of a slow rise to the perfection of ideal art, followed by a period in which the technical discoveries of great artists are separated from the moral principles which had animated them, and are reduced to rules of 'mere mechanical conduct'. Thus separated and reduced, they fall

> into the hands of men of mean intellects, who, incapable of med-dling with the *ideal*, will operate solely with these mechanical prin-ciples, as their entire stock of trade, and thus bring about a separation between the body and the soul of art, with very little prospect of their being happily reunited afterwards (1: 480–1).

This account of the history of art is not, however, to be interpreted, any more than was Reynolds's, as a history in which the processes of change are internal to the development of the art itself, and indeed Barry's understanding of the relations between the development and decline of painting, and of society, is a good deal more detailed and more sophisticated than that offered in the *Discourses*. 'The same *causes*', he argues, 'by which art was advanced or retarded', have operated in 'invigorating or corrupting' every other aspect of the intellectual culture of civilizations; and the history of art and of civilization itself are so far identical that, because the arts of design employ the first, and the most universal written language, we can trace the history and customs of civilizations that have left very few other records of their existence by studying the remnants of the visual art they produced (1: 380, 371).

In fact, as the language of Barry's account of the development of mere rules of mechanical conduct has suggested, the history of art is

largely a product of the changing relations of commerce and religion, and of the relations to these of the form of governments, which is itself determined by commerce and religion. Art advances more nearly to perfection when the government of a country is carried on in accordance with the principles of religion—which is to say, when the form of government is republican. As the influence of religion, as an active principle of conduct, declines, and is either largely forgotten or preserved only in outward forms and ceremonies, the principles of art are similarly forgotten, or survive only in the form of methodised codes of mere mechanical practice: the division of the 'body' and 'soul' of art is the result of a similar division in religion. In the arts of design, that division will be encouraged by the tendency of commerce, unanimated by the principles of religion, to convert intellectual powers into commodities, into a 'stock of trade', so that an art which should be a public benefit becomes an article for private consumption; and it is further encouraged by the tendency of the governments which, with the decline of religion, succeed to the republic, to govern in such a way as treats government as an opportunity for private gain, and commerce as an end in itself, disjoined from the moral ends for which mankind was created.

In the earliest examples of art that have survived, it is evident that such a division has already occurred. The art of the Egyptians, for example, is entirely emblematic and allegorical: 'nothing was shown for itself, but as the symbol or type of some other thing'. Such an art, actuated 'by mere blind practice' working 'after traditionary recipes', speaks to us of a civilization in which religion has already been reduced to mere observances, and is unanimated by any vigorous spiritual energy. Whether as a cause or an effect of this process, art was left to be carried on 'by debased and enslaved orders or casts of men', 'robbed of their mental faculties', and of their sense of 'human dignity' and 'natural equality'. But the traditional recipes are evidently an abridgement of 'very complex usages', of the practices of 'a more entire, principled, and more perfect art'; they bear the marks of being 'really the wrecks and vestiges which might have been preserved after such a general catastrophe as the deluge' (1: 356, 359–61); and from his letters we discover that he believed Atlantis to have been the original birthplace of the visual arts.[32] Though Barry will not say so directly, he is certainly inviting us to believe that the true principles of the arts of design were originally revealed to mankind by God. One of the purposes of his late painting of Pandora appears to have been to suggest as much: Minerva is represented as giving Pandora the materials, and imparting to her the knowledge, necessary to the 'art of painting in tapestry', which Barry believes to

have been the earliest form of the arts of design. In his account of the picture, Barry argues that 'the vestiges' of pagan myth 'may be consecrated' and made 'subservient to the cause of Christian piety', and it seems that he has reinterpreted the story of Pandora in this way partly to overcome the inconvenience of the fact that there is no record in the scriptures, similar to the account of God's gift to Adam of language, of the divine institution of painting (2: 144n, 147–8).

It was when the arts were transplanted to the republics of Greece that their true principles were rediscovered; and so great is Barry's enthusiasm for the 'public spirit' and the 'love of virtue and liberty' fostered in those republics, that he even manages to persuade himself that among the Greeks there were 'no degrading and vile distinctions of tyrants and slaves'. The Greek republics are Barry's ideal of civic society, as befitted an adherent to the tradition we considered in the introduction. Barry's encomium to these republics is perfectly conventional in its enthusiasm: 'all were invited to a competition, where whatever was truly excellent in nature, in conduct, and in arts; whatever was great, admirable, graceful, and becoming; whatever could tend to give the utmost degree of finish, and compleatness to the human character, was the object of general admiration'. The competition was won by 'he who could manifest the greatest personal worth and the most superior ability', in whichever of the various but mutually co-operative pursuits of knowledge he was employed; and 'the collision of all these noble emulations could not fail of producing with the public at large the most highly cultivated and expansive mode of thinking'. Because the 'prime object of Grecian attention' was to arrive at 'the utmost extent of the human capacity', the Greeks had no interest in 'mere riches', or 'all those shewy, pompous exteriors which are calculated . . . to divert the attention from matters of real value' (1: 364–5). But the triumph of Greek art was not the simple result of their attitudes to politics and luxury, for these in turn were based on the nature of the Greek religion, which, however erroneous in its polytheism, was apparently able, by representing (as we have seen) the different perfections of human character in the forms of the different gods, to arrive at true notions of the natural equality of mankind and of the highest excellences of which mankind was capable.

Barry sees no particular decline in Greek art, even after it had migrated to Rome, and found itself established in an Empire, and no longer in republics. It was not easily corrupted, because its original foundation had been so secure, and the memory of its principles was still active when 'the enormous mass of destructive power' represented by the Roman Empire 'was happily beaten to pieces by the

barbarous nations'. The embers of Greek art were kept alive, however, by the Greek and Latin churches, to be kindled again into flame after the Dark Ages, when the universal establishment of Christianity, and the more settled political situation in Europe, enabled mankind to turn their attention again to the arts of design, and to devote them again to their proper purpose, to be a support to religion. In the republics of pre-reformation Italy, and in particular in the 'little republic of Florence', the decoration of churches was regarded as 'a matter of public utility and interest'; art was not 'a useless foppery and appendage to luxury'; and, as in Greece, 'the public grew up in judgment and taste in the same progressive manner that the artist did in his practice' (1: 370, 374; 2: 529, 208). Since then, with the collapse of republican governments in Italy, with the rise of protestantism, which as we shall see cannot aspire to be the kind of *public* religion that Roman Catholicism is, the influence of commerce has increased, and the principles of art have once again been reduced to mere rules of practical technique. The results of this process are most visible in the art of the Dutch, who, by their 'sordid disposition, which will ever be epidemic in a country so generally devoted to gain', and by 'the differences of religion', by which they have 'accustomed themselves to look with ridicule . . . on those great subjects which the Italians executed with the utmost possible sobriety', have 'disqualified themselves for serious pursuits in the arts' (1: 376). But the results of the process are more complex, and of most urgent concern to Barry, in Britain, and throughout his writings he turns continually to examine the causes of the lack of any general grasp of the true purposes of art in Britain, and the complete absence of anything which, by comparison with Greece or Florence, could be called a 'public'.

The causes of that failure are to be looked for in the nature of religion in Britain: not simply, or even primarily, in the hostility of Protestantism to the decoration of churches, but, more crucially, in the fact that the Church of England had failed, and of its nature could not but fail, to establish itself as a public religion, as Barry understands the notion. This is a notion of great importance to Barry's account of the sickness of civilization in Britain, and he gives an account of it at some length in his early *Inquiry*: the account is offered in the course of an argument that the people of Britain are not predisposed, by climate, to commit suicide, though they may be for other reasons; but as that argument is of no particular importance to the considerations of this essay, I will detach Barry's account from the context in which it appears.

The different religions, Barry suggests, of the Greeks, the

Romans, the Italians, and the Jews of Old Testament history, appear to have one important common characteristic, that they made great use of public ceremonies—as a Roman Catholic, Barry has no objection to such observances, if they do not come to stand in place of the spirituality they should serve. These ceremonies were of value insofar as they were used, as the arts of design should be, to manifest the truths of religion to those who could not grasp them in the form of 'abstract, naked, speculative opinions'. Thus, the religions of these various nations were 'constructed in such a manner, as to afford a sort of general pursuit and source of occupation and entertainment, which grew up with every man at the same time that he was pursuing his particular avocation in life' (2: 287). The public ceremonies provided, that is, an occasion in which those who were employed in their particular and separate occupations could come together, and discover that they had something in common; they had the function which, according to Kames, 'public spectacles' still have now. For Kames,

> the separation of men into different classes, by birth, office, or occupation, however necessary, tends to relax the connexion that ought to be among members of the same state; which bad effect is in some measure prevented by the access all ranks of people have to public spectacles, and to amusements that are best enjoyed in company. Such meetings, where every one partakes of the same pleasures in common, are no slight support to the social affections.

But the sharing of common pleasures by the members of a divided society is not quite what Barry has in mind; it was essential to the societies he is discussing that their public ceremonies were religious ceremonies. Their religion was, as William Law had stated that Christianity should always be, their 'common life' which united 'all orders and conditions', so that, whatever the diversity of men's callings, they shared 'the same calling', the 'same important business'. Barry's point, then, is that public religious ceremonies confirm in us an awareness of our common nature and our common purpose, as Law put it, 'to act up to the excellency' of our 'rational nature', and to make 'reason and order the law' of all our 'designs and actions';[33] or, as Barry might put it, to realise in common the full potential of our nature, open to be pursued by all the members of a society in whatever different tasks they performed.

In Britain, the hostility, after the Reformation, to the representation of the abstract truths of religion in visual terms, has deprived the members of society of any such 'general pursuit' and sense of common identity, and this deprivation has been further exacerbated

by the fact that Protestantism 'allowed every man to think for himself in matters of doctrine and faith, and to expound the scriptures as suited his ambition or interest'. No *settled* religion can be founded upon such a permission, for a man whose conscience is 'suited to his interest and inclinations' will change his opinions 'with times and circumstances'; and no religion thus permissive can be a *public* religion, for it will disintegrate, as has happened in England, into numerous sects which have 'mutually ruined the credit of each other, and, generally speaking, left nothing remaining but a great chasm of doubt and disbelief' (1: 333; 2: 455, 288). Barry's attitude towards dissenters is complex, and he makes the charge, that Protestantism permits men to decide moral issues out of interest and not on principle, in the same text in which he goes out of his way to praise the English dissenters for their adherence to civic, egalitarian and libertarian principles.[34] His admiration for them, however, did not prevent him regretting that there should be any *need* for the religious toleration which he, like they, was committed to advocating. For it is the nature of a society divided by the division of labour that, unless it is also united by its religion, men become 'strangers to real sociability'; and if religion is not a '*general* stay' (my emphasis), they will remain alienated from a society in which there is no visible and accessible 'public': no public space in which they can discover that they share with others a common identity and a common destiny (2: 436, 288).

The arts of design, Barry believes, can be nourished and developed to the highest perfection of which they are capable only in conditions of religious, political and economic stability, but for reasons which are various but all to do with the nature of protestant religions, England has not enjoyed any kind of stability since the Reformation, and, more particularly, since the reign of Charles I, and has become instead a country where 'the human passions are all afloat'. Because Protestantism, instead of inhibiting the pursuit of personal interests, actually encourages it, the institution of landed property, conceived of by English political theorists as a stable counterpoise to the more fluid and fluctuating profits of commerce, has itself become a species of moveable property, and its ownership 'almost like a game of chance' (2: 288). The religious dissensions of the seventeenth century have, in the eighteenth, been converted into political dissensions, but faction has turned out to be no more a basis for national stability than was religious zeal, and the bitter oppositions kept alive by the party-system have engrossed not only the attention of those who might otherwise have encouraged the development of the arts, but also a good deal of the money that might otherwise have supported them, so that in ten years Walpole spent twice as much money on political

propaganda as Louis XIV, in a reign of seventy years, disbursed in the form of annual pensions to learned men throughout Europe. This enormous sum was thus directly employed in the corruption of the arts and the nation, whereas, had it been spent in the support of a properly civic art and literature, it would have contributed, in the most efficacious way, to the development in Britain of an awareness of the public interest (1: 376–7). A similar reflection is offered on the more general operations of the luxury which Protestantism can do nothing to check: the great and the wealthy throw away each year on 'waiters and cards' so much money that, if only three or four refrained, they would save enough to present eight historical pictures to St Paul's, 'which would remain as a monument of their public spirit'. For Barry, as for Reynolds, the main problem faced by 'such nations as are exposed to a vast influx of wealth', is that the 'overplus' which accrues to their wealthier members:

> can never lie dormant; and if it be not employed in arts which afford occupation, and useful intellectual entertainment to the people at large, will infallibly operate destructively, and produce such a corruption of public principle, as must finally end in a worse than savage ferocity, and the consequent utter subversion of all civil establishments (2: 389, 514–15).[35]

By the centrifugal tendency of Protestantism, by the instability of property, by political faction, by the pursuit of commerce as an end in itself, and by the gratification of the appetite for personal luxury, the state of Britain has disintegrated into a loose aggregate of private men: there is no public, and so there is no public for art. The patrons of Michelangelo and Raphael, even when 'nothing more' than merchants, were men of 'great minds', of an 'elevation of soul'; but in Britain, what is loosely or tendentiously called the 'public' for art is no more than a collection of 'particular patrons'—Barry seems to use the word 'particular' always with a sense of its meaning in such phrases as *homme particulier* (2: 247, 306). The employment of such patrons works to 'interfere and tamper' with the arts of design, not to encourage them. Barry acknowledges that there are in Britain 'some characters of true taste, and real discernment', who are 'neither preoccupied by the anxieties or distractions of accumulation, or squandering', but the only examples he seems able to offer of such men of public spirit are the members of the Society of Arts who allowed him to decorate, free of charge, the Great Room in the society's building in the Adelphi (2: 530, 322).

The difficulties placed by the Reformation in the way of the development of a properly public art have been exacerbated by the

fact that the employers of artists who regard themselves as 'particular men', or at least who behave like them, will treat paintings simply as articles of personal property, and will commission images only of what is of personal interest to them, or of whatever is or can be converted into personal property. The 'vogue amongst us' is for 'portraits of ourselves, of our horses, our dogs, and country seats'; our houses are stuffed with 'landscapes, and other inanimate matters', with pictures of the birds and fish we have killed or would like to kill, even of 'oysters'—in short, with nothing but 'little things', 'the trifling particulars of familiar life' (2: 246, 242, 254, 258, 306). The 'servile, trifling views' of such patrons provide employment for artists who, if not themselves originally 'mercenary and sordid', quickly learn to become so, and their passion for 'well-deserved glory is meanly sacrificed to a factitious thirst of lucre'. They are reduced to the production of 'pot-boilers', and come to treat the studio as a shop, estimating their success by the number of rich and fashionable customers who contribute to its 'annual profits'. Their views become as 'contracted' and 'confined' as those of their employers. Some people have argued that the failure of the English to commission historical paintings is an accident arising from the nature of English architecture, which is, in comparison with that of France and Italy, more domestic in scale; but it is, replies Barry, 'a vulgar error that our rooms are not sufficiently capacious; it is our minds that want expansion: if these could be brought to a noble size, there would be found space enough for great works in our apartments' (2: 306–9, 247, 225).

To satisfy more efficiently the demand for an art thus commodified, it has proved necessary not only to divide the body of painting from its soul, by reducing the principles of art to simple rules of thumb, but also to subject the art to a thorough-going division of labour; so that, 'instead of expanding our minds to take in such an enlarged noble idea of the art as was worthy a great and learned nation, our practice, until lately'—until, presumably, the admission of students to the Academy schools—'has been rather to contract the art itself, to split into pieces, and to portion it out into small lots, fitted to the narrow capacities of mechanical uneducated people. We have looked upon the arts, as we do upon trades, which may be carried on separately, and in which seven years apprenticeship was the best title.' Now as we have seen, Barry sees nothing intrinsically evil in the division of labour, which has appeared as something necessary, and of positive value, so long as the practitioners of the trades it divides do not lose sight of the common end towards which their different labours are directed. He does not always write, as he does here, as if art, because it is not a trade, should not be divided as trades may be.[36] Indeed, a

view of the republic of taste as a microcosm of the political republic could certainly sanction its division: in his lectures, for example, he says that, as the taste for 'the good, the beautiful, and the sublime of nature and art . . . comprehends whatever is interesting to us in the moral as well as physical properties of things', it 'affords an infinite variety of pursuit, admirably accommodated to all the different genius and dispositions of men' (2: 252; 1: 405).

The republic of the fine arts may therefore be regarded as composed of different 'characters', with 'one class of artists and admirers of art pursuing the simple, others the serious, . . . or the sublime', and so forth. There is therefore 'no department of art' which may not be a legitimate object of pursuit, as long as its practitioners and amateurs are capable of pursuing it in such a way as does not divert them from the moral purpose which constitutes the true end and the ground of unity of all the various genres. We are right to admire the works of landscape-painters, when these are replete with the 'ethical associations' that are the proper justification for Pastoral—a hatred of the 'vanities, affectations, and senseless pageantries, so frequently found in the courts of the great, and in large cities'. Even the representations of deformity offered by such comic painters as Hogarth are to be valued, 'where the humour is not merely local'[37]—though he also suggests that life may be too short to be spent entirely on satire, to the neglect of representations of 'the amiable and the admirable' (1: 405–6, 465; 2: 385–7). No genre is 'mean in itself'; it becomes so only 'when it gets into the hands of men of contracted powers'—as has portrait-painting in England, where its practitioners have 'no ideas of looking further than the likeness and in its moments of still life', and in whose works, consequently, the mind has 'little or nothing to employ itself upon' (2: 246–8, 242).

The correct light, Barry argues, in which to view the division of labour in art, is the light in which Bacon regarded the division of the arts and sciences in general, whereby 'all partitions of knowledge' are to be 'accepted rather as lines and veins, than for sections and separations; and that the continuance and entireness of knowledge be preserved'. But Barry interprets this notion of unity in division in different ways: by one interpretation, he can justify the existence of the various genres of art in the way we have already considered; by another, he suggests that any division which allows an artist to specialise in one particular genre will inevitably result in the contraction of his powers of mind. In this view, there is no longer any room in the republic of taste for men with a particular disposition towards a particular object: the lesser genres are still permissible, but the only artists who will practise in them successfully will be those whose

primary practice is as history-painters: only an artist like Poussin will paint properly ideal landscapes; only such artists as Titian or Raphael will be able to rescue portraiture from a preoccupation with actual nature. The basis of this view is that, properly speaking, history-painting is not a genre of art, more elevated, but equally as specialised a pursuit as are the lesser genres. It is itself the totality of knowledge, of which the lesser genres are veins, not sections. The history-painter, like the poet as described by Imlac, or like the writer of epic poetry as characterised by Johnson, must be the master of all genres:[38] he must be skilled as a painter of ideal portraits, of ideal landscapes, of ideal birds, fish, and oysters; he combines the separate objects of the lesser genres into one whole, and when he does choose to confine his attention to one particular object, he represents it as if it were still part of an ideal and comprehensive whole from which it has been, as it were, only temporarily disjoined (2: 246–8). If only the history-painter can successfully practise in the lesser, divided genres, that is because only he can also transcend their division, and has a comprehensive view, not only of the republic of the fine arts, but also, as we shall see, of the political republic.

8. The knowledge and character of the painter

The painter of history, according to Barry, must have at his disposal 'information, respecting all the concerns and dearest interests of humanity'; he requires fertility, novelty, dignity, an originality and extent of invention, a penetrating, deep judgment, piety, wisdom, morality, elegant classical erudition; he must 'possess a great and noble mind, of ability to penetrate the depth, entire compass, and capability of his subject; to discern in one view all its possible circumstances, to select and unite whatever is most essential, most interesting, and of the greatest consequence' (2: 595, 398; 1: 456). Barry writes as if he were James Thomson, or Bolingbroke, describing the depth and range of social knowledge necessary to the great civic statesman, the man who grasps the principle of unity in a society of divided interests—a man like Lord Chancellor Talbot, for example, who according to Thomson could see 'With instantaneous View, the Truth of Things', whose comprehensive understanding of the history of states and the nature of man gave him exactly that knowledge that Barry demands in the painter, and in whose comprehensive vision resided the ability that Barry also demands, to grasp the relation between the permanent and the temporal, the essential and the circumstances contingent to it.[39] And though we may object, that these extraordinary powers and acquisitions are directed, finally,

only to the production of pictures, that objection will carry no weight with Barry, for whom 'that consistent, perfect, and extraordinary totality' which he aims at, and which demands the exertion of the 'highest powers of the mind', is a means to an end no less great than that aimed at by the statesman—the creation of a united and virtuous society. This aim is not to be achieved simply by studying the art of painting itself, but through 'an intimate acquaintance' with all the 'various arts and sciences' that form the sum of our knowledge of man and society (1: 383, 410).

There is nothing new in Barry's account of the omnicompetence of the history-painter, or of the omniscience he requires for his task. The ability of such a painter to paint all subjects and so to produce works in every genre had been suggested by Alberti, Aglionby, de Piles and Richardson, for example; the vast range of knowledge he required had been described by Pliny, Vasari, Junius, Shaftesbury, Richardson, Turnbull, and no doubt by many others.[40] What is important is the context in which Barry situates his account—the context of a society so divided by the division of labour, that only the history-painter can command the social knowledge necessary to understand its structure, and to reveal it to others. It is therefore essential to Barry's point that, for various reasons, the task of the history-painter, to unite, by virtue his character, as well as of his art, the divisions in a commercial society, is a good deal harder than was the task of the civic statesman of earlier in the century. When Shaftesbury and Thomson, when Richardson or Turnbull, were writing, it was still possible to believe in the visible existence of a public sphere; but 'where', asks Barry, in late eighteenth-century Britain, is the artist to turn 'for the acquisition of that comprehensive thought, that necessary knowledge of all the parts of history,[41] and the characters who act in it; that power of inventing and adding to it, and that judgment of making the old and new matter consistent, and of one embodied substance?' (2: 252)

What is more, the history-painter must see further than the statesman, and further, too, than the interdisciplinary, speculative historians against whom the *Inquiry* is directed. For the widest breach opened by the separation of the arts is that between those who are skilled in one or another, usually practical study, and those who in their pursuit of a general knowledge are content to be expert in none; and the distinction, which is discussed on the opening page of the *Inquiry*, must leave few enough people equipped to write such a work as the *Inquiry* itself, concerned as it is with the relation of one particular professional practice with the whole history of civil society. 'Some men', writes Barry, 'wrapt up in the knowledge of a few particular sciences, have made use of this knowledge as a rule to measure the depths of

other sciences', while others 'have conducted themselves in another manner, and by gently sliding over the surfaces of all the sciences and the arts, like travellers riding post through a great country, they venture to discuss the most minute particulars'; but 'the nature and extent of their enquiries did not qualify them to enter minutely into the number of little successional studies and researches, upon which the growth and the species of arts depend'—they are too 'remote' from the 'labyrinths of practical art' (2: 175, 178, 205).

This distinction, between those who know well only their own, specialised art, and those who, by an acquaintance with no one art in particular, claim to be for that reason better equipped to grasp the relations among all the arts, and therefore the structure of civil society considered as united by the joint-labour of the aggregate of its occupations—this distinction is one which becomes increasingly troublesome to writers in the late eighteenth century who do consider society to be structured in some such way. It leads to the displacement of the landed gentleman from the chair of comprehensive knowledge, his replacement by the philosopher, and, for example, in Ferguson's version of history, to a questioning whether 'the public' has not become 'an object to extensive' even for the comprehension of the philosopher: for 'thinking itself' may now be just another trade, inextricably involved in the separation of the arts and professions, its views limited by its involvement in the processes of exchange.[42]

Barry's qualification to write the *Inquiry* is, precisely, his qualification to paint history; for both require the comprehensive knowledge of the statesman and philosopher, but, equally important—and this leads to an important difference of emphasis as compared with Reynolds—the education of the history painter is as much an education in practical skill as in theoretical knowledge. Though we have seen that Barry, like Reynolds, is suspicious of mere 'mechanical dexterity', separated from any view of an ideal purpose, he does not therefore subordinate, as Reynolds does, the 'mechanical laborious assiduity' necessary to the production of paintings, to the 'intellectual vigour' also necessary to it; for the 'small and trifling particulars' which Reynolds despised are for Barry 'no longer such when . . . dignified by . . . exalted associations' (1: 389, 477). Nor does there seem to be a division, for Barry, between these two attainments of the history-painter: the combination of 'much, various, and deep information' and 'practical skill' should represent itself to him as 'a confederation and union of talents'; and, more than that, he develops his comprehensive views of society and of history, not by the superficial pursuit of a merely general knowledge, but by 'an *intimate* acquaintance' (my emphasis) with 'the various arts and sciences',

practical as well as intellectual, which, in a civil society, are the basis of social difference and should be the basis of social unity (2: 145; 1: 410). By Barry's account, it seems that only the history-painter can develop a truly comprehensive understanding of the public and the public interest—for his is the only profession which admits of this relation of practical to intellectual knowledge, and so only he can escape a vision either 'confined to narrow limits' or merely general and superficial; and this is why, for him, the test of the greatness of a nation is to be looked for primarily in its history-painting (2: 247–8).

The history-painter becomes for Barry a kind of public hero, and he frankly acknowledges as much: 'it should be permitted', he wrote, 'only to a hero to commemorate a hero'; insofar as it is the function of his art still to represent heroes, then that may now best be done by representing those who combine the various occupations that divide mankind in one single character—like the Orpheus of the first work in the Adelphi series, at once 'the legislator, the divine, the philosopher, and the poet, as well as the musician', who represents the original unity of the arts which, as he transmits them to mankind, will be separated (1: 472n; 2: 324). Or else the hero is to be recognised in the maker of the Adelphi series as a whole, who is able to grasp the history of society as the history of the birth, separation, and slow rise to perfection of the arts, and yet is still able to grasp the relations among them, as he (at least) still has an understanding of their common end, and as he has (the fiction is) a knowledge of them all. The history-painter becomes, in fact, another version of that quintessentially eighteenth-century hero, Peter the Great, or Thomson's Knight of Industry, who is a jack-of-all-trades and a master of them all; and who reassures us that, if all possible occupational identities may be combined in his single character, a society divided by the division of labour may still be united.[43]

That Barry felt such an extreme form of reassurance was necessary, is a measure of how far he feels that the sense of a common, a public purpose is absent from the society of Britain. Some of the members of that society might be well-, some ill-employed, but evidently to be well-employed in eighteenth-century, protestant Britain may now no longer be a guarantee of an ability to see the connection between the particular task one performs and the ultimate end served by its performance: it is no guarantee, that is, against alienation, or against the failure to perceive that one's private virtues are also public. Such a guarantee will be available only when 'the public' is already, and visibly, *in situ*—because in Britain it is not, it has to be discovered, and its discovery has to be experienced, on behalf of each virtuous, separate occupation, by a man adapted, and educated, to perform

10. (left) James Barry, *Orpheus* (1777–84), London, Royal Society of Arts.

11. (below) James Barry, etching and engraving of plate 10 (first published 1792, and entitled *Orpheus Instructing a Savage People in Theology & the Arts of Social Life*).

them all. The history-painter must therefore unite all the characters he paints, as God unites in himself all the separate characters represented by the gods of the ancients, and as, therefore, by another part of Barry's theory, it was impossible for a man to do; and it finally emerges that Barry's belief that history-painting is still adequate to represent a society as complex as that of Britain is based upon a belief in the universal character of the artist which, because it is only comprehensible as myth, only underlines the inadequacy of any imaginable human artist to do his public duty.

With some embarrassment, therefore, and with something of a desire to protect himself from the consequences of a failure that now appears inevitable, Barry suggests, in the last paragraph of his lectures, that of course 'no artist ever did, or ever can, arrive at the perfection of such a standard, any more than at that of the Stoicks' *perfect man*, or any other of those ideal objects of imitation, so judiciously recommended by the ancients'. Yet he 'must insist, let unfairness, cavilling, and peevishness say what they may, that excellence of any kind has never been attained to upon other principles' (1: 553–6). It became usual, after Barry's death and probably before, to explain his determination to remain independent of private patronage, and his conviction that other artists were involved in private 'cabals', factions and conspiracies to devalue his work and even to prevent him from working, as the products of a deranged mind. But it is possible to see them also as Barry saw them, as the reasonable convictions of an artist entirely dedicated to the preservation of the ideal of history-painting as a civic and a Christian art, consecrated to the cultivation of the excellence for which man was created; and of an artist who, because of that dedication, was able to see that the habitual compromises made by his contemporaries were made out of a concerted refusal to acknowledge what art was still capable of achieving. If they did not recognise that they were compromising the art and themselves, then as far as Barry was concerned that was simply because to compromise had become their second nature.

9. Physiognomy, individuality, and the division of labour

I want in conclusion to consider an issue which, whether or not it would, in the late eighteenth century, have been recognised as being raised by Barry's account of the public function of art, will certainly seem to be raised by it now. The issue is whether a theory of art like Barry's which seeks to categorise and distribute the range of individual identities that compose a mass society into physiognomic

types, is not a sinister theory—one which invites us not simply to comprehend the variety of that society, but also to control it, by enabling us to recognise and punish those who deviate from the canon of 'acceptable', 'useful' types: either, by Barry's theory, by falling into the 'unacceptable' and useless types of deformity, or by simply failing to subordinate their individuality to the type to which they are required to affiliate, and to the task to which they must adapt their bodies.

There are various reasons why the classifying of society in terms of physiognomy is usually found objectionable. The first of these that I will consider is that the 'science' of physiognomy has usually been based on the assumption of a division between two groups of people, subjects and objects: those who observe society and those who compose it; those who are able to classify the varieties of men and women, and may seem to escape classification themselves, and those who are denied that ability, and are treated simply as the objects of the classifying power of others. It is clear from Barry's account of the history painter, who occupies, in his theory and in the society it is an attempt to realise, an extraordinarily privileged position, with access to a range of social knowledge available to no one else, that some such division into subjects and objects is crucial to that theory. But the position occupied by Barry's artist is rather different from the position occupied by those mythical characters—Peter the Great, the Knight of Industry, the 'philosophic eye'—with which I compared it in the previous section. For other middle and late eighteenth-century accounts of the viewing position occupied by such observers do not distinguish, as does Barry's theory, between the ability to originate a knowledge of the social structure, and an ability to apprehend that knowledge once it has been originated. For Pope, for example, or for Thomson or Adam Smith, or—we might add— for Reynolds, only from a position elevated above the accidents of the ground can an understanding of the structure of society be originated or apprehended: each act is inseparably involved in the other.[44]

For Barry, on the other hand, all have the ability to recognise general ideas, and so the general classes into which men are grouped: only the artist has the power of originating this knowledge in the clarity and perfection necessary to its representation as a ground of social affiliation; but once originated it is 'easily and with pleasure recognised by all men' (1: 384). A picture does not offer more knowledge to some than to others, and so does not offer to some power over others; and if, for Adam Smith, the unity of a society divided by the division of labour was to be looked for in the fact that each

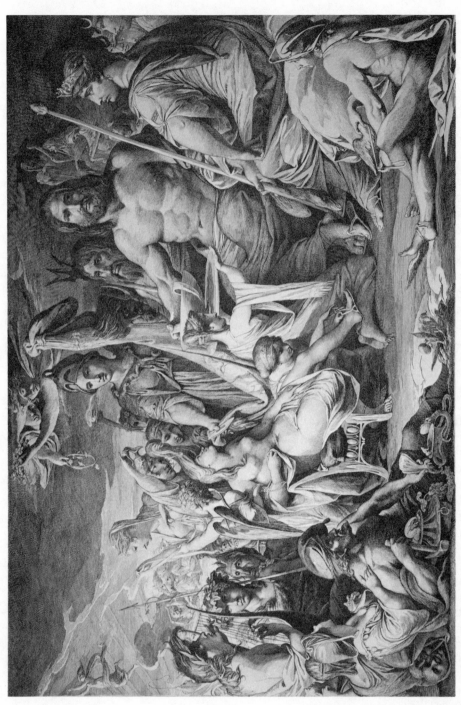

12. James Barry, *Pandora* (c. 1804–5), etching and engraving after his own painting, *The Birth of Pandora* (c. 1791–1804).

individual is 'led by an invisible hand to promote an end which was no part of his intention',[45] for Barry the practitioners of divided occupations are perfectly capable of intending that those occupations should conduce to the public good, and of understanding, when it is revealed to them by art, how they are thus conducive. The artist is, for Barry, a hero, by virtue of the knowledge he originates and by virtue of his persistence in originating it in spite of the opposition of interested, private men; but beyond that—and I do not seek to deny the element of tragic dramaturgy in Barry's self-characterisation—his theory is to be understood as an attempt to adapt the civic theory of history-painting in such a way as to enable it to represent and foster what he understands to be the properly egalitarian nature of a mass society; a society, moreover, all of whose members are distinguishable in terms of physiognomy, whether the actions they contribute to its well-being are physical or intellectual.

It will be harder to treat Barry's theory of painting as benign, however, if we consider it in the light of the painting in which, more than in any other, we might expect to find it exemplified. There are no rules in Barry's account of composition for the positioning of the central figure such as we considered in the last chapter; he always describes the principal object in a painting as a group, or mass; and accordingly, in his largest, most public paintings, there are no individual *heroes*, except in the *Pandora*, where the enormous, off-centre figure of Jupiter is an image of the universal, divine character in whom the powers of the subordinate deities are joined, as they could not be in any terrestrial creature apart from Barry himself; and except in the *Orpheus*, where the god-hero does occupy the centre of the composition, and appropriately so, in that he represents the original unity of labours now divided. The picture, however, which—as far as we can judge from Barry's account of it—most fully attempts to represent the ideal unity which can be exhibited by a society of divided occupations is *The Distribution of Premiums in the Society of Arts*, and it points clearly to an inadequacy in Barry's account of how painting might represent that unity, and thus to a familiar problem in the attempt to claim that a society thus divided is an equal society, which permits differentiations of occupation but not of status—a society in which, as Adam Smith suggested, the philosopher and the street-porter exchange their services on equal terms.[46]

Once again, the picture has no central figure, and no single figure elevated above the level of the others; the Prince of Wales is placed, perhaps pointedly, to one side, looking out of the picture to the left,

13. James Barry, *The Distribution of Premiums at the Society of Arts* (1777–84), London, Royal Society of Arts.

14. James Barry, etching and engraving of plate 13 (first published 1792).

though slightly in front of the other members of the Society, who are distributed across the painting, mostly in the same plane. The composition is, in short, of the kind that Reynolds found particularly reprehensible, for all the figures are 'making equal pretensions to notice'.[47] The picture, according to Barry's account of it, represents both those who are 'of service to the community' by virtue of their 'labours', and those who 'cannot (generally speaking)' serve the community by labour, but to whom 'there remains . . . a sphere of action no less glorious and interesting to mankind in assisting those that can' (2: 344). The picture therefore—if we do not read it as subversive of this account, but as an adequate expression of it—attempts to depict the ideal equality of these two classes, each equally 'glorious', whether their service is direct or indirect. But those who can perform useful labour are mostly represented by machinery, and the few who appear in their own persons are represented in attitudes or with expressions of deference. The picture can attempt to minimise the fact that the relations between those who work, and those who encourage others to do so, are relations of rank and deference, by employing an apparently egalitarian mode of composition, but that can hardly escape being recognised as a device, whose purpose is to conceal rather than to abolish an inequality elsewhere everywhere apparent.

A second objection to the attempt to classify the members of a society by a system of physiognomy would be that, in the past, such systems have usually been employed to encourage the belief that by an attention to physical appearance we can distinguish the virtuous from the vicious. By Barry's account, to have a 'useless' or 'deficient' frame of the body or set of the face is certainly to be branded as vicious, though not, perhaps, as beyond moral regeneration through a course of virtuous labour; and, at least in the case of those who are not in a position to choose their occupations, to choose to be 'well-employed', their bodies will indicate the deficiency of society rather than of themselves. But the examples of deformity that most engage Barry's attention are those which do most to complicate the question we are considering. For, according to Barry, we cannot always distinguish the types of character and deformity in terms of mere appearance, abstracted from context. The deformed Polyphemus is easily distinguishable from Hercules; but Hercules tying a bow-knot seems deformed, because his strength seems cumbersome; Aeneas and Mezentius are distinguishable by what they do, not by how they appear (1: 402). It is therefore essential to exhibit sublime characters as engaged in virtuous action. To have a body adapted to vigorous exertion in a specific task is a necessary, but not a sufficient qualification, for virtue; it may also be a qualification for vice.

But perhaps the main evil of physiognomy is usually thought to be the fact that the categories it proposes are eternal and immutable; if we are classified by appearance, we are classified forever, and will be forever unable to escape into another identity. As far as we can deduce from his accounts of character and deformity, Barry's idea of society was not one which permitted (though it does not specifically prohibit) the migration of souls from type to type; though character appears to be the result of adaptation and education, and not defined at birth, there is still no suggestion that we can change characters, by changing the task which is our means of affiliation to society. It is not clear that Barry's theory of society would be compromised by such a permission, but his theory of painting might be; for how does one represent, unambiguously, a man who used to be a soldier but is now a ploughman? no more easily, I imagine, than the activity of the Gladiator, the delicacy of the Apollo, and the strength of the Hercules, could all be combined in a uniform image of ideal beauty.

What is certainly clear is that Barry regards it as essential to the health of an egalitarian and religious republic that all its members should exhibit the qualities of one generic character or another, and that the cost of citizenship is the extinction of such personality as might be represented by an appearance which corresponded with no character-type at all. However many uniforms may be kept in the stores, and even if we can choose which one to wear, no one is allowed to wear mufti, and all must obey what Durkheim describes as the categorical imperative proposed by the division of labour, '*Make yourself usefully fulfil a determinate function*'.[48] In comparison with the theory of art which Barry's account of character is written to oppose, the cost of citizenship in his republic may not seem too excessive, whether or not, in its own terms, it seems worth paying. The entire exclusion of the mechanic from Reynolds's republic, and the definition of the citizen in terms of his ideal uniformity with other citizens, made no more space for personality, for individuality, than does Barry's theory, which does at least offer the citizen a *range* of generic identities to identify with. But to the objection that any demand for subordination of individuality to a civic identity is, in the modern sense, an 'illiberal' demand, Barry can have no defence other than to argue that his concerns are no less humane than are those of a more 'liberal' humanism. Barry's theory of the public function of painting is based on the fact that human life is social life, and on the belief that it is only in society that our highest human potential can be realised. The pursuit of excellence in each of us is inseparable from the pursuit of excellence in us all; and the inseparability of the two aims is preserved, he believes, only when we are aware that in

working for ourselves we must also be working for others. It is that awareness which a public art must foster, by offering us an understanding of how far we may be different if we are also to be the same; of what our different characters and tasks are for, and of what common aims they serve.

A BLAKE DICTIONARY

1. Introductory: Blake and Romanticism

THIS BRIEF essay is intended as a note on Blake's opinions about art, and not as the more extended kind of reading attempted for the other writers considered in this book; for I do not believe that it is possible to discover, among those of Blake's writings that are specifically concerned with the arts of design, a structure of opinion and argument of the same kind of consistency as we can find in the writings of Reynolds, Barry, Fuseli, or even Hazlitt. I do not mean that Blake did not have a coherent theory of art—he may well have done—but that the kinds of text in which his views on art found detailed expression were not such as required or enabled him to present those views in the form of a theory that we can compare and contrast with the theories of those other writers. Most of these texts are prospectuses, or advertisements, or accounts of his own works; and unlike Reynolds, Barry and Fuseli, Blake had neither the opportunity nor the inclination to write as a teacher of art: he never lectured, though his 'Public Address' may have been intended as a lecture, and he did not believe, in any case, that the principles of painting could be *taught*, though some parts of the art could be *learned*.

Those critics who have been most successful in eliciting a theory of painting from Blake's writings have attributed a particular importance to his annotations of Reynolds's *Discourses*; in this essay I have chosen rather to concentrate on those few of his writings on the arts of design which he either published, or apparently intended for publication, even if this intention may have been abandoned before they were completed. I have assumed that it is these texts which were intended to communicate his opinions to an audience, and to one which had a familiarity with the important issues in contemporary criticism of painting; and I have asked what these texts might have meant to an

audience thus informed. I shall refer quite often to Blake's private annotations to Reynolds, but in general, my attitude to the annotations is that, though they provide us with intriguing hints about Blake's views on art, they are not presented in such a way as enables us often to expand these hints into clear statements of position. It seems to me that the meaning of the annotations has been considerably over-determined by critics of Blake, who, responding to the energy and urgency with which—sometimes by little more than a single expletive—Blake indicates his disagreement with and contempt for Reynolds, assume that such urgency could only be the expression of views the absolute contrary of Sir Joshua's.[1]

This readiness to contrast Reynolds to Blake as black to white is reinforced by the practice of applying to Reynolds's theory the term 'neo-classical', to Blake's views the term 'romantic', and by developing a distinction between the two men which is based on the assumption that the two terms are themselves opposites. To do this has been a characteristic rather of literary critics than of art historians: fortunately, 'Romanticism' has never become a well-established term in the discussion of English painting, and art historians do not seem, on the whole, to have found the term of great explanatory power even when applied to such obvious subjects as Turner, Palmer, or Blake himself. In the discussion of romantic poetry, literary criticism has learned to make subtle distinctions between Romanticisms, and may take the greatest pains to discriminate between the Romanticism of Wordsworth and that of Shelley, and even between the Romanticism of one poem by Wordsworth and another written the same afternoon. But this caution has not always characterised literary critical discussion of Blake's view on art and on Reynolds, who is too often seen as the common enemy of Blake, Wordsworth and Shelley, in opposition to whom the Romantic poets are obliged to put on a common uniform, and to forget their differences in the common aim of asserting the greater value of a particularly naive version of Romanticism—a version which, if it can often be found in critical discussions of romantic poetry, is usually rather better disguised.

In the discussion of the annotations, and of Blake's other writings on art refracted through them, the ideological functions of the terms 'neo-classical' and 'romantic' can become particularly evident. Thus in the most ambitious and comprehensive account of Blake's 'theory of art' to have appeared so far, by the literary critic Morris Eaves,[2] the eighteenth-century concern to define a public is represented as a simple concern to punish as 'social deviants' those who do not 'conform' with the 'group'—as though Reynolds treats the audience he is

addressing as already, unproblematically, a public, one hostile to outsiders merely because they are hostile to the group, and appropriating to itself the power of denouncing the works of outsiders on the grounds not that they threaten the principles for which the 'public' stands, but that they threaten, simply, the sense of group solidarity. Once this move has been made, it is an easy matter to insist that Blake is trivialised by being represented as a mere 'unruly adolescent' who won't join the church youth club, and to define Blake's virtues and opinions in such a way as is intended to remind us that those whom the group cannot contain may be more sensitive individuals—more sensitive because more individual—than the members of the group. The effect of this move is not simply, as I shall argue, to misrepresent Blake, but to trivialise his opinions in such a way as to make them the polar opposite of a trivialised neo-Classicism. Blake's defence of 'individual character', and of 'originality' as the prime virtue of the artist, are interpreted in such a way as to represent him as the proponent of an 'expressive' art—an art expressive of the unique individual identity of the original artist. He becomes the exponent of the 'original or characteristical style', attributed by Reynolds to the singular manner of Salvator Rosa; his concern with 'minute particulars' is taken to be a concern to discriminate the unique individuality of particular objects and persons; and he is seen as similarly anxious to engage his audience not as an 'impersonal' public, but as individuals, joined in a personal relationship of love.[3]

Some of these words and phrases—and in particular 'individual', 'original', 'character', all of them key words in Blake's value-language—have meant slightly different things to different interpreters of Blake: it may not be too much of a generalisation to say that in Britain Blake has most often been represented as a humane individual deeply sensitive to the infringement of personal identity by 'mass civilization', whereas in America this version of him has been in competition with a more aggressive Blake, the man who goes his own way and walks tall. In either case, however, Blake becomes a founding father of the liberal individualism which has been the prevailing ideology of 'Blake Studies', and which can understand the public only as an invasion of private space—as 'standardization', as 'big government'; and in either case, the interpretation can be reinforced by an appeal to the vocabulary of fixed meanings, the Blake 'dictionary' in which the definition of all Blake's terms is founded on the same liberal ideology.

In this note, I shall be suggesting that Blake deserves to be admired much less than he is by his liberal critics, and I shall do this by offering a brief contribution to the Blake dictionary. I shall be arguing, for

example, that, for Blake, an 'original' artist will certainly differ in style and subject-matter from those other artists, at least, whom Blake does not consider to be artists at all; but that this difference is only an indication of his originality, and not constitutive of it—for what constitutes his originality is the fact that he has access to a vision of the heavenly origin of what it is that art should represent; and the more accurately he can represent the 'originals' of things, the less his work will differ from that of other 'original' artists. I shall be arguing that Blake's concern with 'individual character' is a concern with the accurate delineation of the individual *classes* of men and women; and that his notion of 'individuality' is the very opposite of a concern with uniqueness of character or personality.[4] In short, I shall be arguing that what is at issue in Blake's departures from Reynolds is best understood in terms not of a conflict between Neo-Classicism and Romanticism, but of a disagreement about how, and how far, the theory of art defined by the 'traditional' discourse of civic humanism is to be adapted so as to enable painting to describe a modern, complex society, and to create a public capable of understanding that description and its significance to the conduct of civic life.

2. *'Original' (I)*

The word 'original' seems to have two distinguishable meanings in Blake's writings on the arts of design, though both of these are related in the definition offered by the *OED* for 'originality': 'the fact or attribute of being primary or first-hand: authenticity, genuineness'. The first of these two meanings is not at all troublesome, and can best be conveyed by saying that an original work or artist is the opposite of a copy, or of a copyist engaged in directly reproducing another man's work or invention. Thus, when Blake says that 'No Man can Improve an Original Invention', his primary meaning in the context of this remark is that no engraver can improve on the work he is engaged to reproduce, as Tom Cooke believed he could improve on Hogarth's designs. It is to this sense of the word that Blake is appealing, when, in a draft prospectus for the engraving of his own 'fresco' of Chaucer's Canterbury Pilgrims, he writes that the engraving 'is minutely labour'd, not by the hands of Journeymen, but by the Original Artist himself'. In this sense also, he writes that an 'original' artist cannot employ 'numerous Journeymen in manufacturing (as Rubens and Titian did) the Pictures that go under his name' (594–5, 587–8, 583). *

* All page-numbers in this chapter refer to *The Complete Writings of William Blake*, ed. Geoffrey Keynes, London 1966.

Because, for Blake, 'Invention depends Altogether upon Execution', which is 'the Only Vehicle', the 'Chariot' of 'Genius', an original artist cannot remain so when he entrusts the execution, even of what Reynolds would regard as the subordinate parts of a work, to 'the Hands of Ignorant Journeymen' (446, 453–4, 595).[5]

But even in the examples quoted above, this simple meaning gains an additional force by the use of the word 'original' in a wider sense, in which it is opposed to what we might prefer to call 'imitation', though Blake usually persists in calling it 'copying'. In this enlarged sense, an artist is original, first of all, when he does not imitate other artists, for 'none but Blockheads Copy one another'; and the work of an artist who forms his style on, or borrows his inventions from, other artists, cannot have that consistency which is a mark of 'authenticity, genuineness': 'The Man, Either Painter or Philosopher, who Learns or Acquires all he knows from Others, Must be full of Contradictions'. But equally, an artist cannot be original if he imitates *nature*. To some extent, Blake's opinion here coincides fully with Reynolds's: it depends on a distinction between those who 'Copy Nature' directly— mere copyists of actual nature—and those who are 'Copiers of Imagination' (601, 449, 594–5). But the fact that those who copy imagination do not, for Blake, do so in any way that Reynolds could approve, is clear from Blake's inclusion, among the copiers of nature, not only of Rembrandt, but of Reynolds himself. For the central form which for Reynolds was derived empirically by the imagination is for Blake derived by the form of reasoning he describes as 'ratio': the central form is simply 'A Ratio of All we have Known'. The imagination is not involved at all, but simply the powers of calculation and memory; thus 'the Greek Muses', for example, are 'daughters of Mnemosyne, or Memory, and not of Inspiration or Imagination'; and thus the annotations of Reynolds's third discourse, in which he announced the doctrine of the central form, begin with a quotation from Milton's *Reason of Church Government* to the effect that a work of Genius is 'Not to be obtain'd by the Invocation of Memory and her Syren Daughters, but by Devout prayer to [the] Eternal Spirit' (475, 566, 457).[6]

Blake is not opposed to copying *per se*. It is essential to the education of an artist that he should learn 'the Language of Art by making many Finish'd Copies both of Nature & Art'; and even an original artist must be a copyist, must indeed be a more perfect copyist than an uninspired artist could ever be. 'The difference between a bad Artist & a Good One Is: the Bad Artist Seems to Copy a Great deal. The Good one Really Does Copy a Great Deal', and the more (in an ironic application of Reynolds's sense of the term) his

copying is 'Servile', the better a good artist will be. What is more, the works which a good artist produces by copying will be far more 'correct', more 'servile', than those produced by a mere copyist of actual nature or of the images begotten by the ratio upon the daughters of memory, for the images seen by the 'imaginative and immortal organs' of the genius will be far more 'organised and minutely articulated'—will be far more detailed, will require *more* to be copied— than the objects which 'we see reflected in this Vegetable Glass of Nature', this 'world of Dross', where 'Reality' is 'Forgot', and only 'the Vanities of Time & Space' are 'Remember'd & call'd Reality' (455–6, 595, 576, 605, 600). For that reason 'Nature' becomes to its 'Victim', its copyist, 'nothing but Blots & Blurs'. What is at issue, then, is not whether but what the artist should copy: and the answer is evidently imagination and inspiration, or 'vision'—the original artist 'Copies That without Fatique' (595–6, 457). I want now to consider what that vision is, and why to copy it minutely and faithfully should be the mark of an 'original' artist; the question of originality of style, or of manner, I shall defer until after we have examined some other of the terms of the value-language of Blake's writings on art.

Throughout those writings, the influence of Barry upon Blake— sometimes as mediated, perhaps, by John Opie—is very apparent.[7] Blake contemplated, and composed a few lines of, a poem about Barry (553–4), and on one occasion when—as occasionally he does—Blake finds a thought to admire in the *Discourses*, he suggests that 'Somebody else wrote this page for Reynolds. I think that Barry or Fuseli wrote it, or dictated it'. The relations between Blake's ideas on art and Fuseli's will be apparent when we come to the discussion of Fuseli; the main point I want to make about Barry's influence is that, pervasive as it is, his history and theory of art are continually reinterpreted by Blake so as to adapt them for the purposes of an idea of art as the activity of the visionary. Like Barry, Blake believes that the earliest examples of art that have survived bear the marks of being derived 'from some stupendous originals now lost or perhaps buried till some happier age'. These 'wonderful originals' were produced in 'the ancient republics, monarchies, and patriarchates of Asia', and are referred to in the scriptures as the 'Cherubim', which 'were sculptured and painted on walls of Temples, Towers, Cities, Palaces, and erected in the highly cultivated states' (for 'The Bible says That Cultivated Life Existed First, Uncultivated Life comes afterwards') 'of Egypt, Moab, Edom, Aram, among the Rivers of Paradise' (463, 565, 446).

There are significant differences, however, between Blake's account of the origins of art and Barry's. To begin with, for Blake, the art of the Greeks cannot, as we have seen, be regarded as the

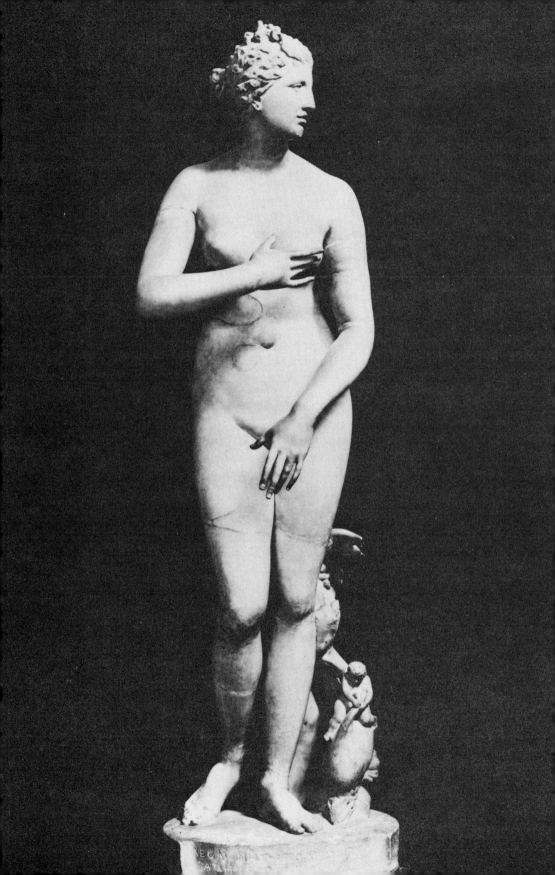

product of a rediscovery of the principles of art: though the Hercules Farnese, the Venus de'Medici, and the Apollo Belvedere are 'justly admired', they are 'copies' of the original images of the Cherubim, of the vision, that is, as already mediated by other artists. Secondly, Blake is not obliged, as Barry is, to deduce the original existence of a more perfect art— indeed, for Blake, of a perfect art—from the vestiges of it that survive in the work of those who remembered it, more or less immediately. Blake, 'having been taken in vision' to the ancient states of Asia, 'has seen those wonderful originals', which he can therefore assure us 'were some of them one hundred feet in height; some were painted as pictures, and some carved as basso relievos, and some as groupes of statues', all 'executed in a very superior style' to the works of the Greek artists, or to all except the Torso, which is the only Greek work that Blake believes to have been an 'original' work, a genuine 'invention' (565–6).

Blake's claim to be an original artist is founded on his vision of, among other things, these originals of art. Whereas if the Greeks copy these originals they produce only imitations, if Blake copies them he will produce works of art equally original; and the difference is that while Blake sees them with his imaginative eye, the Greeks either saw them with their moral, their perishing organs of sight, or did not see them at all, and copied only the memory of them as transmitted perhaps by intermediate copies. But Blake's claim is founded also on a more general capacity for vision, an ability like that of the prophets to receive visions of 'what Eternally Exists, Really and Unchangeably', the 'Eternal Forms' of things 'as they were reveal'd to Mortal Man in the Series of Divine Revelations as they are written in the Bible'. For this reason, Blake can claim to be 'an inhabitant' of Eden, 'that happy country' among 'the Rivers of Paradise' where the originals of art wait to be rediscovered; and for that reason he can state that 'The Nature of my Work is Visionary or Imaginative; it is an Endeavour to Restore what the Ancients call'd the Golden Age'. On the other hand, 'The Man who never in his Mind & Thoughts travel'd to Heaven is No Artist'—the distinction is not between original artists and unoriginal artists, but between artists, all of whom are original insofar as they have access to a vision of the originals of art, or eternal forms, and those who are not artists at all; the 'nature' of all art is 'visionary', 'imaginative', and original (604–6,

15. *Venus de'Medici*, Florence, Uffizi.

578, 565, 458). Originality does not consist in any quality of novelty that the best artists may display, but on their ability to penetrate through the accidents of time and place to the substances of things, which are discoverable only by imaginative vision. The difference between Reynolds's notion of originality and Blake's does not reside in any greater power in Blake's artist to produce inventions out of nothing, or inventions which originate in his individual self; it depends entirely on the fact that, for Reynolds, substance is discoverable by the imagination working empirically; for Blake, by the imagination working intuitively, seeing into things, through to their original forms.

It seems that this faculty of vision is available to everyone, and that we all have the power to 'see . . . above the shadows of generation and death'. Blake certainly believes that genius is innate, and that it is nonsense to speak of 'Acquiring Invention and learning how to produce Original Conception'; and insofar as 'there cannot be more than two or three great Painters and Poets in any Age or Country', and 'inspiration and vision' are 'the gift of God', it may seem that originality is a grace vouchsafed only to a happy few (578–9, 469, 561). Insofar, however, as the knowledge of ideal beauty is (as it was for Barry) given by conscience—by 'Con-Science or Innate Science' (457, 459)—it seems that, however insuperable the difficulties interposed to the imagination of most people by the obstructions of the vegetable world, the vision is accessible to all who will follow their conscience. Thus, in the account of his 'Vision of the Last Judgment', he insists that:

> If the Spectator could Enter into these Images in his Imagination, approaching them on the Fiery Chariot of his Contemplative Thought, if he could Enter into Noah's Rainbow or into his bosom, or could make a Friend & Companion of one of these Images of wonder, which always intreats him to leave mortal things (as he must know), then would he arise from his Grave, then would he meet the Lord in the Air & then he would be happy (611).

Whether the spectator 'can' do these things seems to depend on the will rather than on the possession of the faculties necessary to the apprehension of visions; for it seems that he has an imagination, and 'contemplative thought', and the images of wonder would not (one presumes) 'intreat' him to do the impossible. Why so many men should ignore the intreaty, when 'the Whole Business of Man Is the Arts', is a question we may defer till the end of this note (777).

It is partly because the vision is a gift of God, a grace, that its minute details must be copied as accurately as they are perceived: to

do anything less would be to reject a part of God's gift.[8] Therefore the colours must be 'clear' and 'unmudded by oil', and the lines 'firm and determinate' and 'unbroken by shadows'; for the aim is to display the vision, and not to conceal it, as the original artist will do if he succumbs to the influence of the painters of Venice or the Low Countries, who 'cause that the execution shall be all blocked up with brown shadows', and who 'put the original Artist in fear and doubt of his own original conception'. For that reason too 'Art can never exist without Naked Beauty displayed': drapery will conceal the clarity of the lineaments (564, 582, 776). The resemblance between Blake's and Barry's views on the importance of the representation of detail is clear enough: for Barry, generalised form and drapery conceal the minute and perfect organisation of the body of the sublime character, as for Blake they conceal the same quality in the figures perceived in vision. But the resemblance goes further than that, as we shall see in the next section.

3. 'Character'

Genius and Inspiration, by which the painter has access to 'original conceptions' of the eternal forms of things, are also, according to Blake, 'the Great Origin and Bond of Society': their function is to create, and to confirm, a society which is also, as we shall see, a public. To ask how it is that art performs this function it is necessary first of all to ask what it is that is revealed to the original artist in his visions, and which it is his task therefore to represent. We have already had some intimation of the answer, in Blake's account of the Greek copies of the scriptural Cherubim, which emerged in the form of the Apollo, the Hercules, the Venus de'Medici: the 'Grecian gods were the ancient Cherubim of Phoenicia', which are 'visions' of the 'eternal principles or characters of human life'. The prime task of the original artist is the representation of these characters, and it is for this reason, and not out of any concern with the *unique* character of the artist, that Blake describes the 'Two Grand Merits of the Great Style' as 'Original and Characteristical' (561, 571, 468). Art is characteristical when it is engaged in the representation of character, and it is 'expressive' when it is engaged in the representation of expression as a function of character, which is the 'stamina' of expression. Both character and expression 'can only be Expressed by those who Feel Them', and neither can exist except in works which employ a 'firm and determinate outline'. But that outline is not characteristic or expressive because it is an indication of the particular character of the

artist or the feelings which, as a particular character, he seeks to express; 'expression' is a property not of the artist but of his subject. Outline, therefore, is characteristic, is expressive, because it marks with minute fidelity the characters and expressions of the persons it delineates: that is why Blake can claim that 'there is not one Character or Expression' in his prints 'which could be Produced with the Execution of Titian, Rubens, Correggio, Rembrandt, or any of that Class' (585, 599).[9]

The most detailed account of character that Blake offers in his writings on art is contained in his description of his painting, *Sir Jeffery Chaucer and the nine and twenty Pilgrims on their journey to Canterbury*. 'Chaucer's characters', writes Blake, 'are a description of the eternal Principles that exist in all ages', and for that reason, in Blake's representation of them, 'every one is an Antique Statue': the Franklin is 'the Bacchus', the Doctor of Physic is 'the Esculapius', the Host is 'the Silenus', the Squire is 'the Apollo', the Miller is 'the Hercules', and so on. I have *quoted* the names of the gods, so as to preserve the definite article that introduces each of them, which serves to suggest that the antique statues have a certain general, or generic character, and that is exactly Blake's point: every one of his pilgrims, like every one of these 'antique statues', is 'the image of a class'.[10] For:

> The characters of Chaucer's Pilgrims are the characters which compose all ages and nations: as one age falls, another rises, different to mortal sight, but to immortals only the same; for we see the same characters repeated again and again, in animals, vegetables, minerals, and in men; nothing new occurs in identical existence; Accident ever varies, Substance can never suffer change or decay.
>
> Of Chaucer's characters, as described in his Canterbury Tales, some of the names or titles are altered by time, but the characters themselves for ever remain unaltered, and consequently they are the physiognomies or lineaments of universal human life, beyond which Nature never steps.

The notion that Blake's concern with character is a concern with the representation of 'individual' character, uniqueness of appearance, is no doubt partly the result of a belief that minute fidelity to particular detail will inevitably result in the minute discrimination of the particular appearances of individual persons; but that will be true, of course, only if it is nature that Blake is copying, and not eternal forms and principles. It is also partly the result of the assumption that, because Blake believes that the representation of character not only

permits but demands a good deal of variety, that variety will (when coupled with minute fidelity) produce a representation of character minutely individualised. But though, for example, Blake claims to have 'varied the heads and forms of his personages into all Nature's varieties', we have already seen that what Nature produces is a taxonomy of generic characters or classes, each varied from the other, but each varied in itself only by 'accidents' which Blake forebears to represent as urgently as if instructed by the early Reynolds— for accidents, of 'time' and 'space', are not realities. In the same way, though the Roman soldiers who appeared in Blake's (now lost) painting *The Ancient Britons* 'each shew a different character, and different expression of fear, or revenge, or envy', and so on, they show these expressions in their identity as characters, and characters are the images 'of a class, and not of an imperfect individual' (571, 567, 580).

There may appear to be a certain latitude of interpretation offered by this last phrase, at least to the most determined believer in Blake as the celebrator of the uniqueness of individual personality: perhaps it could be argued that though an 'imperfect individual' may be one who is perceived in terms of accident, not substance, and so not as a member of a class, there may be another class of (presumably) perfect individuals, to whom Blake may feel more kindly. I doubt it; but we can consider the point when we consider the term 'individual' in the various meanings which Blake asks it to bear. In the meantime, we can at least dispose of the notion that Blake's 'adherence to an expressive theory of art and a concept of individual identity eliminates the possibility of a standard idea of beauty or hero'.[11] Chaucer's knight, Blake tells us, 'is a true Hero, a good, great, and wise man ... and is that species of character which in every age stands as the guardian of man against the oppressor'; he is, apparently, not an individual but a 'species of character' which transcends time, place, or whatever is opposed to 'identical existence', where that term is apparently intended to refer to what 'individual examples of one species' have in common, so 'that any one of them may ... be substituted for any other' (*OED* 'identical'; 567–8).

Blake's characters, his representation of the eternal and substantial forms of human life, are divided between 'good' characters and 'bad'. Thus, if the knight is 'good, great, and wise', and the Parson is an angel, 'an Apostle, a real Messenger of Heaven', others, such as the Pardoner and the Sompnour, are 'Devils of the first magnitude'. The character of Hercules was divided by Chaucer, and so is divided also by Blake, between an angel and a devil: the simplicity, wisdom and strength of the character are attributed to the 'benevolent' plowman; and in this form he represents Hercules 'in his supreme eternal state, divested of his spectrous shadow', which is represented by the Miller, 'a terrible

fellow, such as exists at all times and places for the trial of men'. The Pardoner, also, 'is sent in every age . . . for a blight, for a trial of men, to divide the classes of men'. This division of characters into angels and devils is reminiscent of Barry's distinction between character and deformity: between those whose character is represented in a body adapted for the performance of tasks advantageous to men, and those whose bodies are deformed by their adaptation to selfish or destructive ends. In fact, however, both Angels and Devils among the pilgrims have useful and necessary tasks to perform: the Pardoner is not simply a blight, he is 'sent . . . for a trial of men', and so 'he is suffered by Providence for wise ends, and has also his great use'; the Miller exists 'to curb the pride of Man'; the character of the Wife of Bath is 'useful as a scarecrow' (570–2).

Blake does, however, make two important distinctions in his discussion of character that seem to be related to Barry's distinctions between beauty, character, and deformity. By the first of these, he distinguishes, among the characters of Strength (the Hercules), Ugliness (the Dancing Fawn)[12] and Beauty (the Apollo—for beauty may be a character for Blake, whereas for Barry character is a sublime distortion of beauty), those images of each character which are, and are not, 'the receptacles of intellect'. This distinction relates to his remark that Reynolds 'thought Character Itself Extravagance & Deformity'; for these three characters are fit for representation in high art, only when clearly marked as fit for the different tasks they are 'sent' to perform, and so uncontaminated by any appearance of a propensity to folly, or imbecility, or (in the case of Strength) mere bulk without spiritual energy, of the kind represented for Barry by Roubiliac's statue of Hercules tying a bow-knot. Insofar as these characters are not represented as 'the receptacles of intellect', it seems they cease to be characters: not because mere individuals, but because unfit to fulfil their tasks; and in the same way as, for Barry, the images of deformity, of unfitness to perform 'useful' tasks, are fit subjects only in comic painting, so for Blake these useless variants of generic character are 'a subject for burlesque and not for historical grandeur' (579–80, 460).

Blake also appears to make a distinction in relation to character which may be derived from Barry's distinction, between the notion of a proper division of labour, among different characters all working to a common end—the perfection of man—or among figures of deformity which treat the tasks they perform as ends in themselves. The error of the Greeks was, according to Blake, that they, and 'since them the Moderns, have neglected to subdue the gods of Priam'. By this he means that the characters represented by original artists—the

16. *Dancing Faun*, Florence, Uffizi.

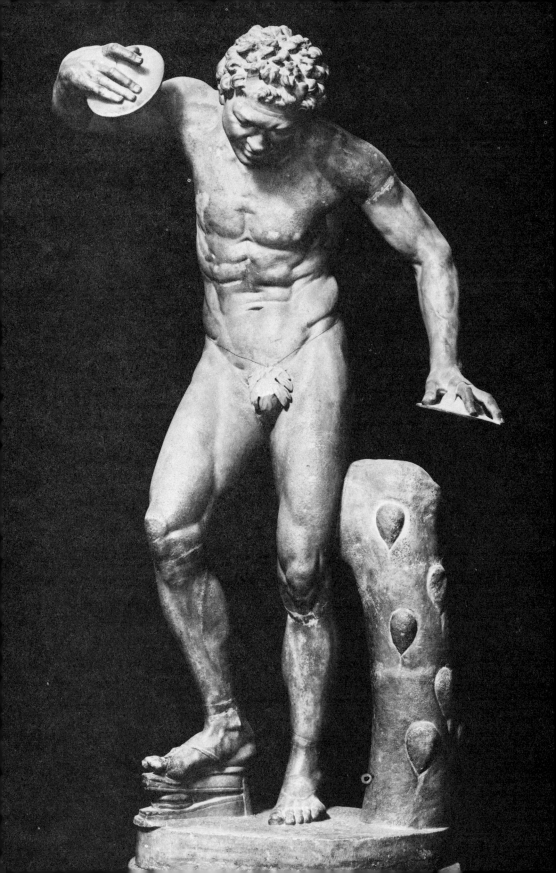

Cherubim, for example, are properly to be regarded as 'visions of the eternal attributes, or divine names': the separate characters, that is, are attributes of an omnipotent deity, whose powers are distributed among the different classes of men by the same 'natural' division of labour as formed, for Barry, the distinction of characters. As long as the characters are thus regarded as having a common ground of unity, in Christ, they remain as they should do, the 'servants, and not the masters, of man, or of society'; for all the 'Permanent Realities' of things, including the 'eternal principles or characters of human life' are for Blake 'comprehended in their Eternal Forms in the divine body of the Saviour', whose body is the body of the public; and for that reason, insofar as we are characters, we are 'members' of Jesus, in the same way as the different characters represented by the Greek gods are for Barry comprehended in the unity of an omnipotent God. The Greeks, however, by erecting the characters into separate gods, dissolved the ground of their unity and 'separated' them from man or humanity, who is Jesus the Saviour. The sense of common purpose, and of community, was therefore destroyed: the Greek gods became the representatives of tasks pursued as ends in themselves, and so became not the servants of mankind but 'the masters'; and instead of being 'made to sacrifice to Man', they 'compelled' man to sacrifice to them (571, 605–6, 776).

'Every age', argues Blake, 'is a Canterbury Pilgrimage; we all pass on, each sustaining one or other of these characters; nor can a child be born, who is not one of these characters of Chaucer' (570). For Blake, unlike Barry, generic identity is innate, not the result of education and adaptation; and the function of painting appears to be to represent to us the characters of life, in such a way as enables us to realise our different, innate identities in them. I mean 'different' in two senses: the representation of these 'eternal principles or characters of humanity' is intended to reveal to us how, when we see the images of character stripped of accident, we may all recognise that our different identities are united with those of others in one of the various classes of humanity; and to reveal to us that those classes are indeed various, though finite in number, according to the number of tasks God has sent the various characters to perform. Thus far, and except that the audience are to identify with one or another specific class, rather than with a uniform central form, it seems that Blake's idea of the function of art is close to Reynolds's: art is the 'origin' of society because it reveals to us our common humanity, the ground of social affiliation; it is the 'bond' of society because it continues to do this, continually offering to us images which confirm that common humanity.

But Blake's notion of the function of art goes further than this: its

task, as we have already seen, is to 'Restore what the Ancients call'd the Golden Age' (605), and as far as we can deduce from his writings on art, this will be achieved when the 'gods of Priam' are subdued, and we recognise ourselves not only as members of the separate classes of humanity, but as united in a common purpose, and a common sense of identity—when we recognise that the characters we represent are united in Jesus, and, thus understood, are the servants of man and society, and no longer the tyrannous agents of division. In this, Blake's idea of the function of art seems to depart from Reynolds's almost exactly as Barry's did, and in such a way as to acknowledge the need for variety in art and society, but not for the kind of variety which opposes one activity, one character, to another, instead of uniting them. There are, however, important differences between Blake's notion and Barry's. First, though for both men the function of art, and the forms of character, may be grasped by an appeal to conscience, for Blake conscience can go so far as to reveal to the imagination an unmediated vision of the difference and unity of those forms. Second, it was for Barry essential that the forms of character should be represented as engaged in moral actions, so that we can distinguish them from the forms of deformity they may resemble, and perhaps also (if Barry is following, though it is not clear that he is, Alison's associationist theory)[13] so that we will learn to associate them with the performance of acts of virtue. For Blake, as for Reynolds, the point seems to be that by the exhibition of ideal forms, we will learn the grounds of social affiliation; to this end they do not need to be represented in action; but because the ideal forms are fitted, are designed for action, Blake believes that they will teach us (as the central forms of Reynolds do not) that the sense of community among the varieties of character is to be achieved by deeds which are of service to a Christian community.

4. 'Individual'

To an art with such a function as this, individuality—or the assertion that one is an individual, a member of no class—can only be an obstruction. Now it is not clear what Blake means when he says that the Pardoner is 'sent' to divide the classes of men: he may be sent to separate the classes from each other, by dividing them from the Saviour who is the ground of their unity; or he may be sent to divide each class into individuals who, seeing only with the perishing mortal organ of vision, see accident and difference instead of substance and identity, and so lose a sense of their common humanity by becoming

aware of themselves only as 'individuals', necessarily 'imperfect' because impaired by the process of division. In either case, the 'trial' that the Pardoner makes of men must be accepted and resolved; and it must be resolved in the second case, because, in so far as mortal sight blurs the bounding line which separates one class from another, it returns the world to chaos, and 'the line of the almighty', which marks the lineaments of each class, 'must be drawn out' again before 'man or beast can exist'; for 'where there are no lineaments there can be no character'.[14] It is perhaps worth repeating here that it is because the function of art is to represent character, and not because its function is to represent individuality, that the 'Greatest Artists' are 'the Most Minutely Discriminating and Determinate': individuality, for Blake as for Reynolds, Barry and Fuseli, is accidental, and 'Minute Discrimination is Not Accidental' (585, 575, 453). For Blake as for Barry, the sublimity of art is the result of the representation of generic character, and if 'All Sublimity is founded on Minute Discrimination', that is because, for both men, the representation of different classes or characters, finely organised and so finely discriminated from each other, is the representation of the 'sublime', the 'stupendous' and 'wonderful' originals of character also represented, according to Blake, in the Cherubim. 'The whole of Art', Blake argues in his annotations to Reynolds, is comprised in an attention to 'Complicated & Minute Discrimination of Character'; this is what the 'Ancients' were 'chiefly attentive' to; and only a reading of the annotations which is based on the assumption that Blake's views were the polar opposite of Reynolds's, and that therefore he was chiefly attentive to the minute discrimination of *unique* characters, could fail to grasp his meaning. The representation of men as mere individuals is for Blake, as for Barry and Reynolds, the humdrum employment of the mere face-painter, whose 'sordid drudgery' is directed to 'facsimile representations of merely mortal and perishing substances' (453, 466, 576).

There is, however, a large number of uses of the word 'individual' and its derivations in Blake's writings on art where its meaning is clearly not pejorative, and it is to the meaning of the word in these uses that I now want to turn. For when Blake says, for example, of the oak-tree, that its 'Eternal image and Individuality never dies'; when he says that nothing 'can be Changed or Transformed into Another Identity while it retains its own Individuality' (605, 607); or when he claims that 'Every Class is Individual', or inveighs against those writers who 'militate against Individual Character', or against those who cannot bear 'Individual Merit' in an artist (460, 453, 593)—is he not surely arguing that there is a value in that individuality which is

separable from the generic, which finds expression in images of unique individual characters, and that these may be as much 'eternal images' as the images of generic character?

It will help us to answer these questions if we examine in some detail Blake's account of one of his 'experiment pictures', which he exhibited in 1809 along with *Chaucer's Canterbury Pilgrims* and *The Ancient Britons*. The 'experiment pictures' were works in which Blake was concerned to experiment with colours, but which required him to labour so hard that some of them he could never finish, and in a number of them, at least, he found that his concentration on the effects of colour 'destroyed the lineaments', by which he means that the firm and determinate lines by which the figures were marked came to be concealed by the 'blotting and blurring' which is the only language of art known by those who value colour over line. In his account of these pictures, Blake represents the struggle to preserve the lineaments as a struggle against the 'blotting and blurring demons', among whom he includes Titian, Rubens and Correggio; and it is appropriate therefore that one of the 'experiment pictures' should have been of *Satan calling up his Legions, from Milton's Paradise Lost*.[15] This picture, he explains, was the result 'of temptations and perturbations, labouring to destroy Imaginative power, by means of that infernal machine called Chiaro Oscuro, in the hands of Venetian and Flemish Demons', who 'cause that every thing in art shall become a Machine. They cause that the execution shall be all blocked up with brown shadows. They put the original Artist in fear and doubt of his own original conception' (581–2).

By Rubens, for example, 'a most outrageous demon', this 'original conception' is 'loaded' with 'hellish brownness'; the special delight of Correggio 'is to cause endless labour to whoever suffers him to enter his mind'—for that reason he established 'manufactories of art', dark satanic mills, where the manual labours of impoverished journeymen are divided in such a way as they are divided by the gods of Priam, so that those employed there are unable to perceive the common end of their separate tasks, the vision which is the unity of those tasks in Christ. The 'spirit of Titian' attempted to persuade Blake of the impossibility of 'executing without a model', to persuade him therefore to copy nature, and in this way he was able to 'snatch away' from Blake 'the vision', his 'original conception'. Instead of the vision, his mind became possessed by the 'memory of nature, and of Pictures of the various schools', and his execution, which should have been 'appropriate' to the 'invention', became the execution not of an 'original' artist but of an imitator, a copyist of nature and of the styles of artists who, if they had ever 'travel'd to Heaven', had been thrown

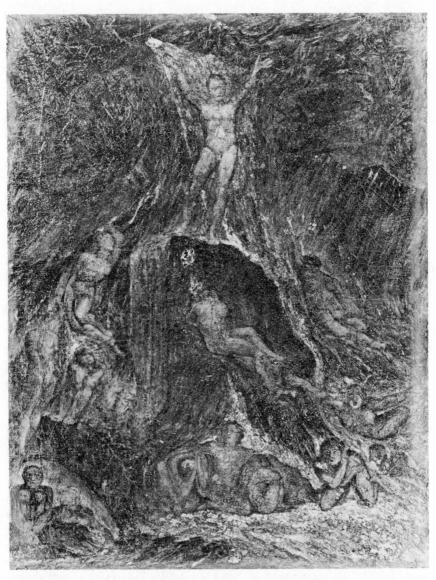

17. William Blake, *Satan calling up his Legions* (*c.* 1800–9), London, Victoria and Albert Museum.

out of it again. And Blake describes the influence of the blotting and blurring demons in such a way as may well seem to invite us to believe that it is his unique personality as an artist that is being threatened and compromised. Rubens, 'by infusing the remembrances of his Pictures and style of execution, hinders all power of *individual* thought'; Titian, by stirring up in Blake the memories of other men's work, persuaded Blake to execute his picture as if he were 'walking in another man's style, or speaking, or looking in another man's style and manner, unappropriate and repugnant to your own *individual* character' (582–3, my emphases).

To understand the meaning of the word 'individual' here, it will help us if we consult a passage in Book V of *Paradise Lost* in which the angel Raphael begins to recount to Adam and Eve the history of the 'exploits' of the 'warring Spirits' in Heaven: in Blake's universe it was no accident, of course, that the names of the angels Raphael and Michael should have been inherited by the greatest of the Italian painters, for they, like the angels, are the 'Progenie of Light', opposed to the demons of hellish brownness.[16] In this passage, indeed, Raphael makes a distinction between the loyal and the rebel angels in exactly these terms:

> Hear all ye Angels, Progenie of Light,
> Thrones, Dominations, Princedoms, Vertues, Powers,
> Hear my Decree, which unrevok't shall stand.
> This day I have begot whom I declare
> My onely Son, and on this holy Hill
> Him have anointed, whom ye now behold
> At my right hand; your Head I him appoint;
> And by my Self have sworn to him shall bow
> All knees in Heav'n, and shall confess him Lord:
> Under his great Vice-gerent Reign abide
> United as one individual Soule
> For ever happie: him who disobeyes
> Mee disobeyes, breaks union, and that day
> Cast out from God and blessed vision, falls
> Into utter darkness, deep ingulft, his place
> Ordaind without redemption, without end.
>
> (*Paradise Lost*, Book V,
> lines 600–15).

The similarity between the plot of this passage, and that of Blake's account of his work on the 'experiment pictures', is clear enough: the blotting and blurring demons, the angels of darkness, tempt Blake, and when he succumbs to their temptation, and loses sight of his

original conception, his vision of origins, he is 'Cast out from God and blessed vision', and must fall 'Into utter darkness, deep ingulft'. To disobey God is the same thing as to disobey Christ, in whom the unity of the angels, and (as we have seen) of humanity subsists; and to 'break union' is to dissolve the 'individual Soule' which is the unity of all the 'Progenie of Light' under Christ, and in him.

The word 'individual' is thus used, as it regularly is by Milton, to mean—as the *OED* defines it—'that cannot be separated, inseparable'; 'forming an indivisible entity; indivisible'. This is the meaning of the word also, for example, in Book IV, where Adam is recorded as saying to Eve:

> to give thee being I lent
> Out of my side to thee, neerest my heart
> Substantial Life, to have thee by my side
> Henceforth an individual solace dear;
> Part of my soul I seek thee, and thee claim
> My other half.
>
> (*Paradise Lost*, Book IV,
> lines 483–8).[17]

The meaning of the word in both these passages is perhaps best conveyed by Johnson's dictionary, which cites them both: 'undivided; not to be parted or disjoined'; for whether he means to or not, Johnson gives his definition in a form which indicates the possibility that what '*cannot* be separated' may indeed be separated—it is not so much that an 'individual soul' cannot be, it should not be, divided, from other souls, or from Christ. It is this meaning that I am suggesting Blake has in mind when he speaks, in his account of *Satan calling up his Legions*, of his 'individual character' and his 'individual thought'.

Thus, Blake's 'individual' character is individual, not because it is uniquely his—as we have seen, no character can be that—but because, insofar as it is his 'character', it is what constitutes the ground of his unity with eternity ('characters' are the 'eternal principles . . . of human life'), with Christ, and so with other men insofar as they acknowledge their generic character. Indeed, it is because the visions of artists are visions of (among other things) these 'eternal principles or characters', that for Blake to lose sight of the 'blessed vision', of characters and their unity in Christ, is also to lose sight of his 'individual', his properly indivisible, character, which in being divided will divide him from others who partake in the same individual character, and leave him a mere, an 'imperfect' individual. And to lose sight of his individual character is also to lose sight of his

original conception, his 'individual thought'—the thought and the conception which, because a vision of the original and the eternal, is what unites him with eternity.

It is in terms of this definition of the word that 'individual' is redeemed of its pejorative overtones, but in being so its meaning becomes the opposite of that notion of uniqueness of personality, which emphasises difference rather than similarity, and which is the notion of individuality continually appealed to by those who wish to oppose Blake's ideas on art to the uniform principles of Reynolds. When Blake uses the term in that way, in his writings on art, he uses it as an accusation: it is the 'ignorant Insults of Individuals' that threaten to hinder Blake from doing his 'duty' to his art (561).[18] When he uses the term in a positive sense, however, it seems that we can only understand his use of it as consistent with his notion of 'character' if we attribute to the word the meaning which Milton also attributes to it. Thus, if nothing 'can be Changed or Transformed into Another Identity while it retains its own individuality', that is because the eternal identity of each thing—its 'substance', as opposed to its accidental qualities—is the characteristic mode of participation in, and indivisibility from, the eternal, ordained for it by God: if it were to change that mode, that identity, it would cease to be what in God's eye it is, and would 'break union'. If the 'Eternal Image and Individuality' of the oak-tree 'never dies', that is because its individuality, in the sense of its inseparability from eternity, is its eternal image, as the singular verb indicates; but as its eternal image is also its generic character, no understanding of 'individual' which is inconsistent with the meaning that Blake clearly attributes to character seems to be invited by the remark.

And that is the nub of my argument: I do not deny that within the local contexts in which the word appears in Blake's writings on art— local contexts, I mean, of a single sentence, or a few phrases—it is sometimes plausible to interpret the word as referring to a notion of unique, personal identity. I can sum up my point by saying that I believe that the first strategy we should adopt towards a writer is to attempt to understand her writings as making coherent sense; and, if we come to believe they do not, our next task is to try to understand how and why they do not. It may be that we cannot read Blake's writings on art as the statement of a coherent set of opinions. I happen to believe that we can; but if we always attribute to the word 'individual' the meaning that is attributed to it in, for example, the *Blake Dictionary* ('The INDIVIDUAL is unique . . . Each Individual is sacred . . . The Individual's duty is to be himself . . .'),[19] we can make no sense of Blake's use of 'character'. If we attribute the meaning I

have proposed, it is not only consistent with the meaning of 'character', it positively reinforces the complex reference of that word.

5. *'Original' (II)*

There are still some uses of the word 'individual' that require our attention, but it will be convenient to examine these in the course of considering Blake's opinions on individuality, or uniqueness, of manner or style, and whether it is, for him, a characteristic of an 'original artist'. If 'walking in another man's style' is 'repugnant to your own individual character', is to walk in your own, unique style the proper expression of the uniqueness of your own personality as an original artist, and indeed a ground of your claim to originality? It might well seem so: for Blake writes 'I know my Execution is not like Any Body Else. I do not intend it should be so; none but Blockheads Copy one another'. If Blake copies no other artist, and regards it as an indication of his superiority, his originality, that his style is not like anyone else's, surely this amounts to a claim that, as far as style, manner, execution are concerned, it is indeed the very basis of his originality that his style is his own, an expression of how he is unique, and differs from everybody else? When 'Protegenes struck his line, when he meant to make himself known to Apelles', did he not expect to be recognised by the fact that his line was like no one else's? And when Blake praised the drawings of Thomas Heath Malkin, who had died at the age of seven, because they proved him to have had 'a determinate vision of *things in his own mind*', was he not admiring the peculiar quality of Malkin's personal vision? (601, 439).

I don't think that Blake meant any of these things. I have quoted Blake's remark on Malkin with the emphasis attributed to it by Eaves, but my understanding of it is that Malkin had 'a determinate *vision* of things *in his own mind*', and was not a mere copyist of nature. The remark is probably, indeed, an echo of Reynolds's judgment on Titian, that, as compared with Raphael, he was deficient as an artist insofar as he did not possess 'the power . . . of correcting the form of his model by *any general idea of beauty in his own mind*' (my emphasis); where what is at stake is not a supposed difference between the ideas or visions of beauty proper to different minds, but the difference between the accidental forms of objects and an intellection of general forms by which those accidents may be recognised and removed; an intellection which characterises the great masters of form.[20] We are certainly wrong to presume that Apelles recognised

Protegenes as a particular artist with a singular style, and not as a true fellow-artist in that he drew in the one style, the 'true Style'; for Blake makes it clear that both artists 'knew each other' by the ability of each to draw 'the bounding line', the same line by which also Raphael, Michelangelo and Dürer are known to us as true artists—and it is in these or similar terms that, among Blake's predecessors and contemporaries, Junius, de Piles, Mengs, West, Fuseli and Haydon interpreted the famous anecdote.[21] In his account of the *Ancient Britons*, Blake claims that his figures in that work are 'not inferior to the grandest Antiques. Superior they cannot be, for human power cannot go beyond either what he [i.e. Blake] does, or what they have done; it is the gift of God, it is inspiration and vision' (600, 585, 579). If we record the vision faithfully and minutely, our representation of it will not be worse than that of other artists who have attempted to do the same; it will not be better, because the powers of true artists are all equal, and they are all copying the same vision, the same eternal images. For that reason Blake says 'I do not pretend to Paint better than Rafael or Mich. Angelo or Julio Romano or Alb. Durer', or 'to Engrave finer than Alb. Durer, Goltzius, Sadeler or Edelinck'. True artists must endeavour to 'emulate' other true artists, but do not suppose they can surpass them. To imagine that modern artists can improve on the works of their predecessors 'is not knowing what Art is; it is being blind to the gifts of the Spirit'—and we can understand that last clause as meaning that those who believe that the arts are progressive either do not partake of the vision, or do not realise that God gives the same gifts to all men. At one point in the 'Public Address' Blake writes that it has been his life's task to recover art to the 'Florentine Original & if possible to go beyond that Original', but as we shall see he means by that that his ambition is to produce an art which is not different in kind from that of Raphael and Michelangelo—theirs is 'the true Style of Art'—but to perceive the vision yet more clearly than they do. His images of beauty are 'not greatly different' from theirs or the antique; insofar as they differ, this is the result of how near each artist has approached to the same end (594, 600, 579).

The works of an original artist will not be 'greatly different' from those of another, either in invention or in style, for there is only one 'true Style', for Blake as for Reynolds, and those 'who endeavour to raise up a style against Rafael, Mich. Angelo, and the Antique' do so 'for the purpose of destroying art' (573). This is true because the 'true Style' is a function of the vision: it is true when it is 'appropriate' to, when it is 'resulting from' the 'inventions', the gifts of God, the same

1. Apelles 2. Protegenes 3. Apelles

18. Haydon's illustration to his account of the contest between Apelles and Protegenes (see below p. 354 n. 21). Haydon interprets the contest as concerned with degrees of correctness in drawing: each line improves on its predecessor, and the final line is perfect; each artist is known to the other by the correctness of his draughtmanship, and not by the expressive singularity of his line.

to all men. When Blake condemns 'walking in another man's style', this is because to walk in the style of any individual artist, who has his own individual style, is *ipso facto* to abandon the 'true Style'—for any man's personal 'style and manner' must be 'unappropriate' to the invention it is intended to represent. It is for that reason that Blake does not 'intend' that his execution should be 'like Any Body Else'— it should be 'like' the invention, the vision; the point is made clear by the fact that those who complain of the difference between his execution and that of other artists are complaining that his works 'are unlike those of Artists who are Unacquainted with Drawing' (591). When he himself complains that 'Commerce Cannot endure Individual Merit', his point is not that unique, individual styles are suppressed by commerce, though of course they may be. He certainly does mean that because commerce divides the labours of those who mass-produce pictures, and organises them in a factory system, the public has to be persuaded that the original authorship of a work is unimportant, and that 'all can do Equally well' at the task of picture-manufacture. But he means also that the factory-system, by dividing invention from execution, divides 'Journeymen' artists from the vision, the original conception which should unite the artist's labours (593). A work in the 'true Style' can only be produced by one man, because only in one man can invention and its appropriate execution be united. It does not affect the point whether we understand the word 'individual' here as meaning 'undivided from eternity' or 'single', for only single artists who execute

their own inventions can aspire to the 'individual' merit which is the result of being thus undivided.

That Blake does not think 'individual merit' is the function of any singularity of personality is further suggested by a note he made in his copy of Fuseli's translation of Lavater's *Aphorisms on Man* (1788). 'Take', suggests Lavater,

> from LUTHER his roughness and fiery courage; from CALVIN his hectic obstinacy; from ERASMUS his timid prudence; hypocrisy and fanaticism from CROMWELL; ... from RAFAELLE his dryness and nearly hard precision; and from RUBENS his supernatural luxury of colours:—deduct this oppressive EXUBERANCE from each; rectify them according to your own taste—what will be the result? your own correct, pretty, flat, useful—for me, to be sure, quite convenient vulgarity ... he alone has knowledge of man, who knows the ferment that raises each character, and makes it that which it shall be ...

To begin with, Blake responds to this aphorism by appearing to agree with it:

> Deduct from a rose its redness, from a lily its whiteness, from a diamond its hardness, from a spunge its softness, from an oak its heighth, from a daisy its lowness, & rectify every thing in Nature as the Philosophers do, & then we shall return to Chaos, & God will be compell'd to be Eccentric if he Creates, O happy Philosopher.

But as his note continues he begins to realise that Lavater has failed to distinguish between a notion of character as merely individual, as accidental, and a notion of it as generic and substantial, and we will remember that it was the want of the bounding line, the determinant of generic character, that Blake, in his *Descriptive Catalogue*, had warned would return the world to the chaos which, for Lavater, appears to be threatened by the failure to discriminate and value the accidental exuberances of each man. Thus Blake can agree that 'variety does not necessarily suppose deformity': a rose and a lily 'are various & both beautiful', but in so far as they are both differently beautiful, their beauty for Blake is substantial, not accidental. The variety that is produced by ugliness, however, is accidental, so that 'if Rafael is hard & dry, it is not his genius but an accident acquired, for how can Substance and Accident be predicated of the same Essence?'[22] Insofar, then, as Raphael's style is beautiful—insofar as, in the terms of Blake's writings on art, it is the 'true Style'—it partakes of his true character, his eternal substance; insofar as it is

ugly, it is accidental, and merely peculiar to him. And that Raphael's 'true character' is his generic character is made clear by what follows: 'substance gives tincture to the accident, and makes it physio-gnomic'— it makes accident, that is, indicative of the *kind* of charac-ter of which an individual partakes, for physiognomy is not the study of individuals, but of generic types (81).

There seems, then, to be nothing valuable about the way in which the style of one original artist differs from that of an other; but how do such accidental differences occur? If Blake's 'ideas of strength and beauty' are not 'greatly different' from those of the great Italians, why are they different at all? Such differences are partly, as we have seen, the result of the influence of demons such as Titian, Rubens and Correggio, but Blake does not, it seems, usually give way to the temptations they propose to him: he did not, apparently, in *The Ancient Britons*, but his ideas in that picture were still slightly different from the antique. Such differences as are not the result of a surrender to mere copying, Blake explains in spatial terms: it is all a matter of where you see the vision from, for the 'Vision is seen by . . . Every one according to the situation he holds'. The Last Judgment, the subject of one of Blake's most ambitious pictures, 'is one of these Stupendous Visions. I have represented it as I saw it; to different people it appears differently as everything else does; for tho' on Earth things seem Permanent, they are less permanent than a Shadow'. For this reason, though 'the Real Vision of Time is in Eternal Youth', Blake has 'somewhat accommodated' his 'Figure of Time to the common opinion, as I myself am also infected with it & my Visions also infected, & I see Time Aged, alas, too much so'. To the degree to which Blake sees Time as aged, to that degree his imagination is separated from the eternity in which Time is always young, and it is separated either by the obstructions of the vegetable world, or by the weakness of his will to overcome them. But in proportion, also, as his vision is not of the eternal, original vision, the same vision offered by God to all men, so he regrets, and does not celebrate, the degree to which his works are therefore peculiar to his own viewing situation, and less 'original'. The differences among the works of original artists are not a matter for rejoicing (604–5, 614).

These differences caused in our perception of eternal images by the differences of our situations becomes something of a recurrent theme of Blake's account of his now lost tempera version of the *Vision of the Last Judgment*. In this work he appears to have been concerned with the representation of 'states' rather than with character: 'states' are stages which we pass through, supposing as we pass through each that it exists no more. But in fact states are 'Eternal', and may therefore

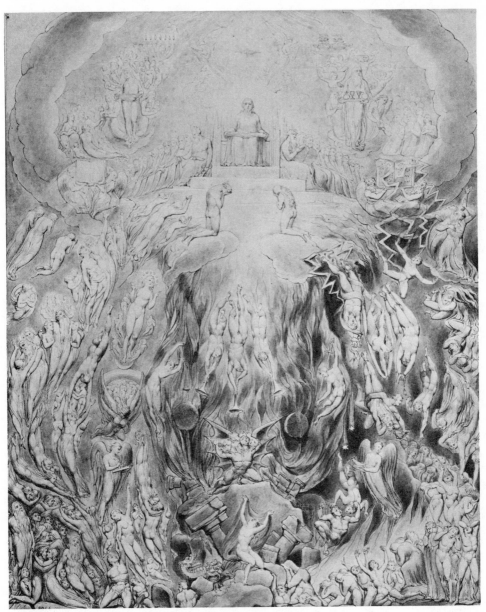

19. William Blake, *A Vision of the Last Judgment* (1806), a water-colour version of the lost painting of the subject.

be perceived in vision: 'Visions of . . . States . . . were reveal'd to Mortal Man in the Series of Divine Revelations as they are written in the Bible'. Because states are 'eternal principles of human life', they, like characters, are generic. The 'Individuals' in Blake's picture, the 'Persons', for example, of 'Moses & Abraham', are not, he insists, depicted *as* individuals, but as 'representatives or Visions' of the various states, and the representative, generic nature of his figures is repeatedly pointed out by Blake throughout his account: thus 'The Persons who ascend to Meet the Lord . . . are representations of those States described in the Bible under the Names of the Fathers before & after the Flood'; 'Above Noah is the Church Universal, represented by a Woman surrounded by Infants', and so on and on throughout the account (606–7, 609–10).

Blake insists as often as he does on the representative, the generic nature of his figures, because it is just this which will be misunderstood by those who inspect the picture from a situation further removed from the vision of eternity than his own. The more remote the situation, the more the states are in danger of appearing as mere individuals. When the states are 'distant they appear as One Man, but as you approach they appear Multitudes of Nations', and Blake himself, 'when at a distance' has seen 'Multitudes of Men in Harmony appear like a single Infant'. But such 'General Knowledge is Remote Knowledge', as Blake reminds us in this text and throughout his annotations to the *Discourses*: 'To Generalize is to be an Idiot. To Particularize is the Alone Distinction of Merit'; 'Generalizing in Every thing, the Man would soon be a Fool'. To understand the true meaning of his figures, the spectator must try 'approaching them on the Fiery Chariot of his Contemplative Thought', and the nearer he approaches, to the figures and to eternity, the more he will realise that states, like characters, are representative, and for that reason eternal (609, 611, 451, 460).

Blake's account, then, of his *Vision of the Last Judgment*, makes two particular points of importance to the argument I have been conducting. It helps confirm the fact that the differences among artists—among original artists—are to be regretted and are usually the result of their relative remoteness from their visions of eternity; for the different viewing positions occupied by each artist are not conceived as different points scattered in various directions at various distances from the object of vision, but as occurring at different points along a unilinear approach to eternity. It also makes the point that the further we are removed from eternity, the more prone we are to see persons as 'individuals' rather than as 'characters' or the representatives of eternal states, and so the more we are in danger of mistaking

'Time' and 'Space' for 'Realities' (605), and of fixing on the local and temporary accidents of singularity to the exclusion of the eternal and generic substance of human life. The more we see Blake as the proponent of an individualistic aesthetic, which defines originality as singularity, the further away we, also, are from understanding, on the terms on which he understood them, his writings and his art. Blake differs from Reynolds in many ways—in the hospitality he offers to a certain kind of particularity, a certain kind of variety, in his substitution of a visionary for an empirical imagination—but the first step towards understanding how they differ is to understand what they have in common. I can perhaps best suggest what that is by quoting a remark by Barry: 'in a great concourse of people, of what importance is it to be informed of the numberless trifling particulars in which each man differs from the other?'[23] For the Reynolds of the early discourses, that concourse is the whole world, or the whole of Europe at least; for Barry and for Blake, that concourse is one of several, which correspond to the several varieties of character. But within the perimeter of each concourse, however widely drawn, the function of the artist is to concentrate on the common, not the singular—to create a public.

Blake's account of character, though in its emphasis on the visionary and the innate it differs slightly from Barry's, is open to the same objections as I outlined in the last section of the previous essay, and can perhaps avail itself of fewer of the answers I offered to those objections. Physiognomy is, for Blake, a means of sorting sheep from goats, even though it is acknowledged that God created both.[24] It remains true, however, that for Blake as for Barry the aim to create a public is intended as a democratic aim, and it is to be created by what is intended as a democratic art—an art which presumes an equality, or a potential equality, of comprehension among its audience: the public it seeks to create is everyone, or at any rate is every man. Such an art will do without individual heroes except as the representative embodiment of human principles, in which terms everyone may be a hero, or, at worst, a representative villain; and it may, like Barry's art, do without a predominant central figure—as the *Canterbury Pilgrims* does, the composition of which is held together by the central figure of the host, who does not rise above the level line of the frieze, and who is the principle of sociability, 'equally free with the Lord and the Peasant' (569).

That last phrase, however, points to a problem in Blake's theory similar to the one disclosed by Barry's *Distribution of Premiums in the Society of Arts*:[25] that, if a democratic art is one which seeks to reveal the unity, and the equality, of a society divided by occupation, and if

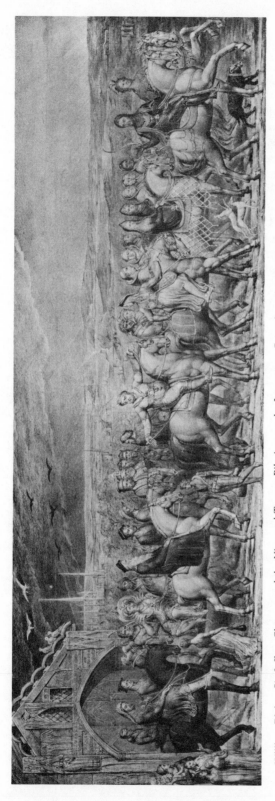

20. William Blake, *Sir Jeffery Chaucer and the Nine and Twenty Pilgrims on the Journey to Canterbury* (1808), Glasgow, Pollok House.

it attempts to equalise the different stations of men by representing them as all involved in a system of co-operative exchange, then it may well rest content with concealing, and so legitimising the inequalities it pretends to abolish. If we read the composition of the *Canterbury Pilgrims* from its centre outwards, then it is indeed united by the equable and equitable host; if we read it in terms of an order of precedence which dictates who shall lead and who follow, we discover that the 'Knight and Squire', although they may be conceived as 'the servants, and not the masters, of man, or of society', nevertheless 'lead the procession: as Chaucer has also placed them first in his prologue'; and if the knight, as a 'true Hero', is not therefore an individual hero, he is nevertheless claimed to exhibit a social superiority which is, or should be, the characteristic of the class he represents. Thus the dress and the horses of the knight and his son the esquire 'are of the first rate, without ostentation, and with all the true grandeur that unaffected simplicity when in high rank always displays'. The phrases 'true grandeur', 'unaffected simplicity', are such as enable an aristocracy to legitimise distinction by concealing it, and the intimation that 'unaffected simplicity' is the mark of a natural aristocracy makes it clear that Blake's democratic aims are partially compromised by a system of physiognomy by which the 'class' of an individual—now evidently meaning 'rank' as well as, more neutrally, 'type'—is determinable at birth, and forever determined thereafter (571, 567–8).

6. *'Public'*

'Mr B. appeals to the Public, from the judgment of those narrow blinking eyes, that have too long governed art in a dark corner.' It is an appeal he repeats throughout his writings on art. The first prospectus of his designs, etched in 1793, was addressed 'To the Public', and in the 'Public Address', of about 1810, he 'begs Public Protection' from those who have called him a madman, and seeks to 'rouse the Public Indignation of Men of Sense' at the contemporary state of art in England (563, 207, 508). He represents his labours as an artist, and as a commentator on art, as 'a Public Duty'. Thus it is 'a duty which Mr B. owes to the Public' to place his works on 'public Exhibition'; he thinks it 'his duty to Caution the Public' against the 'Impostors' who, 'in a Commercial Nation', will claim membership of the republic of taste (591, 573, 601). The duties of a true artist are always public duties: that is why those who seek to hinder Blake from doing his 'duty' to his 'art' are 'ignorant individuals', and that is why 'England

expects that every man should do his duty, in Arts, as well as in Arms, or in the Senate'—the two more usual theatres for the display of public virtue (561, 584).

The 'public' is however quite as much a 'forcible designation' for Blake as for Reynolds or Barry: very few, if any, of the citizens of Britain can claim membership of it, and one of the advertisements for his 1809 exhibition of pictures bears a motto from Milton, '*Fit audience find tho' few*'. His usual opinion of Englishmen is that they 'have a Contempt for Art'; they 'have been so used to Journeymen's undecided bungling that they cannot bear the firmness of a Master's Touch', and consequently, 'when they look at a Picture', they 'immediately set about searching for Points of Light & clap the Picture into a dark corner'—it is against this practice of 'Most Englishmen' that we saw, in the previous paragraph, Blake making his 'appeal' to 'the Public' (560, 596, 603, 599). At one point in his 'Public Address', Blake asserts that the opinion that 'The English Public have no Taste for Painting' is a 'Falsehood', and he argues that this is so because of their 'Contempt for Great Collections of all the Rubbish of the Continent brought here by Ignorant Picture dealers'—this is probably a conscious echo of Barry's repeated denunciation of 'our importations and numerous sales of pictures' which 'can hardly be considered in any other light, than as a common cloaca and sink, through which all the refuse and filth of Europe is emptied into this country'.[26] But for Blake the 'English Public' is evidently something different from 'Most Englishmen', who do indeed buy 'these Smears & Dawbs at an immense price' (601).

It seems that for Blake the English audience is only a public when it exhibits (as it rarely does) the qualities necessary to appreciate his work, or Barry's, or Fuseli's, or the works of the Roman and Florentine schools: 'I say the English Public are true Encouragers of real Art, while they discourage and look with Contempt on False Art'—and while they do not, they are not a public at all. In fact, the 'public' is for Blake as for his immediate predecessors best understood as a concept rather than as an identifiable body of people, however small:

> Call that the Public Voice which is their Error,
> Like as a Monkey peeping in a Mirror
> Admires all his colours brown & warm
> And never once percieves his ugly form.

By this account, the true public is the general will: when the judgment of the audience is correct, it is a public; it remains a mere audience when its judgment is mistaken—when it admires, like a monkey, only imitative art, and so admires pictures only as they reflect back

its own quotidian self and world: 'the shadows of generation and death' as 'reflected in the Vegetable Glass of Nature' (601, 597, 578, 605).

What then prevents the audience for art in England from realising its true, spiritual identity as a public, and what encourages it to prefer the 'Contemptible Counter Arts', and to contemplate images only of its false material self? The immediate answer is that 'in a Commercial Nation Impostors are abroad', who have imposed upon the English as they have upon all the nations of contemporary Europe, and introduced a false taste 'originally set on foot by Venetian Picture Traders'. Works of art have been converted into marketable commodities, and the 'public' has degenerated into a commercial cartel: 'The Rich Men of England form themselves into a Society to Sell & Not to Buy Pictures' (600–1, 452). But the success with which commerce has managed to represent works of art as the objects of manufacture, investment and private consumption is only a part of its wider success in the corruption of all public spirit. For commerce obscures the vision of the public: it blinds the imaginative eye of the audience, and conceals from them a conception of their unity. It has done this in the same way as, for Barry, it had divided the genres of painting, so that the properly and 'naturally' divided labours of different classes of men are represented as entirely separate, selfish activities which have no purpose in common, and the lines of distinction among men become not veins but sections. Thus divided, and denied any comprehensive vision of the final purpose of social organisation, men come to focus myopically on their own activities as ends in themselves, 'ignorant', in Ferguson's words, 'of the system in which they are themselves combined'. Because this condition of separation and myopia is the lot of all who have not persisted, as Blake has done, in keeping the several parts of a task united, and because, in a commercial society, success is measured in terms of material gain, the most admired men in contemporary Britain, whether artists or not, are those who have been most successful in disembarrassing themselves of any notion of the public, the common, and whose eyes, like those of Reynolds, are 'on the Many, or, rather, on the Money' (469).

It is because a vision of the public is fostered, for Blake as for Barry, by the arts and sciences that they are 'The Foundation of Empire', 'the Great Origin and Bond of Society'; and it is because commerce denies any notion of 'the public' that 'Empires flourish till they become Commercial, & then they are scatter'd abroad to the four winds' (445, 561, 594): 'where there is no vision, the people perish'. And because 'Empire follows Art & Not Vice Versa as

Englishmen suppose', Empires cannot 'Encourage Arts, for it is Arts that Encourage Empires'. Evidently, however, empires, governments, can 'hinder' the arts if they cannot help them: 'The wretched State of the Arts in this Country & in Europe' has its origin in 'the wretched State of Political Science', by which commerce has been permitted to convert the characteristic aptitudes of men into the masters, not the servants of society, and has thereby suppressed any vision of the unity of the people which it is the task of art to represent (597, 600).

It is therefore essential to Blake's determination 'to recover Art . . . to the Florentine Original' (600) that he should conceive of himself as a public artist, and attempt to produce public works: he seems indeed to regard the exhibition of his works only as a prospectus, or an advertisement, for the public frescos which he should, properly, be engaged upon. He 'wishes it was now the fashion to make such monuments' as those he has seen in his vision of the Cherubim, in which case 'he should not doubt of having a national commission to execute' his images of the 'spiritual forms' of Pitt and Nelson 'on a scale that is suitable to the grandeur of the nation'. For only by such monuments can we make 'England What Italy is, an Envied Storehouse of Intellectual Riches'. But for all the patriotic tone in which this wish is expressed, it is not a *national* public, if that is not a contradiction in terms, that Blake hopes to create by such public works (564, 566, 601). Though he is motivated by 'Love to My Art & Zeal for my Country', his patriotism is continually held in check by a more universal aspiration: in his 'Public Address' he declared, at first, that 'to recover Art' is 'the only pursuit worthy of an Englishman', but on second thoughts deleted 'an Englishman' and wrote instead 'a Man'; and in a verse-fragment of about the same date, he appears to suggest, or to warn, that France is more likely to 'restore' the 'arts of Peace' than is England (594, 600, 557).

Nor is it a *merely* civic ideal of the public that Blake hopes to represent and create in his future commission, for the true vision of the public is not, any more than was Barry's, a vision in which 'mere moral, peaceful, civic demeanour' was all that was required.[27] The public, for Blake too, was a religious notion, in which, as we have seen, the ground of unity among the different characters of society was that they were all 'members' of Christ's body, in which universal form their different aptitudes were comprehended. And because the public was for Blake, as it was for Barry, a religious and not merely a civic concept, it comprehended all men, it was a democratic ideal except that, like Barry's, it appears to have excluded women, or represented them only indirectly, through their relationship with

men: 'In Eternity Woman is the Emanation of Man; she has No Will of her Own'. It was because, in this limited sense at least, the public that Blake envisaged was a democratic vision, that he can describe his (relatively) cheap engravings, as well as his future giant 'portable frescos', as public works; and it is because the public properly comprises all men that its establishment must be based on a perception—or, at least, on an appearance—of equality among mankind (613, 207, 560). That perception is obscured by commerce, which obliges or encourages men to become 'servants' or 'Hired Knaves', 'held in vassalage', as Barry described them, by 'degrading, contaminated motives'. Commerce does of course impose a kind of equality on men, by the invention of means of production that ask us to be satisfied 'by What all can do Equally well'; but such an ideal of equality, by which the aptitudes of men are defined not by their differences in character but simply by the tasks they are obliged to perform, and so by which those aptitudes are depressed before being equalised, and constrained by being divided, cannot produce an ideal of the public as a common aim, and as an ideal of the highest potential of mankind (445, 593).[28]

Such an ideal of the public must be based on a concept of equality such as Blake implies when he claims to emulate, to equal, the productions of other original artists: who are 'equal' insofar as God vouchsafes his vision of 'the eternal principles of humanity' equally to all of them, and insofar as they overcome the obstructions of nature and commerce to represent that vision as accurately as possible. But it is only the obstructions of commerce that cause nature to be an obstruction, by representing it as some thing to be possessed and consumed; it is only commerce and private interest, in the final analysis, which prohibit an understanding of equality not as the lowest common denominator, but as the highest common factor of human ability. It is by dispelling the clouds of private and individual interest that a public art can reveal its vision of the public—of a religious republic of taste which *is*, for Blake, the political republic, where 'The Whole Business of Man Is The Arts, & All Things Common' (777).

HENRY FUSELI

I. Introductory: the two voices of Fuseli

To NONE of the writers we are considering was it more evident than to Fuseli that the failure of Britain in particular, and of post-renaissance Europe in general, to produce art in the grand style—what Fuseli called 'higher art'—was the result of the process of 'privatisation' which I discussed in my introduction. Indeed, that process is explicitly offered by Fuseli as the efficient cause of all change in the visual arts in Europe: 'in this point of sight we can easily solve all the phaenomena which occur in the history of Art,—its rise, its fall, eclipse, and re-appearance in various places, with styles as different as various tastes'. In modern Europe, he argues, the production of art has ceased to be governed, as it had been in republican Greece and in the Italy of Michelangelo and Raphael, by aims common to all its practitioners: there is now no 'uniformity of pursuit', and artists now seek 'individually to please': to please individuals, and to please *as* individuals, in the post-Miltonic, but (for Fuseli) pejorative sense of the word. 'As zeal relented and public grandeur gave way to private splendour, the Arts became the hirelings of Vanity and Wealth; servile they roamed from place to place, ready to administer to the whims and wants of the best bidder.' Artists have become servants, no longer of the public, but of the wealth they seek to secure and of the patrons, themselves also the creatures of capricious, artificial wants, from whom they seek to secure it. 'The ambition, activity, and spirit of public life is shrunk to the minute detail of domestic arrangements—every thing that surrounds us tends to show us in private, is become snug, less, narrow, pretty, insignificant.' This decline, into what Gibbon had characterised as the 'languid insensibilities of private life', is denounced with all the fury of John Brown castigating the refusal of his contemporary Britons 'to go . . . beyond the beaten Track of private Interest', so that 'he who merely does his *Duty* in any conspicuous Station, is looked on as a Prodigy of

Public Virtue'.[1] To imagine that a public art can emerge or survive, Fuseli argues, in societies thus privatised, at least 'without a total revolution', is only ... less presumptuous than insane'; for though the public arts may, for Fuseli as for the earlier writers we have considered, create a public, they must also be, in some measure, a creation of it: and 'where', Fuseli asks, is 'the public prepared to call them forth, to stimulate, to reward them'? (3: 45–9; 2: 94)*

There is much in Fuseli's account of modern society that can be understood simply as a more systematic rehearsal of what Barry had said and what Blake was saying, and, like them, Fuseli uses that account as the basis for a violent attack on the corruption of modern Britain, and on modern artists who, partaking of the corruption of their audience, treat art as a commodity, and materialise the spiritual and the ideal by converting style to manner, and means to ends. But to Fuseli it did not always seem possible to arrest the processes of privatisation and commercialisation by protesting against them, or even by redefining the public function of art and of criticism in the belief or hope that a public art, however redefined, could of itself create a public. 'What hinders modern Art to equal that of classic eras, is the effect', he insists, of 'general', of 'irremovable causes', which are to be looked for in the 'bent, the manners, habits, modes' of European nations, and which have no clear origin or end, and seem to deny access to whoever would seek to act upon them (3: 8, 47).

Nor is it always clear that Fuseli would have wished it otherwise: as Eudo Mason has written of Fuseli's disagreements with the members of Godwin's circle, 'he not only fails to share their optimistic faith in civilisation and its future; he does not even *want* to share it'.[2] Mason is no doubt right, in part, to attribute this attitude to a studied cynicism in Fuseli, but it seems to me that he did not 'want' to regret or to believe, also because he thought that to do so was to convict oneself of a kind of false-consciousness. If we, like the arts, are as much the products of a general, diffused and often invisible cultural conditioning as Fuseli believed, then, though we may wish that our individual lives were different, we cannot really wish that 'life' were different, because we cannot imagine how it could be; and to 'want' things to be different may simply be to indulge another of the artificial wants by which our nature has been shaped—a want, moreover, which is indulged only in the assurance of the impossibility of its being fulfilled.

Thus Fuseli's denunciations of modern art and of the societies which have produced it must be interpreted with caution, and understood in terms of a complex irony by which the pronouncements of two

* All volume and page numbers in this chapter refer to *The Life and Writings of Henry Fuseli*, ed. John Knowles, 3 vols., London 1831.

different voices are often mingled and passed off as harmonious. On the one hand there is the voice of the stoic guardian of public virtue, the gentleman, as Fuseli claimed to be,[3] of comprehensive vision, who looks with exasperation on a society becoming ever more disorganised, who denounces all indications of a centrifugal flight into privacy, and treats them as the result of a 'wilful perverseness' on the part of 'men' who 'declare that they know what is best, and approve of it, but must, or choose to follow the worst' (3: 48). On the other hand is a milder voice, sympathetic to human weakness, and able to appear more so as the stoic voice becomes more angry; so that we sometimes seem to be witnesses at the interrogation of a corrupt public by a couple of TV cops, one irascible and threatening violence, one soothing and pacific—one determined to stamp out corruption, one hopeful of re-forming the corrupt, but both with visions of a society fit for decent people which are similar if not quite the same. This second voice is that of a man who knows himself to be the victim of history rather than its critic, who sees himself as inescapably part of the corruption he attacks, and which no modern can escape.

Both voices are heard in Fuseli's account of Rubens's work, for the Luxembourg Palace,[4] which, 'if it be not equal in simplicity, or emulate in characteristic dignity, the plans of M. Agnolo and Raffaello, it excels them in the display of that magnificence which no modern eye can separate from the idea of Majesty' (2: 370). To conceive of such a judgment, Fuseli must conceive of himself as the critic of history, capable of eluding its determinations, and able to judge Rubens's work by the standards of the great era of Italian art, and to see that, in comparison with the values which guided that era, Rubens has nothing to offer but manner and *mere* magnificence, where Raphael and Michelangelo offer us majesty. That judgment, however, is never uttered, but an entirely opposite one, by which magnificence is proclaimed to be a worthy, indeed a noble aim for the artist to pursue. The modern eye, which finds immense satisfaction in these works of Rubens, and whose satisfaction is shared—as his enthusiastic tone clearly enough declares—by Fuseli, is so habituated to mistaking magnificence for ideal majesty, to taking things as the embodiments of value, the artificial for the simple, the shadow for the substance, the signifier for the thing signified, that though it may still be able to distinguish a work by Raphael from a work by Rubens, it cannot tell the difference between the values each embodies. It seems that to prefer Raphael to Rubens, by this account, would be to claim that one can do what is existentially impossible, and elude the 'irremovable causes' that determine our vision; at the same time as— and to make that very point—Fuseli writes as if he can, and does, elude them.

Fuseli's writings on art can be taken as an attempt to define a mode of painting that will somehow acknowledge and account for divisions which, in their various forms, produce in him these opposed voices and judgments, and will propose a mode of relation between public and private: between the public virtue of the stoic, and the private vices of the moderns, 'enamoured of our wants' (3: 42). Such an art will seek to perform something, at least, of the public function performed by Greek art, or by the painting re-established in the Renaissance: it will address us, if no longer as members of a public, at least as members of some common body that can appear as a plausible substitute for a lost public sphere. But it will also have to acknowledge that the modern fall into privacy is largely irredeemable, that our very desire to possess works of art is the symptom of an acquisitive individualism, and that an art which seeks to make us aware of our common identity must address us also in our identities as private individuals, and as private individuals who are very largely content, indeed anxious, to remain so. Simply to reaffirm and to demand our allegiance to the ideal of a public art as defined by the traditional discourse of civic humanism, Fuseli sometimes believed, is to fail to allow for the wind: the generic identity of the free citizen as defined by civic republicanism has become to the modern an image not of freedom but of a uniformity which is taken to be its opposite; for though the freedom of the individual was born, Fuseli believes, out of the exclusion from political participation of those who, in republics, had been citizens, and though this freedom is (in the eyes of the stoic) a poor and deceptive substitute for the truly civic liberty then enjoyed, it is the only freedom known and understood by the moderns. The actual, if not the proper function of art has become to offer us images of our freedom to want what we like, to behave as capriciously as we like—and an orthodox public art which demands that we exchange this freedom for another, which it claims is far nobler, may in fact be offering 'a tame remembrance of antiquated heroism', of no relevance to the conduct either of public or private life.[5]

This introduction is running ahead of itself, as is the way of introductions; for, as anyone familiar with Fuseli's writings will know, they are full of denunciations of modern corruption, and of proclamations of his allegiance to the ideal, epic, heroic art of Michelangelo in particular: more often than not, it is the voice of a Spartan civic humanism that demands most of our attention, not least because it is possessed of a more demanding rhetoric. But as Fuseli got older—his Academy-lectures were published over a quarter of a century, from 1801 to 1825—his belief in the value of an art of compromise, an art

which acknowledges our fallen nature and our attachment to a de-
based version of freedom, became increasingly clear, and the terms
of the compromise are worked out in his continual redefinitions and
revaluations of the art of Michelangelo and Raphael. But that these
painters remain for him, throughout his writings, the only painters
that seriously and for any length of time engage him, is an indication
also that his allegiance to the notion of a public, or at least a common
art, never disappears. The argument between the voice which pro-
claims that allegiance, and the other which acknowledges that we are
all, Fuseli included, 'enamoured of our wants', is not won by either
party; and on some occasions it issues, appropriately enough, in the
elevation of 'dramatic' painting to the top spot in the hierarchy of
genres, above 'epic'. Whatever we think of it, it is this especially that
Fuseli contributes to the debate we are examining: so that whereas
Barry and Blake seek to reaffirm the pre-eminence of an epic art, by
redefining it in such a way as to enable it to affirm the compati-
bility of our differentiated identities and the idea of the public, the
dramatic art admired by Fuseli is one which seeks to acknowledge the
tension between them, and to exhibit 'character in the conflict of
passions with the rights, the rules, the prejudices of society' (2: 195).

2. *The history of painting in Greece*

According to Fréron, 'the arts and sciences have their beginnings,
their progress, their revolutions, their decadence, and their final fall
just as do the empires of the world'. Fuseli writes as a historian of art,
and seems to think of himself as the first writer to develop a history of
painting able to account, systematically and in detail, for changes in
subject, style and technique in such a way as represents them as the
effects of such general changes in the history of civil societies as
Fréron is concerned with. He employs a three-phase model of
history, by which the development of the art should properly proceed
through periods of preparation, establishment, and refinement; and
the plot of his historical narrative turns on the failure of modern art to
repeat the normative pattern of development accomplished by the
Greek artists: in modern Europe, the third phase has been one of
depravation rather than refinement. This account of the progress of
the history of art—at least of the ideal progress it exhibited in
Greece—seems to owe more to Vasari's three-phase system than to
the various, more complicated systems proposed by Winckelmann,
from whom, however, Fuseli borrows more of his vocabulary. But
whereas Vasari had envisaged that history as a process of steady

improvement towards a single perfection achieved by Michelangelo, Fuseli's account of the progress of Greek art is one in which the artists of each phase of art propose to themselves a particular kind of excellence, achieve it, and thereby oblige the artists of the next phase to regard the goal of their predecessors as the origin of their own journey towards whatever they propose to themselves as the new excellence that art must aim at. And Fuseli's notion of the development of painting is more pessimistic than Vasari's: the 'refinement' of the third phase of Greek painting is the only goal available to artists whose predecessors have already brought the art to perfection. The failure of modern artists of the third phase to aim even at the qualified excellence of refinement does mean, of course, that like the last Greek painters as characterised by Winckelmann, they fell into decadence; but, unlike Winckelmann, Fuseli accounts for this decline in terms of the processes of history as described by civic humanism— by John Brown, for example—and not in terms of causes to be looked for, as those offered by Winckelmann are, within the nature of the art itself, or in the tendency of nature at large to fall into corruption.[6]

Unlike Barry and Blake, Fuseli has no interest in the theory that there might have arisen, in pre-historical times, a school of painting worthy of comparison with that of the Greeks: for Fuseli, the arts are entirely the products of civilization, and it was quite simply the pre-eminence of Greek civilization which produced the pre-eminent art of Greece. Essential to the relationship between the two was the fact that the '*civil* and *political* institutions' of the Greek republics required that life be led in public, and that the function of art was to create and confirm that public space by representations whose purpose was 'to record the feats, consecrate the acts, perpetuate the rites, propagate the religion, or to disseminate the peculiar doctrines of a nation'. The arts 'led the public', and the public, aware of the importance of the arts to its awareness of itself, and to its survival as a public, was content to be thus led (2: 24, 32; 3: 45).

That art had this function, and this function alone, ensured the creation not only of a coherent and unified public, but of a coherent tradition of art: one principal reason 'why the Greeks carried the art [of painting] to a height which no subsequent race or time has been able to rival or even to approach' was the 'simplicity of their end, that uniformity of pursuit' which emerges from all accounts of the painters and paintings of Greece; so that their art 'in all its derivations re-traced the great principle from which it sprang, and like a central stamen drew it out into one immense connected web of congenial imitation'. It would take too long to disentangle the word-play (or the

simple confusion) involved here in Fuseli's imagery, but clearly
enough his point is that, through all its varieties of style and subject,
Greek painting, always 'various in its applications', was also always
'uniform in the principle': in such a way that it was possible to see
through any individual work to the tradition of which it formed a part:
to grasp at what point and in relation to what aspects of that tradition
it had been produced. Thus each work could be seen also as an image
of the relation of the individual and the public: each performing
different tasks, and proceeding by different routes, to the same end
and with the same common, 'congenial' purpose. Greek painting
could exhibit a considerable freedom in its choice of style and subject,
but it was an organised freedom, like that of the citizens by and for
whom it was produced (2: 24–5).

This was true, at least, of the first two periods of Greek art, the
periods of preparation and establishment; it would seem rather less
true of the final period, were it not that, in his account of the last
Greek painters, Fuseli changes voice, and is able to approve, as a
modern, private man, what as a traditional civic humanist he would
have been obliged to condemn. The period of preparation is rep-
resented by Fuseli as having been initiated by Polygnotus, and as
ending with Apollodorus, and by its end the painters of the period
had produced a vocabulary of central forms which they bequeathed
to their greater successors. The works of Polygnotus were produced
in what Fuseli terms 'the essential style': their achievement was to
define the central form of mankind much as it was defined in the early
Discourses: a form which identifies and eliminates the marks of indi-
viduality and of character, so as to discover 'the stamen of the genus',
the mean, the uniform configuration in which all individuals partake
and from which all, to some degree or another, depart. Thus, though
Polygnotus's figures were not without 'glimpses of *grandeur* and ideal
beauty', they were unidealised, the common denominator of the
genus, and not its highest common factor; an image of what mankind
was, not of what it might become (2: 37, 33). The achievement of
Apollodorus was to add to the discovery that 'all men were connected
by one general form', the additional discovery that 'they were separ-
ated each by some predominant power', which 'fixed character, and
bound them to a class'. He understood also that 'in proportion as this
specific power partook of individual peculiarities, the farther it was
removed from a share in that harmonious system which constitutes
nature, and consists in a due balance of all its parts'. He therefore
'drew his line of imitation' at what could plausibly be regarded as 'the
central form of the class': the point where differentiation in terms of
a physical character can still be perceived as generic, not individual,

and can still claim to be worthy of imitation by virtue of a harmony and balance derived from its visible relation to the 'one general form' discovered by Polygnotus (2: 35–6).

There can be no need, at this stage of our enquiry, to expand on how the works of these artists would have been conceived of by Fuseli as constituting, in different ways and with a different balance of emphasis, a public art; or to point out that, though especially in his account of Polygnotus Fuseli places stress on the fables he represented and their appropriateness to his 'public genius' (2: 32), his main concern was to show that the public function of art is primarily fulfilled by the nature of the figures, the public bodies, it depicts. The same concern is, for the most part, evident in his account of the period of establishment, exemplified by Zeuxis, Parrhasius, and Timanthes. In this period central forms were elevated into ideal forms; and what Fuseli will later term the 'historical' style of the first period, which represents mankind as it is, according to its essential nature, develops into the 'epic' style, which represents mankind as it might be, according to an idea of nature as the highest possible development of which a thing is capable. This transformation was initiated by Zeuxis, who 'framed ... that ideal form, which in his opinion, constituted the supreme degree of human beauty, or in other words, embodied possibility, by uniting the various but homogeneous powers scattered among many, in one object, to one end'. The aim is the same as that proposed by Reynolds in the third discourse: an elimination of particular character, achieved by the very plenitude of its representation; so that the ideal figure transcends the determination of character by being all characters at once: Apollo, Hercules, and the Gladiator. The models which Zeuxis had in mind in attempting this transcendent ideal were, Fuseli explains, the Jupiter of Phidias, the 'full type of majesty' in whom the different lineaments and capabilities of all other gods are perceived and combined, and the Achilles of Homer, in whom 'the various but congenial energies' of the lesser heroes of the *Iliad* 'reunite in one splendid centre'. The ideal figure defined by Zeuxis thus combines in himself the entire range of possible identities and functions available to mankind, and, like Peter the Great, Barry's Jupiter, or Blake's Jesus, is that heroic *plenum* in which the balance of uniformity and difference, essential to a healthy and a free society, is perfectly embodied. Or not quite perfectly; for it was left to Parrhasius, by the completeness of his taste and the accuracy of his measurements, to establish the canon of proportion by which the figures depicted in this epic art could infallibly be represented as 'all, the sons of one, Zeus', the god omnipotent (2: 37, 41, 204).

Such images of omnipotence, or of embodied, unlimited possibility, seem to have had, though briefly, a particular value for Fuseli. He describes their value with great brilliance at the conclusion of his first lecture, but he does not refer to it again, perhaps because he was later implicitly to deny (see p. 291 below) that such images *could* be created, and to suggest that the modern art, which it becomes his main concern to define, is an art which represents and communicates with the limitations imposed on the individual by modern, divided societies. His account of their value appears as an argument against Reynolds's remark on Euphranor's Paris, that 'a statue, in which you endeavour to unite stately dignity, youthful elegance, and stern valour, must surely possess none of these to any eminent degree'.[7] 'But may not dignity', asks Fuseli, and 'elegance, and valour, or any other not irreconcileable qualities, be visible at once in a figure without destroying the primary feature of its character, or impairing its expression?'—and he invites us to agree that in the works of the greatest Greek sculptors, though there is a predominant first impression which the artist 'meant to make upon us', there is nothing to oblige our 'contemplation' to stop there. When we consider the beautiful features of the Apollo, 'what hinders us':

> to find in them the abstract of all his other qualities, to roam over the whole history of his atchievements? we see him enter the celestial synod, and all the gods rise at his august appearance; we see him sweep the plain after Daphne; precede Hector with the aegis and disperse the Greeks; strike Patroclus with his palm and decide his destiny.

In the same way, the Paris of Euphranor, as described by Pliny, was of a 'character so pregnant':

> that those who knew his history might trace in it the origin of all his future feats, though first impressed by the expression allotted to the predominant quality and moment. The acute inspector, the elegant umpire of female form receiving the contested pledge with a dignified pause, or with enamoured eagerness presenting it to the arbitress of his destiny, was probably the predominant idea of the figure; whilst the deserter of Oenone, the seducer of Helen, the subtle archer, that future murderer of Achilles, lurked under the insidious eyebrow, and in the penetrating glance of beauty's chosen minion.

These subordinate identities are not claimed by Fuseli to be more than 'collateral and unsolicited beauties', which must immediately, however, 'branch out from the primary expression' of every 'great

idea': the artist *intends* a unity of expression, but of 'one *great* expression', whose grandeur makes it 'inexhaustible' to contemplation, in the sense that it is, like the central moment of an action as defined by Lessing, capable of recalling every moment in the past or future of the story of which the central moment is the present. For Fuseli as for Lessing, however, it is an essential limitation on the fecundity of an image that it can thus be interpreted only by those who know the story: it is not open to every conceivable addition we may care to make, and is 'inexhaustible' only insofar as it does not therefore become ambiguous; for Fuseli, as for Reynolds, an ambiguous art is not a public art (2: 67–71).[8]

In inviting us thus to complete the history of the characters and actions represented by sculpture, Fuseli is not, he insists, intending to 'invalidate the necessity of its unity, or to be the advocate of pedantic subdivision'; for 'all such division diminishes, all such mixtures impair the simplicity and clearness of expression'. The great idea expressed by the sculptor must be a unity, but to say as much supposes that it is not an idea emptied of content, as the central forms of Reynolds were emptied of character, but that it is a unity, a *great* idea, because it makes one an inexhaustible range of possible characters and actions. It is, in short, an image of man as embodied possibility, as 'fitted', in Barry's terms, 'to an infinity of pursuits', but not yet as determined by any one of them, not yet subject to the 'infinity of differences' by which men become distinguishable in the world. And Fuseli's point seems to be that such images, like the so-called 'Juno Ludovisi' as described by Schiller, can return to us a sense of our original, infinite determinability, but only if we grasp the range of possibilities they embody *as* a unity, and do not attempt to privilege one character, one possibility, over another, or over the unity of them all. In the face of the Laocoon, for example, the 'compass' is 'poised' by the artist, so as to be capable of moving freely in all directions; but for us to 'apply' it, so as to steer in one determinate direction, is to negate the pure determinability of the image. We may enjoy that determinability for only as long as we can resist the temptation, as Goethe described it in his own account of the Laocoon, to '*divide* the unity of human nature', and can contemplate the potentially inexhaustible ramifications of the figure as each of equal weight, and as together composing the unity of its grandeur. We too are 'poised' by the Laocoon, as was Schiller by the 'Juno Ludovisi', in such a way as enables us to recover the infinite potential we have lost by the division of labour, and which we will lose again when we turn away from the image.[9] But this redemptive power of beauty is hereafter ignored in Fuseli's Academy-lectures: it is not to be the function of art, as he

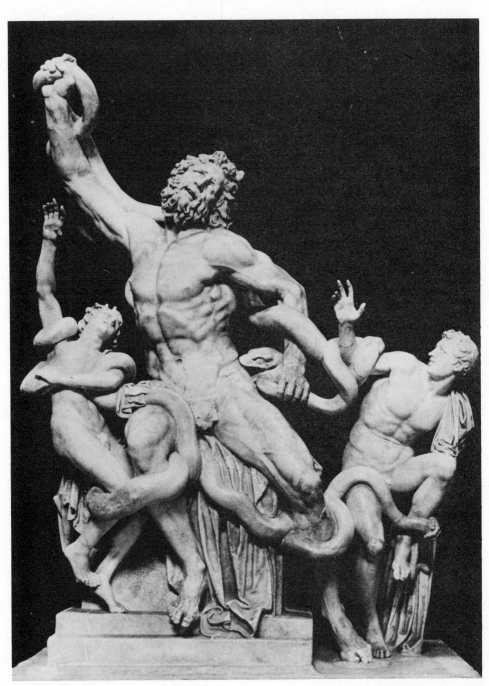

21. *Laocoon*, Rome, Musei Vaticani.

envisages it, to pluck us out of the times and circumstances in which we find ourselves (2: 71–2).

The period of establishment in painting closes with Timanthes, who 'inspired' the forms of Parrhasius with 'mind', and 'animated' them with passions (2: 44). The art seems now complete, and we might imagine that a third phase of art, described as one of 'refinement', would have no other option than to repeat the achievements of the great artists of the previous period—it might polish them a little, but at the price of a loss of power, and could have no sense of initiating anything. This sense of belatedness, of everything worth doing already having been done, is often evident in Fuseli's account of the last Greek painters, whose work 'added grace and polish to the forms it could not surpass', and 'amenity or truth to the tones it could not invigorate'. It is evident, for example, in the account of Apelles, whose reputation for 'unrivalled and unattainable excellence' must be modified by the reflection that 'his great prerogative consisted more in the unison than in the extent of his powers', and that his greatness was founded in the knowledge of his limitations, and of how far they could be concealed by grace of conception and execution and by refinement of taste (2: 58, 62–3). But the same sense of belatedness is apparent in the account of artists who seem less concerned to refine the art, or at least to polish it, and who are anxious to pretend to originality even at the risk of transforming an age of refinement into one of depravation. We can catch it in, for example, the words which, half-quoted from Pliny and half attributed to him, comprise Fuseli's account of the advice given by the first artist of this period, Eupompus, to his pupil the sculptor Lysippus. Excellence, explains Eupompus, is always the aim of art, but is not to be attained by 'servile imitation', even when it seems that everything worth achieving has already been achieved:

> If Phidias and Polycletus have discovered the substance and established the permanent principle of the human frame, they have not exhausted the variety of human appearances and human character; if they have abstracted the forms of majesty and those of beauty, Nature, compared with their works, will point out a grace that has been left for thee; if they have pre-occupied man as he *is*, be thine to give him that air with which he actually *appears* (2: 59–60).[10]

The speech suggests clearly enough that, if the artist of the third phase is not merely to be an imitator, he may have to represent exactly what earlier artists, born at a more fortunate time, would have thought it beneath the dignity of their art to represent: an

unidealised variety of 'familiarised expression', 'character', and 'fleshly charms'. The advice of Eupompus was apparently followed not only by Lysippus but by Aristides, who 'drew the subtle discriminations of mind in every stage of life, the whispers, the simple cry of passion and its most complex accents', and by Euphranor, who 'carried still further' the 'refinements of expression', in such a way as might seem to threaten the principle of generic character which, according to Fuseli's account of Apollodorus and Timanthes, is the only principle on which a public art can admit the representation of differentiated character or passion (2: 58, 61, 64–6, 67).

The age of refinement, as thus described, seems to threaten the dissolution of what had seemed to be the normative pattern of development through the two previous periods: a pattern of uniformity which comes to admit variety, is brought back to uniformity but at a more ideal level, and then learns once more how to admit a variety by which its virtue is not dissipated. Thus Polygnotus discovers the central form of an uniform human nature; Apollodorus divides it into the different central forms of generic character; Zeuxis re-unites these in the figure of the ideal, universal hero, and Timanthes animates that figure with a variety of passions. In the artists, however, who follow the advice of Eupompus, differentiation is followed by more and still more differentiation, so that we might imagine that the public function of painting, insofar as it has been shown to depend on the exhibition of representative figures of humanity, will be increasingly lost among the 'most complex accents', the increasingly individualised images of nature 'as she actually appears', which is the only object of imitation now left to the painter who wishes to be thought an original. We might expect further that Fuseli will find this a reprehensible development, better described as depravation than as refinement: a judgment apparently foreshadowed when he introduces the art of the third phase as 'luxuriant', a word which we recognise by now as gesturing at a connection between the misgrowths of caprice and a superabundance of commercial activity (2: 58).

But, once again, a judgment we seem to have been prepared for is not delivered, and for two kinds of reasons. To begin with, Fuseli reminds us that a decline in art is the effect, and not, for him, the cause of a decline in civilization: the advice of Eupompus was 'less lofty, less ambitious than what the departed epoch of genius would have dictated, but better suited to the times'. A more elevated art would have elicited no response from its audience, for 'when the spirit of liberty forsook the public, grandeur had left the private mind of Greece'. But still 'those who had lost the substance fondled the shadow of liberty; rhetoric mimicked the thunders of oratory, sophistry and metaphysic

debate, that philosophy which had guided life, and the grand taste . . . began to give way to refinements in appreciating the degrees of elegance or of resemblance in imitation'. The art advocated by Eupompus was, it appears, not just the art the tyrannies deserved, but the best art which, in the circumstances, they could have produced, however reduced in scope, and however much directed, of necessity, to the private judgment of men whose taste could no longer be exercised in promoting a public art (2: 60–1).

But as Fuseli's account of the age of refinement proceeds, the sense of belatedness and attenuation seems to give way to a sense of freedom, of proliferating opportunity, and, first of all, to a new kind of congeniality between art and audience. For post-republican Greece, the problem of justifying the apparent decline in the ideal of humanity represented by Eupompus and his followers was deferred by the fact that the 'more familiar' forms of their art elicited a more immediate and a warmer response than an epic art could have done: the human figure, as represented by Lysippus, was converted from 'an object of cold admiration' to 'the glowing one of sympathy' (2: 62). His more familiar, more differentiated, more individual, and so less 'public' bodies, were stripped of enough of the dignity of epic to enable the now privatised audience to respond to them in their new capacity as private individuals, whereas the older image of *vir publicus*, now an ideal they cannot attach meaning to, or even persuade themselves they lack, could now be appreciated by them at best as a cold abstraction, a purely formal achievement which spoke now only of its empty perfection. Thus, by engaging those affections of sympathy by which private individuals can discover a sense of their common humanity, the art of the age of refinement was, Fuseli imagines, able to provide a necessary and valuable substitute for the lost sense of public spirit and solidarity which had been represented, to an earlier age, by an earlier art.

This substitute (as it will appear to be, in the perspective of a criticism founded on the public art of earlier periods) could not, however, have fulfilled its function unless the art of refinement was still an art in which, in some way, 'the great principle from which it sprang' was still visible. That it was so, Fuseli suggests, was guaranteed in two ways. In the first place, the judgment that the citizens of the Greek republics were used to exercise in the conduct of the polis, had now migrated, not just to the conduct of private life, but also to a republic of taste newly divided from the political republic, and it there employed itself in measuring the gap between the unidealised representations offered by contemporary painting, and the ideal forms of earlier art, from which contemporary artists deliberately

depart in search of the familiar and the congenial. When the meaning of a painting depends on our ability to measure that gap, and thus to measure the individuality of a body by the uniform proportions of a 'public' body, that standard may be safeguarded though it is never depicted. In the second place, the artists themselves were careful, or so Fuseli believes, in all the complexities of character and expression they depicted, never to allow 'imitation to deviate into incorrectness' (2: 61). They melted, they softened, they familiarised the ideal, but never entirely obliterated it, and to artist and audience alike, the acknowledgement of what is common to humanity is the essential condition on which the representation of variety is permissible.

Thus the loss involved in the transition from an art which is public to an art which is, at best, common, is forgotten by Fuseli as he contemplates its attractions. It is not simply that the art of refinement was the best art that an age of tyranny can deserve. For what seems particularly to excite Fuseli is the notion that, with the collapse of the republican ideal of political freedom, new kinds of personal freedom emerged: a freedom which allowed the artist to choose how to be original—to choose what to paint, and to pursue an 'inexhaustible variety' of 'new combinations' (2: 61)—and a freedom which allowed the members of the audience individually to judge, to sympathise, and did not oblige them merely to admire. And the Greeks of that period could hardly be blamed for preferring those freedoms, the only freedoms they knew, to those political freedoms which, at least from the perspective of a republic of taste now divided from the political sphere, could look far more like constraints. As long as Fuseli speaks, as I have represented him as doing in the last few pages, in his modern, and private voice, he will seem to prefer the kind of social affiliation based on sympathy which is promoted by this less lofty art, to what his sterner voice insists is the higher, the properly public ideal. But if he does so, that is because he can still recognise in the third phase of Greek art the limitations on personal freedom of taste, by which the representation of individuality is still tethered to an ideal of common humanity. When, in his considerations of the art of post-renaissance Europe, he can no longer discover those limitations, only his public voice is able to be heard.

It may be worth recapitulating here what I take to be the main point to have emerged from this consideration of Fuseli's account of the third phase of Greek art, for it is of importance not only to his account of the equivalent phase in modern Europe, but, as we shall see, to his late decision to propose the art of Leonardo and of Raphael as the art most to be admired in an age of private character. His point, then, is that as long as it can plausibly be regarded as the function of art to

confirm the public spirit of a society at the expense of variety and differentiation of personality, it will remain the duty of artists to fulfil that function. But if the history of civilization itself makes it impossible to perform that function, then though the art itself may decline in importance and value (as measured in terms of its ability to influence the perception and conduct of public affairs), this contraction in its scope may appear to artists as an extension of their individual freedom, to paint what they like, and the works they produce will reflect more accurately the concerns of the societies in which they find themselves, than a public art (could it possibly still be produced) could do. Seen in this light, the problem of an art 'depraved' by the depravation of society, and by its atomisation into individuals, is whether it can do more than reflect—whether it can also in some way redeem—its own fallen condition and that of the society that has produced it. By engaging the 'glowing sympathy' of their audience, Eupompus and his followers succeeded in that second task; and in that light their art, which would have seemed to their predecessors an art of depravation, can legitimately be described by some more positive term. But the artists of modern Europe, taken as a whole, have failed to represent any similarly redemptive equivalent or substitute for the lost public function of art, and they will remain, for Fuseli, simply depraved.

3. The history of painting in modern Europe

Though Fuseli believed that Italian painting could also be described in terms of a three-phase history, he does not pretend that the fit is as neat as it was for the painting of the Greeks, which, as it has all disappeared, offers less resistance to the hammer of the philosopher of history. It is not simply a problem of the third phase failing to repeat the successes and failures of the followers of Eupompus: the first phase exhibits no equivalent to the pattern of uniformity, and then of differentiated uniformity, exhibited by the work of the first Greek painters, and seems simply to be composed of a collection of artists who have in common simply the fact that they were active before the period of establishment, and were less successful or consistent in their achievements than the great painters who followed them. The second phase of Italian painting is more capacious in the variety it exhibits than the period from Zeuxis to Timanthes, and Fuseli seems somewhat at a loss when explaining why some of its members belong there. He offers a couple of general explanations of why, in its two earlier phases, the history of Italian art differs from that of

Greek, though neither of these is adequate to account for the differences that he acknowledges or for those that he does not. In the first place, he explains, though public paintings were of great use to the Christian religion, to subdue the senses of its votaries 'with the charm of appropriate images', and to exhibit 'events and actions, which might stimulate their zeal and inflame their hearts', they were not *essential* to Christianity as they were to the paganism of the Greeks. 'The heroism of the Christian and his beauty were internal': it did not require to be manifested in public images and public customs, and the perfection of human form no longer seemed, of itself, a guarantee of the congruence of the human spirit, and the divine.[11] In the second place, the forms exhibited by the Italians themselves provided an 'unfit' and 'contaminated' starting-point from which to set out on the quest for bodily perfection, for this 'heterogeneous stock' was nothing but 'the faeces of barbarity, the remnants of Gothic adventurers, humanised only by the cross, mouldering amid the ruins of the temples they had demolished' (2: 75–7).

The artists of the period of preparation whom, in his first account of the history of Italian art, Fuseli chooses as representative, are Masaccio, Mantegna, Signorelli, Leonardo, and Bartolommeo, but of these, three at least seem to be included on the basis of having made a few piecemeal discoveries, and not because they mark any such essential stages of the development of painting as were marked by Polygnotus and Apollodorus. Thus Masaccio's contributions were to have 'first conceived that parts are to constitute a whole; that composition ought to have a centre; expression, truth; and execution, unity'; but though 'his line deserves attention', he made no 'investigation of form'. This last task was initiated by Mantegna, but 'his taste was too crude, his fancy too grotesque, and his comprehension too weak' to enable him to arrive at any coherent ideal of perfection, with the result that his figures are eclectic assemblages of antique fragments, tacked on to other fragments copied directly from defective models. Signorelli appears to be the only painter Fuseli mentions to have achieved anything which directly matches the achievements of the painters of the first phase of Greek art: 'he seems to have been the first who contemplated with a discriminating eye his object,' and 'saw what was accident and what was essential'; but beyond that, the irritating fact that Italian pictures have survived while Greek ones have perished obliges Fuseli to attribute to him, too, a random set of other accomplishments: the balancing of light and shade, the 'decided motion' of his figures, and boldness and intelligence in foreshortening. This last achievement is attributed also to Bartolommeo, who was the first painter, however, to give 'gradation to colour, form, and

masses to drapery, and a grave dignity . . . to execution'. Leonardo, on the other hand, who is considered at greater leisure and to better effect in one of the last lectures, 'laid hold of every beauty in the enchanted circle', and would no doubt have been placed by Fuseli in the second period, were it not for the fact that he laid hold of all 'without exclusive attachment to one', and 'dismissed in her turn each': his works, in which the principles of chiaroscuro are first adumbrated, show too many of the effects of inconsistency and a want of perseverance to belong in a period of establishment (2: 78–83).

Of the four painters acknowledged by Fuseli as belonging to the period of establishment, Michelangelo and Raphael seem to have direct equivalents in the corresponding period of Greek art: thus Michelangelo is 'the inventor of epic painting',[12] and seems to fill the slot vacated by Zeuxis, and Raphael, 'the father of dramatic painting', gave to his figures a degree of animation and passion that makes him comparable with Timanthes, though without the Greek's presumed perfection of form (2: 85, 87). Titian, the father of landscape and of portrait, belongs in this period primarily of course on account of the discoveries he made in the science of colour, and Correggio is admitted on account of his harmony and grace (2: 90–1). I have been thus brief in my account of this period, because there will be an opportunity later in this chapter to discuss the first two painters at considerable length, and because, of the other two, Fuseli says little of importance to the argument I am seeking to elaborate. His respect for Titian is enormous, and he is important to Fuseli in that his art offers him the opportunity to show that he is not opposed, in principle, to the colourists. But he does not seem to see Titian's work as raising any of the historical, aesthetic or political issues that are raised by Michelangelo and Raphael. His respect for Correggio is slight, and when later he comes to consider him at greater length, he attributes to him the dubious honour of being the father of the ornamental style, the 'first and greatest' of the 'machinists' (2: 242).

The third phase of Italian and also of European art, like that of Greek, is a history of differentiation, but of differentiation pursued without principle or direction. To begin with, the uniformity of pursuit that had apparently been exhibited at the period of establishment began to disintegrate, and, 'whether from incapacity, want of education, of adequate or dignified encouragement, meanness of conception, or all these together', the schools of Tuscany, Rome, Venice and Lombardy 'separated, and in a short time substituted the medium for the end'. As a result, the Tuscan school, for example, by its 'blind attachment to . . . singularities rather than . . . beauties', and its inattention to the principal concerns of painting, 'expression,

character, propriety of form', came to devote itself to the attempt to give importance to 'trivial' and 'common-place' conceptions by mastery of execution and a bold but mannered outline. The Venetian school, which, after the death of Titian, developed a more local character as a result of the general separation, came to exhibit all the vices of its place of origin, 'the splendid toy-shop of the time', whose 'chief inhabitants' were nothing but 'princely merchants, or a patrician race elevated to rank by accumulations from trade, or naval prowess', and the bulk of whose people were 'mechanics or artisans, administering the means, and in their turn fed by the produce of luxury'. 'Of such a system', demands Fuseli, 'what could the art be more than the parasite?' (2: 94, 103–4; 3: 5).

This separation into schools was not, in itself, always seen by Fuseli as an unqualified disaster: he came to believe, for example, that the very isolation of the Venetian school had enabled it to 'preserve' some 'features of originality' lost to other schools—originality, as something which may be preserved, has here for Fuseli a meaning similar to that attributed to it by Reynolds and Blake. The final disintegration of uniformity of principle and pursuit occurred when artists came to think of themselves as individuals, attached to no particular school, and made it their aim 'individually to please'. Of these, some were content to remain journeymen who made no attempt to develop the art, and who, 'tutored by different schools, or picking something from the real establishers of Art', did 'little more than repeat, or imitate ... what those had found in Nature'. The 'dilution of energy' we find in the work of such artists, however, was no more fatal to the true principles of painting than the efforts of those artists who, pretending to originality, achieved instead only a novelty which has 'added nothing essential to the system', and which 'is nearer allied to whim than to invention'. Such artists have been so successful in persuading the audience for art to mistake novelty for invention, and 'singularity of character' for 'genius', that the history of art is now considered to be best conducted as a branch of bio-graphy, 'swelled into a diffuse catalogue of individuals' (3: 7, 3–4, 73).[13] The true categories in terms of which the history of art should be written, those of period and genre, have been made to seem of little value to describe the work of painters who have themselves so confused the separate departments of the grand style—historical, dramatic, and epic painting—with the result, also, that their works have become incomprehensible: it is essential to understanding— Fuseli agrees with Shaftesbury, Richardson and Reynolds—that we should not be in doubt as 'to what class a work belongs', for how else, Fuseli seems to suggest, can we know what response it invites? (2: 224,

234).[14] Those painters who have pursued novelty most assiduously, the 'ornamental' painters whose 'springs of invention' are 'splendour, contrast, and profusion', have obscured our understanding of subject as well as of genre, by proposing as their principal subject 'the painter, not the story'—or if their works have any other meaning, it can only be as 'the luxurious trappings of ostentatious wealth', or as 'ominous pledges of irreclaimable depravity of taste, glittering masses of portentous incongruities and colossal baubles' (2: 213–14).

As will by now be clear, the main danger of the separation of a uniform pursuit into the incoherent efforts of isolated schools and individuals, is that painting itself will lose any uniformity of principle: each artist will concern himself only with what he does best, or with what, at a particular time and place, is most in demand, and style will be perverted into manner. 'The motive' falls sacrifice to 'the mode', and it becomes the main object of art to make a 'florid', a 'pompous' display of 'magnificence'—that last remark is made of Rubens, the voice of the modern, private, fallen Fuseli here entirely suppressed. For Fuseli, style is distinguished from manner in that 'Style pervades and consults the subject, and co-ordinates its means to its demands', while 'Manner subordinates the subject to its means' (2: 106, 119–20, 322). Style is based on 'form, expression, and character', to which 'colour, grace, and taste' are properly the 'companions'; but by manner, these companions became 'substitutes' for the qualities they should support. In all the various departments of art, style may be (and for the most part has been, in post-renaissance Europe) perverted into manner: thus design becomes mannered when it seeks to exhibit judgment and taste without correctness; composition, if its 'ostentation absorb the subject', or when it degenerates into mere grouping, undetermined by subject; chiaroscuro, when it entirely absorbs the painter's attention (2: 312, 306–7, 243, 275–6).

In every case, it is the characteristic of manner that, instead of 'exerting its power over the *senses* to reach the intellect and heart', it becomes 'their handmaid, teaching its graces to charm their organs for their amusement only'; and because manner has achieved its end when it has succeeded in thus converting a liberal into a servile art, which addresses the sense and appetite, rather than the soul and intellect through the medium of sense, Fuseli identifies the effects of manner most clearly in the perverted use of colour, which, though 'finished by style', has been 'debauched by manner'. It is the aim of colourists to 'divert the public eye from higher beauties' to be 'absorbed' by the 'lures' of colour: and thus 'art is degraded to a mere vehicle of sensual pleasure, an implement of luxury, a beautiful *but trifling* bauble, of a splendid fault'.[15] And for that reason, of course,

those who have been most successful in converting the works of painters into fetishes, commodities, adornments, articles of consumption, have been the natives of commercial and luxurious cities: Venice, 'the repository of the riches of the globe', and Antwerp, 'the depository of Western commerce'—'such ... will always be the birth-place and the theatre of colour' (2: 338, 334, 103, 119).

Fuseli makes a few exceptions to his condemnation of post-Renaissance art: Poussin is sometimes held up for our admiration, and, when, very occasionally and briefly, his softer voice can be heard, it seems that Fuseli can find something of value to salvage from the wreckage, even from the work (as we have seen) of Rubens. The condemnation remains, however, pretty well general, and it is particularly by the conversion of means to ends that post-renaissance art has, he believes, become the expression of, and addressed itself to, the individuality of men, and not their common humanity. An art which identifies the artist of genius with the merely singular of character, and the man of taste with the creature of caprice and of wants which can be satisfied only by the *appropriation* of works that offer themselves to him as luxuries, must always fail to 'subordinate the vehicle ... to the real object', and can never be considered a 'useful assistant' to the 'happiness of society' (2: 332).

Fuseli did not always describe the function of art in such lofty terms: appropriately enough in his *Remarks on Rousseau* (1767), he argues that 'the benefit of the playhouse is wholly negative'; the theatre is at best 'a harmless entertainment', though it is certainly better 'to see *Sir John Brute* than to act him in the streets; 'tis pleasure, instead of debauchery'. In a review of 1793 he goes further, and extends this view from the theatre to the arts in general: 'it is ludicrous', he insists, 'to give a consequence to the arts which they can never possess', for 'their moral usefulness is at best accidental and negative. It is their greatest praise to furnish the most innocent amusement for those nations to whom luxury is become as necessary as existence, and amongst whom alone they can rear themselves to any degree of eminence.'[16] If the moral value of the arts is to be located—as Fuseli locates it in his discussion of the art of Venice, for example—in its power to encourage us to regard commerce as a means whose end is something other than the enjoyment of luxury, then by this account they cannot hope to succeed, for they can never teach us to abandon the very vice that brought them forth.

This, however, is evidently the utterance of the private Fuseli, and was published in a periodical of small circulation; in his public lectures at the Academy, and in whichever voice he speaks, he never doubts that 'the necessity of a moral tendency or of some doctrine

useful to mankind' is the 'great principle' on which the highest art is based (2: 198). Throughout his remarks on modern art, the ultimate test of the value of works of painting is whether or not they represent us, or seek to unite us, as a public, or as members of a common humanity whether in the sphere of the social or the religious. It is for this reason that the greatest works of art are, for Fuseli, Michelangelo's decorations of the Sistine Chapel, and Raphael's of the stanzas of the Vatican: the first exhibiting 'the origin, the progress, and final dispensation of Providence' and the undifferentiated nature of human existence in relationship with God; the second showing how art 'unites man ... in social and religious bands', and how 'human culture ... *proceeds from the individual to society, and from that ascends to God*'. It is by comparison with the 'great principle' embodied in these works that Fuseli dismisses post-renaissance art and society alike as depraved (2: 158–60 and see also 85; 2: 168, 278).

4. The privatisation of modern society and the decay of 'higher art'

There is not much in Fuseli's account of the decline of European art which is particularly unusual, or which represents a considerable departure from many of the opinions already canvassed in this book: the stress he places on the dangers of artists coming to think that the value of their work lies in its individuality, and the dangers of the conversion of the means of art into its end—these are pretty much the standard rhetoric of the civic humanist tradition. What is different about Fuseli's account of that decline is that he sees it as having been determined by historical forces which are irremovable, and it will be worth examining in rather more detail that process of determination, which is the topic of Fuseli's last Academy-lecture, and which is there represented as having produced a society incapable of succeeding in the higher branches of painting.

Why was it, to begin with, that the arts flourished in Greece? Of all the various reasons which historians have offered—'their religious and civil establishments; their manners, games, and contests of valour and of talents; the Cyclus of their Mythology, peopled with celestial and heroic forms; the honours, the celebrity of artists; the serene Grecian sky and mildness of the climate'—the most important, for Fuseli, is that, in Greece, 'Religion and Liberty prepared a public, and spread a technic taste all over Greece'. By the phrase 'prepared a public', Fuseli means more, of course, than that religion and liberty prepared a public for art, in the sense in which we would

now understand the concept, but that they defined a public sphere in which Greek civil and religious life was lived. Political functions were performed, political debates were conducted, in public; religious practices were public practices; and the function of art was less to make visible the beliefs and values of the Greeks, than to confirm a visibility which in some sense they already had: it was this task that afforded 'that perpetual opportunity . . . of public exhibition' which the Greeks, especially of Athens and Corinth, 'presented to the artist'. The public thus supported, and was in turn confirmed by, the arts: artist and public shared the same objectives, so that 'Polygnotus prepared with Cimon what Phidias with Pericles established', and were in a 'reciprocal' relationship, so that the arts 'led the public' at the same time as the artist was, as Pliny had declared, 'the property of the public', and 'considered himself as responsible for the influence of his works on public principle'. The same, Fuseli believes, was true of Italy at the period of establishment: 'the public and the artist went hand in hand' (3: 43-5, 53, 49).

Why then has the art of painting so utterly declined? Fuseli mentions the possibility that 'human nature' may have 'admitted of no more' than was achieved in the two great periods of establishment, so that the arts, which cannot cease to develop, were unable to progress, and were bound to fall back.[17] But his explanation of the rise of art in Greece has already suggested his commitment to the answer that the real reasons for decline are to be looked for in 'the decline of Religion and Liberty' (3: 44, 53). As far as political liberty is concerned, what seems to be at issue, for Fuseli, is not simply whether a state is, or is claimed to be, a democracy or an autocracy; what matters is whether, if it *is* claimed to be a democracy, it is of the kind that enables the free public participation of all its citizens in political life and in the framing of policy. For in tyrannies and representative democracies alike, the same process of privatisation, the same attenuation of public freedom, will occur. For Fuseli, the private freedom of thought and opinion, which an autocracy may try to suppress, and a representative democracy may claim to encourage, is a phenomenon produced by the loss of public freedom, for which it is a substitute of only qualified value: it is a symptom of the disease and not a mark of the health of a society.

'Individual liberty of *thought*', which can find no opportunity for public expression—for expression in a public space—is in danger of being seen by those who enjoy it as being more a 'liberty' the more 'individual' it is, and so of developing as singularity, as caprice, as novelty, in religion as in politics. Thus as the papacy became (as Fuseli believes it did) more authoritarian, individual freedom of

religious opinion was valued and cultivated to the point where there are now 'almost as many sects as heads', and almost every individual, at least in Britain, has his own private religion, incapable of the public expression which for Christians was in any case, by the nature of their beliefs, of less importance than it had been for the pagan Greeks. Though Fuseli denies, at one point, that 'Christianism was inimical to the progress of the arts', and can adduce Raphael and Michelangelo to secure his point, he clearly does regard it as less favourable to their development than paganism had been, and more so when divided between a church which suppressed the public freedoms of its members, and a disorganised and fluctuating set of protestant groups which could see value only in private freedoms (3: 52, 46).

Thus frustrated of public participation in politics and religion alike, the inhabitants of Europe have inevitably come to conceive of themselves as individuals, whose identity and status are derived from some other source than their membership of a public: they have come to place their private interests above the public interest now invisible to them, to direct their energies into acquisition and appropriation, and to estimate their value by the value of the luxuries they acquire. In terms of the volume of production and sales, the art of painting now flourishes: but 'luxury in times of taste keeps up execution in proportion as it saps the dignity and moral principle of the Art; gold is the motive of its exertions, and nothing that ennobles man was ever produced by gold'. The art is thus divested of the 'great principle', the 'public principle', by which only can it claim to be a virtuous activity whose end is the promotion of virtue (3: 53–4).

'Our age', writes Fuseli, 'when compared with former ages, has but little occasion for great works, and that is the reason why so few are produced.' That is the reason, also, why he can imagine no means by which 'higher art' could be revived in Europe. A political revolution seems to offer no solution: for even if it did not accelerate the decline of art, as it had done, Fuseli believed, in France, the conditions for its revival cannot thus simply and immediately be engineered; a public cannot be proclaimed as easily as a republic can be, but is, like Burke's constitution, the slow growth of centuries: 'Religion and Liberty had for ages prepared what Religion and Liberty were to establish among the ancients'. The solutions most often proposed in Britain—an increase in private patronage, or of public patronage by means of premiums and honours for artists—are regarded by Fuseli only as proofs that 'the age is unfavourable to art', and they will not make it less so: 'private patronage, however commendable or liberal, can no more supply the want of general encouragement than the conservatories and hot-beds of the rich, the want of a fertile soil or

genial climate'; indeed, like premiums and rewards, it attempts to cure the disease by the very vices—luxury and avarice—that have accelerated its progress (3: 47–8, 50–1, 53–5).

In fact, Fuseli insists, the privatisation of European societies, which is the 'efficient cause' for the decline of the art of painting, is too general and too diffuse a cause to be acted upon, and it is this view, more than any other, that distinguishes his writings on art from those of Reynolds, Barry and Blake: what is at issue is how far social and political formations determine the development of the arts, and how far they may be determined by the arts. For Barry, whose account of British society is hardly less pessimistic than Fuseli's, it remained an article of necessary, desperate faith that art can create a public out of individuals however blind or loath. It can make visible a public sphere, it can show a people which of their individual, private interests are compatible and which incompatible with the public interest. More specifically, Barry insists that the historical painter— Barry himself, for want of any other example— can and must have the power to convert the false into a true public. For Fuseli, however, the causes of the decline are certainly not such as 'the will of an individual, however great, can remove': the processes of history are not now, if they ever have been, so 'particular' and so identifiable in their effects, as to be acted upon, and least of all by the efforts of individual heroism (3: 47).

No professor of painting at the Royal Academy could, presumably, have imagined that he occupied that position simply in order to impress upon his students that they were members of an institution dedicated to an attempt, to revive the grand style of art, which was utterly futile, and Fuseli was obliged to conclude his final lecture with a show of optimism, however qualified and perfunctory. It was not an easy task, for academies of art, he believed, 'are symptoms of Art in distress, monuments of public dereliction and decay of Taste'; if the public and the artist still 'went hand in hand', there would be no need for academies, which first appeared in Italy 'when the gradual evanescence of the great luminaries in Art began to alarm the public'. Nevertheless, Fuseli argues, however much the 'denudation of the present state moderates our hopes', and shows us that the 'immediate restoration' of art is 'hopeless', it may still 'invigorate our efforts' for the 'gradual recovery' and 'ultimate preservation' of painting:

> To raise the Arts to a conspicuous height may not perhaps be in our power: we shall have deserved well of posterity if we succeed in stemming their further downfall, if we fix them on the solid base of principle. If it be out of our power to furnish the student's activity

with adequate practice, we may contribute to form his theory; and Criticism founded on experiment, instructed by comparison, in possession of the labours of every epoch of Art, may spread the genuine elements of taste, and check the present torrent of affectation and insipidity (3: 56–8).

'This', says Fuseli, 'is the real use of our Institution', but it is a function that he would certainly have acknowledged as inadequate to operate on the causes of 'denudation'. For if the Academy can influence taste, not only to 'check' its depravation but to 'spread' its 'genuine elements', it can do so only by regarding taste as something now disjoined from social and political life, removed to a place of quarantine where it cannot be infected by social decay, but from where it cannot exert a healing influence either. The Academy cannot therefore do anything to bring about those changes in social life, that restoration of the public, which could alone provide an 'occasion for great works', and could again inform the practice of painting with a great principle. It can be at best 'the asylum of the student, the theatre of his exercises, the repositories of the materials, the archives of the documents of our art' (3: 47, 58). If ever the public should revive, the Academy will then be ready and equipped to explain on what principles the art it then will need might be produced; in the meantime, its function must be historical and critical rather than creative.

5. *Two accounts of the hierarchy of genres*

The opening and closing lectures of Fuseli's series, which was composed over a period of a quarter of a century, are for the most part uttered by the stern voice of republican virtue.[18] But, as we have already seen, there is another, less censorious voice sometimes to be heard in the lectures, the voice that could approve the advice of Eupompus as 'suited to the times', when Fuseli had seemed about to condemn it for that very reason. The utterances of this second voice do not often explicitly challenge the conclusions of the first; on very few occasions (of which his judgment of Rubens's Luxembourg cycle is the most notable) does it manage to suggest that there may be examples of modern art which may be of equal value to the art of earlier periods—which may, that is, represent a unity in society in a way which, though necessarily different, might be comparable with how that unity was represented in the period of establishment. This more moderate voice never, indeed, goes so far as to suggest that an

art animated by public principle, or even by some less demanding principle of social coherence, could still be produced in early nineteenth-century Europe. But it does seem able to envisage the form that might possibly be taken by an art which would not only reflect the present condition of modern society, but also redeem it, by representing the members of that society as sharing some common and estimable principle of interconnection. Fuseli can do this, not by pretending to resist the changes he conceives of as irresistible, but by acknowledging the actuality of a society which is apparently no more than a congeries of individuals, incapable of being unified into a 'public', and certainly beyond being so unified by the efforts, or the representation, of an 'antiquated heroism'. If we cannot change the results of the processes of history, we must learn to look at them from some different viewpoint. The prospects that might become visible to us from this different viewpoint are suggested during the course of Fuseli's changing valuation of the art of Michelangelo and Raphael; but to understand the different meanings he attached to their work, we must first examine his account of the hierarchy of styles and genres.

Like Reynolds and Barry, Fuseli has little to say about the lesser genres of painting, among which he includes history-painting in the 'ornamental' style, along with portrait, landscape, and comic subjects, and which he regards, for the most part, as addressing us in our private identities. He makes a version of the usual distinction between 'characteristic'—more or less the equivalent of historical—portraiture, as practised by Titian, Raphael, van Dyke, and (on one occasion) by Rubens, and mere face-painting: in the latter, 'the aim of the painter and the sitter's wish are confined to external likeness'; in the former, there is a 'deeper, nobler aim, the personification of character'. Characteristic portraiture is 'physiognomic': it represents its subject as a generic character, with whom we can identify our own characters or from which we can distinguish them, as classes of humanity. Fuseli is undecided (and it is of no concern to us that he is so) as to whether such portraiture should be ranked above historical but below dramatic painting, or whether, because it is 'content to be directed by the rules of Physiognomy, which shows the animal being . . . at rest', and so 'seldom calls for aid on Pathognomy, which exhibits that being agitated', it should usually be ranked below the historical style. Face-painting, on the other hand, is nothing but 'the remembrancer of insignificance, mere human resemblance, in attitude without action, features without meaning, dress without drapery, and situation without propriety'. When attempted by a painter of genuine ability, it may be distinguished by a quality of

execution which 'leaves us, whilst we lament the misapplication, with a strong impression of his power; him we see, not the insignificant individual that usurps the centre, one we never saw, care not if we never see, and if we do, remember not, for his head can personify nothing but his opulence or his pretence; it is furniture' (2: 214–16, 313). The best thing, it seems, that a painter can do with this kind of commission is to call attention to his own individuality instead of that of his sitter; but his success in doing so can only serve to remind us that it is a success unworthy of him.

The vast increase of the production of this kind of picture is of course regarded by Fuseli as the effect of the same cause as has been responsible for the decline of 'higher art':

> Since liberty and commerce have more levelled the ranks of society, and more equally diffused opulence, private importance has been increased, family connections and attachments have been more numerously formed, and hence portrait-painting, which formerly was the exclusive property of princes, or a tribute to beauty, prowess, genius, talent, and distinguished character, is now become a kind of family calendar, engrossed by the mutual charities of parents, children, brothers, nephews, cousins, and relatives of all colours.

The same explanation, in terms of the increasing importance of the private at the expense of the public (for 'the exclusive property of princes' is for Fuseli presumably also the general property of the public!), will account also for the new popularity of landscape-painting, which may also, however, be divided into an elevated, 'characteristic' branch, and its merely decorative antitype. The latter is an 'enumeration' rather than a representation of 'what is commonly called Views'; which, 'if not assisted by nature, dictated by taste, or chosen for character, may delight the owner of the acres they enclose, the inhabitants of the spot, perhaps the antiquary or the traveller, but to every other eye they are little more than topography'. To be engaged by such landscapes, we must have a species of private, occupational, or even economic, interest in their delineation: they must, like face-painting, reflect back to us some aspect of our private identities. The landscape, on the other hand, of 'Titian, of Mola, of Salvator, of the Poussins, Claude, Rubens, Elzheimer, Rembrandt, and Wilson, spurns all relation with this kind of map-work': instead, it invites us to 'wander through the characteristic groups of rich congenial objects'—objects which, far from being 'insignificant individuals', 'features without meaning', are 'characteristic' in the sense of being representative of nature, and which are congenial to us, not in

our private identities, but as we are the representatives of mankind (2: 216–17).

Comic painting, like face-painting and topography, also fails to address our representative, our public identity, which, because based on permanent and unchanging principles, cannot be engaged by 'representations of local manners and national modifications of society . . . which soon become unintelligible by time, or degenerate into caricature, the chronicle of scandal, the history-book of the vulgar'. And the last of the lesser branches of painting that we need consider, 'ornamental painting', 'the pompous machinery of Paolo Veronese, Pietro da Cortona, and Rubens', is, like face-painting at its unworthy best, a style in which 'the painter . . . is the principal subject', not 'the story'. The luxurious and 'brilliant chaos' of this style often exhibits 'unlimited powers of all-grasping execution', but otherwise it is simply a reflection of the 'ostentatious wealth' of the society that offers it encouragement, and at worst it ministers to a sensuality less sublimated than that which finds its satisfaction in the possession of inanimate objects: the works of the followers of Rubens 'can only be considered as splendid improprieties, as the substitutes for wants which no colour can palliate and no tint supply' (2: 156, 213–14, 120).

Whatever exceptions Fuseli may make in favour of 'characteristic' portraiture and landscape-painting, it remains clear that, to all intents and purposes, 'higher art' is for him, as for Reynolds and Barry, confined to the works of those artists who painted in the grand style. But that style is not, as it had been for the writers we have so far considered, a unity, the 'one' true style in which public painting could be attempted. For Fuseli usually divides invention, the faculty which, as opposed to mere copying, is particularly required for the production of works in the grand style, into three 'branches': historical, dramatic, and epic; to these he sometimes adds a fourth, 'phantasiae', or fancy-pictures, but this branch, probably included largely to justify Fuseli's own practice as a painter, is something of an embarrassment to his account of invention, which can include only three branches if they are to correspond, as we shall see they do, to a three-phase account of history. The three branches that most concern him, and which will be of exclusive concern to us, are seldom, he warns us, strictly discriminated, for human performances are composed of qualities as mixed as those which compose 'the mind and fancy of men' (2: 179); but though it may be useful to bear this warning in mind, when we come to consider Fuseli's habit of praising Raphael both as a dramatic and as an epic painter, it is his normal practice to consider the three branches in isolation from each other,

and, in European art, as represented each by different painters: Poussin, Raphael, and Michelangelo, whose works, respectively, inform, move, and astonish us.

'Historic Invention administers to truth': it represents 'not what might be, but what is or was', the probable, not the possible, not 'fiction' but 'the moments of *reality*'. Thus the history-painter must not give us images of the highest generality, which are the exclusive province of epic, nor is he to exhibit those characters which are 'the fittest to excite the gradations of sympathy', for that is the task of the dramatic painter. He must observe 'costume', and give us a story 'with truth of time, place, custom': his Romans must be identifiable Romans, his Greeks unmistakably Greeks, and, whichever they are, they must 'only appear, to tell the fact; they are subordinate to the story'. The main function of history-paintings is to 'interest our intellect', and we are 'attracted' by them 'as members of society',

> bound round with public and private connections and duties, taught curiosity by education, we wish to regulate our conduct by comparisons of analogous situations and similar modes of society: these History furnishes; transplants us into other times; empires and revolutions of empires pass before us with memorable facts and actors in their train—the legislator, the philosopher, the discoverer, the polishers of life, the warrior, the divine, are the principal inhabitants of this soil.

But though the primary task of history is to inform, and instruct, by the representation of situations analogous to our own, it can do so only by 'bespeaking our sympathy', and in this it differs from dramatic painting in that it engages our sympathy only as a means, not as an end, and so with a lesser degree of intensity. In order to do this, and to enable us to grasp the analogies and comparisons it invites us to make, it must exclude everything 'trivial ... grovelling or mean', and so must be purged of 'mere floating accident, transient modes and whims of fashion': its agents must be represented in their 'physiognomic', their generic character, and if 'deformities are represented, they must be permanent, they must be inherent in the character', so that they will work 'to strengthen rather than to diminish the interest we take in the man' (2: 194–5, 177–8, 101).

'The legitimate sphere of dramatic invention' is 'the exhibition of character in the conflict of passions with the rights, the rules, the prejudices of society'. It differs from history-painting, in the first place because it does not seek coldly to inform us—it does not seek to 'interest our intellect'; rather, it 'inspires, it agitates us by reflected self-love, with pity, terror, hope, and fear'. Thus, unlike history, it

lays 'the chief interest on the *actors*',who become the 'end' of drama-
tic invention, and the 'fact', the story, becomes only its 'medium': for
the dramatic painter selects his fables indiscriminately from fiction or
from reality—his only concern is that 'events, and time and place'
should be 'the ministers of character and pathos', and he moulds
them into 'mere situations contrived' for the exhibition of character
(2: 195–6).

If the historical style represents the probable, and the dramatic,
careless of whether it bases its representations of character on fact or
fiction, can combine the probable with the possible, the third branch
of invention, epic painting, 'the loftiest species of human conception'
according to Fuseli's public voice, represents 'embodied possibility',
mankind not as it is but as it might be, in an ideal state of perfection.[19]
'The aim of the epic painter is to impress one general idea, one great
quality of nature or mode of society, some great maxim.' If the epic
painter bases his invention on historical fact, the grandeur of his style
will liberate the fact from its origin, the local circumstances of time
and place; if he discriminates the characters of his agents, he does so
'without descending to those subdivisions, which the detail of charac-
ter prescribes', and the features of all his figures will reflect the maxim
his painting seeks to substantiate, and will be differentiated only to
discover a new aspect of its affect or meaning (2: 196, 37, 157). As we
saw in Fuseli's account of Zeuxis, the epic painter seeks to raise men
to 'demigods' by uniting all possible determinations of character and
power in one universal character, such as Homer represented in
Achilles: a character modelled on the Jupiter of Phidias, the god who,
for Fuseli as for Barry, represents the ideal unity of all possible
determinations, and so of the various differentiations of a common
humanity.

These three branches of invention, of the grand style, are rep-
resented by Fuseli as arranged in an ascending hierarchy, and, in one
version of his history of painting, diachronically. The historical is
identified with that style which aims to show 'what is essential in the
composition and construction of the human frame': it may admit
generic, or physiognomic character, but does not attempt to rep-
resent mankind distinguished by 'endless variety and difference of
character': nor does it attempt, like the epic, to 'add, or conclude
from what was, to what might be'. In order of thought, if not always of
fact, the historical style must be considered as belonging to a period
of art prior to that represented by the dramatic, which is a style based
on the discovery that, as '*all* were connected by the genus and a
central principle of form, so they were divided into classes, and from
each other separated by an individual stamp, by *character*'. Character

must however be represented, not by sacrificing the 'symmetry' pre-
scribed by the 'generic principle', but by modifying and adapting it 'to
the demands of the peculiar quality which distinguished the attribute'
which the dramatic style undertakes to personify. It is not altogether
clear from Fuseli's words, whether the dramatic style, in representing
'individual' character, represents the characters of individuals, still
somehow purged of deformity, or whether he believes that each *class*
of character bears its own 'individual stamp'; but in either case it is
clear that the emergence of the epic style must pre-suppose the exist-
ence of the dramatic, which it combines with the essential to produce
its images of embodied, ideal possibility: these unite the grandeur of
essential simplicity with the beauty of characteristic variety, to pro-
duce the sublime. The epic is the art of the 'third epoch', so that a new
three-phase history of art is produced, in which the period of refine-
ment or depravation has no place: the healthy development of art will
be from the essential, through the characteristic, to the epic, the
ultimate aim and goal to which the art aspires (2: 383–5).

This version of the history of art, which Fuseli bases on the history
of ancient sculpture, is evidently a pronouncement of his stern re-
publican voice, unconcerned to speculate on the fate of an art after it
has achieved its highest possible condition of development, or con-
cerned only to condemn the period of refinement, or of the desperate
search for novelty, by the lofty standards of the epoch that precedes
it. But as a professor of painting, Fuseli could hardly leave things
there; nor could he, in conscience, insist to his students, as Barry had
done, that no success was worth having which was not achieved in the
highest branch of invention. He knew that no young artist, however
anxious to tread in the steps of Michelangelo, would 'dare to stem the
muddy torrent' of 'the execration of the vulgar, the ridicule of the
false critic and the invective of his hireling', with which his efforts
would be received; his belief that the history of art was determined by
social, political, economic, and religious change persuaded him that
the productions of such a would-be epic painter could not now 'be
uniformly stamped by that lofty and independent confidence in
himself' which distinguished Michelangelo; and he even doubted the
wisdom of persisting in the doctrine that the proper tasks of painters,
in nations in which 'the vital sparks of public virtue' were 'entirely
extinguished', must remain the representation of epic heroism.[20] His
attempts to face these doubts and problems produced another
version of the hierarchy of styles, the implications of which are visible
throughout the lectures, but which emerges clearly in the eleventh,
the penultimate lecture, and by which the proper development of
painting might be towards a style altogether more hospitable to the

representation of the 'endless variety and difference of character' which is especially a feature of modern societies.

The possibility of producing a revised hierarchy of styles has in fact been present in all Fuseli's accounts of European art. For though, in order of thought, in the history of ancient sculpture, and, arguably, in that of ancient painting, the existence of the epic must pre-suppose that of the dramatic, whose existence in turn pre-supposes that of the historical style, the development of European art has exhibited no such tidy progression, but has produced the greatest representatives of each style—Michelangelo, Raphael, and Poussin—in the reverse order to that anticipated by Fuseli's philosophy of history. Since he can offer no explanation, in terms of social or political changes, of why this should have happened, he sometimes treats the three styles as they reappear in European art, not as stages in a diachronic process of development, but as synchronic possibilities, among which an artist and his patrons may choose, one or another, according to their different temperaments. It is not clear that Fuseli was aware of treating them in this way, so that he never finds himself obliged to square this treatment with his belief in the all-determining power of historical change; and he is helped in making this evasion by the fact that since Raphael, only Poussin, and since Poussin, no artist of merit has chosen—and so presumably none has been free to choose—to work in the three great styles of painting. But whatever the confusions and disconnections in Fuseli's theory of styles, this habit of treating style in terms of synchronically available alternatives, instead of in terms of a progressive and historically-determined development from one to another, enables him to consider the question, which style *should* an artist choose to work in? And once the question has been framed in this way, Fuseli is enabled to contemplate the answer, that if the epic is committed to the representation of an ideal heroism which, whatever the principle at issue, is in fact found by the audience for painting to be too 'antiquated' to engage with their perceptions of the structure of modern societies, perhaps the dramatic style would engage it more effectively; for, as we shall see, the dramatic style is able, not only to represent an endless variety of character, but to suggest a principle of unity among the characters it represents as so widely differentiated.

The suggestion, that the epic style may not be the summation of the styles on which it is based, but simply one among a number of alternative paths to excellence, is reinforced in the eleventh lecture by a couple of remarks made by Fuseli on the project, particularly as undertaken by the Carracci, to unite the achievements of the greatest painters and the greatest styles into one eclectic but unified and universal style of painting. The pretensions of this project are dismissed by

Fuseli as bound to 'prove abortive': an art so conceived will soon 'be degraded to mediocrity', and from that will be 'plunged to insignificance'. The reasons for the inevitability of this failure are to be looked for in the limitations of human nature: 'a character', Fuseli argues, 'of equal universal power is not a human character; and the nearest approach to perfection can only be in carrying to excellence one great quality with the least alloy of collateral defects'; for only if 'what is finite could grasp infinity' could 'the variety of Nature' be 'united by individual energy'. The most any artist can do—Fuseli seems to borrow the point from Mengs—is 'imperfectly' to transmit 'one of her features', and this inescapable limitation was well understood by Michelangelo, Raphael, Titian and Correggio, the painters of the period of establishment, whose 'technic legacies' were 'as inseparable from their attendant flaws, as in equal degrees irreconcileable'.[21] These remarks are evidently as fatal to the pretensions of epic painting as they are to those of the Eclectics; for in earlier lectures it had been the very nature of epic that it could indeed unite the achievements of the practitioners of other styles: the epic painter overcame the limitations of probability inherent in the essential and characteristic styles, in the creation of heroes who similarly overcame the limitations of actuality and the determination of character, to become men of that 'equal universal power' which was modelled on the omnipotence of Jupiter, but which (in the epoch of Christianity, and of Fuseli *privatus*) is conceivable in God alone. If the epic painter is also denied the universal power necessary to the creation of such heroes, he will indeed be reduced to taking one of a number of 'approaches to perfection', not necessarily the best approach, and not necessarily (if this is now to be a consideration of importance) that best 'suited to the times' (3: 7–8, 36, and see 2: 107–9 and 2: 277–8; 2: 60).

6. *'The painter of mankind' and 'the painter of humanity'*

We can follow the changes in Fuseli's attitude to the alternative styles—as by the eleventh lecture they have come to be—of epic and dramatic painting, by considering the changes in the comparisons he offers between Michelangelo, 'the inventor of epic', and Raphael, 'the father of dramatic painting': between, more specifically, the means by which each represents character in his work. Broadly speaking, Fuseli's attitude to both painters is consistent throughout the first ten lectures; in the eleventh, where his less censorious voice seizes the initiative, it offers a markedly different valuation of the two

painters, but one which has been prepared for earlier, whenever that moderate voice has managed to make itself heard.

In the early lectures, Fuseli is concerned to present Michelangelo as an artist in whose work, by contrast with Raphael's, differentiation of character disappears—as far as is consistent with subject—under the pressure of his universal theme.[22] The theme indeed of the frescoes of the Sistine Chapel—'the empire of religion, considered as the parent and queen of man; the origin, the progress, and final dispensation of Providence'—is so 'universal' in its 'primeval simplicity' as to render all 'minute discrimination of character' inappropriate; for 'here is only God with man', and the image of man must be, it seems, almost as capacious and indeterminate as that of God, if Adam is to represent the whole of humanity in relation with its creator, and as fit, at the Last Judgment, to be reunited with him. But all the figures represented in the frescoes 'are only engines to force *one* irresistible idea upon the mind and fancy', and just as, in the *Iliad*, 'no character is discriminated but where discrimination discovers a new look of war', so in the frescoes character is admitted only as far as it 'could be made subservient to grandeur'. Where Michelangelo's plan does require him to differentiate among passions and characters—as in the *Last Judgment*, or in the scene of Noah and his sons, where 'the germs of social character are traced'—then he gives 'the general feature of passions . . . and no more', in a 'generic manner', and with a 'generic simplicity': for though he traced 'every passion that sways the human heart', he represented its 'master-trait' only, the 'reigning passion rather than the man'. As far as concerns characters, when it was necessary for him to discriminate among them, Michelangelo did so by making his figures the unambiguous embodiment of various qualities—'*inspiration*', or '*diligence*', or '*consideration*'; by these they are 'individually marked', but by this phrase Fuseli does not mean that they are marked *as* individuals— Michelangelo 'never submitted to copy an individual'—but as different generic characters, differentiated from each other only to stand more clearly for the different qualities personified in them (2: 157–9, 84–6, 162–5).

By contrast with Michelangelo, 'the painter of mankind', Raphael, by virtue of his 'milder genius', is 'the painter of humanity'; and whereas for Michelangelo character is entirely subordinated to maxim, the subjects of Raphael's works are only the 'vehicle' for the exhibition of 'character and pathos'. The same is true of Raphael's use of form: his concentration on the representation of character and passion explains and justifies what might otherwise be imagined to be the shortcomings of his art. Thus, if he never exhibits 'perfect human

beauty', and if his figures should not be taken as a 'standard of imitation', this is because their beauty is always modified, qualified by character and by passion; if his line, colour and chiaroscuro have all been surpassed by other artists, still, 'considered as instruments of pathos', they 'have never been equalled'; and his expression, 'always in strict unison with, and decided by character', and his composition, invention and narrative power have 'never been approached' (2: 87–9).[23]

In the early lectures, the very nature of Raphael's excellence sometimes seems to Fuseli to have disqualified him from treating the most sublime subjects; thus, had he attempted a Last Judgment, 'he would undoubtedly have applied to our sympathies for his choice of imagery', and 'would have combined all possible emotions with the utmost variety of probable or real character'; 'all domestic, politic, religious relations' would have been represented, with the result that 'the sublimity of the greatest of all events, would have been merely the minister of sympathies and passions' (2: 163–4). As long as Fuseli is insisting that epic is a more elevated style than dramatic painting, he must favour in this way a sublime art which commands our awe, over a characteristic art which engages our sympathy: but the effect of this preference, on occasions when it is confronted with Fuseli's own evidently greater sympathy for Raphael, is to persuade him to attempt to present Raphael as an epic, as well as a dramatic painter. This could be done most easily for the sequence of paintings in the stanzas of the Vatican, an 'immense allegorical drama' but one which apparently employed epic subjects, and at times achieves a 'sublimity' which 'balances sympathy' with the 'astonishment' that it is the task of the epic painter to inspire. But if the official intention of this kind of defence is to argue that, at his best, Raphael is capable of approaching the epic grandeur of Michelangelo, its effect is rather different; for it manages to suggest that, if Raphael was capable of inspiring our astonishment and awe, his general preference for the dramatic style was not the result of any weakness of invention, but arose out of a positive belief in the pre-eminence of an art which seeks to elicit our sympathy (2: 170–1, 157).

Throughout the early lectures there are indications that Fuseli too could feel more comfortable with an art which addresses us not as the representatives of mankind but as members of a human community, and which elicits a warmer, if less respectable response than admiration. 'We stand with awe before M. Angelo', he writes, but 'we embrace Raphael': his art is 'less elevated, less vigorous, but more insinuating, more pressing on our hearts, the warm master of our sympathies'. Fuseli the spokesman for republic virtue regrets the

passing of an age in which the best of men, Aristides, Brutus, were to be admired rather than loved, but he does not doubt its passing; and the milder Fuseli seems to welcome its disappearance. Sympathy— not the 'publick sympathy' that Reynolds speaks of, but a more private affection—seems to provide a guarantee of social coherence in a society from which public spirit has been banished, and a more effective guarantee, in a society of private interests, private passions, and private virtues, to which 'admiration' seems 'cold', but 'sympathy' is 'glowing' (2: 87–8, 62). A distinction between epic and dramatic poetry in exactly these terms had already been made by Kames: 'Heroism', he had argued, 'magnanimity, undaunted courage, and other elevated virtues, figure best in action: tender passions, and the whole tribe of sympathetic affections, figure best in sentiment. It clearly follows, that tender passions are more peculiarly the province of tragedy, grand and heroic actions of epic poetry.' What is more, Kames had argued that though 'the roughness and impetuosity of ancient manners may be better fitted for an epic poem', they might not be 'better fitted for society'; and though the 'familiarity of modern manners . . . unqualifies them for a lofty subject' of the kind treated by epic, it seems to follow, for Kames, that the manners of modern society, whose 'cement' is no longer public spirit but 'sympathy', are best represented in drama.[24]

By the eleventh lecture, the comparison of Raphael and Michelangelo is clearly made in such a way as to encourage us to prefer Raphael, and to prefer him because he now seems so much more a 'painter of modern life'; and his work now no longer requires to be accorded the additional respectability of being described as epic as well as dramatic. Early in the lecture, indeed, the stock of Michelangelo has fallen so low as to make him no longer an artist of the period of establishment in Italy, but only of the period of preparation, alongside Masaccio, Leonardo, and Bartolommeo: he had 'power, knowledge, and life sufficiently great, extensive, and long, to have fixed style on its basis, had not an irresistible bias drawn off his attention from the modesty and variety of Nature' (3: 5). Michelangelo was distracted, it seems, from the 'variety of Nature', not now by the search for 'grandeur' and 'generic simplicity', but by some individual character-defect—a judgment which manages at once to convict Michelangelo of a 'singularity' disabling in an artist who pretends to work in the epic style, and to suggest that those pretensions cannot, in any case, justify a refusal to depict nature's variety, which is now, beyond question, a primary aim of the painter. By all earlier comparisons of the artists, and whatever Fuseli's conclusions about their relative merits, Raphael was certainly the more attentive to

variety, and was certainly therefore the more successful in representing it.

By the middle of the lecture, Michelangelo has been restored to the period of establishment, and Fuseli pays him a lengthy tribute repeated almost word for word from the second lecture, in which the two artists had first been compared. Almost word for word, but not quite—for his virtues have now become milder, and what were earlier trifling failings of genius have become substantial vices. He is now represented as having rightly perceived that the 'stamina' of 'works worthy of perpetuity' must be 'the genuine feelings of humanity'—he seems no longer the stern 'painter of mankind', the artist of the 'reigning passion'. But whereas Fuseli had observed, in his second lecture, that Michelangelo's 'line' is 'uniformly grand', he now writes that 'his line became generic, but perhaps too uniformly grand'—it is no longer, it appears, to be a virtue of the epic painter, the very mark of his success, that he makes character and beauty 'subservient to grandeur'. Although, earlier, in a low-key parenthesis, Fuseli had remarked that Michelangelo sometimes 'perplexed the grandeur of his forms with . . . ostentatious anatomy', that ostentatiousness is now apparent to Fuseli in what had earlier been Michelangelo's masterwork, the *Last Judgment*. That image, finally, of universal power, which it is the task of the epic painter to represent whether in his ideal heroes or his God, is now declared to have eluded Michelangelo: 'the Daemons of Dante had too early tinctured his fancy to admit in their full majesty the Gods of Homer and of Phidias' (3: 18, 20; 2: 84, 87).[25]

But if the achievement of Michelangelo could still be summed up, with all these reservations and qualifications, as the representation of 'the human race' in 'generic forms', the achievement of Raphael now seems very different from what it had been in the earlier lectures. Raphael, Fuseli now claims, 'drew the forms and characters of society diversified by artificial wants'. Earlier—even a page or so earlier—it had been central to Fuseli's defence of Raphael's 'characteristic' style that he depicted the representative characters defined by physiognomy: 'he found that certain features were fittest for certain expressions, and peculiar to certain characters; that such a head, such hands, such feet, are the stamen or growth of such a body, and on physiognomy established homogeneousness'.[26] It is this defence, also, which dignifies the characterisation of Leonardo, who 'raised' character 'to a species', and which explains the superiority of Titian's portraits over those of mere face-painters. Thus none of these artists is a mere copyist of individual nature, and none was concerned with those differences of character which arise not from the natural distinctions of physiognomy or humour, but from the accidents of

'climate, habit, education, and rank'. Though such accidental distinctions are properly marked in the historical style, they had earlier been argued to be inappropriate in the highest styles of art (3: 26, 22, 17; 2: 256).

The same, one would imagine, would be true of the diversity of character produced by 'artificial wants', which are by definition not natural, any more than the diversity they create can be; and yet it is precisely the fact that, by comparison with Michelangelo, Raphael is 'richer in social imagery, in genial conceits, and artificial variety' which ensures that, while 'we find M. Angelo more sublime', we 'sympathise more with Raffaello, because he resembles us more' (3: 27). He resembles, of course, our human nature, not as it is *purged* of artificial and accidental distinctions, but as it is *shaped* by them, and shaped by those distinctions which have emerged pre-eminently in modern societies. For 'artificial wants' are defined by Josiah Tucker as those which emerge when a man or a society has developed beyond the '*Brutal State*' of poverty, 'which admits of no Commerce at all', so as to become able to demand and to enjoy 'many things both useful and convenient', the desire for which is peculiar to man, not as he is an 'animal' but as he is 'a Member of Civil Society'—which, for Tucker, is a commercial society.[27]

It is crucial to an understanding of Fuseli's position here, that he does not seem to be arguing that Raphael *is*, therefore, a painter of modern life; it is rather that he will come to seem so, when we abandon the attempt to judge art by the timeless standards, the unchanging principles of the civic humanist tradition, and acknowledge that our perceptions of an artist's work may be shaped by the historical forces that have made us what we are rather than him what he is. It is, then, because the art of Raphael *seems* to be particularly in sympathy with the condition of life as it has developed in modern societies that he can particularly elicit our sympathy. And that it is not the 'publick sympathy' of Reynolds that he elicits, but the private sympathy of the fallen for the fallen, is clear from Fuseli's theory of differentiation: the more character is diversified by accidental and artificial causes, the more, he believes, it ceases to be generic, and becomes individual; and the more the members of a society become individuals, the less they can experience social relation in terms of affiliation to a public, and the more they must experience it in terms of the sympathy of one person for another.

7. The composition of a privatised society

Raphael's paintings can apparently enable us, as individuals, to feel

with and for the individuals he depicts, and can thus reflect the condi-
tion of a society whose members consider themselves rather as in-
dividuals than as parts of a public. They can also, to some extent,
redeem that fall into individuality, by inviting us to recognise the
results of that fall in others. But can they also propose, by exhibiting a
unity among the figures in a picture, that we might have more in
common than a shared experience of separation? The problem can be
posed more sharply by a comparison of Barry's notion of how a
painting, which represents the differentiated characters of society,
might be unified, with Fuseli's account of Raphael as a dramatic
painter. For Barry, the task of the history-painter is certainly to
acknowledge the diversity of characters, by the appropriateness of
their physical forms to the different actions they perform; but there is,
for him, no value in the representation of characters except as they
are also shown to be united with others by their participation in a
common objective, the securing of a public good to which all con-
tribute different but related tasks.

In his early writings, and when he is not considering the problems
specific to the dramatic style, Fuseli expounds a similar view: thus, in
an earlier review of the second volume of Stuart's and Revett's *Anti-
quities of Athens*, he writes of the Parthenon frieze:

> But still they have another claim to superiority over modern art:
> the general composition, notwithstanding a sufficient variety of
> contrast and action, possesses that simplicity, that parallelism or
> continuity of attitude and gesture, which produces energy of im-
> pression and through the eye forces itself on the memory of the
> beholder. One great sentiment predominates over the motions and
> expressions of the actors, and allows only as much variety of both
> as individuals claim. It is by this uninterrupted series of attitudes
> nearly similar, where horse joins man, and man joins horse, and all
> seem bent on the same object only, that the artist, who could
> abstract the general form from the local and saw into futurity,
> contrives to impress us with awe, to interest us for ceremonies
> scarcely remembered.[28]

It is not clear from this account whether Fuseli believed that the
figures in the frieze were diversified by character as well as, to a slight
degree, by action and attitude, and if he did not, it would have been
all the easier for him to see the figures as 'bent on the same object
only', and all the harder for him to represent this mode of composi-
tion as appropriate for modern dramatic art, which seems thus
doomed to remain, at least from this point of view, inferior to the
antique. But in his first lecture on invention, he proposes a similar

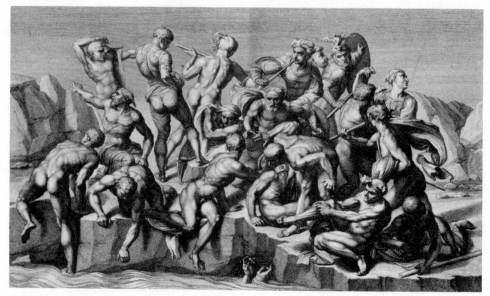

22. Luigi Schiavonetti, after Aristotile da Sangallo, after Michelangelo: the 'Cartoon of Pisa' (*The Battle of Cascina*).

mode of composition as essential to the 'moral element of the art' of painting, whether in Greece or in modern Europe: the exhibition of 'the united exertion of form and character in a single object, or in participation with collateral beings'. In that lecture, the supreme example of such an exhibition of unity is the lost 'Cartoon of Pisa', by Michelangelo, which Fuseli knew only from the descriptions of those who had seen it, and from 'a small copy now existing at Holkham, the outlines of which have lately been etched'. The cartoon displayed a 'scene of tumult', unified by its composition and by the singleness of purpose which appeared in the attitudes and expressions of the different generic characters—'experience and rage, old vigour, young velocity'—it represented. Thus it was composed according to a pattern which will soon become familiar to us: 'from the chief, nearly placed in the centre, who precedes, and whose voice accompanies the trumpet, every age of human agility, every attitude, every feature of alarm, haste, hurry, exertion, eagerness, burst into so many rays, like sparks flying from the hammer'; and the 'scene of tumult' was saved from chaos also by the 'one motive' which 'animates the whole', an 'eagerness to engage' unified with 'subordination to command'. This motive 'preserves the dignity of action, and from a straggling rabble changes the figures to men whose legitimate contest interests our wishes' (2: 135, 151–4).[29]

By composition, it seems—or by a certain structure of composition—a rabble can be converted into a public, with common purposes and ends. But such a notion of the unifying power of composition will not be easily applicable to Raphael, because it is not, in the dramatic style, the event or the action which is the main subject, but the diversity of the characters themselves, and of characters not simply divided, but *'subdivided'*, insisting on their difference from each other (2: 348, my emphasis). Nevertheless, throughout the lectures, Fuseli struggles to show that Raphael's paintings are unified by some such notion of composition, which he attempts to present as a metaphor for an idea of 'human connexion'. Such an idea, he argues, is always Raphael's concern, and for its expression, he believes, 'composition' is essential: thus Michelangelo, when his subject was 'the primeval simplicity of elemental nature', employed 'apposition' only—'a collateral arrangement of figures necessary for telling a single or the scattered moments of a fact'—but employed 'composition' whenever he 'retreated within the closer bounds of society' (2: 87, 240–1). But as we have seen, when Fuseli attempts to argue that the unity of mankind is an important, or the central concern of Raphael's work, he seems to be required also to argue that his paintings are epic works, or are epic at least as much as they are dramatic. In the *Parnassus*, 'Poetry, led back to its origin and first duty ... unites man, scattered and savage, in social and religious bands'; in the *School of Athens*, philosophy teaches us the 'one great doctrine, that, fitted by physical and intellectual harmony, man ascends from himself to society, from society to God'.[30] These are represented as epic subjects, and as employing an epic principle of invention, the substantiation of 'some great maxim'; and the difficulty that Fuseli encountered, in attempting to argue that composition in Raphael's paintings can be understood as an apt representation of human connection, while still maintaining that Raphael was essentially a 'characteristic' and a 'dramatic' painter, is particularly clear in his first attempt at the extensive description of the structure of one of Raphael's works, the cartoon of Ananias (2: 168, 246).

Throughout his writings on art, Fuseli remains consistent, as we shall see, to a belief he first advanced in 1792, that composition is 'the formation of a striking centre into subordinate rays'; and this idea of the relation of the components of a picture to a centre which unifies them is one he finds embodied in the structure of the cartoon. It is a work which, by virtue of its composition, makes us 'partners of the scene', even before 'we are made acquainted with the particulars of the subject': 'the disposition is amphitheatric, the scenery a spacious hall, the heart of the action is the centre, the wings assist, elucidate,

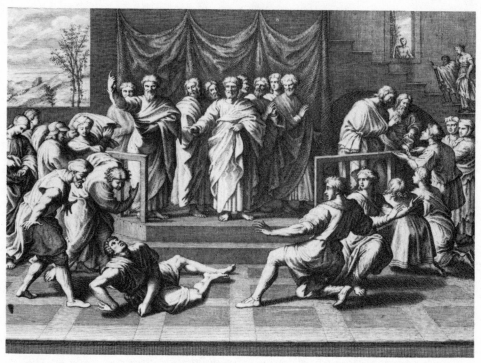

23. Simon Gribelin, after Raphael, *The Death of Ananias*.

connect it with the ends'.[31] To make clear the ability of the composition itself to involve us in the action of the cartoon, Fuseli continues to describe the work, almost until the end of his account, as if the subject were unknown to us: thus, he writes, 'the apoplectic man before us is evidently the victim of a supernatural power, inspiring the apostolic figures, who on a raised platform with threatening arm pronounced, and with the word enforced his doom'. From this centre, the shock-waves radiate out, with diminishing intensity, towards the other actors, so that 'the terror occasioned by the sudden stroke is best expressed by the features of youth and middle age on each side of the sufferer; ... its shock has not yet spread beyond them, a contrivance not to interrupt the dignity due to the sacred scene'. 'In this composition', Fuseli concludes, 'of near thirty figures, none can be pointed out as a figure of common place or mere convenience; legitimate offsprings of one subject, they are linked to each other and to the centre by one common chain, all act and all have room to act; repose alternates with energy' (2: 246–7).

It is perfectly clear from this account how the composition, thus described, communicates to the spectator a sense of the unity of the

figures it includes: we are invited to understand their varied expressions in relation to a dramatic occurrence at the centre of the stage, and thus they may well seem to us to be 'linked to each other and to the centre by one common chain': the terror expressed by 'youth' and 'middle age' elicits our sympathy, which is also elicited in advance on behalf of the more peripheral figures, as we anticipate the passions they will experience when the shock reaches them.[32] It is much less clear, however, how such a 'contrivance' can exhibit 'human connexion' among all the 'near thirty figures' depicted in the cartoon: for in fact it depicts them, not as all reacting to the same terrifying event, but as, most of them, not yet reacting to it. If we remember how emphatically Fuseli argues, in his accounts of Raphael's dramatic art, that event is 'subservient' to the exhibition of character, then the point of the composition may well seem to us to represent, not so much a 'common chain', a connected unity of feeling, as something more akin to its opposite, and the unity of structure may seem an enabling device, to justify the representation of a diversity of characters in terms of an event which does not so much relate to them as provide an opportunity for arranging them together.

This possibility, that the structural principle in Raphael's works is not composition but mere 'grouping', is suggested by Fuseli on at least two occasions. In the 'corollary' to his sixty-fifth 'aphorism', which may have been written at any time between 1788 and 1818, he writes:

> The assertion that grouping may not be composing, has been said to make a distinction without a difference: as if there had not been, still are, and always will be squadrons of artists, whose skill in grouping can no more be denied, than their claims to invention, and consequently to composition, admitted, if invention means the true conception of a subject and composition the best mode of representing it. After the demise of Leonardo and Michael Angelo, their successors, however discordant else, uniformly agreed to lose the subject in the medium (3: 82–3).[33]

Though Michelangelo, of course, long outlived Raphael, the history of influences makes Raphael one of his 'successors'; and the suspicion that some, at least, of the above criticism must apply to the younger painter is confirmed by the 'corollary' to aphorism 126, where Fuseli remarks that 'the desire of disseminating character over every part of his composition made Raphael less attentive to its general effect' (3: 107).

To an artist with the priorities that Fuseli ascribes to Raphael, the advantage of mere grouping over composition, especially as composition is described, for example, in Fuseli's account of the 'Cartoon of

Pisa', is that it can unite in a pictorial unity figures who do not how-
ever appear to be conscious of partaking in a social unity, and that
sense of separateness, of course, has already been ascribed by Fuseli
to Raphael's figures, whom the dramatic style exhibits as characters
involved 'in the conflict of passions with the rights, the rules, the
prejudices of society'. Something like the same sense seems to be
communicated to Fuseli by the cartoon of Ananias, and to be ex-
perienced, there, as something to be desired: 'all act and all have room
to act'. The cartoon, in short, may express an idea less of social
affiliation than of disaffiliation: the characters seem jealous of the
individual, private spaces they occupy, and where they are free *not* to
'seem bent on the same object only'. The cartoon may not, then,
represent the compatibility of society and the individual, but the
tension, the conflict between them; and so may represent not the
experience of human connection but the desires and the difficulties in
its way. In doing so, of course, it must make Raphael that much more,
for Fuseli, a painter of modern life.

What may seem a more convincing account of the function of
composition in creating a sense of human connection appears when
Fuseli considers the structure of Raphael's works as unified by light,
by colour and chiaroscuro. The pictorial unity, at least, that may
relate the figures in a painting illuminated by a central source of light
is described on a number of occasions by Fuseli. In Titian's altar piece
of the Pesaro family, the figures are mere portraits, and are dressed in
the 'habiliments of the time', 'but all are completely subject to the
tone of gravity that emanates from the centre'. In Tintoretto's
Crucifixion, in the Albergo of San Rocco, a 'multitudinous rabble' is
'dispersed' and yet 'connected' by 'a sovereign tone, ingulphing the
whole in one mass of ominous twilight . . . nor suffering the captive
eye to rest on any other object than the faint gleam hovering over the
head of the Saviour in the centre'.[34] At the centre of Titian's painting
stands 'St Peter . . . at the altar . . . his hand in the Gospel-book', and
it is clearly essential to the success both painters have achieved in
unifying their figures that the light emanates from a central image of
divinity or revelation: it is, perhaps, for that reason that the individ-
uals in Titian's work are content to be 'completely subject' to a prin-
ciple of unity (2: 212–13, 295). On two occasions at least, according to
Fuseli, Raphael achieved a similar kind of success: in the *Dispute of
the Sacrament*, but still more notably, in the *Heliodorus*, in which:

> Manifold as the subdivisions of character are, angelic, devout,
> authoritative, brutal, vigorous, helpless, delicate; and various as
> the tints of the passions that sway them appear, elevated, warmed,
> inflamed, depressed, appalled, aghast, they are all united by the

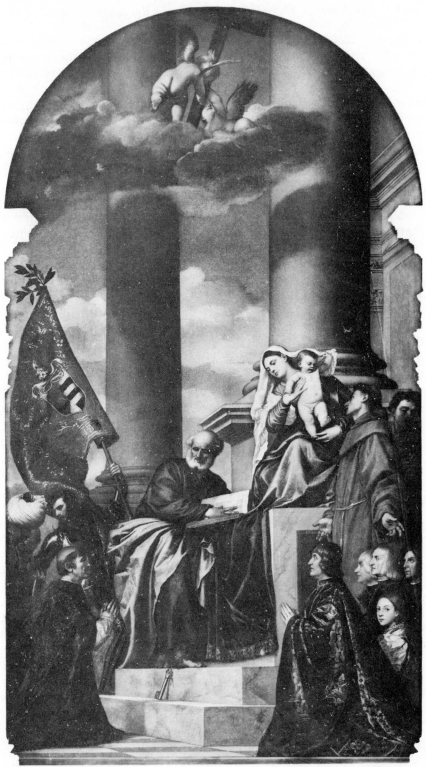

24. Titian, the *Pesaro Madonna* (1519–26), Venice, Santa Maria Gloriosa dei Frari.

general tone that diffuses itself from the interior repose of the sanctuary, smoothens the whirlwind that fluctuates on the foreground, and gives an air of temperance to the whole (2: 351–2).

The diversity of characters, and especially of passions, represented in this picture may suggest that the figures are disunited rather than united, but they are all reacting to the same event, and so, in some sense, the work manages to suggest that they share a common object even as they regard it differently.[35] Of equal importance to Fuseli, however, is the fact that, at least to the spectator, this diversity is registered at the same time as it comes to seem unimportant: for in whatever other contexts a diversity of character may be exhibited by Raphael at the expense of an ideal of unity, the light here emanating from the sanctuary serves to remind us, as it reminded the figures in Titian's altarpiece, that in the light of religion we are all as one.

But more successful, in this light, than any individual work by Raphael, is Leonardo's *Last Supper*, to a discussion of which Fuseli devotes a good part of his eleventh lecture, and in which Leonardo emerges as, on this one occasion, more fully a painter of modern life even than Raphael.[36] The characters of the disciples are carefully discriminated, but none is 'conspicuous' at 'the expense of the rest': though 'the nearest by relation, characters and age' are 'placed nearest the master of the feast', still 'distance is compensated by action', and so each enjoys an equality of attention which Fuseli seems to invite us to understand as an equality of relation with Christ. They are all united by 'the tone which veils and wraps actors and scene into one harmonious whole', and by the structure of the painting, in which 'the centre leads to all, as all lead to the centre', and there to the figure of Christ. Compared with Leonardo's achievement, the version of the same subject, in the Vatican Loggia, 'painted, or what is more probable, superintended by Raphael', 'presents little more than groups busy to arrange themselves for sitting down or breaking up' (3: 14–16).[37]

Fuseli regards Leonardo's version as an example of dramatic art: 'that the great restorer of light and shade', he writes, 'sacrificed the effects and charms of *chiaroscuro* at the shrine of character, raised him at once above all his future competitors; changes admiration to sympathy, and makes us partners at the feast'. It could not be more clear that Fuseli now regards the characteristic, and dramatic style, as the highest style of art; for it is essential to the pre-eminence that, on the basis of this one work, Leonardo can claim over all other painters, that he exchanges the 'admiration' inspired by epic painting, for the 'sympathy' elicited by the dramatic, a sympathy which involves the

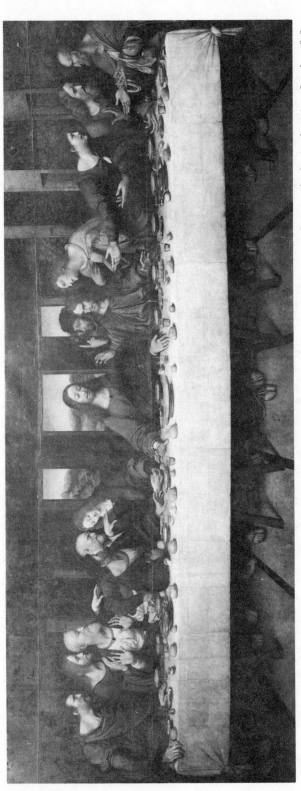

25. Marco d'Oggiono (attr.) after Leonardo da Vinci, *The Last Supper*. According to Ralph N. Wornum, *Lectures on Painting, by the Academicians*, London 1848, p. 532, it was this version of Leonardo's painting, acquired by the Royal Academy in 1821, which Fuseli used to illustrate his eleventh lecture.

spectator in the work, and enables him to experience his own membership of the body of Christ through that of the disciples. That we can arrive at an understanding of our corporate unity more immediately through dramatic painting than through epic may be more a result, of course, of the nature of modern life, than of the nature of the styles themselves: it may not be that 'mankind' cannot, but simply that *we* now cannot react to the sublime imagery of epic except by feeling humbled, unable to experience that transference of power, from image to spectator, that is claimed by contemporary writers on aesthetics to be an effect of the sublime. Whether because the sublime of heroism is now too stern an ideal, or because the Christian religion can ascribe the 'character of equal universal power' to God alone (as Leonardo has depicted 'sublimity' only in the Saviour), we cannot now experience 'human connexion' by admiration, but only by sympathy, and we can sympathise only with characters imperfect as ourselves. For that reason, the disciples in the painting 'neither are nor ought to be ideal'; they resemble rather the 'familiar' forms, offered by the followers of Eupompus to their privatised audience; for the dramatic art of Leonardo and Raphael, placed by Fuseli in the ages of the preparation and establishment of Italian art, bears now all the characteristic marks of the art of the Greek period of refinement (2: 15, 9, 14).

The Last Supper is thus an image of 'human connexion', and is experienced as such by the figures and the audience alike; and Fuseli's account of it is his most complete evocation of a work which reflects that diversity of character which is so especially a feature of modern society, at the same time as it redeems that diversity, by revealing to us a larger principle by which, in all our variety, we are nevertheless—like the characters described by Barry and Blake, or exhibited, by Fuseli's account, in the 'Cartoon of Pisa'—members of one body: diverse, but not a 'rabble'; unified, but not uniform. But it is worth reminding ourselves that Fuseli's account of *The Last Supper* is an utterance made in that voice which feels obliged, however willingly, to abandon the unchanging critical principles of the humanist tradition, and so it is worth remembering also what that voice will not demand, and what the alternative voice of the lectures cannot discover: a means by which the members of a privatised society might recover the sense of participating in a public. In the art advocated by Barry and Blake, the effort is to unite the social and the religious in an idea of the public, our membership of which is constituted both by our common faith and by our common social purposes; in the art admired by Fuseli in the eleventh lecture, the experience of a common faith has, among its functions, to fill the space vacated by a lost sense

of participation in a public, a loss which has left us able to experience social relations only as private relations. I speak of what Blake and Barry 'advocated', and of what Fuseli 'admired'; for even to Fuseli's milder voice, it seems impossible that modern artists could now create such images as Raphael and Leonardo created; he seems to believe, that is, that those works could have been created only in a period when the public was still a visible object, but that it is possible for modern critics to *read* them as descriptive of the modern world, whatever the purpose for which they were originally created.

I do not want to represent this as Fuseli's final position: the final, twelfth lecture is, as we have seen, a demand for public art so uncompromising as to end in desperation; and I see no possibility of interrupting, at one point or another, Fuseli's argument with himself, and claiming that it is *there* that Fuseli speaks as himself. What is most of value in his writings is the urgency with which he engages the social and artistic processes he describes—whether he seems to be arguing for an art which makes diversity of character subservient to public principle, for an art which does the opposite, or for one which dramatises, as his lectures do throughout, the conflict between them.

V

BENJAMIN ROBERT HAYDON AND WILLIAM HAZLITT: TWO ENCYCLOPAEDIA ARTICLES

1. Haydon: public style and individual genius

THE CIVIC humanist discourse and its adaptations that we have been studying, is concerned to define a public art, whose existence may depend on the prior presence within a civilization of a visible public sphere, but whose function may also be to enable the creation of such a sphere. The possibility of a public art was therefore understood to be threatened, in the late eighteenth and early nineteenth centuries, by what was perceived as a process by which society was being privatised, and the primary instrument of that process was the division of labour. Our reading of Fuseli's lectures seemed to suggest, however, that the existence, not simply of a public art, but of the discourse that defined it, was threatened by the same process. For it seemed to be the increasing importance Fuseli ascribed to the notion of individuality, defined in terms of private wants, and to private sympathy, the mode of social affiliation appropriate to a society of individuals, that prompted the emergence of his private voice; a voice which contradicted, attenuated, and softened the voice of civic virtue, whose pronouncements seemed at times to become more

severe the more they were opposed. In the writings of William Haz-litt, a discourse emerges which ascribes, far more often than not, no value at all to the terms—'general character', 'public art', and so on—by which the civic discourse of Reynolds, Barry and Blake had been maintained, and which, by a demand for representations of individual character, by denying the possibility of 'public taste', and by an insistence on individual genius as entirely independent of historical circumstances, attempts to define an art whose aims and satisfactions are represented as being more or less exclusively private. The main object of this essay will be to offer an account of how the discourse we have examined in the earlier essays of this book was directly challenged by Hazlitt.

But that discourse did not simply succumb to Hazlitt's challenge, however considerable his influence. It continued, most notably in the writings of Benjamin Robert Haydon, and it continued the process, initiated by Fuseli, of undermining itself from within. The disruptive term in Haydon's writings is not the same as in Fuseli's—'sympathy'—but, predictably enough, 'genius', which, though at some times and in some places it may be fostered or repressed by the processes of civilization, is always emphatically, for Haydon, the 'primary cause' of art. Haydon regarded himself, throughout his life, as a man with 'public plans for art',[1] and as entirely convinced that the function of art was properly a public function: he had almost no time for any genre other than history-painting. But his insistence on the primacy of genius makes it hard for him to insist, with any great conviction, on the reciprocity of the relations between art and society; and just as he has no very firm belief that (except in Greece) the existence of a public sphere in society is a cause of public art, so he has no clear theory of how the forms of a such an art, as well as the subjects of 'public commemoration' which the artist should represent, could foster the creation of a public. If a genius is to hand, he will produce a public art, whatever social and political circumstances he finds himself in; but though the art he produces will be better if he is in receipt of public patronage, it will still be public art if he is not. The relations between the political republic and the republic of taste are reduced by Haydon almost entirely to relations of patronage, and, as far as form is concerned, the responsibility of the artist to paint public pictures seems reduced to the responsibility to paint in a public *style*—a responsibility which is argued for in a sternly moral language, but which seems to be in no particular moral relation with the society which welcomes or ignores it, beyond the fact that the production of works in that style reflects some kind of moral credit on the society which patronises and welcomes it.[2] The two republics, in

short, are separated by Haydon, even as he seems to write as the legitimate inheritor of the civic humanist discourse which had proclaimed their inseparability.

The most coherent statement of Haydon's theory of art is to be found in the article, 'Painting', published in the *Encyclopaedia Britannica* in 1842. The statements of principle with which the article opens and closes clearly indicate that, though Haydon values the *Discourses* above the lectures of Barry and Fuseli, his opinions have been formed primarily by those two later writers. Thus his insistence that form, not colour, is 'the basis of painting', and his denunciation of the schools of Venice, Flanders, Holland and Britain, in which colour 'has always reigned, to the sacrifice of common sense', have more of the urgency of Fuseli than of the urbanity of Reynolds; and his definitions of the 'great principle of Greek art', that '*the most perfect imitation of reality was not incompatible with the highest style*', and of the 'grand style' as that in which nature is 'elevated not violated, with . . . none of her essential details omitted, and none of her essential principles overwhelmed by useless detail' may both have been derived, as the same beliefs probably were in Hazlitt, from Barry (693a, 701a, 712b).* At the end of the article, Haydon offers an overt criticism of Reynolds (whose 'system' is '*false*, and should be exploded', 730b),[3] not only in the terms in which Barry had criticised Reynolds's account of the relation of general idea and particular details, but also for misconceiving the distinction between the grand and the ornamental styles of history-painting:

> The principle laid down for high art has been, that the lower addresses the eye and the higher the mind, and that the union of the two was incompatible; whereas, the true principle surely is, that both styles address the mind through the eye, but in different ways; the lower walk making the imitation of the actual substance the great object of pleasure only; and the higher walk making imitation the means of conveying a beautiful thought, a fine expression, or a grand form with great power (729b).

As a reproof to Reynolds, this is not especially damaging, and amounts to no more than a criticism of Reynolds's earlier positions by borrowing from his later ones; but as an indication of the poverty of Haydon's theory, the degree to which he conceives of public art largely as a matter of style, it is very instructive. I am thinking of the emptiness, as it seems to me, of Haydon's effort to define what it is

* All page numbers in this section of the chapter refer to *Encyclopaedia Britannica*, 7th edition, vol. 16, Edinburgh 1842. The letters 'a' and 'b', following page numbers, refer respectively to the left and right-hand columns of pages.

that works in the higher style attempt to communicate: 'a beautiful thought, a fine expression, or a grand form'—Haydon has little more than this to say, elsewhere in the article, about what it is that the grand style should represent, or why it should.[4]

Probably the most interesting thing he finds to say about the topic occurs in the form of a criticism of Michelangelo, who, had he seen the Elgin marbles, and in particular 'the Theseus and Ilyssus, Jupiter's breast and horse's head, . . . would have felt the difference between the muscular swing of a blacksmith, and a hero naturally born powerful, without his muscles being distorted by manual labour' (713a). If not in Haydon's, then certainly in Barry's or Blake's writings, an opinion such as this would have been part of a social theory of art, the function of which would have been to argue for the representation of the human figure as unmodified by the demands of divided occupations; and the aim of art, to create a public, to make us aware of the ground of social affiliation, would have been achieved by the representation of the ideal, heroic form of the human body prior to its receiving any specific occupational determination.[5] This may well be Haydon's point, too; but in the absence of any clear social theory of art in the article, the passage seems rather to serve as an instance of that individualistic ideology which continually insists on the priority of nature over nurture, and so on the idea of genius as independent of circumstances. In these terms, Theseus, for example, as a subject for the artist, has a significance for Haydon of the same kind as has the artist of genius—Rembrandt, for instance, who 'seemed born to confound all theory but that of innate genius', or Reynolds, who, 'if ever there was a refutation' of his own theory that '"genius was the child of circumstances"', was 'a living one' (721a–b).

Haydon's article is structured as a history of art, from its earliest origins, now placed among the Ethiopians, to modern Britain, and this history is of interest primarily as it attempts to graft a theory of the primacy and independence of genius on to the circumstantial histories of Barry and Fuseli. The difficulty involved in this attempt is clearest in Haydon's efforts to argue that both genius and circumstances must unite for the production of great art, but to argue also that genius is the 'great primary cause' of art, and that circumstantial factors—climate, the availability of patronage, the presence of visible and active public institutions, the general love of beauty in a nation at any time—are secondary causes. At times, this distinction between primary and secondary causes creates no problems for Haydon's argument, as for example where he argues against the position by which 'the superiority of the Greeks in art is always

attributed to the secondary causes of climate and government'. This position forgets 'the one important requisite, without which the influence of the most genial climate, or the patronage of the most perfect government could avail little; we mean natural and inherent genius'; for though such secondary causes may 'elicit' or 'foster' genius, they 'can never create it' (716b, 696a). Haydon's point here is simple enough, and as long as he is considering the art of antiquity, the notion that genius is the primary cause of art means no more than that genius is not originated by secondary causes, and does not mean that the workings of genius are more or less independent of the circumstances in which it works. Thus such artists as Polygnotus, Zeuxis and Apelles were the 'result' of the union of genius and secondary causes—of the union, then, of innate genius and of favourable circumstances which 'considerably facilitate the development of genius', while, on the other hand, the decay of art in Imperial Rome is the clearest possible evidence that 'the genius and the patron must exist together, or the result will be nothing' (698a, 705a, 706a).[6]

But in his account, for example, of the decline of the Roman school after the death of Raphael, Haydon writes: 'Lanzi attributes this decay to any cause but the right one; namely, the *absence of genius*, the great primary cause, and which no academy can ever supply' (716b). The assumption here—as everywhere, more or less, in Haydon's consideration of modern art—is that genius is independent of secondary causes, and that *something* will result from it, however unfavourably it is circumstanced.[7] Genius is now a 'primary cause' of art in a quite new sense. The shift will appear most clearly, perhaps, if we compare the remarks I have quoted about Polygnotus, Zeuxis and Apelles on the one hand, and Rembrandt and Reynolds on the other: when Haydon avers that 'such men' as the Greek artists were produced by the union of primary and secondary causes, he must mean, not such innate geniuses, but such mature and productive geniuses—it is, if you like, their works which are the product of the union, though their genius was not. But he must mean, also, that the works of Rembrandt and Reynolds were the product of no such union, but simply of their own innate and original abilities.

As the passages that I have cited suggest, the closer Haydon, in his history of art, approaches to the painters of his own day, the more he attributes to genius a power unlimited or unaided by contingency, and the more he abandons the civic humanist discourse of Barry and of Fuseli *publicus*. His account of the decline of Greek art is concluded entirely within the terms of that discourse:

when the art becomes national and glorious, the noble and the opulent become ambitious to share the glory with their country; and the art sinks to the humble office of adorning apartments. As is the demand, such will be the supply; and the genius of a country is thus turned from national objects and public commemorations to private sympathies and domestic pleasures (702a).

The suggestion that the genius of Greek painting was a national rather than individual genius, the sense implicit in 'national objects', that a civilization may define aims for its achievement, and that their achievement may be encouraged by a public art, and the clear statement that a society whose ground of affiliation is no longer looked for in those objects but in 'private sympathies'—all make these sentences as complete a summary of the political ideals and the historical perceptions of traditional British civic art criticism as any to be found in this book. By the time Haydon comes to consider Michelangelo and Raphael, however, he sees them as owing their greatness 'to their own genius' (709b) and to almost nothing else: the secondary circumstances that favoured their development are reduced to their good fortune in finding, in Julius II and Leo X, individual patrons who encouraged and supported them; and by the time of Rembrandt and Reynolds, as we have seen, even such props have become redundant.[8]

We will discover that there is a similar disparity, though for reasons rather different, in Hazlitt's treatment of Greek and modern art. But as far as Haydon is concerned, the disparity seems to be the result of a desire to insist upon the absolute independence of individual genius in such a way as will justify the practice of history-painting, perhaps Haydon's in particular, in the only terms now likely to persuade an audience which has come to regard art as an essentially private thing—as something produced and enjoyed in privacy—and an audience for which the notion of transcendent genius guarantees both the transcendent power of art and its marginal importance to the activities of government, and of commerce and manufacture, which have now come to be understood as occupying, with government, the public space. It is however the misfortune of the painter that, whereas the poet can 'give vent to his immortal thoughts in poverty and wretchedness, independently of the taste of the times, or the patronage of the state', the painter—the examples of Rembrandt and Reynolds notwithstanding—requires the help of secondary causes, or at least of patronage—to 'facilitate' his development. The artist who is reduced by poverty (for a poet something to be welcomed, for it enables him to demonstrate his independence and elevation of

soul) to producing works of a size suitable for the adornment of private apartments is degraded to the level of interior decorators—'upholsterers', 'gilders', 'paper-stainers' (Haydon's word for the painters of decorative watercolours); but the artist of true genius seeks to express 'his own burning conceptions' on a great scale, on the scale, for example, of the 'series of grand works referring to the British Constitution', with which Haydon proposed the House of Lords should be decorated (705a, 706a, 703a, 728a–b).[9] For such works, public patronage was necessary, and an argument for public patronage could most authoritatively, if not most persuasively, be mounted on the terms of the civic tradition of art criticism.[10] Within the economy of Haydon's article, the careers of Raphael, Michelangelo, Rembrandt, and the artists of the British school—notably Reynolds, Hogarth and Wilkie—are used to demonstrate the independence, the transcendence of genius; the Greeks, inevitably, are used to carry the argument for public patronage; and the two arguments are shaken together into a cocktail designed for the consumption of a similarly hybrid audience of 'private citizens'. It is no wonder that a consideration of the public function of an allegedly public art can find no place in an article thus divided between a simplified Romanticism, which measures the value of art by the degree of its elevation above the merely political and social, and a civic rhetoric which is employed neither to describe nor to criticise the failure of modern civilizations—but only that of the Royal Academicians—to embody the civic ideal.

2. The composition of Hazlitt's article

In 1816 William Hazlitt contributed an article, 'Fine Arts', to the supplement to the fourth and fifth editions of the *Encyclopaedia Britannica*. It was reprinted, in various versions, on various occasions, as well as being incorporated into the seventh, uniform edition of the encyclopaedia in 1842: by W. Hazlitt in his father's *Literary Remains* (1836) and *Criticisms on Art* (1843–4), and, along with Haydon's article on painting, in a volume published by A. and C. Black in 1838.[11] The opportunity to write at greater length than was permitted by his contributions to *The Champion* enabled Hazlitt to make a comprehensive attempt to define and organise his opinions on painting: in a letter to the editor of the supplement, he claimed that the article contained 'the best part of what I know about art'.[12] It contained, indeed, a large part of what he had written about art up to that time, for, typically, Hazlitt composed the article by linking together

passages only slightly adapted from his earlier newspaper reviews and periodical essays. There are borrowings from two reviews for the *Morning Chronicle* of exhibitions held by the British Institution in 1814. There are portions of each of the three essays on Reynolds's *Discourses* —'On Genius and Originality', 'On the Imitation of Nature', and 'On the Ideal'—which Hazlitt had contributed to *The Champion* in 1814 and 1815, and a number of paragraphs from the essay on the 'Character of Sir Joshua Reynolds' which had appeared in two parts in the same periodical in 1814. The article includes also sections of five other essays for *The Champion*: 'Wilson's Landscapes', 'Mr. West's Picture of Christ Rejected', 'On Gainsborough's Pictures', and 'Fine Arts. Whether they are promoted by Academies and Public Institutions', all published in 1814, and 'Lucien Buonaparte's Collection' of 1815. The result is a good deal less orderly than we might expect an encyclopaedia article to be—it has less of the tidiness, however superficial, of Haydon's contribution, but less of the confusion too; though there is, as I have suggested, a similar, unexplained abandonment of historical explanations for the development of art as Hazlitt's account moves from the Greeks to the moderns.

I have chosen to limit my account of Hazlitt to a discussion of this essay, his most complete statement on the history and function of painting, and my contention will be that it should be read as a statement of determined opposition to the civic theories of art that had been advanced by Reynolds, Barry, and (with whatever reservations and contradictions) by Fuseli. It takes its stand on the necessity of a complete separation of the republic of taste from the political republic, on an aesthetic by which excellence in painting is achieved by the representation of individual character by individual genius, and on an insistence that the satisfactions offered by painting are offered to us as we are private individuals, not public citizens. This is a stand which I believe to be taken by Hazlitt throughout his writings on art, with the most obvious exception of his essays on 'The Catalogue Raisonné of the British Institution' (1816), where his repudiation of the selfishness of the promoters and of many of the practitioners of art in regency Britain enabled or required him to employ a rhetoric of liberal disinterestedness which led him flatly to contradict a number of his usual opinions.[13] I shall not, however, argue for this belief in this essay, because I am doubtful of the value (at least for my own purposes) of the kind of account of Hazlitt's opinions on art which would attempt to produce coherence among them, or even a coherent explanation for their incoherence. With the exception of 'Fine Arts', the fifty or sixty essays and reviews which Hazlitt wrote on painting

(leaving aside essays on other topics in which there are remarks about painting and painters) were written for inclusion in periodicals and newspapers, many of them in reaction to particular exhibitions, publications, or provocations, and many of them characterised by the habit which Hazlitt 'confessed' to MacVey Napier after piecing together his encyclopaedia article, that he was 'apt to be too paradoxical in stating an extreme opinion' when he thought 'the presiding one not quite correct'.[14] If we do not find Hazlitt's opinions on art entirely contradictory of each other, we continually find asymmetries in his arguments, reversals of emphasis, and (as in the essay on the Catalogue Raisonné) a range of competing critical discourses, committed to the defence of a range of critical beliefs, taken up and abandoned as one provocation or another dictates.

There seem to me to be two ways of attempting to produce from all this a coherent account of Hazlitt's opinions on painting. One would be impracticable, perhaps even in a book devoted to doing nothing else, for it would require lengthy and close analyses of Hazlitt's vocabulary and arguments over the whole range of his writings on art. The other, which was the method employed by John Kinnaird in his excellent *William Hazlitt: Critic of Power*,[15] requires continually that we refer Hazlitt's pronouncements on painting back to wherever else in his writings—on metaphysics, psychology, general aesthetics—we believe we can find a ground where they can be shown to have a coherent origin. The danger of doing this—apart from the obvious danger of assuming that it is in what a writer says about *deep* topics that we should look for the *deep* ground of his opinions—is that we produce by this method a *biographia literaria*, an account of Hazlitt's 'literary life and opinions', and of each of those opinions in the light of all the rest, which we can be sure has not much to do with how Hazlitt's unsigned writings on art would or could possibly have been read by his contemporaries. It is for these reasons that I have chosen to devote the space available to me to an account of one piece of writing on art—the longest piece, by Hazlitt's account the most representative of his opinions, at least as they were in 1816, and, if not the most widely read, the one most variously available in the years after his death.

3. *'The immediate imitation of nature'*

The stated aims of Hazlitt's article are two-fold: he means 'to develop the principles upon which the great masters have proceeded', and this involves distinguishing these principles from those developed by

Reynolds in the *Discourses*; and he intends 'to enquire . . . into the state and probable advancement' of the fine arts in Britain, a task he reserves for the final section of his article. The 'great masters' he acknowledges are the Greek sculptors, the 'celebrated Italian masters', 'those of the Dutch and Flemish schools', and Hogarth; and all these artists, claims Hazlitt, 'owe their pre-eminence and perfection to one and the same principle—*the immediate imitation of nature*'. Whether in the Greek statues or in the grotesque figures of Hogarth, perfection arises from 'the truth and identity of the imitation with the reality; the difference was in the subjects—there was none in the mode of imitation' (155–6).*

This last clause does not turn out to mean that the mode of each artist was the same, in that (as in Reynolds's, or Barry's, or Blake's scheme) they saw, more or less perfectly, the same nature in the same way, and attempted to imitate it in the same manner, whatever the differences their styles actually exhibit—the notion that still seems to hold in Haydon's article. Like Du Bos—by whose *Réflexions* he may have been substantially influenced—and like Mengs, Hazlitt does not believe that the different styles of great artists can be judged in terms of their greater or lesser success in copying an identical reality, but that each artist saw a particular portion, a particular aspect, of a various and variously aspected nature, and that all imitated the portion disclosed to them in the same way, only inasmuch as all attempted to represent as truthfully as possible the particular aspects of nature that they saw.[16] Thus Hazlitt attacks those who believe that the difference between the Greeks and Hogarth is that the Greek sculptures are more like nature than Hogarth's works: it consists instead in 'the different forms of nature which they imitated' (156)—the different aspects that nature had revealed to them, or that the particular bent of their minds had led them to concentrate upon. In short, differences of style are now to be welcomed and delighted in for what they variously show of a various world; they are a legitimate source of pleasure to the man of true taste, and not just to the connoisseur skilled in the recognition of different hands.

If this position is to be persuasive, Hazlitt must argue not simply against the notion that there is no difference in the ways we each see nature, but also against the particular form in which the notion of a unitary nature had appeared in recent theory—against, that is, Reynolds's notion of ideal or abstract nature, whereby the greatest artists are those which best succeed in producing representative

* All page numbers from here to the end of the chapter refer to the second edition of William Hazlitt, *Criticism on Art and Sketches of the Picture Galleries of England*, ed. W. Hazlitt, London 1856. For an explanation of this choice of text, see below, p. 357, n. 11.

images, images which may stand for whole classes of objects rather than for particulars. Hazlitt does not believe that the task of art is to *represent*, in this sense, but to *deceive* us with images of actual nature (211), and he begins his attack on the notion that ideal nature is something quite different from actual nature by suggesting that it derives from the perfection of the Greek statues, which, since they correspond with nothing we can now see, are usually concluded to have been 'created from the idea existing in the artist's mind, and could not have been copied from anything existing in nature'. Against this belief, Hazlitt offers five arguments: that the 'Greek form appears to have been naturally beautiful' (as compared with that of other peoples); that the Greeks 'had, besides, every advantage of climate, of dress, of exercise, and modes of life to improve it'; that the Greek artist was afforded 'every facility' to study the human form; that the 'religious and public institutions' of the Greeks 'gave him every encouragement in the prosecution of his art'; and the 'superior genius' of the Greek people, which 'consisted in their peculiar susceptibility to the impressions of what is beautiful and grand in nature'. Of these causes, the first two are offered as the most important, the second two as less so, and the fifth is presented as a consideration we should also 'allow for' (157–8).

The privileging of the first two arguments is essential to Hazlitt's point: he must show that the Greek statues, though ideal, are not 'abstractions', and he goes so far as to offer as a proof of this the fact that Greek statues of 'individuals', or individual mortals, are superior to their 'personifications' of Gods. He must argue, that is, that the representation of actual nature *is* the representation of individuals; and if identity with actual nature is the criterion of value in imitations, it will follow that 'personifications' of unseen Gods (and necessarily therefore invented personifications, in some sense abstractions) will be of less value than imitations of actual nature. But Hazlitt goes further than this: the best Greek statues (as Reynolds would have agreed, though for different reasons) are representations of figures in poses that can be held, as opposed to 'those which affect . . . action, or violence of passion', for still figures may be copied exactly, but representations of moving figures must be, to some extent, invented (158).[17]

As evidence of the fact that 'the beauty and grandeur so much admired in the Greek statues were not a voluntary fiction of the brain of the artist, but existed substantially in the forms from which they were copied', Hazlitt adduces the Elgin marbles, in which there is no sign of 'fastidious refinement and indefinite abstraction': 'the figures have all the ease, the simplicity, and variety, of individual nature'. In the

'scrupulous exactness' of 'the details of the subordinate parts', Hazlitt finds 'true nature and true art': the marbles 'are precisely like casts taken from life'.[18] Thus the ideal, he concludes, is not

> the preference of that which exists only in the mind to that which exists in nature; but the preference of that which is fine in nature to that which is less so. There is nothing fine in art but what is taken almost immediately, and, as it were, in the mass, from what is finer in nature. Where there have been the finest models in nature, there have been the finest works of art (159–60).

The privileging, then, of the natural and acquired beauty of the Greek body is essential to securing the principle Hazlitt has enunciated. More problematic, in terms of the larger economy of the argument in the article, is that Hazlitt even admits the argument that the religious and public institutions of the Greeks encouraged and developed the abilities of their artists. It would have been hard to deny the point, perhaps, in the face of the weight of contemporary agreement, but though the argument will eventually turn out to serve an important purpose in the article, of permitting a contrast between the public for art in Greece and in contemporary Britain, in the medium term it will cause problems, insofar as—and still more than in Haydon's article—there will be a virtually entire absence of such historical, such circumstantial explanations from Hazlitt's account of the achievements of later artists. The discussion, as we shall see, of Italian, Flemish and Dutch art will be conducted in terms of a transaction between individual genius and a variously aspected nature, a transaction unmediated by the circumstances of history, and virtually unmediated by patronage.[19] Thus, if we ask why the Greek sculptors were able to imitate nature as exactly as later painters, the main answer that Hazlitt offers is that the Greeks were encouraged to do so by their religious and public institutions, with some help from their superior genius which was, however, the genius of the entire people. If we ask, on the other hand, why the later Greek statues 'display a more elaborate workmanship, more of the artifices of style', and seem to lack 'that entire and naked simplicity which pervades the whole of the *Elgin Marbles*' (163), no answer is forthcoming, and certainly none of the kind that Fuseli offers, or that Hazlitt's own argument seems to require, in terms of the corruption of Greek institutions. If, finally, we ask why the Italian painters, for example, were able to imitate nature as exactly as the Greeks, the answer is simply that they were men of genius who carefully cultivated that genius—this is everywhere Hazlitt's view, except for one brief moment, as we shall see, at the end of the article. The virtual refusal

even to consider the possible operation of historical factors derives, like Haydon's, though for different purposes, from a determination to represent modern art as being, when it is great art, a transaction between nature and individual genius, and a private transaction.

4. *The aristocracy of character*

Hazlitt's survey of the masters of modern art, though it is arranged more or less chronologically, is not intended as a history of art: it is more like the kind of 'diffuse category of individuals ... tutored by different schools' that Fuseli had deprecated. Occasional, casual attempts are made to understand the differences among artists in terms of the societies in which they worked: Titian's flesh-colour, Hazlitt suggests, 'partakes ... of the luxuriousness of the manners of his country'; van Dyck's portraits have 'a certain air of fashionable elegance, characteristic of the age in which he flourished'; English artists cannot paint history because English faces are habitually too inert to express the passions, though national character is not seen by Hazlitt, as it was by Barry, as itself subject to determination or change (169, 176, 217). The function of the survey of the moderns is:

> to show that their pre-eminence has constantly depended, not on the creation of a fantastic, abstract excellence, existing nowhere but in their own mind, but in their selecting and embodying some one view of nature, which came immediately under their habitual observation, and which their particular genius led them to study and imitate with success (176).

There is no suggestion that it might be possible or desirable to attempt a historical account, as well as one founded in individual psychology, of why one or another 'view of nature' should have come under the 'habitual observation' of one artist or another.

I shall not offer much by way of a summary of Hazlitt's account of the great Italian masters; for most of my purposes it will be sufficient to say that their various individual styles and characters are defined by distinguishing their particular excellences and then (to demonstrate the point that genius is necessarily biased towards a particular excellence, to the exclusion of others) their particular defects. Thus Leonardo, for example, 'excelled principally in his women and children', but 'his style of execution is too mathematical', while Correggio's works have 'the utmost softness and refinement of outline and expression', and his colouring 'is nature itself', but 'his style is in some degree mannered and confined'. The discussion of Raphael,

however, is of more interest, insofar as, for Hazlitt as for Fuseli, Raphael excelled in 'expression', and thus in exciting 'sympathy' (166–8, 164). As expression is the key to character, and as great artists are concerned to imitate individual character, the account of Raphael enables Hazlitt to initiate what will be an important theme of his article, that the highest art is to be looked for in the representation of individual character.

We shall consider that theme at more length later in this essay, but for the present it will be enough to point out that Hazlitt's discussion of Raphael is directly aimed at Reynolds, who:

> constantly refers to Raphael as the highest example in modern times (at least with one exception) of the grand or ideal style; and yet he makes the essence of that style to consist in the embodying of an abstract or general idea, formed in the mind of the artist by rejecting the peculiarities of individuals, and retaining only what is common to the species.

Against this position, Hazlitt argues that in Raphael's cartoons, 'and in his groups in the Vatican, there is hardly a face or figure which is any thing more than fine individual nature finely disposed and copied'; and to reinforce the point, Hazlitt enlists the support of Barry, 'who could not be suspected of prejudice on this side of the question':

> 'In Raphael's pictures (at the Vatican) of the *Dispute of the Sacrament*, and the *School of Athens*, one sees all the heads to be entirely copied from particular characters in nature, nearly proper for the persons and situations which he adapts them to; and he seems to me only to add and take away what may answer his purpose in little parts, features, &c., conceiving, while he had the head before him, ideal characters and expressions, which he adapts their features and peculiarities of face to.'[20]

Barry's support for Hazlitt is, of course, qualified: his claim that Raphael copies 'particular characters' does not mean that those characters are exactly, but only 'nearly' proper for the characters he seeks to represent; their 'features and peculiarities of face' must be 'adapted' if they are to be converted into 'ideal characters and expressions'. Hazlitt allows these qualifications to pass without comment, for they would qualify his own claim that Raphael's excellence, like that of all artists, is the result of the 'immediate imitation of nature', and that the ideal is not 'the preference of that which exists in the mind to that which exists in nature'. For Barry, the ideal is *conceived*; for Hazlitt, it is *discovered*; and so for Barry the excellence of

Raphael is his ability to produce representations of general character which still 'stamp the distinguishing differences betwixt one man's face and body and another's', while for Hazlitt his excellence—and it is this that makes him the pre-eminent artist, with Titian, among the moderns—is his ability to discover and to copy characters at once individual and ideal (160–1).[21]

Hazlitt's account of the Dutch, and especially of the Spanish schools, introduces a new principle into the article, by which we are enabled to make distinctions of value among the various objects of imitation. If the principle that a painter should imitate general nature required the addition of a further principle by which an artist could decide whether it was better to paint history or still-life, so too does the principle that excellence is the result of the imitation of actual nature. Hazlitt first indicates what this principle might be in a remark on Teniers, which he may have adapted from Du Bos,[22] but from which, however, he draws a conclusion that Du Bos would not have drawn:

> I should not assuredly prefer a *Dutch Fair* by Teniers to a *Cartoon* by Raphael; but I suspect I should prefer a *Dutch Fair* by Teniers to a *Cartoon* by the same master; or, I should prefer truth and nature in the simplest dress, to affection and inanity in the most pompous disguise. Whatever is genuine in art must proceed from the impulse of nature and individual genius (179).

What it best suits an 'individual genius' to paint is best; what is best imitated, or most immediately imitated, is best; only if the truth and identity with nature of two paintings are equal, are high subjects preferable to low.

An indication of how we might distinguish between high and low subjects is given in Hazlitt's discussion of Velazquez and Murillo, who:

> may be said to hold a middle rank between the painters of mind and body. They express not so much thought and sentiment, nor yet the mere exterior, as the life and spirit of the man. Murillo is probably at the head of that class of painters who have treated subjects of common life. After making the colours on the canvas feel and think, the next best thing is to make them breathe and live. But there is in Murillo's pictures of that kind a look of real life, a cordial flow of native animal spirits, which we find nowhere else (180).

The distinction made here, between thought and feeling on the one hand, and native animal spirits on the other, becomes of the first importance when we reflect that for Hazlitt individual character is

represented by expression, and that expression is the outward sign of profound thought and feeling. Character, for example, is an excellence that Titian exhibits in his portraits, and it manifests itself in the expression of 'thoughtful sentiment', in the 'look of piercing sagacity, of commanding intellect, of acute sensibility'. It is the lesser degree of 'thought and feeling' in Michelangelo's figures which make him less a painter of expression and individual character than Raphael (171–2, 165). But thought and feeling are not, for Hazlitt, to be found in all people, but only in those who can be thought of as individuals: all people are not individuals; and, as we shall see from Hazlitt's reiteration of the word in the final section of his article, those who partake of the 'common' life that Murillo painted are not,[23] for that is why it is *common* life, differentiated by individuality.

What is emerging here, is a social structure in that part of the republic of the fine arts that has to do with the persons represented in art, and one which will be repeated as a distinction among artists and among spectators. The smaller group of those who are represented in art can think, can feel, are characters, are individuals, for, except in Hazlitt's account of Hogarth, 'character' is always understood in the article to be 'individual'; the rest, the mass of the people in 'common life', can display at best a 'cordial flow of native animal spirits', but though they are differentiable, of course, by the 'distinguishing difference betwixt one man's face and body and another's', those differences are no longer for Hazlitt , as they were for Reynolds and Barry, such as he would dignify by the word 'character'.

This distinction in the republic of the fine arts is suggested again in Hazlitt's account of Reynolds's *Count Ugolino*, and of Wilson's landscapes. The fault of Reynolds's picture, the 'highest subject' he attempted, was the result of the fact that he tried to pass off the 'attitude and expression' of 'a common mendicant at the corner of a street, waiting patiently for some charitable donation' as appropriate to the 'fierce, dauntless, unrelating', the 'grand, terrific, and appalling' character of 'a lofty, high-minded, and unprincipled Italian nobleman'. There is not the 'mighty energy of soul' of Dante's Ugolino in Reynolds's, for of course a *common* mendicant, by definition, could not exhibit such a character as Ugolino's, or any character at all (205–6). The distinction seems to make a figurative appearance in the difference Hazlitt sees between Wilson's Italian landscapes, on the one hand, and his English and historical landscapes, on the other. English landscapes, Hazlitt explains, are rarely if ever ideal; they are not 'fine nature', but 'clumsy common nature', and in his paintings of them, therefore, Wilson could find only 'common-place confusion' and 'trees . . . without character'; in his *Niobe*, the figures, 'are not

like the children of Niobe, punished by the gods, but like a group of rustics crouching from a hail storm' (187–9).

The distinction, between those objects of imitation which do have 'character' and those which do not, is defining itself in the language of class distinction: 'grand', 'noble', 'lofty', as against 'mendicant', 'rustic' and 'common', where the last of those words operates as the opposite, not only of nobility, but also of individuality. It is evident, of course, that we are not to take this language too literally—at least that we are not to assume that Hazlitt believes that it is generally an attribute of the grand and noble that they are distinguished for individuality of character, whether or not it is generally true of mendicants and rustics that they are not. The aristocrats in Hazlitt's republic of taste are aristocrats of intellect and sensibility rather than of blood, and the great and fashionable may be as 'common-place' as the mean and humble, as Hazlitt's discussion of Hogarth makes clear.

It might be imagined that the notion that those in 'common life' are incapable of individuality will be questioned by Hazlitt's account of Hogarth, whom we might expect to be treated as a painter of character, and therefore of individual character, as it is manifested in common as well as in 'fashionable life'; and indeed Hogarth is praised for his 'absolute truth and precision in the delineation of character', and for his 'profound insight into the weak sides of character and manners' (182, 180–1). This last phrase, however, which conjoins character with manners, may suggest that in this instance Hazlitt is not thinking of character as necessarily individual, for the plural, 'manners'—and it is primarily as a painter of manners that Hogarth is described—directs attention to what is common, in the sense of what is typical, in the behaviour of people of one type or another, as 'manner' directs attention to what is singular. The emphasis Hazlitt places on 'manners' invites us to see Hogarth as the painter of 'human life and manners' in general, or in general terms: he paints 'the absurdities and peculiarities of high or low life', '"of the great vulgar and the small"'—and the peculiarities appear to be generic, peculiar not so much to individuals as to classes of people, amongst whom more individual discriminations of character and expression cannot be made. This seems to be the point, also, of Hazlitt's praise for Hogarth's ability to depict 'the effects of the most dreadful calamities of human life on common minds and common countenances' (183), as if, on such countenances, experience has effects more predictable than it has on uncommon faces.

It is a point which Hazlitt can make without endangering his contention that Hogarth paints 'actual nature', but only on the understanding that those who participate in common life actually do exhibit

common manners and characters. Hazlitt's usual assumption, therefore, that to paint character is to paint individuality—the assumption made in his discussions of Raphael and Titian, and in his general account of portraiture which we shall consider in the next section—seems to be qualified by the claim that Hogarth, too, is a master of character. In the terms of the article, that claim is essential, if Hazlitt is to justify his placing of Hogarth among the greatest masters; but the qualification is essential too, if the particular characteristic distinction of Hogarth, as distinct from the other great masters, that he is a satirist, is to be substantiated.

The problem for the coherence of Hazlitt's article involved in his use of the word 'character' is not the only problem raised by his account of Hogarth, to whom 'criticism', he asserts, 'has not done . . . justice, though public opinion has. His works have received a sanction which it would be vain to dispute, in the universal delight and admiration with which they have been regarded, from their first appearance to the present moment' (181). Whether the point of this remark is to suggest that it is the peculiar distinction of painters of common life that their works are enjoyed and appreciated by common people, or whether this acknowledgement of a respect accorded to 'public opinion' has simply been taken over from the *Morning Chronicle* review in which it first appeared, without thought for its consequences for the consistency of the article, it is not possible to determine; but no such respect is shown elsewhere in the article, which elsewhere maps out a social structure for the audience for painting which corresponds closely with that for the objects of imitation. It is a structure which compares closely with the structure of the republic of taste embodied in the *Discourses*, of an élite group (of persons imitated, spectators, and also of artists) capable of high thought and feeling, and of a mass incapable of either. Hazlitt's view of that structure is arguably more democratic than Reynold's, in that his theory is hospitable, as Reynolds's is not, to actual nature, where common as well as individual life is to be found, but for that same reason his view of the republic of taste is of a more privatised society. The most valuable part of actual nature, and where, for Hazlitt, its actuality is most evident, is in character and expression; but except in his account of Hogarth, those are by definition individual, to be found not in the mass but only in the élite group. The superiority of that group is a function of an individuality which—in terms of the civic tradition—is private: it consists in their difference from each other, and not (as for Reynolds) in their likeness to others, their representativeness—for Hazlitt, likeness is a property of the mass, not of the élite.[24] By Hazlitt's system, too, the greatest artists (with the

exception of Hogarth), those who best capture the differences among individuals, do so, as we have seen, as a function of their difference from others, of their individual bias of mind, and also of the fact that they are independent of historical circumstances, which cannot determine their productions as they do those of artists who are merely fashionable, or merely imitate others.

5. *Hazlitt and Reynolds*

We can sum up Hazlitt's second principle, by which we discriminate among the objects of representation, by saying that the best objects are those which are most immediately imitated, but that where the truth and identity to nature are equal, the human form is more worth representing than what Barry had called 'inanimate matters', and that the human form may be represented, in ascending order of value, as body, or exterior appearance, as animate, or living and breathing, and finally in terms of character, or thinking and feeling. But in order to secure his theory from the charge to which it is still open, that the high valuation thus put on individuality will promote an art in which variety proliferates at the expense of unity, Hazlitt needs to produce a third principle, which is announced at the beginning of the discussion of Reynolds's *Discourses* that follows his account of Reynolds as an artist. This account is framed as a refutation of the 'general and invariable rule' enunciated by Reynolds, that '"*the great style in art, and the most* PERFECT IMITATION OF NATURE, *consists in avoiding the details and peculiarities of particular objects*"'.[25] Reynolds 'appears to have been led to the conclusion', writes Hazlitt, 'from supposing the imitation of particulars to be inconsistent with general rule and effect'; and, in opposition to Reynolds's binary system of intellectual virtues and negative, sensual defects, he announces a rule by which general and particular, mind and body, would be united, rather than organised in a relation of high and low: 'the highest perfection of the art depends, not on separating, but on uniting general truths and effect with individual distinctness and accuracy' (207).

To explain this principle, Hazlitt distinguishes two extremes of style: the *gross*, which 'consists in giving no detail', and the *finical*, which consists in 'giving nothing else'. The true style, as defined by Hazlitt's principle, is not the mean between these two extremes, but their union: 'the utmost grandeur of outline, and the broadest masses of light and shade, are perfectly compatible with the utmost minuteness and delicacy of detail, as may be seen in nature'; for

'Nature contains both large and small parts, both masses and details; and the same may be said of the most perfect works of art', so that the 'union of both kinds of excellence, of strength with delicacy . . . is that which has established the reputation of the most successful imitators of nature' (208–9).

There is nothing in this definition of the true style, as the union of general and particular, that is especially original, or that had not been anticipated in the passage by Barry cited earlier in the article. But as Hazlitt proceeds to consider the operation of his principle in 'the imitation of expression', he departs entirely, not only from Reynolds, but from the whole tradition of writing about 'public art' in Britain. Hazlitt considers the imitation of expression in relation to, in turn, ordinary, or informal portraits, 'historical' portraits, and the ideal of history-painting, but in every case his principle turns out to apply: that 'if we had to choose between the general character and the peculiarities of feature, we ought to prefer the former' (though this does not mean, as we shall see, that we ought to prefer 'general character' in Reynolds's sense of the term), but that in fact no such choice is forced upon us. For 'general character' and 'individual peculiarities' are 'so far from being incompatible with, that they are not without some difficulty distinguishable from, each other' (211). As far as the subjects of informal or familiar portraiture are concerned,

> there is a general look of the face, a predominant expression arising from the correspondence and connexion of the different parts, which it is of the first and last importance to give, and without which no elaboration of detached parts, or marking of the pecu- liarities of single features, is worth any thing; but which at the same time is not destroyed, but assisted, by the careful finishing, and still more by giving the exact outline, of each part (211–12).

In the same way:

> the giving of historical truth to a portrait means . . . the rep- resenting of the individual under one consistent, probable, and striking view; or shewing the different features, muscles, &c., in one action, and modified by one principle. A portrait thus painted may be said to be *historical*; that is, it carries internal evidence of truth and propriety with it; and the number of individual peculiarities, as long as they are true to nature, cannot lessen, but must add to, the strength of the general impression (213).

The clearest example of how this union of particular and general might be achieved has been offered earlier in the article, in a version of Hazlitt's often-repeated analysis of Titian's portrait of Hippolito de'

Medici, in which 'all the lines of the face . . . the eye-brows, the nose, the corners of the mouth, the contour of the face, present the same sharp angles, the same acute, edgy, contracted, violent expression' (172). And, finally, the proper way to paint the ideal figures of history:

> is not to leave out the details, but to incorporate the general idea with the details: that is, to show the same expression actuating and modifying every movement of the muscles, and the same character preserved consistently through every part of the body. Grandeur does not consist in omitting the parts, but in connecting all the parts into a whole, and in giving their combined and varied action (213–14).[26]

Insofar as Hazlitt intends the rules thus derived from his third principle as a refutation of Reynolds, he has entirely misinterpreted Reynolds's theory. For according to Hazlitt, 'these modifications of form or expression can only be learnt from nature' (214)—that is to say, the figures of the men and women who are the objects of imitation exhibit in nature, and by nature, the union of general character and peculiarity of feature that the painter must therefore represent. His belief—it may derive from Alison—is that there is in all people worth representing a self-identity, a consistency of the self as it is organised by one principle, which is the gift of nature, not of art; and Hazlitt assumes that Reynolds, too, believed this, and that in his preference for the general over the particular, he was preferring the 'general impression' of 'the character of the individual' to the 'peculiarities of single features' (212) as the proper object to be imitated. But this was not Reynolds's point at all: for Hazlitt, all people who have character are so far perfect, that they exhibit a union of general and particular; for Reynolds, 'all the objects which are exhibited to our view by nature . . . will be found to have their blemishes and defects. The most beautiful forms have something about them like weakness, minuteness, or imperfection.'[27] They are imperfect insofar as they do not exhibit the general character, not of their own individual selves, for in that sense 'general character' has no meaning for Reynolds, but of the species. Their individual selves are imperfect by definition, in that, whether or not they may be adjudged to exhibit a unity of individual features and individual character, they do not exhibit that unity of one self and another which is the general character of the species, and the only possible location of perfection of form. Unity of character is thus for Reynolds not something that is to be found in actual nature, but something which it is the proper function of art to produce. The exclusive value which Hazlitt places on 'individual character', so that he can conceive of no meaning of

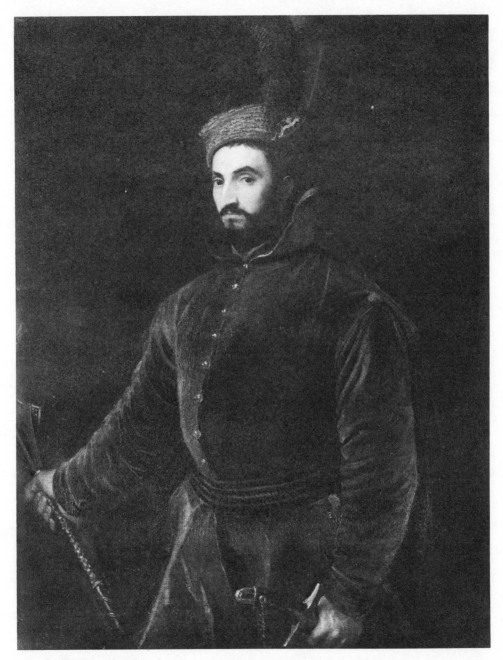

26. Titian, *Cardinal Ippolito de' Medici in Hungarian Costume* (1532), Florence, Palazzo Pitti.

Reynolds's use of the term 'general character' other than the general character of an individual, will I hope have emerged by the end of this essay as a crucial element in the 'private plans for art' that Hazlitt's criticism most usually encourages.

6. *Private art and public patronage*

In his final section, Hazlitt turns to the second of the two aims he had announced at the beginning of his article, 'to enquire . . . into the state and probable advancement' of the fine arts in Britain. He presents this enquiry in the form of a discussion of the increasingly widespread belief that all that is wanting 'to the highest splendour and perfection of the arts in this country might be supplied by academies and public institutions'. There are, he suggests, '*three* ways' in which such institutions 'may be supposed to promote the fine arts; either by furnishing the best models to the student, or by holding out immediate emolument and patronage, or by improving the public taste' (219–20). He offers to consider each of these ways in turn, but the essay he now begins to transcribe—'Fine Arts. Whether they are promoted by Academies and Public Institutions'—is not as tidily organised as this offer suggests, and in my account of this part of the article I shall rearrange Hazlitt's arguments so as to fit the order of his discussion to the order he has proposed.

To the contention that the progress of the fine arts will be promoted by academies and institutions which amass collections of the 'best models' of painting and sculpture, Hazlitt replies that a 'constant reference' to such models 'necessarily tends to enervate the mind . . . and to distract the attention by a variety of unattainable excellence'.[28] An 'intimate acquaintance' with great paintings 'may indeed add to the indolent refinements of taste', but it 'will never produce one work of original genius, one great artist' (220). He supports this position with two arguments, from the history of art, and from the principles he has enunciated earlier in the article. The history of art, he maintains, seems rather to suggest that the truth is the very reverse of the contention he is considering: the greatest artists have invariably appeared soon after the introduction of painting into their country; 'the arts have in general risen from their first obscure dawn to their meridian height and greatest lustre, and have no sooner reached this proud eminence than they have rapidly hastened to decay and desolation'—and this in spite of the fact that, though the early masters had only nature to imitate, their successors had 'a double advantage', 'not nature only to form themselves upon', but also the works of their

great predecessors (223–4).[29] In Italy, in the Low Countries, and in Britain, the greatest masters, who produced the greatest models, were followed in each case by 'copyists', and for the reason that 'the triumphs of art were victories over the difficulties of art', and 'genius can only have its full scope where, though much may have been done, more remains to do; where models exist chiefly to show the deficiencies of art'. But 'where the stimulus of novelty and necessary exertion is wanting, generations repose on what has been done for them by their predecessors' and 'rest satisfied with the knowledge they have already acquired' (225, 228–9).[30]

But the problem, as Hazlitt understands it, is not simply that the best paintings seem thus to exhaust the possible triumphs of art over difficulty, and, by their evident mastery, seem to propose themselves, rather than nature, as the object of imitation. More significant, for our purposes, is that the variety of great paintings, which is the variety of individual genius, proposes to the student of art a variety of excellences, the whole range of which seems to require to be represented in the student's work. 'The modern painter is bound not only to run the circle of his own art, but of all others. He must be "statesman, chemist, fiddler, and buffoon". He must have too many accomplishments to excel in his profession. When every one is bound to know every thing, there is no time to do any thing'. It is not, of course, the characteristic of a great genius that he can do everything; genius is not, to Hazlitt, the universal power it was to Barry—it is the power, not to produce a mere 'balance' of 'good qualities' (226), but to do one thing supremely well. 'There is', Hazlitt explains,

> a certain pedantry, a given division of labour, an almost exclusive attention to some one object, which is necessary in Art, as in all the works of man. Without this, the unavoidable consequence is a gradual dissipation and prostitution of intellect, which leaves the mind without energy to devote to any pursuit the pains necessary to excel in it, and suspends every purpose in irritable imbecility (226).[31]

The importance of this passage, for what it contributes to the understanding of Hazlitt's article as an attempt to challenge the discourse by which painting had been represented as, properly, a public art, cannot be overstressed. We can grasp its importance by observing that the justification Hazlitt proposes for the enjoyment of art is that it extends our range of knowledge, and, arguably—though I shall defer the consideration of this point—of sympathy, and that is why an acquaintance with the variety of great art may 'add to the . . . refinements of taste'. Our vision is refined, and our knowledge is

enriched, by the fact that great artists reveal to us aspects of a various nature, which we may not before have imagined to exist, but which some of us, at least, are capable of recognising when they are shown to us by art. To reveal to us these various aspects of nature, however, is necessarily the task of various artists, who cannot permit themselves to share the extensive vision of the spectator, but must develop an intensive power by which they are made blind, as it were, to any aspect but one, so that the artist achieves greatness, I have suggested, by the very reverse of the principle which Barry, especially, had declared.[32] For Barry, the function of art is that it enables those who enjoy it to enlarge the occluded, the privatised vision, forced upon them by the division of labour—thus far Hazlitt would agree—but art must therefore be the production of artists whose vision is itself enlarged, is a vision of the public, which transcends the private interests of its originally private spectators. But Hazlitt, whether attributing an intensive power of vision to the artist, or an extensive power to the spectator, is proposing a function for art which, in Barry's or Blake's terms, would hasten the process of the privatisation of society— whether there might be a way in which this would not be the case can be discussed later.[33]

That this would be the result of Hazlitt's account of particular genius is no doubt clear enough; that it would be the result also of his characterisation of the spectator has so far been suggested by the phrase 'the indolent refinements of taste'. It may be regrettable that an artist, exposed to the variety of excellence, will be encouraged 'to repose in indolence on what others have done', but that a similar exposure will refine taste is certainly not; and by his description of that refinement as 'indolent' Hazlitt means to point out, simply, that, unlike genius, taste has nothing to *do*, and it is in this that taste differs also from the faculties and powers we employ in the public world. The power of extensive vision, which seems to guarantee, for earlier critics, the power of perceiving the public interest, has now become an ability which has nothing to do with the public world, whose interests are served by submission, not resistance, to the division of labour. The meritocratic élite group, those capable of extensive vision, are now those whose refinement of taste elevates them above the world of the public and the common; and this point will be made still more clearly in Hazlitt's consideration of the notion that academies and institutions 'may improve the public taste', in which Hazlitt once again produces a negative image of the structure of the republic of taste as it appears in the *Discourses*, by reversing the areas in that structure which are to be seen as public and private.

Before he comes to that issue, however, Hazlitt discusses the

notion that the fine arts may be promoted by public patronage. He acknowledges one situation in which they might be, and two instances in which they actually were thus encouraged. There is no doubt, he acknowledges, that 'the arts in any country may be at so low an ebb as to be capable of great improvement by positive means, so as to reach the common level to which such means can carry them'; but when, by 'native genius and industry', they have 'reached their highest eminence', it is impossible to imagine that they will, 'by mere artificial props, and officious encouragement, arrive at a point of 'still higher attainment''' (222).[34] There is, as we have seen, a meridian height above which the arts cannot be elevated, when the triumphs of art have exhausted the difficulties to be overcome, and no encouragement will enable them to transcend that natural law of their development. It is also true, Hazlitt acknowledges further, that in Greece, and afterwards in Italy—this is Hazlitt's belated acceptance of the fact that 'circumstances' might have had something to do with the development of Italian art—the religious institutions of those countries afforded to artists a public patronage of real utility, with the result that 'the enthusiasm of genius was exalted by mingling with the flame of national devotion'.[35] In Greece and Italy 'the artist was not . . . degraded

> by being made dependent on the caprice of wealth or fashion, but felt himself at once a public benefactor. He had to embody, by the highest efforts of his art, subjects which were sacred to the imagination and feelings of the spectators; there was a common link, a mutual sympathy, between them in their common faith (231–2).[36]

The 'public patronage' available to the artists in these civilizations arose 'from the general institutions and manners' of the 'people' (232); and it is remarkable that Hazlitt does not even consider the possibility that public patronage of the same kind could possibly arise in Britain. Perhaps one reason for this is to be looked for in the phrase 'common faith'—perhaps, that is, the non-conformist Hazlitt, like the catholic Barry, could imagine no common faith in a country where there were 'almost as many sects as heads', and could imagine no secular substitute for such a community of belief or interest. But it seems also likely that Hazlitt pays no attention to these possibilities because of his impatience at the appropriation of the word 'public' by bodies which he felt to be in fact actuated by private interest, and at its use in the phrase 'public opinion', to which Hazlitt (except once, as we have seen) imputes only the unsteadiness of caprice: on such hard times has the word fallen, so much has it become a 'forcible designation',[37] that he can attach to it only a pejorative meaning. Public

patronage, as Hazlitt points out, is necessarily administered by 'public bodies', and though it is not impossible that 'individuals' of 'discernment and liberal spirit' will occasionally find their way on to such a body, 'their good sense and good nature' will condemn them to being a minority, and will simply reflect credit on the decisions of a majority at once self-imporant and self-interested—with 'no interest in the arts, but what arises to them from the importance attached to *them* by regular organization' (my emphasis). And because those decisions are 'before the public', the members of a public body have 'to manage the public opinion, in order to secure that of their own body', for the majority will never decide to act in the face of public opinion. In a brief glimpse of the civic vocabulary of his attack on the *Catalogue Raisonné*, Hazlitt remarks that 'such bodies of men, instead of taking the lead of public opinion, of giving a firm, manly and independent tone to that opinion ... make it their business to watch all its caprices, and follow it in every casual turning', until their taste becomes 'servile' (230–1). It is a remarkable version of the discourse of civic humanism which can find no room for the public except as the embodiment of caprice.

In one sense, Hazlitt's insistence that public patronage is 'indiscriminate patronage' is to be applauded, in that it arises in part from a refusal to countenance the bad faith by which institutional bodies could claim to be *public* bodies, by definition, as it were, and irrespective of how they were composed and of how they conducted themselves. It is nevertheless an instance of bad faith on Hazlitt's part that he refuses to consider the possibility, even, that public bodies could ever now be anything else, and the convenience of doing so is that he can thereby represent the only possible modern form of patronage as of that kind which Titian received from Charles V and which arose 'from the real, unaffected taste of individuals' (234, 232); and such patronage is of course far more conducive than public patronage of any kind could be, to arts whose proper home is 'the closet', not 'the ante-chambers of the great', and which 'have their seat in the heart of man and in his imagination', where, 'unseen and unthought of' they 'perform their ceaseless task' (221).[38] In the light of these words, Greek art, both in the account of it here and in Hazlitt's earlier consideration of Greek sculpture, seems to have been contemplated less as an example to modern Britain than as a source of comfort. There is no possibility now of an art which will be shaped by public considerations and concerns, and thankfully so.

There remains, finally, the possibility that public opinion and public taste are now vicious only because they have not been 'improved', and that the arts might be promoted if academies and

institutions could succeed in that task of improvement. This suggestion Hazlitt sets out to repudiate—the word is not too strong—by a distinction between taste and common sense, which develops as a means of repudiating also any suggestion that the structure of the republic of taste might replicate, or in any way re-organise, the structure of the political republic. Taste Hazlitt defines as 'the highest degree of sensibility, or the impression of the most cultivated and sensible minds'; and those with a true taste for the arts, and there are very few of them, are asserted to be men of taste *by nature* (238–9).* They have an 'innate sensibility to truth and beauty', which distinguishes them from those in common life, and this makes them peculiarly fitted to be the encouragers of genius, for the 'independent strength of mind' they thus develop, 'in the midst of ignorance and barbarism', leads them to sympathise with the struggles of independent and individual genius, and the effect, therefore, of their patronage, is to conform the resolution of the great artist to 'give way' to 'the powerful bent of his own genius' (233–4).

As long as the arts were not fashionable, the 'great' had no interest in them: their time and thoughts were occupied by 'religion, war, and intrigue', and only 'those minds of superior refinement would be led to notice . . . works of art, who had a real sense of their excellence'.[39] But as the arts became objects of fashion, these true critics were joined by, and submerged in, a crowd of 'pretenders to taste' (233, 234)—at first drawn apparently from the ranks of the great, for Hazlitt's élitism (there will be by now no objection to my calling it that) is determinedly meritocratic, but more recently from 'Wapping' and 'Ratcliffe Highway', from 'Hackney and Mile-end': the 'great vulgar and the small', and those in between, all participate in common life, and now make up the formless and dehumanised 'herd of spectators' which now attends the Academy exhibition (236–7). The effect of these 'pretenders to taste' has been disastrous for painting, because, lacking a 'natural taste' for art, they have judged it by a common sense which does not recognise true merit, sees merit where there is none, and thus ignores or corrupts the true painter while factitiously multiplying the 'candidates for fame' (233–4). For common sense, which 'has been sometimes appealed to as the criterion of taste, is nothing but the common capacity, applied to common facts and feelings', but it is not 'the judge of anything else'. Because, however, all but a few of those who now pass judgment on works of art have no other faculty to judge them by, 'the highest efforts of genius . . . can

* Page numbers from 235 onwards refer to the passage added by W. Hazlitt to his father's original article, and represent the continuation of the *Champion*–essay, part of which Hazlitt had borrowed in composing his encyclopaedia article (see p. 357, n. 11).

never be understood by mankind in general: there are numberless beauties and truths which lie far beyond their comprehension' (238).[40]

It is impossible, therefore, that taste could be improved 'by public institutions and other artificial means' (234),[41] because taste, being innate, is something one either has or does not have: the most that public institutions can achieve is a diffusion, not of taste but of the pretence of it, and taste is 'necessarily vitiated, in proportion as it is public; it is lowered with every infusion it receives of common opinion'. As the diffusion of what passes for taste appears, however, to be irresistible, it follows for Hazlitt that 'the decay of art' is 'the necessary consequence of its progress', and he adduces the Academy exhibition in confirmation of this claim. For there, nothing succeeds which does not aim at producing 'a popular effect by the cheapest and most obvious means, at the expense of everything else', and art is reduced to a lowest common denominator by which it may appeal to the common and the vulgar.[42] It is particularly, of course, the representation of individual character that will suffer in an art thus motivated: 'all the delicacy and variety of nature', all 'precision, truth, and refinement of character', will be submerged 'in one undistinguished bloom of florid health', in 'the *same* harmless mould of smiling, self-complacent insipidity' (235–6, my emphasis).

It is the impossibility of art's appealing to a wide audience in terms of its highest object, the representation of character, that in part persuades Hazlitt against the argument that taste is, after all, 'capable of gradual improvement, because in the end the public do justice to works of the greatest merit'. The true process, he argues, whereby works at first little noticed by the public become their favourites, is a process by which the judgment of independent minds stamps itself on the malleable opinion of those without taste: the works of Michelangelo, Milton and Shakespeare (and notwithstanding the 'universal delight' in the works of Hogarth, where public opinion got the start of taste) have the 'stamp of genius' affixed to them by 'authority, not by popular assent', and even when they come to be admired by the public, it is for the wrong reasons. Thus Shakespeare is popular merely because of (and this is, we may reflect, not altogether a mistake) 'his power of telling a story,—the variety and invention,—the tragic catastrophe, and broad farce of his plays!'—and not for what is of true value in them, the 'refinement of character or sentiment', which is 'little understood or relished by the generality of readers' (238–9).[43]

'By authority, not by popular consent, nor the common sense of the world': insofar as, for Hazlitt, the vulgar may occupy a place in

the republic of taste, it is not as citizens, but always, and irrespective of any effort they might make, as those 'born rather . . . to be obedient to the Laws' than 'to be the Dispensers of them'.[44] It now finally appears how entirely the political republic must be kept separate from the republic of taste, which is not now simply a private realm, but one governed by an aristocracy of genius and taste, while the political republic may properly be, for Hazlitt, democratic. 'The principle of universal suffrage', Hazlitt explains, 'however applicable to matters of government, which concern the common feelings and common interests of society, is by no means so to matters of taste', for these 'can be decided upon' only by the 'most refined understandings', by those few which can 'recognise a work of the most refined genius from the most common and every-day performance' (235–6).[45] The meaning attributed to the word 'common' in this article has now been made unambiguously clear, by thus being opposed to 'refined'. With the exception of the irrecoverable 'common faith' by which the citizens of Greece and Italy were elevated to a true appreciation of the works of their artists, the word denotes, throughout the essay, not only life in the mass, but life as it is necessarily represented as an undistinguished mass by a mass civilization, and particularly perhaps by such a civilization democratically organised. The public sphere—the world of government, and now perhaps of everyday affairs such as commerce and occupation—is the sphere of *merely* common feelings and common interests, where we are, and where we may legitimately be, treated as indistinguishable from one another, and where refined distinctions in terms of individual character are not possible. The function of art in such a civilization is to provide a refuge, not for all, but for those few who are individuals, and whose individuality is left out of account in determinations by popular consent; for it is only in the private sphere of art that they can recognise themselves as individuals, and can come to understand how they differ, not only from other individuals, but from the undifferentiated herd.[46]

There is probably no need by now to consider at any length the argument that what Hazlitt offers us is, in a modern sense, a liberal theory of art, which is concerned to enable us to perceive, and, by a mode of sympathy, to respect the individual differences among people whom 'common life' aggregates and represents as indistinguishable, and which therefore might enable us, in some such way as Raphael's art did for Fuseli, to find in art a ground of social affiliation which might substitute for the public sphere absent from a society divided by occupation. For, leaving aside the question of whether or not we might prefer such a theory of art to a theory like Reynolds's,

which seeks to homogenise humanity, for whatever moral end, or to a theory like Barry's, which invites us to see sameness reconciled with difference, though not with individual difference, such an account of Hazlitt's theory is unconvincing, and for two reasons. To begin with, though we might regard it as a necessary preliminary to the formation of such a theory that the link between the political republic and the republic of taste should be dissolved, so that the respect that art encourages us to have for individuals may be opposed to the homogenising influence of 'common', of everyday life, it does not seem to be imagined in this article that the two spheres can later be brought closer again, so that the respect we learn from art might *change* the way we regard people in life. And secondly, the evident fact is that Hazlitt does not come to respect 'other people' as individuals, but only a few of them, and that his sense of the undifferentiable nature of those who are not individuals, and can never become so, is positively reinforced by his account of their attempt to enter the republic of taste. And as Hazlitt's imagery has suggested to us, those who are unable to exhibit individuality of character are not only excluded from citizenship in that republic, but from the right to regard themselves as full members of human society. The 'herd' may be allowed to vote, but not because it is capable of profound thought and feeling.

7. Conclusion

The story I have been telling may be allowed to end with the separation of the republic of taste from the political republic, which Hazlitt set out to effect, and which Haydon effected, it seems, partly in spite of his intentions. After them, no writer appears who still believes that the civic humanist discourse can be adapted so as to define a republic of taste whose structure can replicate the structure of what is now recognised as a 'mass society'. That this is so is not to say that there will be no more attempts to argue that a primary function of painting is to make us aware of what we have in common, and if that were all that this book has been concerned with, we would need another, long chapter on Ruskin before the book slowly petered out. In various ways, however, Ruskin's project is very different from that of the writers whom I have discussed, and overwhelmingly the most important of these is that he stakes his claim for the unifying power of painting on the representation, not of the human body, but of landscape. That in part he regrets this—that the nineteenth-century preoccupation with landscape is the result of 'mistakes in our social economy', and is the expression of a love of liberty which can no

longer find satisfaction in the civic life—indicates at once the simi-larity and the difference between *Modern Painters* and the works we have been considering. For Ruskin, as for Reynolds, or Barry, or Fuseli, the history of painting is a political history; but for Ruskin, also, modern painting is inevitably the place of privacy, of private freedom; however it may lead us back to the body of the public, it must first lead us away from it, to where we can 'lose the company of our friends among the hills'.[47]

The answers this book has offered to the question of why the discourse of civic humanism was progressively attenuated and aban-doned are not new answers. They seem to reduce themselves to the fact that the discourse could not contemplate the growth of commerce, and of capitalism, except as evidence of historical decline, and that, because it found its models of social organisation and civic virtue among small republican city-states, it could not be used to describe a complex, modern, commercial society. The traditional discourse had offered only one identity to the members of a civil state—that of the citizen, whose freedom derived from his participa-tion in government. But when the public became, or was believed to have become 'an object too extensive' to be comprehended, then, as Fuseli points out, the private freedom which is experienced as freedom from that civic identity came to seem more immediately satisfying than the public freedom of the citizen, available to rela-tively fewer and fewer men, even among the enfranchised.

If these answers are not new, however, they may come to seem more so if we ask a different question: why does the theory of painting change as it does, in the period from Shaftesbury to Hazlitt? The most helpful answers we can return to this question, I suggest, are the same as we can return to the first. The increasing concentration, first on the varieties of character, and then on individual character; the increas-ing concern with genius as what marks the difference between one painter and another, and with art as offering private satisfactions to private men—these phenomena, I believe, are best attended to and best understood in terms of the history of the survival, the adapta-tion, and the final abandonment of the civic humanist discourse. That history is not independent of social and economic changes: it is, on the contrary, the history of a discourse which claimed to be so, but which, under the pressure of commercial capitalism, of more pri-vatised social practice, of an extension of the candidature for citizen-ship, and of a competing discourse committed to promoting those changes, was seen to become steadily more marginal to modern life.

In that process, of course, painting itself became steadily more marginal, if not to the private, then certainly to a public life ever

NOTES

Works cited on a second and subsequent occasions are referred to simply by the author's name, or (in the cases where more than one work by an author is cited) by the author's name and a short title. Italicised page-numbers in the Index refer to the first citation of a work, where its full title and publication details are given. Where an edition other than the first is cited, the date of original publication is given in brackets immediately following the title. The place of publication is London unless otherwise stated. Volume and page-numbers are given thus: 1: 234.

Introduction: A Republic of Taste.

1. 'Anthony Pasquin' (John Williams), *Memoirs of the Royal Academicians; being an attempt to improve the national taste*, 1796, 99n, 89; Sir Joshua Reynolds, *Discourses on Art*, ed. Robert R. Wark, 2nd edition, New Haven and London 1975, 13, 11; James Northcote, *The Life of Sir Joshua Reynolds* (1813), 2nd edition, 1819, 1: 173; John Flaxman, *Lectures on Sculpture* (1829), 1865, 17; John Galt, *The Life, Studies, and Works of Benjamin West, Esq.* (hereafter 'West'), London and Edinburgh 1820, 2: 80.

2. John Knowles (ed.), *The Life and Writings of Henry Fuseli* (hereafter 'Fuseli'), 1831, 3: 48; the fullest discussion of the body of writing considered in this book is Johannes Dobai, *Die Kunstliteratur des Klassizismus und der Romantik in England*, Bern, 3 vols, 1974–77.

3. J. G. A. Pocock, 'Between Machiavelli and Hume: Gibbon as Civic Humanist and Philosophical Historian', *Daedalus*, Summer 1976, 153–4; for an exceptionally full account of civic humanism, see Pocock, *The Machiavellian Moment: Florentine Republican Thought and the Atlantic Tradition*, Princeton, N. J., 1975; see also Isaac Kramnick, *Bolingbroke and his Circle: the Politics of Nostalgia in the Age of Walpole*, Cambridge, Ma., 1968, and Donald W. Hanson, *From Kingdom to Commonwealth: The Development of Civic Consciousness in English Political Thought*, Cambridge, Ma., 1970.

4. Pocock, *Politics, Language and Time: Essays in Political Thought in the Seventeenth Century*, 1972, 90; the phrase 'politikon zoon' is Aristotle's: see for example *Politics*, Loeb edition, tr. H. Rackham, Cambridge, Ma., and London, 1977, 8.

5. Hume, *A Treatise of Human Nature* (1739–40),

eds. L. A. Selby-Bigge and P. H. Nidditch, Oxford 1978, 587; James Thomson, *Liberty* (1735–6), *The Complete Works of James Thomson*, ed. J. Logie Robertson, 1908, pt. 5, lines 121–3, 93–4; Pocock, 'Between Machiavelli and Hume', 154; *Politics, Language and Time*, 113.

6. Shaftesbury, *Characteristicks of Men, Manners, Opinions, Times* (1711), 4th edition 1727, 1: 104; 2: 86–7; 1: 37; John Brown, *An Estimate of the Manners and Principles of the Times*, 2nd edition, 1757, 58.

7. *Characteristicks*, 1: 98–9; for a full discussion of these issues, see John Brown, *Essays on the Characteristics of the Earl of Shaftesbury*, 2nd edition, London 1751, Essay III, section vi.

8. *Characteristicks*, 1: 98 and n.; Reynolds, *Discourses*, 151; James Thomson, *The Seasons* (1730–46), ed. James Sambrook, Oxford 1981, 'Winter', lines 596–7.

9. *Characteristicks*, 1: 63.

10. Aristotle, 577, 575, 197, 637.

11. Aristotle, 23, 203, 65, 17–19.

12. Aristotle, 213, 65, 503, 575, 193–7.

13. *Characteristicks*, 1: 127; 2: 55; for an amplification of the points raised in this paragraph, see John Barrell, *English Literature in History 1730–80: An Equal, Wide Survey*, 1983, 25–49, 51–108.

14. Brown, *Estimate*, 24, 72, 25; Stephen Copley (ed.), *Literature and the Social Order*, 1984, 6.

15. *Characteristicks*, 2:133, quoted by Copley, 6; Bolingbroke, *Letters on the Spirit of Patriotism* (1749), in Copley, 49.

16. Copley, 2.

17. Copley, 6–7; for more on this topic, see Pocock, *Machiavellian Moment*, chs. 13, 14; A. O. Hirschman, *The Passions and the Interests: Political Arguments for Capitalism before*

its Triumph, Princeton, N.J., 1977; C. B. Macpherson, *The Political Theory of Possessive Individualism*, Oxford 1962; John Sekora, *Luxury: The Concept in Western Thought, Eden to Smollett*, Baltimore, Md., 1977, chs, 2 and 3.

18. Prince Hoare, in Hoare (ed.) *The Artist*, 1810, 2: 409.

19. George Turnbull, *A Treatise on Ancient Painting, containing Observations on the Rise, Progress, and Decline of that Art amongst the Greeks and Romans*, 1740, 15, 134–7.

20. Pocock, *Machiavellian Moment*, 466.

21. Joseph, Weston, 'An Essay on the Superiority of Dryden's Versification over that of Pope and the Moderns', prefixed to his translation of John Morfitt's *Philotoxi-Ardenae, The Woodmen of Arden: A Latin Poem* (1788), reproduced in F. W. Bateson and N. A. Joukovsky (eds.) *Alexander Pope*, Harmondsworth 1971, 154.

22. Brown, *Estimate*, 25; Burke, *Reflections on the Revolution in France* 1790, in *The Works of the Right Honourable Edmund Burke*, 5 (1815): 96; Shaftesbury, *Characteristicks*, 1: 192; Abate Luigi Lanzi, *The History of Painting in Italy* (final revised ed. 1809), tr. Thomas Roscoe, 1847, 1:16.

23. Pliny, *Natural History*, Loeb edition, tr. H. Rackham, 9, Cambridge, Ma., and London 1984), 323–5 (all subsequent references to Pliny are to this volume and this edition); Burke, *A Philosophical Enquiry into the Origin of our Ideas of the Sublime and Beautiful* (1757–9), ed. James T. Boulton, Notre Dame, Ind., and London 1968, 19–20; see also Franciscus Junius, *The Painting of the Ancients*, 1638, 214; Roger de Piles, *The Art of Painting* (1707), 2nd English edition, 1744, 80–1, and *The Principles of Painting* (1708), *translated into English by a Painter*, 1743, 183; Johnson, *The Rambler*, no. 4, March 31 1750; Reynolds, *Discourses*, 233.

24. Burke, *Enquiry*, 22–3.

25. Plato, *Republic*, Loeb edition, tr. Paul Shorey, London and Cambridge, Ma., 1970, 2: 451, 459.

26. Reynolds, *Discourses*, 170; Plato, 2: 451 (I have preferred the translation here of H. D. P. Lee, Harmondsworth 1955, 380); Henry Home, Lord Kames, *Elements of Criticism* (1762), 1839, 454; *The Works of Anthony Raphael Mengs*, tr. Don Joseph Nicholas D'Azara, 1796, 2:21; Turnbull, 99.

27. See Marian Hobson, *The Object of Art: The Theory of Illusion in Eighteenth-Century France*, Cambridge 1982, 13–15, 18–61; also André Fontaine, *Les Doctrines d'art en France. Peintres, amateurs, critiques, de Poussin à Diderot*, Paris 1909.

28. Mengs, 1: 136; 2: 114, 126.

29. Mengs, 3: 69; 2: 21; 3: 75.

30. Reynolds, *Discourses*, 93, 117, 97; Daniel Webb, *An Inquiry into the Beauties of Painting; and into the Merits of the Most Celebrated Painters, Ancient and Modern* (1760), 3rd edition, 1769, 5, 18.

31. Aristotle, 639, 643; Pliny, 319; *Leon Battista*

Alberti on Painting (1435–6), tr. John R. Spencer, revised edition, London and New Haven, Ct., 1966, 66; Vasari, *Lives of the Most Eminent Painters, Sculptors, and Architects* (1550–68), tr. Mrs Jonathan Foster, 1876, 1: 12–13; Junius, 93; see also below, 41–2.

32. William Aglionby, *Painting Illustrated in Three Diallogues*, 1685, 44–5; Conte Francesco Algarotti, *An Essay on Painting Written in Italian*, 1764, 183; Thomas Hope in *The Artist*, May 2 1807; see also John Robert Scott, 'A Dissertation on the Progress of the Fine Arts' (1804), Augustan Reprint Society, Los Angeles, Ca., 1954, 148.

33. Webb, 31; Benjamin Robert Haydon, *Lectures on Painting and Design*, 1 (1844): 6.

34. See below, 209–14.

35. Aglionby, 98; Jonathan Richardson, *An Essay on the Theory of Painting*, 1725, 26; William Sanderson, *Graphicè. The Use of the Pen and Pensil. OR, The Most Excellent Art of Painting*, 1658, preface (unpaginated); Webb, 18; Shaftesbury, *Characteristicks*, 3: 162; Richardson, *Theory*, iii, and *Two Discourses*, 1719, 1: 218 (mispaginated for 198), 2: 222.

36. For Richardson, see Carol Gibson-Wood, 'Jonathan Richardson and the Rationalization of Connoisseurship', *Art History*, March 1984, 38–56; Lawrence Lipking, *The Ordering of the Arts in Eighteenth-Century England*, Princeton, N.J., 1970, 109–26; Dobai, *Kunstliteratur*, 1, 633–64.

37. Shaftesbury, *Characteristicks*, 3: 156.

38. For Steele and Defoe, see Barrell, *Survey*, 37–9; Richardson, *Two Discourses*, 2:229.

39. Shaftesbury, *Second Characters, or, The Language of Forms*, ed. Benjamin Rand, Cambridge 1914, 135, 134, 18, 22, 16 (but see 4); see Edgar Wind, 'Shaftesbury as a Patron of Art', *Journal of the Warburg and Courtauld Institutes*, 2(1938): 185–8; W. Wells, 'Shaftesbury and Paolo de Matteis. The Choice of Hercules', *Leeds Art Calendar*, 3 (1950): 37–59; Francis Haskell, *Patrons and Painters*, New Haven Ct. and London, 1963, 198ff.

40. Richardson, *Theory*, 26–8.

41. Shaftesbury, *Second Characters*, 19, 26; *The Critical Works of John Dennis*, ed. Edward Niles Hooker, Baltimore, Md., 1 (1939), 455; Turnbull, 15, xvi.

42. For the rules of epic, see H. T. Swedenberg, *The Theory of Epic in England*, Berkeley, Ca., 1944; Hooker's introduction to vol. 2 (1943) of Dennis, sect. 4, and vol. 1: 454–5; Peter Haegin, *The Epic Hero and the Decline of Heroic Poetry*, Bern 1964.

43. René Le Bossu's *Traité du poëme épique*, Paris 1675, was translated by 'W. J.' and published in 1695 as *Treatise of the Epick Poem*.

44. Dennis, 2: 113–14.

45. Turnbull, 114; Shaftesbury, *Second Characters*, 117; John Gilbert Cooper, *The Power of Harmony* (1745), in *The British Poets including Translations*, Chiswick 1822, 72, 70; Dennis, 1:

114; James Harris, *Three Treatises* (1744) in *The Works of James Harris*, Oxford 1841, 22.

46. Richardson, *Theory*, 174, and *Two Discourses*, 2: 62, 48, and see also 216–17.

47. Richardson, *Theory*, 15–16, and *Two Discourses*, 2: 46–7; see also Reynolds, *Discourses*, 13; West, 2: 79; and below, 357, n. 10 (for Haydon).

48. Among the numerous discussions of this topic, see Shaftesbury, *Second Characters*, 103–4; Richardson, *Two Discourses*, 2:44; *The Guardian*, no. 21 (4 April 1713); Hogarth, 'Autobiographical Notes' in *The Analysis of Beauty* (1753), ed. Joseph Burke, Oxford 1955, 203–9; Horace Walpole, *Anecdotes of Painting in England* (1762–80), revised Rev. James Dallaway, ed. Ralph H. Wornum, no date, 1: xxii. Reynolds, 'A Journey to Flanders and Holland', in *The Works of Sir Joshua Reynolds*, ed. Malone, 2nd edition, 1798, 2: 339–42; Hoare, *An Inquiry into the Requisite Cultivation and Present State of the Arts of Design in England*, 1806, 16–18, 103; William Hazlitt, *Conversations of James Northcote, Esq., R. A.* (1830), in *The Complete Works of William Hazlitt*, ed. P. P. Howe (1930–4), 11: 250, 268; *The Works of James Barry, Esq., Historical Painter*, ed. Dr Edward Fryer, 1809, 2:210; John Opie, *Lectures on Painting* (hereafter 'Opie'), 1809, 93; Martin Archer Shee, *Rhymes on Art*, 2nd edition, 1805, 102; West, 2:52–3; Haydon, *Some Enquiry into the Causes which have obstructed the Advance of Historical Painting . . . in England*, 1829, 13ff.

49. Shaftesbury, *Second Characters*, 118–19; Richardson, *Two Discourses*, 2: 203.

50. Richardson, *Two Discourses*, 2: 62, 44, 15, 196

51. *Spectator*, no. 226 (November 19 1711); Richardson, *Two Discourses*, 2: 16–17, and *Theory*, 10–11, 13.

52. Blair, *Lectures on Rhetoric and Belles Lettres* (1783), Edinburgh 1813, 2: 168, 214; see Longinus, *On the Sublime*, ed. W. Rhys Roberts, Cambridge 1907, 155–7; Pocock, *Machiavellian Moment*, 58.

53. See, e.g., Quintilian, *Institutio Oratoria*, tr. H. E. Butler, Loeb edition, London and New York City 1921, 1: 295; Cicero, *De Oratore*, tr. H. M. Hubell, Loeb edition, London and Cambridge, Ma., 1952, 359–61; Alberti, 77, 90.

54. Turnbull, ix, x; Pocock, *Machiavellian Moment*, 59.

55. See for example Shaftesbury, *Second Characters*, 19.

56. Kames, 40; Aglionby, preface (unpaginated); Dryden, *Prose Works*, ed. Malone, 1800, 3:305; Shaftesbury, *Second Characters*, 149; Webb, 182; Opie, 18.

57. De Piles, *Principles*, 19–20; the problem is also discussed by Junius, 257–65.

58. Opie, 18; Turnbull, 45; Quintilian, book 9, sect. 4; Cicero, *De Oratore*, book 3, sect. 50.

59. Though Du Bos is firmer than anyone in arguing that it is a rule constitutive of a rhetorical aesthetic that the 'public' are competent judges of art (*Réflexions critiques sur la poësie et sur la peinture* (1719), Paris 1746, 2: 232–40), he limits his definition of the 'public' to a considerable degree. The public are 'ignorant', but only of the principles of painting—they are not generally ignorant (2:334). Everyone, including 'le bas peuple', can judge whether an individual work is good or bad, whether it pleases or moves them (2: 325, 331–2, 338–9), but the 'public' are only those who by their reading or knowledge of the world are in a position to *compare* works of art (2: 334–6). See also Félibien, *Conférences de l'Académie royale de peinture et de sculpture*, Paris 1669, preface (unpaginated): painting teaches the ignorant, but it 'satisfies' the 'plus habiles'; de Piles, *Art*, 61: the ignorant are sensible of the effects of a work, but not of the principles of its production; Sanderson, 50: paintings are 'to be perceived by each observer; to be liked of the most part; but to be judged, only, of the learned'; Allan Ramsay, 'A Dialogue on Taste', 2nd edition, in *The Investigator*, 1762, has no doubt that the 'lowest and most illiterate of the people' can judge paintings, and do so, for example, when they remark that they are 'vastly natural'—the only judgment Ramsay allows (56–7); for James Barry's view, see below, pp. 182–9.

60. Turnbull, xvi; Richardson, *Two Discourses*, 2: 16.

61. Shaftesbury, *Second Characters*, 18, and *Characteristicks*, 3: 349–50; for Prodicus's version of the story, see Xenophon, *Memorabilia*, II. i. 21; for other uses of the story in the eighteenth century, see Mark Akenside, *The Pleasures of Imagination* (1744 version), book 2 and the opening of book 3; Robert Lowth's poem, 'The Choice of Hercules', in *Sermons and other Remains*, 1784—the poem originally appeared in Joseph Spence, *Polymetis*, 1747, 155–62, and see also 139–43; Turnbull, xix. For other examples see Ronald Paulson, *Emblem and Expression: Meaning in English Art of the Eighteenth Century*, 1975, 237, n.22, and see also his account of Shaftesbury's 'invention', 38–40. For useful general discussions of Shaftesbury's views on art, see Dobai, 1: 47–91, and R. W. Uphaus, 'Shaftesbury on Art. The Rhapsodic Aesthetic', in *Journal of Aesthetics and Art Criticism*, vol. 27, no. 3, Spring 1969, 341–8.

62. Shaftesbury, *Characteristicks*, 3: 386, 363, 360, 366–7.

63. *Characteristicks*, 3: 371, 351, 385–6, 382.

64. *Characteristicks*, 3: 381–2, 385.

65. Shaftesbury, *Second Characters*, 26; *Characteristicks*, 3: 350–2.

66. *Characteristicks*, 3: 362–3, 365–6.

67. *Characteristicks*, 3: 370–1, 355, 360.

68. *Characteristicks*, 3: 378–9.

69. *Characteristicks*, 1: 143.

70. *Characteristicks*, 3: 362, 357–8, 352, 370, 374.

71. Charles Alphonse Du Fresnoy, *The Art of Painting, with Remarks and Observations* (by

de Piles), tr. Dryden, edition of 1769, lines 132–6 and 159–61, and, in de Piles's commentary (henceforth 'de Piles, "Observations"'), see for example 89, 101–2, 129–30; Félibien, preface (unpaginated), 83 (Lebrun), 125, 143 (Bourdon). 'All speaking at once': de Piles, *Principles*, 65; Winckelmann, *Reflections on the Painting and Sculpture of the Greeks*, tr. Fuseli, 1765, 34; Algarotti, 111 (and citing Hogarth, 111n.).

72. Plato, 2: 449–53.

73. De Piles, *Principles*, 42.

74. Shaftesbury, *Second Characters*, 22–3; Turnbull, 99 (and for Longinus, 99n.).

75. Hume, *Essays Moral, Political and Literary* (1741–2), Oxford 1963, 265; Scott, 147; Thomson, *Liberty*, part 2, lines 159–70; Harris, *Hermes* (1751), in *Works*, 239.

76. Shaftesbury, *Characteristicks*, 3: 138; Thomson, *Liberty*, part 2, lines 365–6; Flaxman, 183–4 (for art as coming to be seen as promoting 'private' as well as 'public' virtue, see below, 58–60).

77. Scott, 165, 149–50, 162; Northcote, 1: 301; Pliny, 347–9 (and see Fuseli, 3: 53); West, 2: 89; Shaftesbury, *Second Characters*, 22; and see also Junius, 186; de Piles, *Art*, 81, and 'Observations', 66; Du Bos, 2: 139–40.

78. Dennis, 1: 320, 322; Shaftesbury, *Second Characters*, 23, 20; Richardson, *Theory*, 223–5, and *Two Discourses*, 2: 52–6; see Barrell, *Survey*, 119ff.

79. Thomson, *Liberty*, part 5, lines 440–548; Akenside, book 2; Turnbull, 109–10; Algarotti, iv; for West, see Haydon, *Lectures*, 2 (1846): 102ff., Shaftesbury, *Characteristicks*, 1: 107.

80. See Elizabeth Rawson, *The Spartan Tradition in European Thought*, Oxford 1969; Hume, *Essays*, 265; Turnbull, 108; Brown, 29; *The Complete Writings of William Blake*, ed. Geoffrey Keynes, 1966, 593–4. For discussions of eighteenth-century notions of the enervating effects of luxury, see Sekora, esp. chs. 2 and 3 (Sekora's notes contain an excellent bibliography of the topic); Pocock, 'Virtue and Commerce in the Eighteenth Century), *Journal of Interdisciplinary History*, vol. 3, no. 1 (1972), 119–34, and *Machiavellian Moment*, esp. chs. 13 and 14.

81. Shaftesbury, *Second Characters*, 20; Kames, 454; George Berkeley, *An Essay towards preventing the Ruin of Great Britain* (1721), in *The Works of George Berkeley*, ed. A. C. Fraser, Oxford 1871, 3: 203, and also in Copley, 93; for a general account of the topics raised in this and the following paragraph, see John D. Schiffer, 'The Idea of Decline and the Fine Arts in Eighteenth-Century England', *Modern Philology*, vol. 35 (1936), 155–78.

82. Brown, *Estimate*, 47, and see his *Essays*, 389–90; Roland Fréart de Chambray, *An Idea of the Perfection of Painting* (1662), tr. John Evelyn, 1668, 77, and see 2; for 'war', see

Pocock, 'Between Machiavelli and Hume', p. 157; Adam Ferguson, *An Essay on the History of Civil Society* (1767), ed. Duncan Forbes, Edinburgh 1966, 153; J. R. Western, *The English Militia in the Eighteenth Century: The Story of a Political Issue*, 1965; discussions of the decline of painting into mannerism, and into a trade, are so common in the period covered by this book as to make exemplification unnecessary.

83. Du Bos, 1: 184–92. This section of my introduction is not to be read as arguing that there is no evidence, in eighteenth-century France, of a republican discourse in the discussion of painting. There is, of course, as Thomas Crow has shown (*Painters and Public Life in Eighteenth-Century Paris*, New Haven and London 1985), ample such evidence. But it emerges, as Crow reveals, in the unofficial and oppositional writings on *Salon*-exhibitions, and is almost entirely absent from writings on art before the re-institution of the *Salon* in 1737. Before that date, the attempt to invent a 'public' for art—an attempt indeed obliged to borrow the terms of republican discourse—was one which always envisaged that the public thus invented would become a constituent element of an absolutist state, its function to confirm the absolutism of the crown; and as such, the republicanism inherent in the notion of the public could find no coherent discursive presence in theoretical writings on art in the late seventeenth and early eighteenth centuries.

84. Félibien, preface (unpaginated), and 111 (van Opstal).

85. Poussin, quoted in Anthony Blunt, *Nicolas Poussin*, text volume, London and New York City 1967, 372, and see Blunt's remarks on the passage, 355, n. 74, and, in *Nicolas Poussin: Lettres et Propos sur l'art*, ed. Blunt, Paris 1964, 164, n. 20; Félibien, preface (unpaginated); Du Bos, 2: 72, 6–7 (he may have in mind the painters of the *maîtrise*, the 'journeyman'-members of the Guild in opposition to which the Academy was founded—see Crow, *Painters and Public Life*, 23–8).

86. Pliny, p. 319; Fréart, preface (unpaginated); de Piles, 'Observations', 66, 157–8; Mengs, 1: 135, 204.

87. Hobson, 45—the opening chapters of this book are of great importance to the topic of illusion in French art-criticism; Du Fresnoy, line 261; Du Bos, 1: 388, 37–8; 2: 4–5; de Piles, *Art*, 36; *Principles*, 2.

88. Blair, 2: 168, and see the distinction between republican and imperial oratory made by Tzvetan Todorov, *Théories du symbole*, Paris 1977, ch. 2, and esp. 63–4: 'Dans une démocratie, la parole pouvait être efficace. Dans une monarchie (pour parler vite), elle ne le peut plus (le pouvoir appartient aux institutions, non aux assemblées); son idéal changera nécessairement: la meilleure parole sera celle

qu 'on jugera *belle*' (Todorov's emphasis); Du Bos, 1: 38–9; 2: 331, 338, 1; for Kames, see *Elements*, 34–7; Du Fresnoy, lines 5–6 and, for Dryden's translation, 3.

89. Du Bos, 2: 130ff, 135ff, 143–4.

90. De Piles, 'Observations', 91; Peter Burke, 'Tradition and Experience: The Idea of Decline from Bruni to Gibbon', *Daedalus*, Summer 1976, 137–52; Vasari, 1: 19–22, 32–3; Fréart, 3; Winckelmann, *History of Ancient Art* (1764), IV, vi, 50 and 55; and see also Lanzi, 1: 355; 2: 233; Aglionby, 83; Turnbull, ch. 5.

91. Pocock, *Machiavellian Moment*, 461; *Politics, Language and Time*, 90.

92. See Hume, *Essays*, 579ff.

93. Tucker, *The Elements of Commerce and Theory of Taxes* (1755), in Copley, 113; Steuart, *Principles of Political Oeconomy* (1767), in Copley, 120–2; Smith, *An Inquiry into the Nature and Causes of the Wealth of Nations*, eds. R. H. Campbell, A. S. Skinner and W. B. Todd, Oxford 1976, 1: 25–7.

94. Hume, *Essays*, 268–9; Bernard Mandeville, *The Fable of the Bees* (1714–24), ed. Phillip Harth, Harmondsworth 1970, 256.

95. Ferguson, 143; for Steuart and Tucker, see Copley, 121, 115; Smith, *Wealth of Nations*, I: 422.

96. Brown, *Estimate*, 22, 102–4.

97. Shee, lvi–lviii.

98. Shee, 51–4; Thomas Paine, *Rights of Man* (1791–2), ed. Henry Collins, Harmondsworth 1969, 80, and see Matthew 3: 10; Brown, *Estimate*, 111.

99. Shaftesbury, *Second Characters*, 115; Ferguson, 218–19, 183; Smith, *Wealth of Nations*, 1: 21–2, 30 and n.

100. Brown, *Estimate*, 220; Northcote, 2:78; see also Barrell, *Survey*, esp. 40–9.

101. *The Microcosm*, no. 4 (27 November, 1786).

102. For a good account of the ethics and aesthetics of Hutcheson, see W. J. Hipple, *The Beautiful, the Sublime, and the Picturesque*, Carbondale, Ill., 1957.

103. Hume, *A Treatise*, 587, 603, 605.

104. *A Treatise*, 599–601.

105. *A Treatise*, 601, 604, 588.

106. Smith, *The Theory of Moral Sentiments* (1759), eds. D. D. Raphael and A. L. Macfie, Oxford 1976, 23–5, and, for Hume, 23n.; Kames, 14, 44.

107. Webb, 28–9, 34; Poussin's *Death of Germanicus* (1628) is in the Institute of Arts, Minneapolis; *The Plague of Athens* (private collection) is no longer attributed to Poussin.

108. Burke, Enquiry, 51, 111, and see Hume, *A Treatise*, 607–8; Gerard, *An Essay on Taste*, 1759, 18, 204.

109. Smith, *Lectures on Jurisprudence*, eds. R. L. Meek, D. D. Raphael, P.G. Stein, Oxford 1978, 539–41 (Report of 1776); Ferguson, 77, 55.

110. Ferguson, 56, 178–9; I have borrowed this and the surrounding paragraphs from my essay 'The Functions of Art in a Commercial Society: The

Writings of James Barry', in *The Eighteenth Century: Theory and Interpretation*, vol. 25, no. 2, Spring 1984: 117–40. And on the subject of that essay, I would like to take this opportunity of dissociating myself from almost all the opinions in the article 'Marxism, Ideology, and Eighteenth-Century Scholarship', by G. S. Rousseau, the editor of this special number of the journal. In particular, I take strong exception to Rousseau's characterisation of Raymond Williams's lack of 'erudition' (113), and still stronger exception—for here Rousseau expresses himself more strongly—to what I take to be an offensive caricature of Donald Davie's critical and scholarly procedures (107ff).

111. Northcote, 2: 313; Joseph Warton, *An Essay on the Genius and Writings of Pope* (1756), 5th edition, 1806, 1: 275–6. Thomas Warton, in his *History of English Poetry* (1774–81; 2: 462–3), argues that modern manners are not conductive to epic, and the belief became a common one in the middle and late eighteenth century: see, for example, Berkeley, 'Verses on the Prospect of Planting Arts and Learning in America' (1752), in *Works*, 3: 232; Thomas Blackwell, *An Enquiry into the Life and Writings of Homer*, 1735; Kames, 401n.; William Hayley, *An Essay on Epic Poetry*, 1782; Blair, *A Critical Dissertation on the Poems of Ossian*, 1763; John Brown, *Dissertation on the Rise, Union, and Power, the Progression, Separations, and Corruptions of Poetry and Music*, Dublin 1763; Robert Wood, *An Essay on the Genius and Writings of Homer*, 1775; Scott, 'A Dissertation'.

112. Pliny, 281, quoted by Reynolds, *Discourses*, 21.

113. Wordsworth, 'Essay, Supplementary to the Preface' (1815), *The Prose Works of William Wordsworth*, eds. W. J. B. Owen and J. W. Smyser, Oxford 1974, 3: 84; Blake, 597.

114. Pasquin, *Memoirs*, 148.

115. Wollstonecraft, *A Vindication of the Rights of Women* (1792), ed. Carol Poston, New York 1975, 54. Lowth, *Lectures on the Sacred Poetry of the Hebrews* (1753), tr. G. Gregory, 2 vols. London 1787, 2: 127; Johnson, anonymous dedication in Charlotte Lennox, *The Female Quixote* (1752), ed. Margaret Dalziel, London 1970, 1 or 3 (pagination faulty); Hazlitt, 20: 41; Alison, *Essays on the Nature and Principles of Taste* (1790), 6th edition, Edinburgh 1825, 2: 309; Mengs, 3: 147.

116. Mary Wollstonecraft, *Mary, and The Wrongs of Woman*, eds. James Kinsley and Gary Kelly, Oxford 1980, 28.

117. *Second Characters*, 131. Wollstonecraft, *A Vindication*, 24.

Chapter One: Sir Joshua Reynolds

1. Compare the observation of West (2: 107): 'there is no surer way, either to fame or fortune, than by acting in art, as well as life, on those

principles which have received the sanction of experience, and the approbation of the wise of all ages'.

2. See Reynolds, *Discourses*, 284–336. Blake's annotations were first published by E. J. Ellis, *The Real Blake*, 1907; Hazlitt's essays on Reynolds in *The Champion* (1814–15) were first reprinted by A. R. Waller and Arnold Glover, in *The Collected Works of William Hazlitt* (1902–6), vol. 11. Geoffrey Keynes, Blake 445–79, reprints Blake's annotations, including (940–2) some newly deciphered passages.

3. Haydon, *Lectures*, 1: 3. Those who have agreed with Haydon include Wark (*Discourses*, p. xvii), Elder Olson, introduction to *Longinus on the Sublime . . . and Sir Joshua Reynolds's Discourses on Art*, Chicago, Ill., 1945; David Mannings, 'An Art-Historical Approach to Reynolds's *Discourses*', *British Journal of Aesthetics*, vol. 16 (Autumn 1976); David Bindman, *Blake as an Artist*, Oxford 1977; Hazard Adams, 'Revisiting Reynolds's *Discourses* and Blake's Annotations', in *Blake in his Time*, eds. Robert N. Essick and Donald Pearce, Bloomington, Ind., 1978. A detailed account of this view and its implications for Reynolds's pedagogic method is offered by Hipple, *The Beautiful*, ch. 9, and 'General and Particular in the *Discourses* of Sir Joshua Reynolds: A Study in Method', *Journal of Aesthetics and Art Criticism*, vol. 11 (1953), 231–47. The opinions of these writers have most effectively been challenged by Lipking, 185ff., and by Morris Eaves, *William Blake's Theory of Art*, Princeton, N. J., 1982, 94ff. For a more general account of the pedagogic concerns of the *Discourses*, see R. W. Uphaus, 'The Ideology of Reynolds's *Discourses on Art*', *Eighteenth-Century Studies*, vol. 12, no. 1 (Fall 1978), 59–73. For the shift from 'classic' to 'romantic' in the *Discourses*, see S. H. Monk, *The Sublime*, New York City 1935, 186–90; C. B. Tinker, *Painter and Poet*, Cambridge, Ma., 1938; W. J. Bate, *From Classic to Romantic*, Cambridge, Ma., 1946. The best general accounts of the contents of the *Discourses* are those of Wark and Hipple, of Dobai (2: 735–816); and of Lipking, to whom this section, in particular, of my chapter is indebted. Of value also are Ernst Gombrich, 'Reynolds's Theory and Practice of Imitation', *Burlington Magazine*, vol. 80 (1942), 40–5, and Joseph Burke, *Hogarth and Reynolds: A Contrast in English Art Theory*, 1943.

4. For Pliny, see above, 347, n. 112; on the delivery of the *Discourses* as a public occasion, see Wark, in *Discourses*, xvi.

5. Reynolds, *Works*, 2: 339; for similar opinions, see above, 345, n. 48.

6. Johnson's idea of history seems to derive here from Plato, 1: 161 and n.; for a consideration of this belief in the civilizing

power of commerce, see Pocock, *Virtue, Commerce, and Liberty*, Cambridge 1985, esp. 176–7, 188–9; for a view of the history of the arts more in tune with Reynolds's see Johnson, *Lives of the English Poets* (1779–81), 1952, 2: 320.

7. See Aristotle, 31ff.; see Berkeley, *Works*, 3: 201; Thomson, *Liberty*, part 5, lines 374–88; Brown, *Estimate*, 151, 182–3.

8. Reynolds, *Works*, 2: 234; for Venice as corrupted by trade see for example Berkeley, *Works*, 3: 203, and Fuseli, below, 276.

9. Pocock, *Machiavellian Moment*, 281.

10. *The Idler*, no. 79 (October 20 1759), in Reynolds's *Works*, 2: 229–30.

11. Reynolds, *Works*, 3: 100.

12. See Johnson's *Dictionary*, 'liberal'.

13. Quoted in F. W. Hilles, *The Literary Career of Sir Joshua Reynolds*, Cambridge 1936, 38; see also Northcote, 1: 101, 133.

14. That the superfluous wealth of a commercial nation should be mopped up by expenditure on the arts was a common theme of civic humanist writers: see Shaftesbury, *Characteristicks*, 2: 133; Richardson, *Two Discourses*, 2: 45; Turnbull, 13, 124; and (especially) Kames, 'Dedication', *Elements*; see also Hume, *Essays*, 267; for Barry on this issue, see below, 208.

15. The essay from which this phrase, and the earlier quotation from 'Tickell', are cited, is attributed to him on conjecture (*Guardian*, no. 23, 7 April, 1713). For other examples of the common belief that the vulgar were incapable of abstracting, see Winckelmann, *Painting and Sculpture*, 58, and Harris, *Works*, 218.

16. Hume, Essays, 260.

17. See for example *Discourses*, 50, 244, 268.

18. Reynolds, *Portraits*, ed. Hilles, 1952, 129; compare Burke, *Works*, 5: 97: 'It cannot escape observation, that when men are too much confined to professional and faculty habits, and, as it were, inveterate in the recurrent employment of that narrow circle, they are rather disabled than qualified for whatever depends on the knowledge of mankind, on experience in mixed affairs, on a comprehensive connected view of the various complicated external and internal interests that go to the formation of that multifarious thing called a state.'

19. Compare Harris, *Works*, 453 (Reynolds's source for this passage).

20. De Piles, *Principles*, 20–9; see above, p. 25–6.

21. This is a common ground of distinction between Roman and Venetian, Raphael and Titian: see for example Félibien, 55. For Haydon's redefinition of the distinction, see below, 310.

22. Reynolds, *Works*, 3: 174.

23. Johnson, 'Preface to Shakespeare', in *Johnson on Shakespeare*, ed. Arthur Sherbo, *Yale Edition of the Works of Samuel*

Johnson, 7: 74–81; de Piles, *Principles*, 72.
For Coleridge on why 'wax-work figures' are
'so disagreeable', see 'On Poesy or Art', *Mis-
cellanies, Aesthetic and Literary*, ed. T. Ashe,
1892, 45.

24. Harris, *Works*, 218.
25. Shaftesbury, *Second Characters*, 149.
26. Cicero, *De inventione*, II. i. 1–3; Pliny, 309,
sites the anecdote in Agrigentum.
27. For Raphael, see his letter to Count Baldass-
are Castiglione (1514?), in *Artists on Art*, eds.
Robert Goldwater and Marco Treves, 1976,
72–4, alluded to in *Discourses*, 196; for
'sublunary nature' etc., see G. P. Bellori,
quoted by Dryden, *Prose Works*, 3: 297–8;
Gerard, 181–2.
28. *Discourses*, 132–3; see below, 145.
29. Compare Shaftesbury, *Characteristicks*, 1:
144–5.
30. Johnson, *The History of Rasselas Prince of
Abyssinia* (1759), ch. 10; for Opie's extensive
use of this chapter in his *Lectures* (pp. 56ff),
see below, 353, n. 40.
31. See above, 344, n. 23.
32. *Rasselas*, ch. 10.
33. Reynolds, *Works*, 2: 237–9.
34. Reynolds, *Works*, 2: 237.
35. *The Poetical Works of the late Thomas
Warton*, 5th edition, corrected and enlarged,
Oxford 1802, 1: 59–60, lines 63–8.
36. For Bellori, see above, n. 27; for Poussin, see
Blunt, *Nicolas Poussin*, text volume, 364;
Richardson, *Two Discourses*, 2: 184, and 1:
49; Kames, 42.
37. Kames, 42.
38. Richard Payne Knight, review of Northcote's
Life of Reynolds, *Edinburgh Review*, vol. 23,
1814, 291.
39. Shaftesbury, *Second Characters*, 93.
40. *Second Characters*, 98.
41. *Second Characters*, 93., 107–8.
42. Dennis, 1: 56; for similar opinions, see Du
Bos, 1: 104–5, and Harris, *Works*, 30; and for
Reynolds's further reflections on fables, see
his *Works*, 3: 103–5.
43. Reynolds's had seen Rubens's *Altar of St
Augustine*, also known as the *Marriage of St
Catherine* (*ca*. 1628) in Antwerp in 1781, the
year before this discussion of it in Discourse
10; see *Works*, 2: 308–14.
44. For other statements of the need for unam-
biguous fables, see Félibien, preface
(unpaginated), and 83, 125; Richardson,
Theory, 56–62; Opie, 44.
45. On the danger to the legibility of a picture
caused by a superabundance of detail, see
Kames, 84–5, Mengs, 1: 166.
46. Du Fresnoy, lines 129ff, tr. Mason, in
Reynolds, *Works*, 3: 42; de Piles, 'Observa-
tions', 100, and compare Haydon, *Lectures*,
1:226; Fuseli 2: 12; for Bourdon, see Félibien,
125; de Piles, 'Observations', 89, 102; Du
Bos, 1: 264–5; Richardson, *Theory*, 62. On
the dangers of ambiguous composition in

general, see Richardson, *Theory*, 113; Webb,
188–9; Opie, in *The Artist*, vol. 2, number 10,
157–60.
47. Reynolds, *Works*, 3:125.
48. Hilles, *Literary Career*, 230.
49. On the danger of colour and lighting to the
comprehensibility of a painting, see Félibien,
143; Richardson, *Two Discourses*, 1: 28–9;
Pasquin, *Memoirs*, 90; Opie, 139.
50. For a general discussion of this notion, see
Dennis Mahon, 'Eclecticism and the Carracci:
Further Reflections on the Validity of a
Label', *Journal of the Warburg and Courtauld
Institutes*, vol. 16, 1953.
51. On the dangers of ambiguity of expression,
see Du Bos, 1: 82; Opie, 64, 75; for a discus-
sion of Reynolds and 'character', see R. E.
Moore, 'Reynolds and the Art of Charac-
terisation', *Studies in Criticism and Aesthetics,
1600–1800*, Minneapolis 1967, 332–57.
52. The 'Apollo' is in the Belvedere Courtyard of
the Vatican Museum; the 'Farnese Hercules'
is in the Museo Nazionale, Naples; the
'Borghese Warrior', or 'Borghese Gladiator',
is in the Louvre; the 'Dying Gaul', or 'Dying
Gladiator' is in the Capitoline Museum,
Rome. For an account of each, see Francis
Haskell and Nicholas Penny, *Taste and the
Antique: The Lure of Classical Sculpture
1500–1900*, New Haven, Ct., and London
1982, esp. 229–32, 221–4, 224–7, 148–51.
53. Pliny, 185; see also below, 265–9.
54. For Wark's opinion as to which painting by
Guido Reynolds has in mind, see *Discourses*,
78n.
55. On the differentiation of passions by social
rank, see Félibien, preface (unpaginated),
and 6–7, 90–1; Gerard Lairesse, *The Art of
Painting*, tr. Fritsch, 1778, 30–3; Henri
Testelin ('Henry Testeling'), *The Sentiments
of the most Excellent Painters concerning the
Practice of Painting*, 1688, 5, 6; de Piles, *Prin-
ciples*, 109, and 'Observations', 123; Du Bos,
1: 90–1 and esp. 253; Shaftesbury, *Charac-
teristicks* 1: 190ff.; Richardson, *Theory*, 93;
Mengs 1: 164; on passions such as 'can be
held', see Félibien, 7; Winckelmann, *Painting
and Sculpture*, 32–7; Lessing, *Laocoon*
(1766), esp. chs. 1–4.
56. Webb, 194–5; for contrary opinions of the
Cartoons, see Du Bos 1: 94–7; Richardson,
Theory, 57–8, 96–8; Opie, 86. Barry believed
that Raphael was sometimes casual in the
marking of expressions, but not in the
Cartoons; see *Works* 1: 68–9; for Blake, see
Complete Writings, 565.
57. For Pliny on Timanthes leaving the expression
of Agamemnon to the imagination, see
Natural History, 315–17, quoted in Webb,
200, and see also Webb, 192; Du Bos 1: 86;
Lessing, *Laocoon*, tr. Sir R. Phillimore, no
date, 67ff; *Oeuvres d'Étienne Falconet,
statuaire*, Lausanne 1781, 5: 62ff., cited by
Reynolds, *Discourses*, 163–4; for Fuseli, see

below, 265–9; on 'leaving something to the imagination' as a general principle, see Richardson, *Theory*, 63–6, 182.

58. Gombrich, *Art and Illusion: A Study in the Psychology of Pictorial Representation*, 4th edition, 1972, ch. 6.

59. Gombrich, *Art and Illusion*, 159; see also Félibien, 17, and de Piles, *Art*, 12.

60. Edward Young, *The Complaint: Or, Night Thoughts*, book 6, in *The British Poets*, 49: 190; James Harris, *Works*, 34n., Laurence Sterne, *The Life and Opinions of Tristram Shandy, Gentleman* (1759–67), 2: ch. 11, and 4: ch. 38; Shaftesbury, *Characteristicks*, 1: 206. For sketches and indeterminability, see also Félibien, 67; de Piles, *Art*, 46–7; for a consideration of Reynolds's account of sketches in a different context, see Barrell, 'The Private Comedy of Thomas Rowlandson,' *Art History*, vol. 6, no. 4, December 1983, 423–41, from which this and the following paragraphs have been adapted. For an attempt to connect the account of the 'accidental', in the *Discourses*, with Sterne's procedures in *Tristram Shandy*, see Peter J. de Voogd, 'Laurence Sterne, the marbled page, and the use of accidents', *Word and Image*, vol. 1, no. 3, July–September 1985; de Voogd does not appear to have noticed, however, the constraints which, in the *Discourses*, confine the proper 'use of accidents' to the lower genres of painting, especially landscape (see below, p. 120–1).

62. Compare Richardson, *Theory*, 154: a sketch may be crude, incorrect, unformed, but still of great interest and value. 'But when Correction is pretended to, (and this is always the Case of a Finish'd Drawing, or Picture) then to have any Defect in Drawing ... is a Fault.'

63. Northcote, 1: 138.

64. Compare Du Bos, 1: 68; 2: 70–3; Mengs, 2:25.

65. Reynolds, *Works*, 2: 338, 369.

66. Compare Barry, 1: 405.

67. Reynolds, *Works*, 2: 226, and 361, 363–4; compare Blake, 599: 'A point of light is a Witticism; many are destructive of all Art. One is an Epigram only & no Grand Work can have them.'

68. Compare Shaftesbury on comic painting, *Second Characters*, 100; John Scott of Amwell, 'On Painting' (*British Poets*, 70: 167), argues that Hogarth's failure to paint 'general nature' has resulted in his works having become dated, and difficult to understand; the same point is made by Barry, 1: 465, and by Fuseli (see below, 286); for Hazlitt's opinion, see below, 324–5.

69. Reynolds, *Works*, 2: 249; 3: 133–4.

70. For a definition of accidents of light in landscape-painting, see Francis Nicholson in the *Somerset House Gazette*, vol. 1, 1 November 1823, 61–2; for accidents of light more generally, see Félibien, 49, and Mengs 1: 55.

71. Pasquin, *An Authentic History of the Professors of Painting, Sculpture and Architecture who have practised in Ireland*, no date, 11n. ('Thunder and lightning': 'applied to a cloth, app. of

glaring colours, worn in 18th century, and perhaps later' (*OED*).

72. Richardson, *Theory*, 167.

73. Reynolds, *Works*, 2: 262.

74. De Piles, *Principles*, 123.

75. Hazlitt, *Conversations*, in *Complete Works*, 11: 257; Richardson, however, was content with the notion that portraits might, without any alteration of style, perform at once a public and a private function: to those unacquainted with the sitters, they could 'answer the Ends of Historical Pictures', and they could serve also as pleasing memoranda to 'Relations, or Friends' (*Two Discourses*, 1: 46); on this topic, see also Coleridge, *Miscellanies*, 49.

76. De Piles, *Principles*, 169; compare Reynolds's description of Titian's portraits with Northcote's remark, that 'you feel on your good behaviour in the presence of his keen-looking heads, as if you were before company', *Conversations*, in Hazlitt, *Compete Works*, 11: 198.

77. Shaftesbury, *Characteristicks*, 1: 144.

78. Richardson, *Theory*, 218; West, 2: 116, and (on Leonardo) 131; Shaftesbury, *Characteristicks*, 3: 368; Johnson, *Lives*, 1: 123.

79. Compare Johnson, *Lives*, 1: 14–15: the metaphysical poets 'had no regard to that uniformity of sentiment which enables us to conceive and to excite the pains and the pleasures of other minds; they never enquired what, on any occasion, they should have said or done; but wrote rather as beholders than partakers of human nature ... Those writers who lay on watch for novelty could have little hope of greatness; for great things cannot have escaped former observation.'

80. Young, *Conjectures on Original Composition in a Letter to the Author of Sir Charles Grandison*, 1759, 22–3, 37, 54–5; compare Reynolds's use of the image with Mengs, 1: 145.

81. Young, *Conjectures*, 4, 42–3, 5, 34.

82. Northcote, 2: 56.

83. Reynolds, *Works*, 2: 419–20.

84. Du Fresnoy, lines 455, 177–81—the verse translation quoted is Mason's, in Reynolds, *Works*, 3: 47–8; Poussin, in Blunt, *Nicolas Poussin*, text volume, 364; de Piles, *Principles*, 104; Du Bos, 2: 63, 33.

85. Quoted from Abraham Cowley, *Davideis, A Sacred Poem of the Troubles of David* (1656), book 1, line 714; the passage had been quoted by Johnson in his life of Cowley, *Lives*, 1: 44; see Wark's note, *Discourses*, 203n.

86. Pocock, *Machiavellian Moment*, 279.

87. Francis Bacon, 'Of Beauty', in *The Essays*, ed. Samuel H. Reynolds, Oxford 1890, 304.

88. Quoted in Lipking, 204–5, from Madame D'Arblay, *Memoirs of Doctor Burney*, 1832, 2: 281–2.

89. Lipking, 204.

90. See Barrell, *Survey*, esp. introduction and ch. 1.

91. Defoe, *The Compleat English Gentleman*, ed. Karl Bülbring, 1890, 98; for Roderick Random, see Barrell, *Survey*, ch. 3.

92. For the dating on the essay on Shakespeare, see Reynolds, *Portraits*, 107.

93. *The False Alarm* (1770), *The Patriot* (1774), and *Taxation no Tyranny* (1775), all reprinted in Johnson, *Political Writings*, ed. Donald J. Greene, Yale Edition, vol. 10, 1977.

94. Johnson, *Political Writings*, 391, 328, 428.

95. See Sir John Davies, *Le Primer Report des Cases & Matters en les Courts del Roy en Ireland*, Dublin 1615, preface (unpaginated).

96. For Shee, see above, 50–2; Coleridge, 'On Peace. IV', *Morning Post* 4 January 1800, reprinted in *Essays on his Times*, ed. David V. Erdman, Princeton, N. J., 1978, 1: 75. For evidence of a radicalised version of the discourse of civic humanism in pre-revolutionary writings on painting in France, see Crow, *Painters and Public Life*, esp. ch. 6.

97. Claude Buffier, *Traité des premières vérités et de la source de nos jugements* (1724), summarised by Smith, *Theory of Moral Sentiments*, 198–9; Reynolds, *Works*, 2: 236, 238; for Reynolds on Hogarth's *Analysis*, see also his letter to James Beattie, March 31 1782, in Hilles (ed.) *Letters of Sir Joshua Reynolds*, Cambridge 1929, 92; Joseph Burke, *Hogarth and Reynolds*, and Edgar Wind, '"Borrowed Attitudes" in Reynolds and Hogarth', *Journal of the Warburg and Courtauld Institutes*, vol. 2 (1938), 182–5.

98. Pocock, *Machiavellian Moment*, 85, 184.

99. Compare Du Bos, 1: 259: 'in imitation, the received, and generally established idea, stands in place of the truth.'

100. Goldsmith, *The Traveller, or A Prospect of Society*, 1765, 18.

101. Reynolds's insistence that the history-painter should represent 'neither woollen, nor linen, nor silk, sattin, or velvet', but 'drapery ... nothing more' (*Discourses*, 62) is unusual even in the civic tradition, and, in its emphasis on the universality and uniformity aimed at by the great style, is in direct opposition to the views in particular of de Piles (see *Principles*, 116).

102. Compare *Johnson on Shakespeare*, 7: 61: 'nothing can please many, and please long, but just representations of general nature.'

103. Reynolds, *Portraits*, 127.

104. Hilles, *Literary Career*, 227–8.

105. Burke, *Works*, 5: 168, 186, 79; for the notion that God 'willed' the state, see also Lowth, *Sermons and other Remains*, London 1834, 110.

106. Brown, *Essays*, 375; *The Spectator*, no. 61, May 10 1711.

107. Blackstone, *Commentaries on the Laws of England*, 1, Oxford 1765: 44–5, 74.

108. Blackstone, 1: 74–5; see Pocock, *Machiavellian Moment*, 341, and for a general comment on this issue, Barrell, *Survey*, 119–20.

109. Du Fresnoy, lines 261–6, and p. 27: colour 'has been accused of procuring Lovers for her Sister' (*viz*. Design).

110. Burke, *Works*, 5: 305; Johnson, *The Plan of a Dictionary of the English Language*, 1747, 10.

111. Now in the Bibliothèque de l'Institut, Paris.

112. Hilles, *Literary Career*, 228.

113. Burke, *Works*,, 5: 59, 304.

114. See Reynolds, *Portraits*, 107; in the letter to Beattie, cited above (n. 97), Reynolds writes as if his opinions had never changed, and he had always believed that the 'beauty of form' was to be 'attributed entirely to custom or habit'; 'I am inclined to habit', he writes, 'and that we determine by habit in regard to beauty without waiting for the slower determination of reason.' (*Letters*, 90, 93.)

115. Reynolds, *Portraits*, 130, 127; Burke, *Works*, 5: 95, 104.

116. Reynolds, *Portraits*, 144, 142, 128; for Paine, see above, p. 347, n. 98; and for a discussion of the image of axe and tree, see Paulson, *Representations of Revolution (1789–1820)*, New Haven and London 1983, 73–9; Burke, *Works*, 5: 123, 124.

117. Reynolds, *Portraits*, 129, 130, 142.

118. For Johnson on this topic, see *The Rambler*, no. 156, September 14 1751, and *Johnson on Shakespeare*, 7: 66–9; for Burke's views, see 'Hints for an Essay on the Drama', in *Works*, 10 (1818): 157–60.

119. Reynolds, *Portraits*, 117–19, 112.

120. *Portraits*, 112, 122.

121. *Portraits*, 109, 113; and compare *Discourses*, 59.

Chapter Two: James Barry.

1. See below, 182–3, and William L. Pressly, *The Life and Art of James Barry*, New Haven, Ct., and London 1981, esp. 77–82, 179–81. For Barry's contempt for portrait-painters, and his jealousy of Reynolds's success 'in a humbler walk of the art', see Hazlitt's essay 'James Barry' in his *Works*, 18: 131. Other works concerned with, or touching on, Barry's writings, include Richard Payne Knight's review of Barry's *Works*, *Edinburgh Review*, vol. 16, August 1810, 293–326, and Haydon's rejoinder, 'To the Critic on Barry's Works in the *Edinburgh Review*', *The Examiner*, 26 January, 2 and 9 February, 1812, 60–4, 76–8, 92–6; Robert R. Wark, 'James Barry', unpublished Ph.D. dissertation, Harvard University 1952; David Irwin, *English Neo-Classic Art: Studies in Inspiration and Taste*, 1966; Dobai, 2: 817–61. Pressly's book is an essential introduction to the study of Barry, and his catalogue of the Barry exhibition at the Tate Gallery, *James Barry: The Artist as Hero* (1983), is also of considerable value. Barrell, 'The Functions of Art', is not recommended, as its account of Barry's theory of the representation of the body is quite mistaken.

2. Barry, *Inquiry*, 1775; for a full bibliography of Barry's writings, see Pressly, *Life and Art*, 303–4; for Burke, see Barry, *Works*, 1: 249; for Hoare's endorsement of Barry's attack on Du Bos, Montesquieu and Winckelmann, see

Hoare, *An Inquiry*, 190–210; for Opie's endorsement, see *Lectures* 91–3.

3. On the tendency of national character to change through time, see Du Bos, 2: 313–19.
4. Smith, *Wealth of Nations*, 1: 29–30.
5. For man's capability of 'infinite directions', see Harris, *Works*, 43, 63; Harris may be the source of this passage, as also of Barry's understanding of the idea of the division of labour—see especially Harris 62–4; for physical difference as the result of occupation, see Du Bos 1: 90; Hogarth, *Analysis of Beauty*, 1753, 85 ff.; Alison, 2: 309; for a detailed account of the deformations of the body caused by fashion, see Shaftesbury, *Second Characters*, 117.
6. Reynolds, *Discourses*, 44; for the difficulty of 'decompounding' the body so as to arrive at an idea of its original form, see de Piles, *Art*, 13–14; for Mengs's belief that 'Man ... would be beautiful, if ... accidents ... did not spoil him', see Mengs 1: 16–17, 19.
7. See *Works* 2: 223; Barry refers to Shaftesbury again on 2: 292.
8. In West's translation of the *Odes of Pindar*: see below, n. 29.
9. For Rubens, see de Piles, *Principles*, 91; see also Du Bos 1: 376 (citing Rubens); Shaftesbury, *Characteristicks*, 3: 138–9, and *Second Characters*, 116; Turnbull, 44 (citing Shaftesbury); Winckelmann, *Painting and Sculpture*, 4–7; Mengs, 2: 14–15; Algarotti, 18.
10. See Barry's remarks on Raphael, 2: 10; quoted by Knight in his review (see above, n. 1), 305, and by Hazlitt, see below, 321.
11. For Reynolds, see *Discourses*, 45; for 'perfect beauties', see Dryden, *Prose Works*, 3: 303 (quoting Bellori); see also Du Bos, 1: 80–107.
12. For the date of the lectures on 'Design', see *Works* 2: 485; for beauty as a 'point', see Mengs, 1: 7–9; for truth as a 'point', see 'Richardson, *Two Discourses*, 2: 120.
13. Mengs, 1: 11.
14. Pope, 'Epistle to a Lady', line 2; Webb, 56; Alison, 2: 379–414, 316–17; for the distinction between the active bodies of men and the passive bodies of women, see also Joseph Spence, *Crito; or, A Dialogue on Beauty. By Sir Harry Beaumont*, Dublin 1752, 10; West, 2: 97–8; Flaxman, 130.
15. In common with other readers of Burke, I base my belief in the (for him) gendered nature of aesthetic experience, on such passages in the *Enquiry* as 51, 67, 111; for 'modification of power', see 64; for Polyphemus, 158; for a similar gendering of the sublime and beautiful, see Walpole, 1: xvi–xvii.
16. Alison, 2: 311–12, 315–16, 318, 326–7.
17. Aristotle, 187.
18. Fielding, *The History of Tom Jones* (1749), book 8, ch. 8.
19. *The Birth of Pandora* (1791–1804), Manchester City Art Galleries, Pressly, *Life and Art*, cat. no. 36, p. 236; for Benjamin West's attribution of a similarly universal perfection to Apollo, see

West, 2: 99–101, and for Blake attributing the same perfection to Jesus, see below, 236.
20. Schiller, *On the Aesthetic Education of Man*, ed. and tr. Elizabeth M. Wilkinson and L. A. Willoughby, Oxford 1967, esp. 109, 151; for Fuseli, see below, 286–9.
21. Turnbull, xiii, 13; for Turnbull cited by Barry, see below, no. 35.
22. For Francis Bourgeois's recommendation that Barry should be expelled from the Academy on the grounds of his 'avowed democratical opinions', see Pressly, *Life and Art*, 180; for Tooke, see Barry, 2: 535; for Godwin, for the invitation to paint Washington, for Barry's defence of the Irish Catholics, and for his friendship with Priestley and Price, see Pressly, *Life and Art*, 141 and 179, 82, 84–5, and 175–8, 81. The remarkable similarities between Barry's attitudes to the Academy and to the function and dignity of the history-painter, and those of David, will be evident to anyone who compares Pressly's biography of Barry with Thomas Crow's account of David's early career (*Painters and Public Life*, ch. 7). It seems unlikely that either imitated the other, and much more likely that the attitudes of both men are the result of a sustained consideration of the practice of painting in the light of a radical, republican discourse.
23. Shaftesbury, *Second Characters*, 107–8; Hogarth, *Analysis* (1753), 80.
24. Compare Alison, 2: 319–20; Barry's list seems to be based on the similar list of 'homely phrases' by which Comenius had defined 'Deformed and Monstrous People' (*Orbis Sensualium Pictus*, tr. Charles Hoole, 1659, 91).
25. Compare Burke, *Enquiry*, 13–16.
26. See Winckelmann, *History of Ancient Art*, book 4, ch. 2.
27. The rules for the keeping of 'costume' were first set out by Fréart, in *An Idea*; according to Du Bos, 'costume', which he calls 'la vraisemblance poëtique (1: 258), is the most important part of painting, after the choice of subject (1: 260–1).
28. See Plato, 1: 149–71; Plato's account had been imitated by Hume, *A Treatise*, 485 ff., and Harris, *Works*, 59 ff; Brown, *Estimate*, 73.
29. *The Progress of Human Culture*, 1777–84, and occasionally retouched thereafter. The fourth picture is *Commerce or the Triumph of the Thames* (Pressly, *Life and Art*, cat. no. 25, p. 233); the fifth is *The Distribution of Premiums in the Society of Arts* (*Life and Art*, cat. no. 26, p. 233). Barry discusses these paintings in various writings collected in his *Works*; the best recent discussions are those of D. G. C. Allan, 'The Progress of Human Culture and Knowledge', *Connoisseur*, June 1974, 100–9, and February 1975, 98–107, and Pressly, *Life and Art*, (esp. 285–98) and *James Barry: The Artist as Hero*, 24–8, 79–97. The subject of the fifth painting may be influenced not only by the Society's practice of awarding premiums, but by

Barry's reading of Gilbert West's translation of Lucian: 'That a wise and prudent Governor of a State may dispose the People to such Sports and Diversions, as may render them more serviceable to the Public; and that by impartially bestowing a few *honorary prizes* upon those, who should be found to excell in any *Contest* he should think proper to appoint, he may excite in the Husbandman, the Manufacturer, and the Mechanick, as well as in the Soldier, and the Sailor, and Men of superior Orders and Professions, such an Emulation, as may tend to promote Industry, encourage Trade, improve the Knowledge and Wisdom of Mankind, and consequently make his Country victorious in War, and in Peace opulent, virtuous, and happy.' (West, 'A Dissertation on the Olympic Games', *Odes of Pindar... translated from the Greek*, 1776, 3: 276). The third picture in Barry's sequence (*Life and Art*, cat. no. 24, p. 233) is *Crowning the Victors at Olympia*, and seems intended to represent the model upon which the Society's distribution of premiums is or should be based.

30. Hume, *Essays*, 268; Burke, *Works*, 5: 291; 7: 404.

31. See Pressly, *Life and Art*, 138–9, and Barry, 1: 302.

32. For Flaxman's similar opinion of Egyptian art, see his *Lectures*, 144–79; for Vasari on the ante-diluvian origins of painting, see *Lives* 1: 9ff.; for Barry on Atlantis, see Irwin, 144.

33. Kames, 452; William Law, *A Serious Call to a Devout and Holy Life* (1728), ed. Norman Sykes, 1906, 109, 111; for other remarks on the beneficial cultural effects of Roman Catholicism, see Barry 2: 432ff., 526ff.

34. 'The same text'—viz., *A Letter to the Right Honourable the President, Vice-Presidents, and the rest of the Noblemen and Gentleman, of the Society for the Encouragement of Arts, Manufactures, and Commerce*, 1793. For Fuseli on the divisive effects of dissent in Britain, see below, 281.

35. Barry also quotes Turnbull to this effect: 'Wealth in a State is a Nuisance, a poisonous Source of Vileness and Wickedness, if it is not employed by publick Spirit and good Taste in promoting Virtue, Ingenuity, Industry, and all the Sciences and Arts, which employ Mens noblest Powers and Faculties, and raise human Society to its most amiable glorious Estate' (Turnbull, 124; see Barry 2: 295).

36. For arguments for the necessity of a division of labour among artists, so that each will specialise in representing a particular aspect of nature, see Mengs, 1: 37–8 and 196; Fuseli, see below, 291; Hazlitt, see below, 331.

37. See above, 119, 350 (n. 68); and for Fuseli and Hazlitt on Hogarth and comic painting, see below, 286, 324–5.

38. Johnson, *Lives*, 1: 117–18.

39. Thomson, 'To the Memory of the Right Honourable the Lord Talbot' (1737), line 27,

in *Poetical Works*, 444–55; for a discussion of the poem, see Barrell, *Survey*, 51–2.

40. 'Works in every genre': see Alberti, 75, 95–6; Aglionby, preface (unpaginated), 14–15; de Piles, *Principles*, 33, 235–6, and note that he argues that landscape-painters, also, should have this ability (*Art*, 32); Richardson, *Theory*, 38. 'Vast range of knowledge': Vasari, 3: 55; Junius, 252–3; Shaftesbury, *Second Characters*, 135; Richardson, *Theory*, 17–21, 24; Turnbull, 20–1 (citing Pliny). Opie (56–7) writes on this topic quite as enthusiastically as Barry: 'he who wishes to be a painter or a poet must, like Imlac, enlarge his sphere of attention, keep his fancy ever on the wing, and *overlook no kind of knowledge*' etc. (Opie's emphasis). The whole passage is a paraphrase of *Rasselas*, ch. 10.

41. *Inquiry*, 1775, 141, has 'his story' for 'history'.

42. See above, 51.

43. *Orpheus*, Pressly, *Life and Art*, cat. no. 22, p. 233; for similar contemporary claims for the omnicompetent, undifferentiated character of the ancient poets, see Lowth, *Lectures on the Sacred Poetry of the Hebrews*, tr. G. Gregory, 1787, 1: 97; Ferguson, 173; Thomas Percy, *Reliques of Ancient English Poetry* (1765), 1906, 1: 11; for Peter the Great and the Knight of Industry, see Barrell, *Survey*, 72–2, 84–5.

44. For Pope and Thomson, see Barrell, *Survey*, 35–6 and ch. 2; for Smith, see *Theory of Moral Sentiments*, 135.

45. Smith, *Wealth of Nations*, 1: 456.

46. Smith, *Wealth of Nations*, 1: 29–30 and 30n., and *Lectures on Jurisprudence*, 349, 493.

47. Reynolds, *Discourses*, 147.

48. Émile Durkheim, *The Division of Labor in Society* (1893), tr. George Simpson, Glencoe, Ill., 1949, 43.

Chapter Three: A Blake Dictionary

1. Hazard Adams (see above, 348, n. 3) offers a good corrective to this assumption.

2. Morris Eaves, *William Blake's Theory of Art*, Princeton, N. J., 1982. As will appear from what follows, I disagree with this book profoundly; so that I had better say now that I also admire it profoundly. What is at issue between Eaves and myself will emerge clearly in this chapter, and it was what I believe to be Eaves's misreading of Blake's critical vocabulary that prompted me to cast the chapter in the form of a 'dictionary'. On its own terms, however, or on the terms of its interpretation of Blake's, Eaves's work is remarkable for the coherence with which it manages to describe Blake's 'theory of art'. The next most extended account of Blake's writings on art is Dobai, 3: 861–930. My own account is probably closest to David Bindman's, especially in his 'Blake's Theory and Practice of Imitation', in *Blake in his Time* (see above, 348, n. 3), where he

argues that 'Blake's attitudes towards art are in a profound sense eighteenth-century in spirit, and are predominantly determined to the end of his career by classical idealism'; see also Bindman's *Blake as an Artist*, Oxford 1977.

3. Reynolds, *Discourses*, 85; for Eaves's attitude to the topic discussed in this paragraph, see *Theory*, esp. 75, 53–4, 184–202.

4. In this, I disagree not only with Eaves (see e.g. 29–38, 92–3, 111–12, 143–5), but also with Northrop Frye on Blake's 'individualism', *Fables of Identity: Studies in Poetic Mythology*, New York City 1963, 149.

5. See Eaves, 67–78, for his view of 'originality'.

6. Milton, *The Reason of Church Government*, 1641, 41.

7. For Opie, see below, notes 14, 17; the structure of the fragment, 'Barry, a Poem', seems likely to have been based on a paragraph in Opie's first lecture, 23–4.

8. Compare Félibien, 219 (mispaginated; should be 129).

9. For a radically different interpretation of the terms 'expression' and 'character', see Eaves, esp. 45–67; the interpretation I offer will be found exemplified by various of the writers whom Eaves cites for the purpose of indicating the difference between them and Blake; for 'expressive' used to mean 'good at painting expressions', see Mengs, 2: 67.

10. *Sir Jeffery Chaucer and the Nine and Twenty Pilgrims on their Journey to Canterbury*, 1808, Pollok House, Glasgow; a full account of the picture is offered by Claire Pace, 'Blake and Chaucer: "infinite variety of character"', *Art History*, vol. 3, no. 4, December 1980, 388–409. For other accounts of the 'antique statues' as paradigms of character, see above, 105 (Reynolds); 181 (Barry); Shaftesbury, *Second Characters*, 144–5; Opie, 29; Flaxman, 123ff.

11. Eaves, 77.

12. The Dancing Faun is in the Uffizi, Florence; see Haskell and Penny, 205–8; for Apollo and Hercules, see above, 349, n. 52.

13. See above, 178–9.

14. Compare Opie, 15, on the danger of 'breaking down the boundaries and destroying the natural classes, orders, and divisions of things (which cannot be too carefully kept entire and distinct)'; for Blake as linearist, see Eaves 18–38, and, for a full bibliography of discussions of the issue, 19n.

15. 1809, Victoria and Albert Museum.

16. Fréart, 67, also plays on the angelic names of Michelangelo and Raphael.

17. See also Book 12, l. 85: right reason has 'no dividual being' apart from true liberty.

18. Compare Opie, 34–5, on the English artist as 'condemned for ever to study and copy the wretched defects, and conform to the still more wretched prejudices, of every tasteless and *ignorant individual*' (my emphasis).

19. S. Foster Damon, *A Blake Dictionary: The Ideas and Symbols of William Blake*, revised edition, 1979, 196.

20. Eaves, 35; Reynolds, *Discourses*, 196.

21. The anecdote appears in Pliny, 321–3; see Junius, 197; de Piles, *Art*, 77; Mengs, 1: 222; West, 2: 129; Fuseli 2: 63–4; Haydon's account of the anecdote will be found in *Encyclopaedia Britannica*, 7th edition, 16 (Edinburgh 1842): 702. For Eaves's interpretation, see 35, 175 ('Artistic line is the expression· of personal identity').

22. The 'dryness' of Raphael's early manner is one of the clichés of eighteenth-century art criticism: see for example Mengs 1: 147; Reynolds, *Discourses*, 15; Opie, 48.

23. Barry 2: 445.

24. See Anne K. Mellor, 'Physiognomy, Phrenology, and Blake's Visionary Heads', *Blake in his Time*, 53–74.

25. See above, 186.

26. Barry, 2: 217; see also Opie, 94–5; Shee, 28–9, 31.

27. Barry 2: 448.

28. For the particularly 'public' nature of portable paintings, see Pliny, 349; for Barry, see 1: 363n; for an interesting account of Blake's ideas of art and commerce, see Kurt Heinzelman, 'William Blake and the Economics of the Imagination', *Modern Language Quarterly*, vol. 39 (1976), 99–120.

Chapter Four: Henry Fuseli.

1. Edward Gibbon, quoted in Pocock, 'Beyond Machiavelli and Hume', 163; Brown, *Estimate*, 63; cp. Wordsworth, *The Prelude* (1805), Book 2, lines 435–8:

> good men
> On every side fall off we know now how
> To selfishness, disguised in gentler names
> Of peace and quiet and domestic love.

2. Eudo C. Mason, *The Mind of Henry Fuseli: Selections from his Writings with an Introductory Study*, 1951, 179. Mason's volume is by far the best account of Fuseli's writings: it is a model of selection, presentation, and interpretation; it also contains a list (356–8) of Fuseli's numerous contributions to the *Universal Museum* and the *Analytical Review*. See also Dobai, 3: 931–86.

3. For Fuseli's representation of himself as a 'gentleman', see Mason, 25.

4. The 'Medici Cycle', 1662–5, now in the Louvre.

5. Review of Murphy's *Tacitus*, *Analytical Review*, November 1793, 241ff., and February 1794, 121ff., quoted in Mason, 184.

6. E. C. Fréron, quoted in H. Vyverberg, *Historical Pessimism in the French Enlightenment*, Cambridge, Ma., 1958, 120; Vasari, 1: 32–3, 302–3, 306ff.; 2: 358–9; Winckelmann, *History of Ancient Art*, book 4, ch. 6, esp. sections 2, 3.

a genius will not submit to the demands of private patronage. For Lanzi on the decline of art, see 1: 430ff.

8. In Haydon's tenth lecture (2: 111), Phidias too is represented as the beneficiary of the 'individual' patronage of Pericles.

9. Compare West, 2: 97, on paintings as 'ornamental manufactures'.

10. *The Athenaeum*, which thought highly of Haydon's article, believed like him that 'Michelangelos' can 'be raised by no other means than annual grant of public patronage (the same thing as from the Exchequer)', 511. But the *Edinburgh Review*, in the same year, and in an account of G. F. Waagen's *Works of Art and Artists in England* (1838), remarks that 'as the handmaid of religion, nay, as part of religion itself, Art had been [in Greece, and in renaissance Italy] a principle apart from the patronage which is bestowed upon it ... Patronage, indeed, and reward followed in its train.' But as 'this state of society has passed away', 'neither in England nor elsewhere do we anticipate' a 'coming millenium of the arts'. Painting 'will hereafter ... be everywhere essentially a decorative art, rather than a means of exciting solemn thoughts or high imagination' (no. 67, 1838, 389–91). In his lectures, Haydon bases his argument for public patronage on the now more popular and promising grounds that a developed school of history-painters in Britain would benefit the advancement of manufactures (1: 50–3, 329; 2: 117–18, and compare Richardson, *Two Discourses*, 2: 46–7; Reynolds, *Discourses*, 13; West, 2: 79).

11. For Black's 1838 volume, see above, n. 2. I have based my account of Hazlitt's article on the version in W. Hazlitt, ed., *Criticisms on Art and Sketches of the Picture Galleries of England. By William Hazlitt*, first series (1843), 2nd edition, 1856. By those with a developed interest in painting, the article was probably most widely consulted in this version after its appearance in 1843. W. Hazlitt (this is how I shall refer to Hazlitt's son) interpolated a few additional passages into the article from the original essays out of which it had been composed, though everything that is included in W. Hazlitt's version is by his father. I have chosen to refer to this version in the face of many sound principles of scholarship, and even some of my own, in order to take advantage of the opportunity thus afforded of discussing the important passages on the 'division of labour' among artists, and on the 'diffusion of taste', there added to the portion of the essay 'Fine Arts. Whether they are promoted by Academies and Public Institutions.' (*The Champion*, 28 August, 11 September, 2 October 1814; *Complete Works*, 18: 37–51) that Hazlitt had more sparingly drawn upon in composing his encyclopaedia article. The interpolations by W. Hazlitt are recorded in the notes, as is the only important discrepancy between my quotations from W. Hazlitt's version and the original text of the article.

12. P. P. Howe, *The Life of William Hazlitt*, New York City, 1922, 197.

13. See especially *Complete Works*, 4: 143–5. For an account of the dispute to which these essays were a contribution, see Peter Fullerton, 'Patronage and Pedagogy: The British Institution in the Early Nineteenth Century', *Art History*, vol. 5, no. 1, March 1982, 59–72.

14. Howe, *Life*, 198.

15. New York, 1978; for Hazlitt's opinions on art, see especially chs. 3 and 4. I am substantially in agreement with Kinnaird's account of those opinions (granted his method), and in particular with his account of the importance for Hazlitt of what Kinnaird calls his 'Louvre experience' of 1802, which resulted in his dedication to 'a power of concrete vision which could reach the heights or depths of human experience and communicate that universality from self to self without squinting at the consequences for virtue' (86). That last phrase seems particularly apt, and goes to the heart of Hazlitt's abandonment of the civic discourse; my agreement with what goes before is more conditional. I am less convinced by the process of communicating universality from self to self, unless Kinnaird means to limit this (as no doubt he does) to a very few selves, and unless he also means to imply that these selves are not thus brought into any form of relation that we could call *social*. And when Kinnaird writes that 'as Hazlitt later said' of the Louvre experience, 'it was " a means to civilize the world" (*Complete Works*, 18: 102), but the beauty and truth of genius here revealed was a means to that end only because it was an end in itself' (85), it seems clear to me (see 18: 102, 'Where the triumphs of human liberty had been, there were the triumphs of human genius') that for Hazlitt the process of civilizing the world was separate from, and posterior to, the process of liberating it, in which art had no part to play. The claim I make later in this chapter, that Hazlitt reproduces (though in different terms of value) the social structure of the republic of taste implicit in Reynolds's *Discourses*, is perhaps nowhere more substantially born out than in Hazlitt's account of the 'Louvre experience' in his life of Napoleon: Napoleon's Louvre was a threat, Hazlitt claims, to inherited power, but the language in which he praises the masters of art is oddly suited to that claim: 'Art, no longer a bondswoman, was seated on a throne, and her sons were kings ... These are my inheritance, this is the class to which I belong! (13: 212, and see 18: 102—'The crown she [Art] wore was brighter than that of kings'). This royal language is employed to dignify, of course, an aristocracy of merit, not of blood, but of merit which, like blood, is innate, as also is taste (see below, 335). Other

works of interest which are concerned with, or
touch on, Hazlitt's criticism of the fine arts,
include Stanley Chase, 'Hazlitt as a Critic of
Art', *PMLA*, vol. 39, 1924, 189–93; Elizabeth
Schneider, *The Aesthetics of William Hazlitt*,
1933; J. D. O'Hara, 'Hazlitt and Romantic
Criticism of the Fine Arts', *Journal of Aesthet-
ics and Art Criticism*, vol. 27, no. 1, Fall 1968,
73–86; Roy Park, *Hazlitt and the Spirit of the
Age*, Oxford 1971; Dobai, 3: 318–58; Richard
Read, 'Evocative Art Criticism: Hazlitt,
Ruskin, Pater and Adrian Stokes', unpub-
lished Ph.D. dissertation, University of
Reading 1981. This last, and Kinnaird's book, I
have found of particular value.

16. Du Bos, 1: 217–18: painters reveal aspects of
an ever-various nature, new to us, and missed
by other artists: thus nature is never used up as
a subject for painting. According to Mengs (1:
37), 'Nature ... is too extensive for human
understanding', and so the great painters of
Italy 'chose each a particular part, to bestow
upon that all his application'. Hazlitt makes the
point more extensively in his second essay 'On
Genius and Common Sense' in *Table Talk*:
'Nature has her surface and her dark recesses.
She is deep, obscure, and infinite. It is only
minds on whom she makes her fullest impres-
sion that can penetrate her shrine or unveil her
Holy of Holies. It is only those whom she has
filled with her spirit that have the boldness or
the power to reveal her mysteries to others.
But nature has a thousand aspects, and one
man can only draw out one of them. Whoever
does this, is a man of genius. One displays her
force, another her refinement, one her power
of harmony, another her suddenness of con-
trast, one her beauty of form, another her
splendour of colour. Each does that for which
he is best fitted by his particular genius'
(*Complete Works*, 8: 42). On the argument
that 'there is no difference of style' among
practitioners in the highest sphere of art, but
only difference of execution, see Haydon,
Lectures 1: 19.

17. Haydon denies that the best, or indeed any,
Greek sculptures are of figures 'in repose';
Lectures 1: 25.

18. See Hazlitt's two essays on the Elgin Marbles,
Complete Works, 18: 100–3 and 145–66, and
his review of Joseph Farington's life of
Reynolds, 16: esp. 207: the marbles 'contain
the truth, the whole truth, and nothing but the
truth'. For Hazlitt's attitude to the marbles, see
Frederic Will, 'Two Critics of the Elgin
Marbles: William Hazlitt and Quatremère de
Quincy,' *Journal of Aesthetics and Art
Criticism*, vol. 14 (1956), 462–74.

19. Compare the review of Farington's *Life*, where
Hazlitt explicitly denies the influence of any
external circumstances on the productions of
art, and asserts that 'where a faculty or genius
for any particular thing exists in the most emi-
nent degree ... it is sure to show itself, and

force its way to the light, in spite of all obstac-
les' (*Complete Works*, 16: 194).

20. Barry, 2: 10.

21. *The Athenaeum* (28 July 1838, 527) also points
out Hazlitt's misuse of Barry (as it elsewhere
attacks his misrepresentation of Reynolds),
italicising 'nearly', 'adding or taking away',
and 'ideal', and arguing that Hazlitt had
ignored the qualifications they make of his
position.

22. Du Bos, 1: 68, 70–3.

23. For an extended exemplification of the mean-
ings attached by Hazlitt to the word 'common',
see 'On Paradox and Commonplace', in *Table
Talk*: *Complete Works*, 8: 145–56.

24. Compare 'On the Ideal' (*Complete Works*, 18:
78): The 'finest historical head' has 'the look of
nature, *i.e.* of striking and probable nature,—
as it has a marked and decided character, and
not a character of indifference: and as the
features and expression are consistent with
themselves, not as they are common to others
... Any countenance strikes most upon the
imagination ... which has most distinctness
from others, and most identity with itself.'
From the essay on 'Lucien Buonaparte's Col-
lection' (18: 86), it appears that such heads are
not to be expected among mechanics: a por-
trait of Lucien himself 'has just the appearance
of a spruce holiday mechanic, with all the
hardness, littleness, and vulgarity of expres-
sion which is to be found in nature, where the
countenance has not been expanded by
thought and sentiment'.

25. Reynolds's argument is countered by Hazlitt at
length in the essay 'On the Imitation of
Nature', *Complete Works*, 18: 70–7. See also
Eugene C. Elliott, 'Reynolds and Hazlitt',
Journal of Aesthetics and Art Criticism, 21:
1962, and L. M. Trawick, 'Hazlitt, Reynolds,
and the Ideal', *Studies in Romanticism*, vol. 4
(1965).

26. See also 'On Beauty', in *The Round Table*:
Complete Works, 4: 70. 'The historical in ex-
pression is consistent and harmonious,—
whatever in thought or feeling communicates
the same movement, whether voluptuous or
impassioned, to all the parts of the face, the
mouth, the eyes, the forehead, and shews that
they are all actuated by the same spirit.' For
Hazlitt's most extended account of Titian's
portrait of Hippolito de'Medici (1532—now in
the Pitti at Florence, but Hazlitt had seen it as
part of his 'Louvre experience', see above,
n. 15), see 'On a Portrait of an English Lady by
Vandyke', in *The Plain Speaker*: 12: 286–7.

27. Alison, 2: 336–46, and compare Mengs, 1: 22;
Reynolds, *Discourses*, 44.

28. For a longer account of how models 'block up
the path of genius', see the review of
Farington's *Life*, *Complete Works*, 16: 199.

29. These quotations are from a passage inter-
polated into Hazlitt's article by his son: see
Complete Works, 18: 39.

30. Compare Winckelmann's explanation of the decline of art, above, 44, 263; for Hazlitt's earliest but fullest account of that decline, see 'Why the Arts are not Progressive', *Complete Works*, 18: 5–10.

31. Quotations in this paragraph are from a passage interpolated by W. Hazlitt: see *Complete Works*, 18: 41 and n. The argument may again derive from Du Bos (2: 58–9); see also Hazlitt's review of Farington's *Life*, on the danger of studying art surrounded by examples of excellence in Rome, whose many variety inflames the student with an ambition to become 'all painters that ever were', 16: 199.

32. For other statements of this position, see for example the review of Farington's *Life*: 'A small part of nature was revealed' to each of the great masters 'by a peculiar felicity of conformation; and they would have made sad work of it, if each had neglected his own advantages to go in search of those of others, on the principle that genius is a large general capacity' (*Complete Works*, 16: 188). Or, in 'On a Portrait ... by Vandyke', 'there have been only four or five painters who could ever produce a copy of a human countenance really fit to be seen; and even of these few none was ever perfect, except in giving some single quality or partial aspect of nature, which happened to fall in with his own particular studies and the bias of his genius' (12: 29). Or, in 'On Genius and Common Sense', 'Genius ... does some one thing by virtue of doing nothing else: it excels in some one pursuit by being blind to all excellence but its own' (8: 42). For a less sanguine account of what is achieved by this blindness, see 'On the Qualifications Necessary to Success in Life' in *The Plain Speaker* (12: 195–209). *The Athenaeum* claims that English artists are 'illiterate', and imagines one of them asking 'What has a painter to do with books, except now and then to embellish them? Those may read who must write: let *him* [i.e. the artist] study the vast unlettered volume of Nature!' 'Thus,' argues the review, 'he remains lifelong depending on his single mind, which burrows for ever in its own barrenness; thus he remains ignorant of those grand principles, the fruit of protracted, painful, multifarious, co-operative researches and reflections, those philosophical *interiora rerum*, that alone give dignity to his art.' For this reason the 'fraternity' of English artists can 'never rank much above a guild of artizans'. The ignorance of English painters is compounded, further, by 'that politico-economic mania of our age for the division of labour: we have lost the skill, or the will, to develop the whole sum of powers called Man co-ordinately; if a boy exhibit genius with his pencil, he is sent to the school of design, and no other' (July 21, 512).

33. For the clearest account of how art extends the boundaries of the spectator's knowledge and awareness of nature, see 'On Imitation' in *The Round Table* (*Complete Works*, 4: 72–7).

34. Interpolated by W. Hazlitt; see *Complete Works*, 18: 38.

35. There is a strange moment in the review of Farington's *Life* when Hazlitt, attributing the difficulty of producing high art in England to 'our Establishment in Church and State', explains the success of the Italian masters in terms of the different function of the church in Italy: 'She ruled in the hearts of the people by dazzling their senses, and making them drunk with hopes and fears ... Art was rendered tributary to the support of this grand engine of power; and Painting was employed ... to ... rivet the faith of the Catholic believer. Thus religion was made subservient to interest, and art was called in to aid in the service of this ambitious religion.' The tone of this may express not only the dissenter's—by education, at least—dislike of the Catholic Church, but also Hazlitt's dislike of having to acknowledge the success of 'secondary causes' in thus promoting a great tradition of history-painting. But half a page later he has found a tone of appropriate enthusiasm. 'No elevation of thought, no refinement of expression, could outgo the expectation of the thronging votaries. The fancy of the painter was but a spark kindled from the glow of public sentiment. This was a sort of patronage worth having. The zeal and enthusiasm and industry of native genius was stimulated to works worthy of such encouragement, and in unison with its own feelings' (*Complete Works*, 16: 200).

36. *The Encyclopaedia Britannica* (*Supplement to the Fourth, Fifth, and Sixth Editions*, 1 (Edinburgh 1824): 594b, has 'at once the servant and the benefactor of the public'.

37. See above, 65.

38. The quotations here cited from p. 221 are from a passage interpolated by W. Hazlitt (*Complete Works*, 18: 38). For a more extensive account of the evils of public bodies, see 'On Corporate Bodies', in *Table Talk* (8: 264–7). Hazlitt's attack on public patronage is an attack on a position taken by many contemporary spokesmen for the Academy, in particular Shee and Prince Hoare, who writes in *An Inquiry* (92), 'England, as a state, is disgraced as long as the arts are left to individual patronage, however illustrious'. Compare his remarks in *The Artist*, a periodical devoted to publicising the need for public patronage: 'To become the favourite of the great and powerful, by an accommodation to their follies or vices, to humiliate talents, the gift of our Creator, to the purposes of luxury, or to render them the obsequious vassals of caprice ... to "give up to" a narrow individual "what is meant for mankind;"—when such are the conditions of patronage, what but disgrace and inward mortification awaits the pampered

victim!' (vol. 2, no. 5, 58–9). Compare also John Hoppner (vol. 1, no. 3, 11): 'It is not in the power, I fear, of individuals, however great their wealth, or ardent their admiration, to raise the arts to that level best calculated to draw forth the energies of the artist. Government alone, I believe, is competent to the task of bringing a nation to this just degree of feeling.'

39. For a similar account of the difference between the Greek and the modern public for art, see Mengs, 1: 34, 38.

40. Compare *The Athenaeum*, 21 July 1838, 511: 'Princes, with their retinue ... are no longer the committee of taste, which awards fastidious praise, censure, patronage. Almost the whole people may be said to have resolved itself into such a committee; and the middle class, by its superior aggregate of wealth, is now the chief patron of art ... What follows? Why, that the vast majority of works are made to suit medium taste, and wealth, and tenements; pretty, petty things, which display domestic scenes, "bits" of nature, or colour, or effects, portraits of dear nonentities. Popular opinion is on no subject more fallible than this, because purified judgment can only result from an experience too long and an education too refined for the many to attain.' The tendency of 'exhibitions and public patronage' [i.e. patronage by the public] is 'to fritter artistic power, and lower artistic aim, turn exhibition-rooms into bazaars for cheap ornamental chattels, and the pursuit itself into a manufacture of glittering toys for old children. Middle-class domination, with all its merits, has beyond doubt this deleterious effect.'

41. Interpolation by W. Hazlitt; see *Complete Works*, 18: 45.

42. *The Athenaeum* makes much the same point (21 July 1838, 511): among the causes of the decline of British art, it makes much of the fact that it 'is submitted to the public through *Exhibitions*, and so falls to the level of miscellaneous, instead of rising to the level of select judgment.'

43. For a clear statement of Hazlitt's belief that the representation of 'character' and 'expression' is the final end of painting, see 'Mr West's Picture of Christ Rejected', *Complete Works*, 18: 29–30.

44. James Nelson, *An Essay on the Government of Children*, 1756, 329.

45. In his essay 'Judging of Pictures' (*Complete Works*, 18: 182–3), Hazlitt appears at first to argue that the audience for art is a universal audience: 'What is a picture meant for? To convey certain ideas to the mind of painters? that is, of one man in ten thousand?—No, but to make them apparent to the eye and mind of all'. The aim of this remark, however, is simply to secure the position that painters are neither the sole, nor the best, judges of painting—he continues, later in the essay, 'I am far from

saying that *any* one is capable of duly judging pictures of the higher class.'

46. Hazlitt's notion that painting offers private satisfaction to an audience of private persons differs entirely from his notion of how plays are to be enjoyed. Paintings are best appreciated in private—if necessary, in the absence of the pictures themselves, if that also secures the absence of other spectators ('Lord Grosvenor's Collection of Pictures', *Complete Works*, 10: 49). The drama, however, should shape its audience at least into a community of taste of the kind envisaged by Fuseli in his eleventh lecture, and if possible into something very much like a civic republic of taste. 'The audience at a theatre', he writes in 'On Corporate Bodies', 'though a public assembly, are not a public body'—by which he means, they are not 'incorporated into a frame-work of exclusive, narrow-minded interests of their own. Each individual looks out of his own insignificance at a scene, *ideal* perhaps, and foreign to himself, but true to nature; friends, strangers, meet on the common ground of humanity, and the tears that spring from their breasts are those which "sacred pity has engendered". They are a mixed multitude melted into sympathy by remote, imaginary events, not a combination cemented by petty views, and sordid, selfish prejudices.' (8: 266n.) The fact, however, that in England, audiences do not act, and are not affected, as a community, leads him to propose a harder, civic ideal of what, ideally, a theatrical audience should be: 'We are Protestants even in our pleasures, rebels to our own comforts. Without a cabal, without a tilting-match, without a *row*, we can do nothing ... Hence we have no such thing as a theatrical public, though this is not for want of a national drama ... our own box-lobby loungers [are] much more ready to pick a quarrel with their next neighbour than to interchange opinions with him, or to join in admiring the performance. This, they think, would show a want of spirit and independence, and would be unworthy of the manly character of John Bull ... What we need, is a more Catholic spirit in literature; an Act of Uniformity in matters of taste and opinion. Till we have this, we shall be deficient in decency and zeal; and can never expect that "long pull, strong pull, and pull all together," which has been so earnestly called for, and which alone can ensure the triumph and permanence of any public object. What is the good of each person's having his own sulky or fanciful opinions in such matters, as he has his own pipe or pot of porter and newspaper, if there is no point of union, no common creed? Public enthusiasm and support is not made up of solitary whims—of chaotic elements.' ('Covent Garden Theatre', 20: 284–5.)

47. Ruskin, *Modern Painters*, part 4, ch. 17.

48. David Solkin, *Richard Wilson: The Landscape*

of Reaction, 1982; *The Daily Telegraph*, 18 November 1982; and see also Denys Sutton, editorial and 'A Meditative Love of Nature: the Richard Wilson Exhibition', *Apollo*, January 1983. For some account of the reaction to the Wilson exhibition and catalogue, see Alex Potts and Neil McWilliam, 'The Land-scape of Reaction: Richard Wilson and his Critics', *History Workshop Journal*, no. 16, Autumn 1983, 171–5, and Michael Rosenthal, 'Approaches to Landscape Painting', *Land-scape Research*, vol. 9, no. 3, Winter 1984, 2–13.

49. Ruskin, *Modern Painters*, part 9, ch. 5.

INDEX

Entries in italics refer to the location of the full titles and publication—details of works which in the notes are referred to either by author's names only, or by author's names and short titles.